MARVEL

GUARDIANS OF THE GALAXY

THE ART OF THE GAME

Marvel's Guardians of the Galaxy: The Art of the Game

ISBN standard edition: 9781789096743
ISBN limited edition: 9781789098266

Published by Titan Books
A division of Titan Publishing Group Ltd.
144 Southwark St.
London
SE1 0UP

First edition: November 2021

10 9 8 7 6 5 4 3 2 1

MARVEL GAMES
Amanda Avila—Associate Manager, Integrated Planning
Loni Clark—Associate Product Development Manager & Project Lead
Gary Clubb—Executive Director, Business Development & Product Strategy
Laura Hathaway—Associate Product Development Manager
Tim Hernandez—Vice President, Product Development
Dakota Maysonet—Creative Coordinator
Haluk Mentes—Vice President, Business Development & Portfolio Strategy
Eric Monacelli—Senior Director, Product Development & Project Lead
Jay Ong—Executive Vice President
Bill Rosemann—Vice President, Creative
Tim Tsang—Creative Director

DID YOU ENJOY THIS BOOK?
We love to hear from our readers.
Please e-mail us at: readerfeedback@titanemail.com or write to Reader
Feedback at the above address. To receive advance information, news,
competitions, and exclusive offers online, please sign up for the Titan
newsletter on our website: www.titanbooks.com

A CIP catalogue record for this title is available from the British Library.

Printed and bound in China.

MARVEL
GUARDIANS
OF THE
GALAXY

THE ART OF THE GAME

MATT RALPHS

TITAN BOOKS

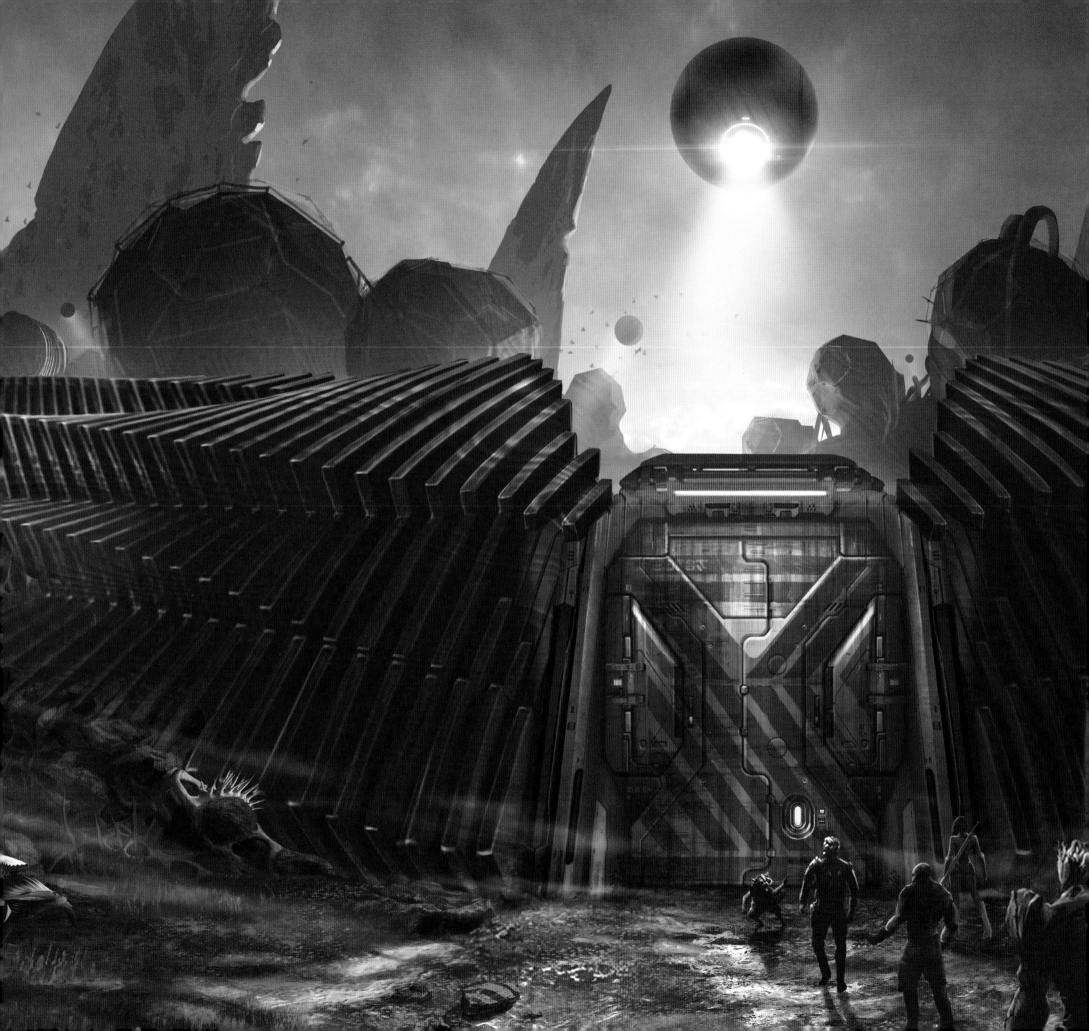

CONTENTS

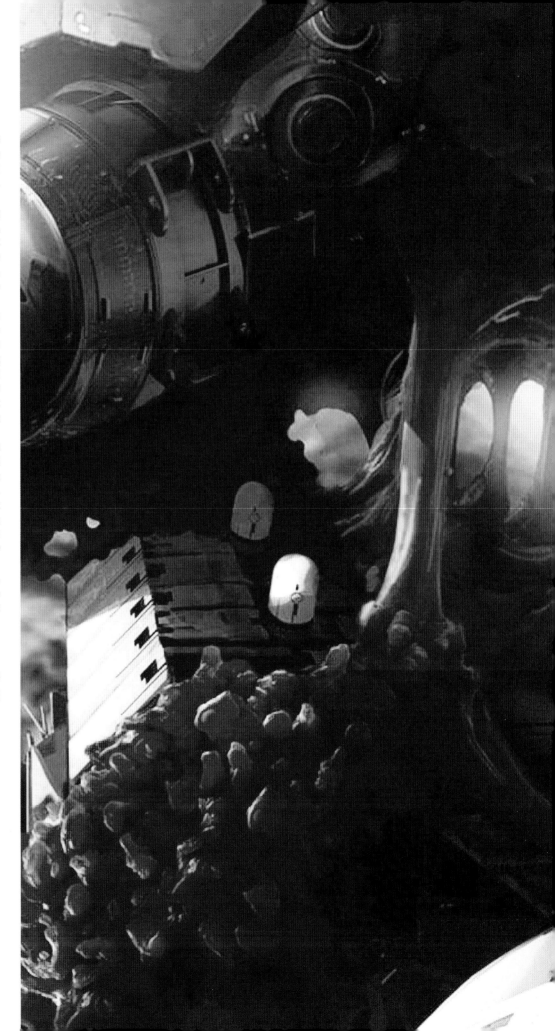

FOREWORD 001

Welcome to this beautifully crafted *Marvel's Guardians of the Galaxy* art book!

I remember the early days of this adventure when we traveled from Montréal to Los Angeles to meet the people at Marvel Games for the first time. We were introduced to a bunch of passionate individuals who, like us, wanted to create a rich and deep game experience—one which embraces the uniqueness that makes the Guardians of the Galaxy universe so exciting to explore. They shared with us their ideas, their deep knowledge about what makes this group of misfit heroes very special, and most importantly, they shared their love for their characters.

And what is not to love about them? Gamora, Groot, Drax, Rocket, and Peter Jason Quill are so uniquely different, and yet they all have the same things in common: they are flawed and tend to screw up (often), but deep down inside, they all have a heart of gold and the same desire to be accepted and loved. In many ways, these characters aren't that different from us human beings. I believe it is a big reason why the Guardians resonate so strongly with people across the world. It is a big reason why they resonated with our team and why we fell in love with them, too.

This art book is an expression of the journey we took on to find our own visual identity for the *Marvel's Guardians of the Galaxy* game. You will see tons of concept art, in which we explored how characters, props, and locations might appear. You will see how early iterations informed the final look of things you see in the game. In a nutshell, this book is taking you with us into our minds as we developed the game's visual identity.

When it comes to giving life to characters and worlds in our games, we at Eidos-Montréal like to push the envelope. We like to provoke strong reactions that, hopefully, resonate positively with you, our players. Admittedly, in the process of fleshing out the aesthetics of our games, we sometimes push too far. But when we do, we always work hard to iterate until it feels right. It's a central philosophy that guides us on the path to originality, to the main visual hooks for any project we take on.

Ultimately, our objective is to give you something to remember. Something to wow you, and at times, something that will get you out of your comfort zone. We believe that if we do our job well, this recipe will have a lasting effect on you, our players, long after you put the controller down. It will make the game hold a special place in your heart.

I need to thank Marvel's Bill Rosemann, Tim Tsang, Loni Clark, and Eric Monacelli, to name just a few, for keeping an open mind all the way through and helping us achieve our vision while staying authentically Marvel. Without their blessing and support, you wouldn't experience the game the way it is now. In the end, it was as important to them as it was to us to deliver something special that would be worth discovering for old and new fans alike.

Marvel's Guardians of the Galaxy is a game filled with twists and turns, where deep, emotional moments coexist with silly and funky ones that will trigger good laughs or, at least, lots of smiles. We wanted the art of the game to reflect that lighthearted vibe, too, by making you explore colorful landscapes, meet crazy aliens and characters, but most importantly, awaken your sense of wonder.

Let's be clear, the real heroes here are all of you, especially in these challenging times. But even the best heroes need a little break and something to make them smile.

Jean-François Dugas
Senior Creative Director, Eidos-Montréal

RIGHT: Star-Lord and the candy-pink world of the Quarantine Zone.

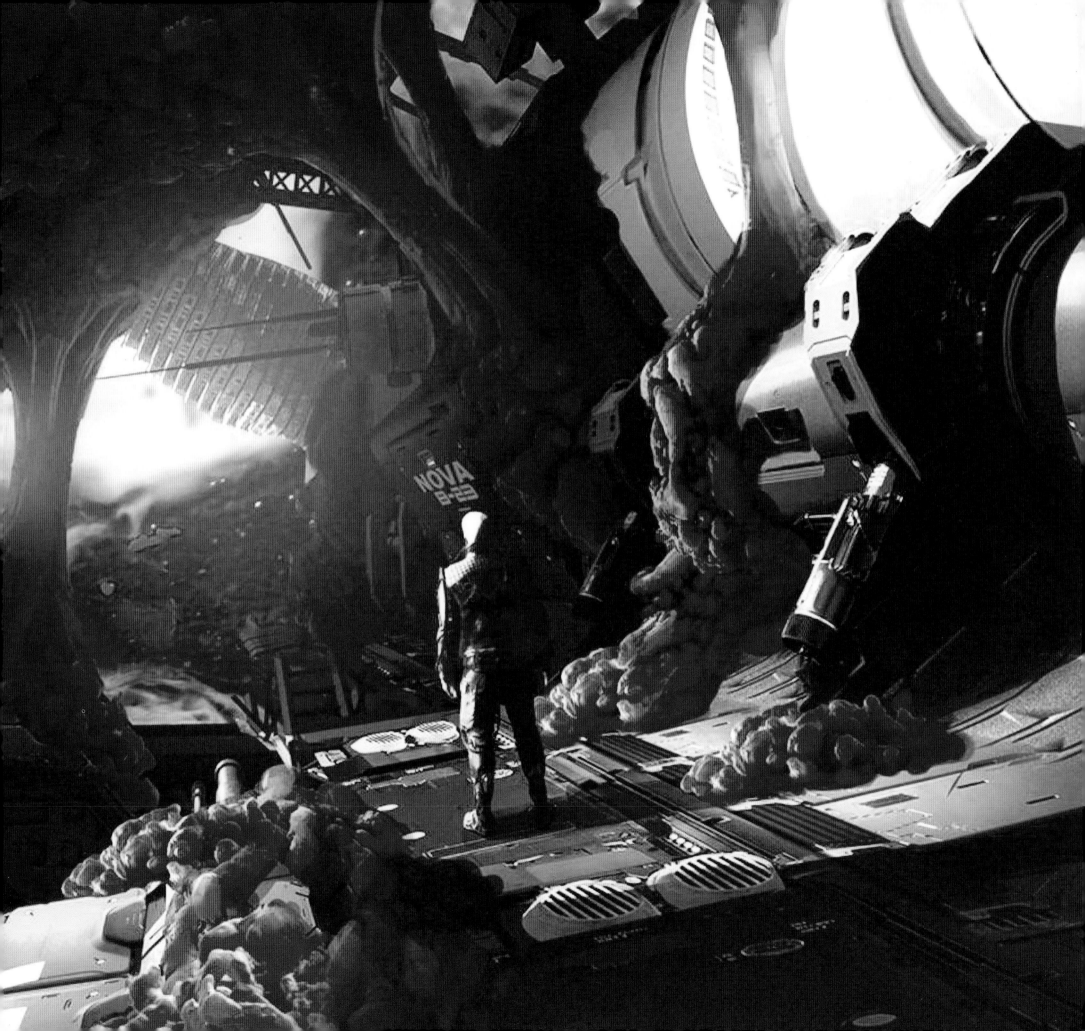

FOREWORD 002

Take a look at the Guardians of the Galaxy and what do you see? A thief, an assassin, a destroyer, and two bounty hunters? A rock 'n' roll pirate, the most dangerous woman in the galaxy, a tattooed madman, a walking tree, and a talking raccoon? Misfits, rebels, and outsiders? Yes, I see all of that, too... But most importantly, I see a family.

The genius of the Guardians was baked into the team's first appearance in the pages of 1969's *Marvel Super-Heroes #18* by legendary comic book creators Arnold Drake and Gene Colan. Sure, the team's roster was different, but at their core, they were desperate survivors, each the last remaining member of their respective alien races. Determined to stop the murderous Badoon from continuing their path of destruction across the universe, the motley crew banded together as heroic freedom fighters.

Throughout the decades and the group's numerous revamps, it is that common connection—and not their differences—that defined them: they were unique loners with a shared trauma, in search of healing through finding their purpose and a sense of belonging. A found family that together are so much more than the sum of their parts. They are the cast aside, the dismissed, the mocked, the underestimated, the 'less than.' In short, they are us.

It was in the spirit of that mighty Marvel tradition that, when asked to oversee the 'cosmic' corner of our comic book line in 2006, I spread out my collected library of The Official Handbook of the Marvel Universe on the floor and poured through numerous pages, seeking to build a roster for a cosmic team comprised of lovable underdogs deserving of a second chance.

As I was hunting, my wife Ali Farrell walked into the room asking, "Billy, what are you doing? You're making a mess!"

"Honey," I responded, holding up an issue. "I'm putting together a new sci-fi team, and here's our star!"

"Is that a squirrel?" she asked.

"No!" I said, excitedly. "It's a raccoon... It's Rocket Raccoon!"

Now here's the truth: those of us who are lucky enough to work in the hallowed halls of the 'House of Ideas' as part of the editorial team are merely the behind-the-scenes custodians. It is the brilliant writers and artists who truly forge the magic, in this case Jim Starlin (creator of both Gamora and Drax), Bill Mantlo and Keith Giffen (creators of Rocket Raccoon), Steve Englehart and Steve Gan (creators of Star-Lord), and Stan Lee, Larry Lieber, and Jack

Kirby (creators of Groot). I also give a well-deserved tip of my Nova helmet to the aforementioned Keith Giffen and Timothy Green, who established the look and relationships between Peter Quill, Mantis, Rocket Racoon, and Groot in the pages of 2007's *Annihilation: Conquest – Starlord*. The MVP of our creative team is obviously Dan Abnett who, along with writing partner Andy Lanning, completely overhauled, expanded, and elevated the Guardians, adding not only Drax and Gamora to the roster, but also inventing Cosmo and Knowhere during their fan-favorite run between 2008 and 2011. In fact, it was Dan who first asked if we could dust off the then-unused Guardians of the Galaxy name for our modern group in classic Marvel 'recycling' fashion. Finally, the world can thank Kevin Feige, James Gunn, and the amazing cast and team at Marvel Studios, who then transformed the core comic material into a transcendent pop-culture juggernaut. Yes, it took a village of amazing storytellers to create and then recreate the Guardians... And that's where the skilled artisans at Eidos-Montréal come in.

What began as a meeting of fans—of each other and the characters—grew into a multi-year collaboration that, like Groot himself, started with a seed of an idea and bloomed into the mighty tree with its endless branches of glorious visuals, sounds, characters, technology, and worlds. Diving into the vault of comic books, animation, and films, the Eidos-Montréal team, led by studio head David Anfossi, executive game director Jean-Francois Dugas, executive narrative director Mary DeMarle, art director Bruno Gauthier-Leblanc, and anchored by senior producer Olivier Proulx, absorbed the very marrow of the Guardians, internalized it in their minds and souls, and then—with great respect, but also a touch of rebellion—crafted a version of our scrappy crew that is instantly recognizable yet surprisingly unique.

Marvel's Guardians of the Galaxy is the full-throttle, jaw-dropping, rib-tickling, leg-slapping, mind-expanding rock-'n'-roll saga blasting forth, direct from the visionaries at Eidos-Montréal. It is in turns fun, scary, challenging, hilarious, dramatic, thrilling, and wild.

In other words, it's you, it's me, it's family... It's us.

Bill Rosemann
VP, Marvel Games

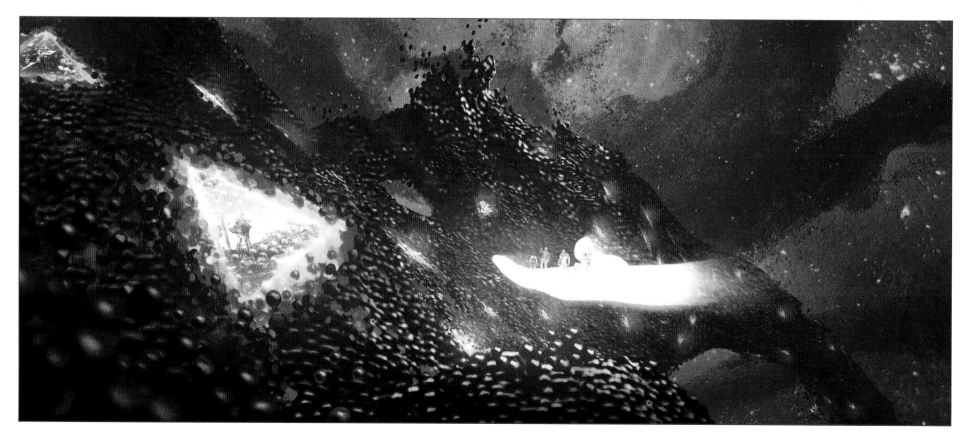

ABOVE: The Guardians of the Galaxy travelling through the Continuum Cortex.

OPPOSITE: On the off chance that you don't know who these guys are, from left to right: Rocket, Drax, Peter Quill aka Star-Lord, Gamora, and Groot.

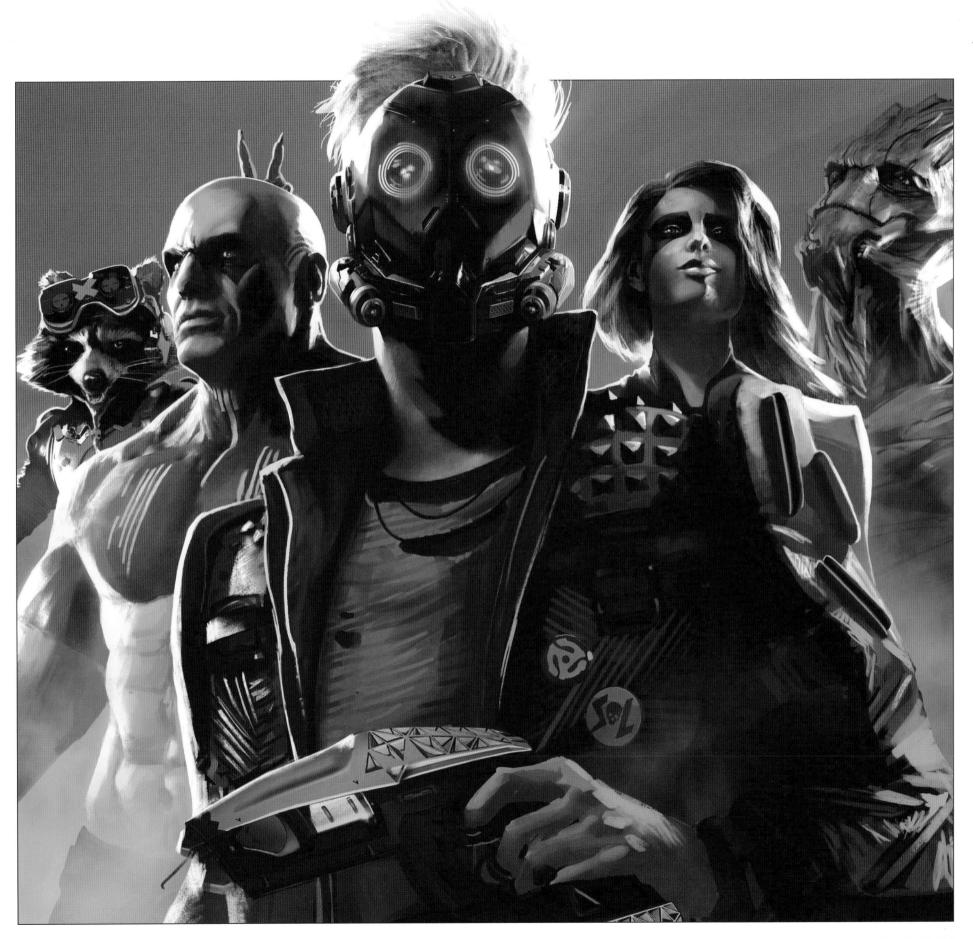

INTRODUCTION

It's hard to overstate the pressure that comes with developing a AAA video game based around a beloved Marvel property such as *Guardians of the Galaxy*. Even a seasoned developer such as Eidos-Montréal, creators of the critically acclaimed *Deus Ex* series, knew that they were facing a hitherto unprecedented challenge—a challenge that required a steady hand on the tiller.

"My role as senior creative director was to come up with the vision for *Marvel's Guardians of the Galaxy*," says seasoned video game developer Jean-François Dugas. "But I didn't do it alone— I had a crew of close collaborators. Together we decided what player experience we wanted to create, and what the game's hook and story would be. We nailed all this down in the early stages, and after that I became the captain of the boat, ensuring that we stayed on course to reach our final destination."

Let's start at the beginning. "I wrote two things on a whiteboard when we began work on conceptualizing the game," Dugas explains. "'How do we leverage the IP that we have in our hands to create a unique experience?' and 'It needs to be a great game first.' In the end, we found our hook on the first day of brainstorming: we wanted the player to enjoy a personal journey as Peter Quill, the leader of this band of misfits, surrounded by the other four characters. That is how we started."

Then came the mammoth task of realizing the initial vision and making the inevitable changes along the way. "A large part of my job is to review the work done by all the development teams, even down to the smallest detail," Dugas continues. "I maintain a holistic view of everything, from start to finish. For example, we might create something and think it works well, but when we play-test it, people get confused or don't understand. So we have to go back to the drawing board to find solutions and make changes, while also ensuring those changes don't disturb the rest of the game. This is the sort of thing I have to keep an eye on."

Some changes were small, others far more fundamental. Animation director Darryl Purdy elaborates, "We actually started out with a much slower game, where the player was just going to hang with the Guardians for a while. But there was always something in the back of our minds, which was like, *Mmm, is this right? After all, we're in the wilder side of the Marvel Universe here, so maybe we need to up the pace.* So we made that shift and sped things up."

This desire for speed extended to the story. Eidos-Montréal strove for something fast paced, exciting, and with plenty of heart. "I'm drawn toward narratively driven games," Purdy continues. "As a child growing up in the 1980s and '90s, movies were a big thing for me. When I started

HIS SPREAD: Eidos-Montréal used a large stable of talented concept artists to help them visualize and create the game's many exciting locations and set pieces.

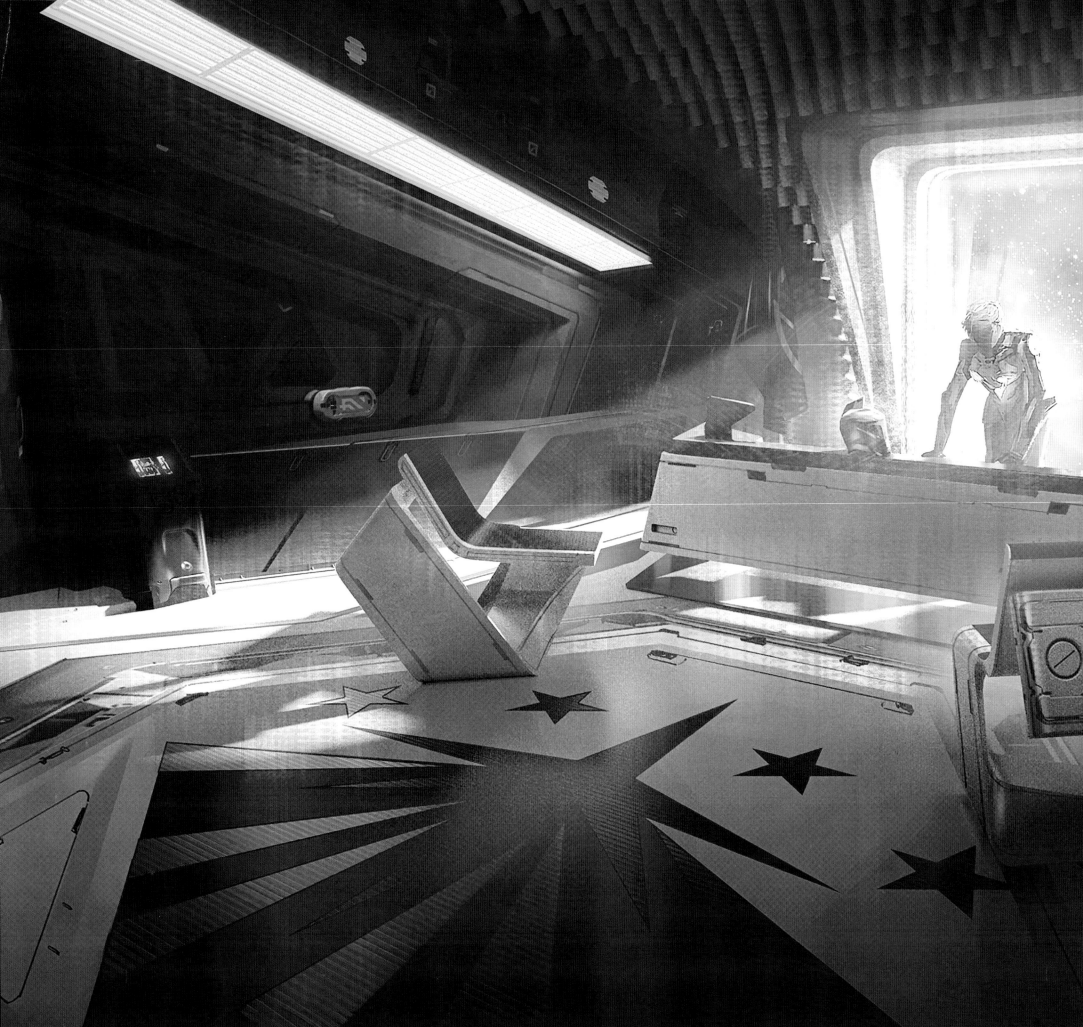

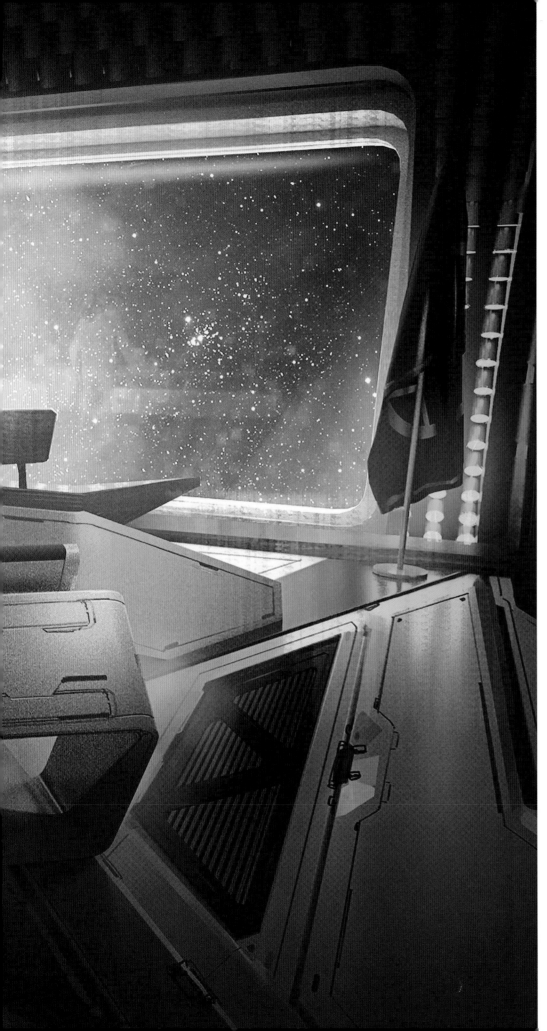

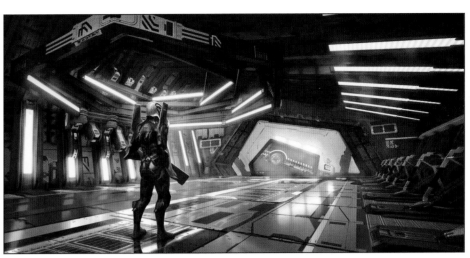

THIS SPREAD: With a whole science-fiction universe to build and plenty of creative leeway given by Marvel, Eidos-Montréal's previous experience of designing pretty much everything that appears in their games from scratch came in handy. Here, we see Nova Corp interiors.

getting into video games, I wanted to play the action heroes I loved when I was younger. I like to be taken for a ride and be able to stand in the shoes of a well-defined character. When I read the script for *Marvel's Guardians of the Galaxy*, I actually laughed out loud. I thought it struck a nice balance—one moment I'd be laughing, and then the tone would shift into something more emotional, tugging on my heartstrings but without it feeling forced. The tones flow really well. I hope the players feel that, too."

Eidos-Montréal's history of creating brilliant story-rich video games served them well with the Guardians, and they knew how to use all the tricks of their trade to create an interactive experience. "We wanted to impart our narrative not just in traditional storytelling techniques like cinematics," Purdy explains, "but also by threading narrative through the gameplay experience. One of the things we developed early on was a 'banter system,' which had to do with how our Guardians talked to each other throughout the game.

"There are 'passive' storytelling conversations, when they talk about things that have happened to them—past exploits, that sort of thing. But there's also 'active' banter that the player can be involved in as well. When the characters are talking, the player can interact by choosing what conversational response to give. All of this happens when the player is 'on-the-sticks,' navigating through the world and even in the middle of combat."

"I really want the player to lose themselves in the game, and then realize there are deep emotional issues going on at the same time," executive narrative director Mary DeMarle adds. "I want them to come away from it feeling affected, for it to have taught them something, as well as being fun."

"We wanted a unique take on science fiction—pop-y, fun, and fresh—a unique vibe and visual style that the player won't have seen before," says Dugas, before going on to talk about something every fan expects from a Guardian's story: humor. "We knew the Guardians of the Galaxy has a strong comedic element. Mary DeMarle and I worked together on *Deus Ex: Human Revolution* [2011] and *Mankind Divided* [2016], which are these very dark and philosophical games. At the start of this project, Mary told me how scared she was about working on Guardians. She said, 'JF, I don't know how to be funny!' But we discovered we could do it."

"I would categorize this game as a comedy," Rocket actor Alex Weiner agrees, hopefully dispelling any lingering doubts in DeMarle's mind. "And like all the best comedies, it also includes some very dark moments that show you the inner workings of life. It's a testament to the narrative team at Eidos-Montréal that the story goes to some really deep places. I think gamers are going to be refreshed when they experience a story that deals with some very mature topics. I would venture to say that this is the best written project I've ever worked on."

Senior audio director Steve Szczepkowski has strong views on what he wants this game to be, and what he wants it *not* to be. "I believe a video game should give the player an experience, a feeling that they've gone through something. A great game generates reaction; I feel the worst thing for our game would be if it generates no reaction at all. Flatline is boring. I'd prefer it if people didn't like it, because then I could say to myself, 'Well, fair enough, but at least that's a reaction.'" Then he smiles and says, "This is like no other game I've ever played. The fun-factor is up to eleven, which is what you want with this kind of brand. I love it."

HE GUARDIANS OF THE GALAXY

Big budget, high-profile video games such as *Marvel's Guardians of the Galaxy* can live or die on any number of things: story, graphics, gameplay; botch even one of these areas and the project could collapse and disappear into a black hole. One thing Eidos-Montréal absolutely *had* to get right was their Guardians: their design, the cast, and how the characters work as a team to enhance the gameplay experience.

"Right from the start, we knew we were dealing not with one main character, but the whole Guardians team," says executive narrative director Mary DeMarle. "Although we had to focus on the player character [Star-Lord], we also wanted each member to have a story arc of their own. Marvel is really keen for their characters to have moments where the audience sees them overcome their problems—doing this for all the Guardians was a challenge, but also a really fun thing to do."

The care and attention given by the writing team to each character certainly chimed with the cast. Drax actor Jason Cavalier says, "Every Guardian gets their moment to shine, and I think the players will finish the game with an appreciation and deeper understanding of these characters. That was not something that I expected, but it is really cool."

"The Guardians are genuine people," senior creative director Jean-François Dugas adds. "They're always true to themselves and they have no filters—they'll come forward with what they think and what they believe, whether they agree with each other or not. They're blunt, but not mean; they clash, they're confrontational, but it never comes from a bad place because they all have heart. Their defensive attitudes stem from the fact that they've been hurt, and I think that makes them very relatable."

As the tale advances, the Guardians change as individuals and as a team. "There's a lot of tension between them at the beginning of the game," Rocket actor Alex Weiner says. "In our story, they've only recently got together and they're not yet sure of each other's allegiances; think of it like being in an elevator with four other strangers... and the elevator breaks down! A lot of the tension comes from Rocket and Star-Lord's relationship, because they both have very different ideas on how to make this thing called the Guardians of the Galaxy work."

Characters only really stand up when they seem real—forged in the fires of their past experiences. "I think this is a story about orphans, family, and finding a place where you belong," Weiner continues. "Rocket was born in a lab; Groot lost his entire planet; Drax lost his family; Gamora was psychologically abused by Thanos; and Star-Lord lost his mother. Each of the characters start the game with their trauma cut fresh into them, but over the course of the game, as they run into countless obstacles and enemies, we see them accept each other and become a family."

"Loss and coming to terms with loss is something that brings the Guardians together," Star-Lord actor Jon McLaren agrees. "Peter was held captive during the Galactic War; Gamora ended up killing her sister; Drax's family was murdered and he was left alone; Rocket had to escape imprisonment; and Groot's planet was destroyed. The losses we suffered in the Galactic War made us into drifters, and we ended up together, striving to survive."

BELOW: Various treatments of the Guardians' emblem.

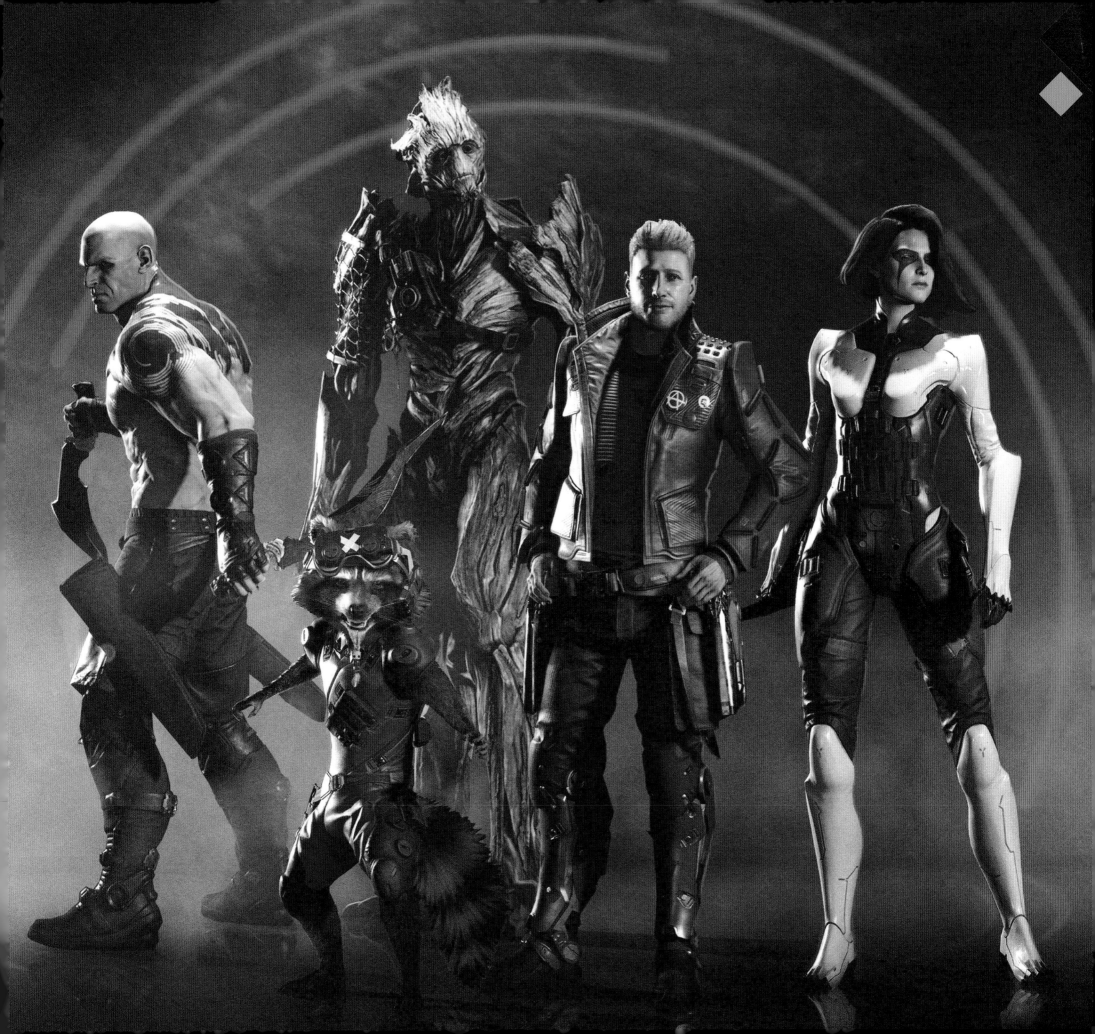

tells them that's his name."

This stroke of inspiration fed directly into Peter's look. Gauthier-Leblanc continues, "Because Peter's kidnapped during his 1980s Star-Lord-loving phase, he never breaks from that style. He adds studs,

artist Nicolas Lizotte. "We ended up with a backlit image of a character on a hoverbike with a guitar and a gun, bashing away at an army of lizard men. It adds a lot of storytelling and speaks to Peter Quill's character—the image is almost his hero alter ego."

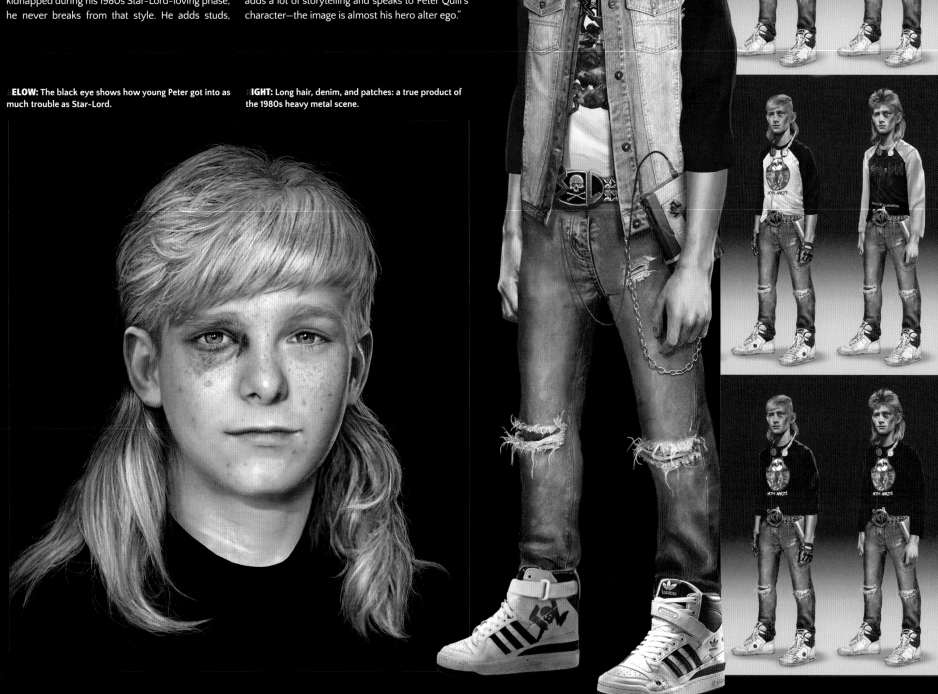

BELOW: The black eye shows how young Peter got into as much trouble as Star-Lord.

RIGHT: Long hair, denim, and patches: a true product of the 1980s heavy metal scene.

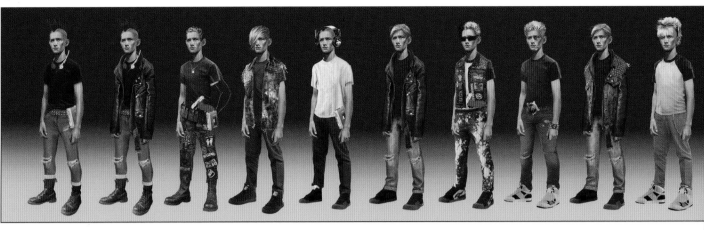

ABOVE & RIGHT: Young Peter in a motley array of punk- and metal-inspired outfits.

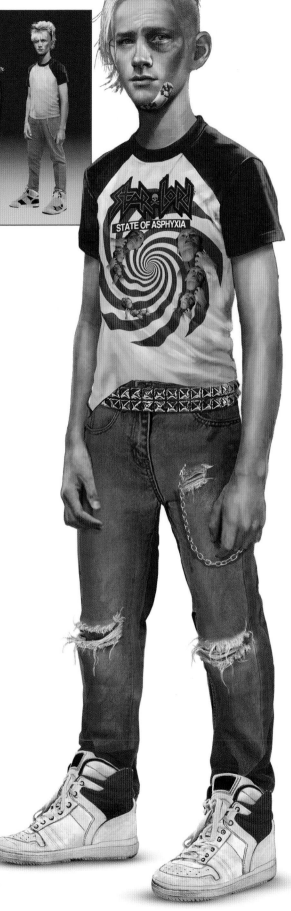

BELOW: Peter's Walkman, complete with worn Star-Lord sticker.

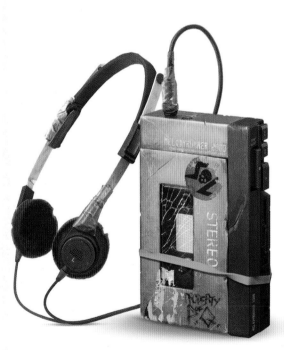

RIGHT: Not only did Eidos-Montréal create an 80s-themed album cover for the band Star-Lord, they also recorded a whole album of original songs.

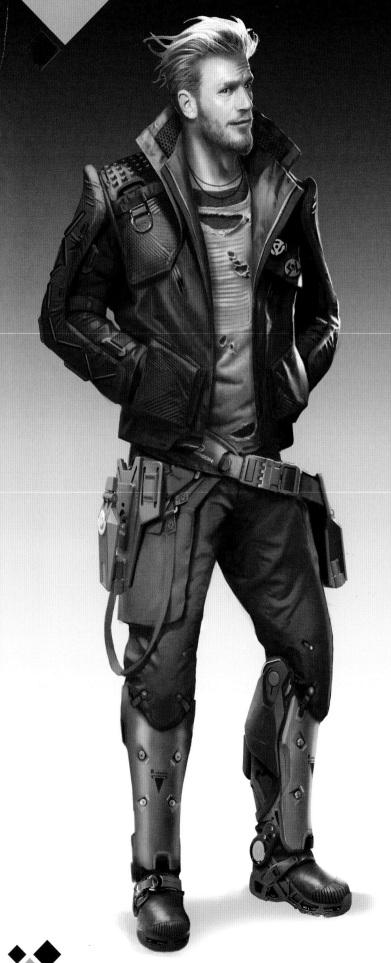

And why stop at a patch and album cover? Anything less than a full CD of original music would just be lazy, right? "I loved the idea of this band, Star-Lord," enthuses senior audio director Steve Szczepkowski, "and the creative team suggested I write a few songs for them. Well, I've been playing rock 'n' roll my whole life, so I hooked up with a musician buddy to record a demo. I was most influenced by the new wave of British heavy metal—bands like Iron Maiden, Saxon, and Judas Priest."

But Szczepkowski's work didn't finish with the demo. "We were planning on hiring people to re-record it," he says with a smile, "but when our creative director heard the demo, he said, 'Steve, is that you singing? I love it!' So on top of doing the game's audio design, I've also written and recorded a ten-song album! When the player starts the game, there's a Walkman loaded with Star-Lord tracks that they can listen to."

So from Star-Lord the band became Star-Lord the man. It's no small task to play the lead role in an AAA Marvel video game,

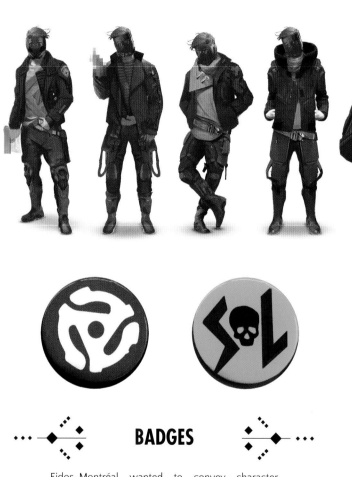

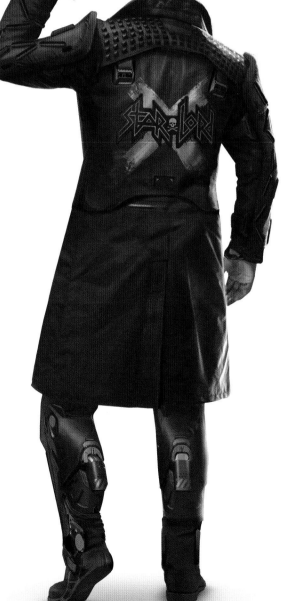

BADGES

Eidos-Montréal wanted to convey character information with the detailing of their outfits. These badges hint at Star-Lord's love of the 1980s—the only Earth time he's ever really known.

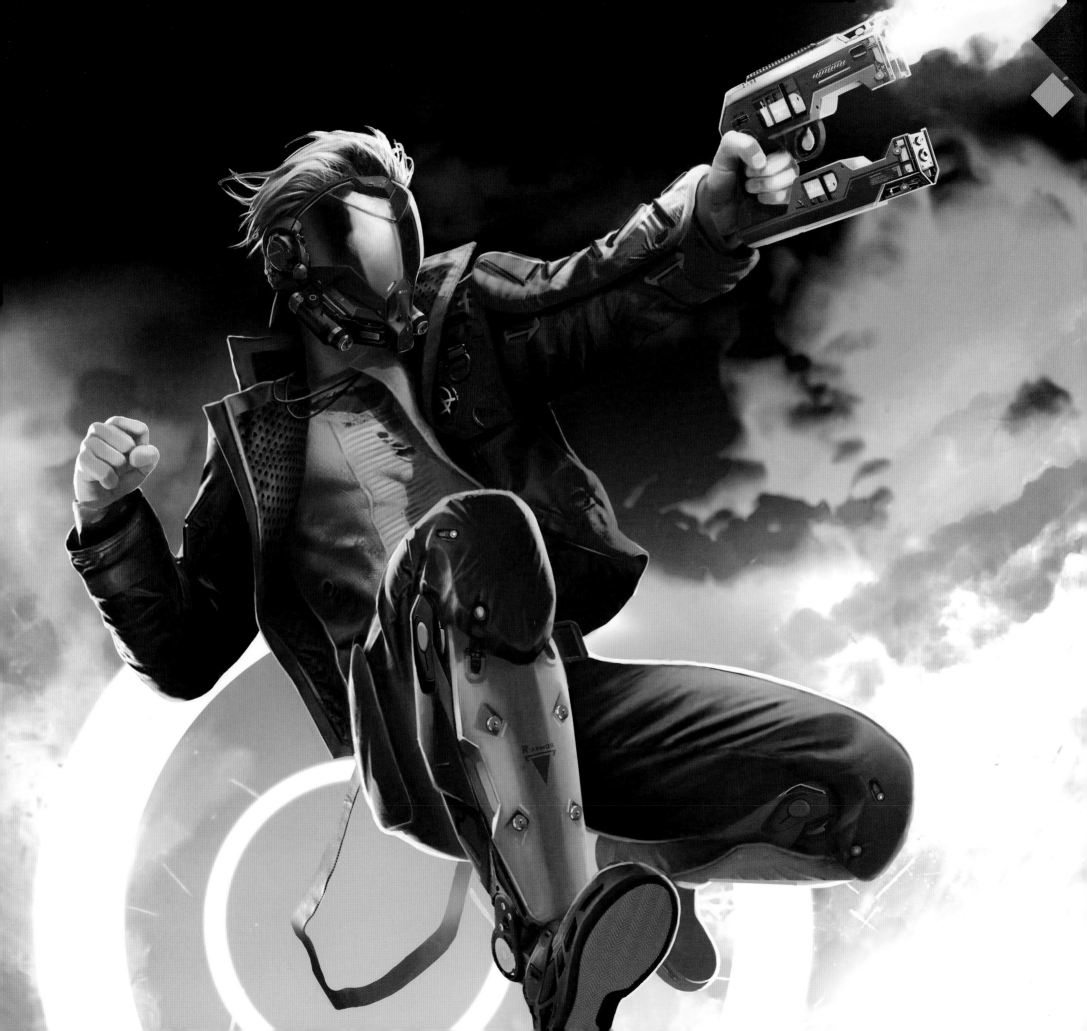

but no one had any doubts that actor Jon McLaren was perfect for the role—although McLaren himself had to overcome some initial (and understandable) nerves. "Getting to play an iconic character like Star-Lord was a massive opportunity—and also a little scary!" McLaren laughs. "I felt the pressure! Chris Pratt played him in the movies, and even though Eidos-Montréal didn't want us to replicate the MCU actors' performances, it was still in the back of my mind that I had big shoes to fill."

McLaren dove headfirst into his task and discussed Peter Quill in detail with the writing team. "Peter often tries to avoid a lot of his problems, and he deflects using humor. He's a bit of a screwup, but he has good intentions. One of the things I love about him is that, ultimately, he always tries to do the right thing. He might get up to some shady stuff and he's always getting into trouble, but deep in his core, he's a good guy with a great heart."

RIGHT: One of Star-Lord's suit designs: stealthy, practical, and combat ready.

ABOVE: One of the many animations that had to be designed and implemented: how Star-Lord pulls and holsters his sidearm.
BELOW: Previous iterations of Star-Lord's outfit.

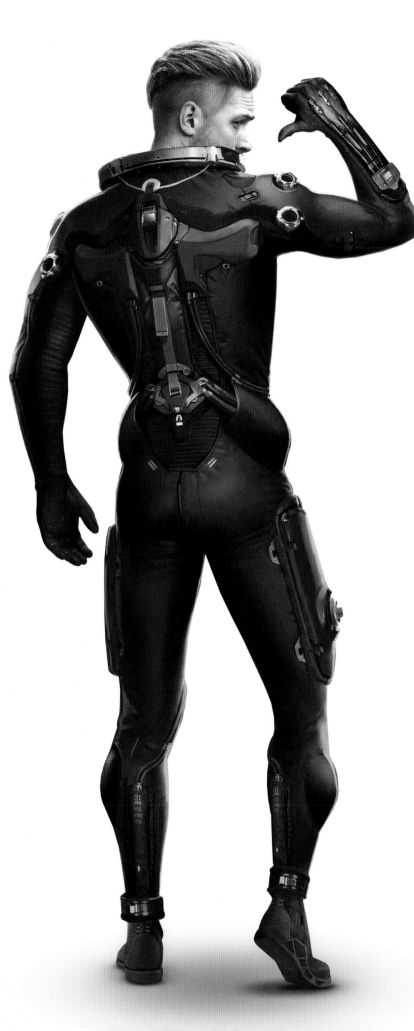

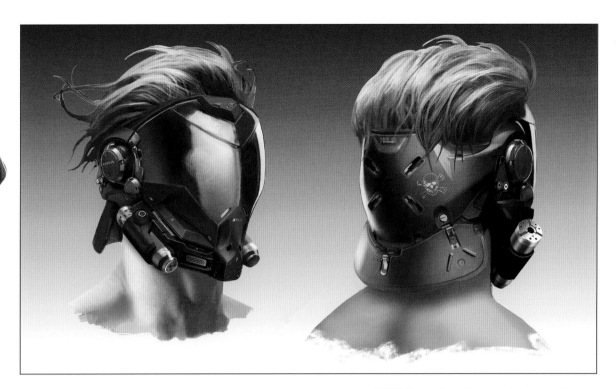

BELOW: Armored boots with rocket boosters.

It's clear that McLaren is fond of Peter. "What he does best is escape sticky situations using wit and charm. He's a survivor, he's charismatic and easy to like. It's funny, because even though Peter's mouth is one of his greatest weapons, it's also what gets him into trouble in the first place! But he's an eternal optimist; he really does think that he can get out of any situation he finds himself in. He has this infectious personality, and he gives people faith that they, too, can survive anything— I think that's one of the reasons the other Guardians stick with him."

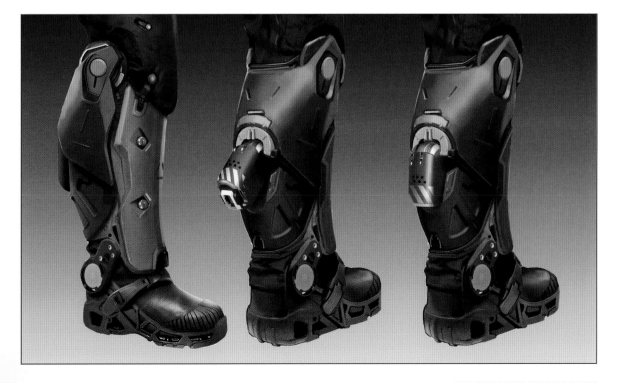

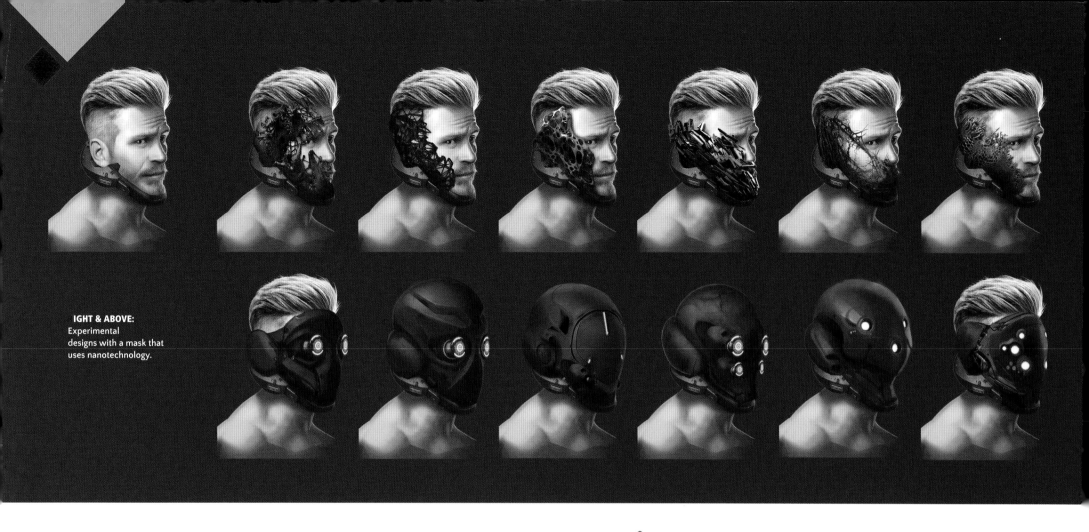

IGHT & ABOVE:
Experimental
designs with a mask that
uses nanotechnology.

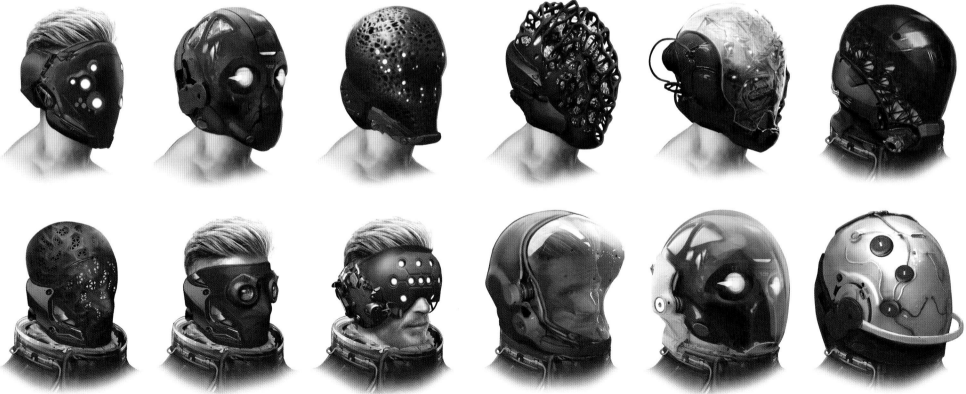

ABOVE: More mask designs, some more extreme and weird than others. In the end, Eidos-Montréal settled on one similar to that used in the movies.

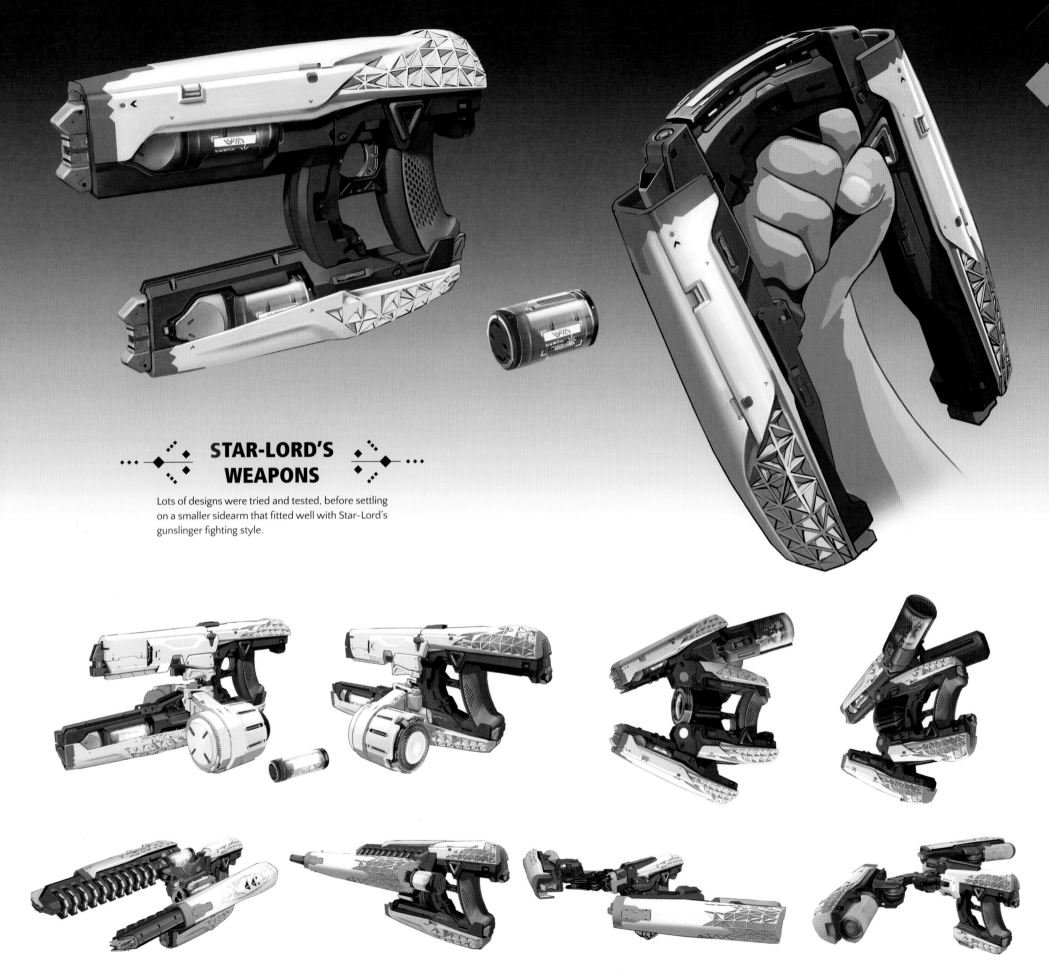

STAR-LORD'S WEAPONS

Lots of designs were tried and tested, before settling on a smaller sidearm that fitted well with Star-Lord's gunslinger fighting style.

BOVE: Combat for Drax is a close and intimate affair, so a knife is the best tool for the job.

THIS PAGE: Drax's tattoos represent enemies he's killed in combat—blood red ink, of course.

ABOVE: Tattoos under the eyes add to Drax's fearsome appearance.

DRAX

Veteran actor and stuntman Jason Cavalier has long been a Super Hero fan, so after landing the plum role of Drax, he gave his performance a lot of thought. "I didn't want my Drax to be too bombastic," Cavalier confides. "He's big and over the top, and for me as an actor, that's not a natural place to go. To be honest, I found it a bit of a challenge. The last time I performed anything that was larger than life was Shakespeare at university! During some moments, I was able to lose myself in the character—I really *was* on another planet or on the *Milano*. With a strong imagination, you can overcome the fact that you only have a plastic chair to sit on and a wooden box doubling as a control panel. I guess I did alright [laughs]. I can only hope I did a good job and that I don't disappoint anyone."

Never for a moment taking this role for granted, Cavalier turned to some classic sources for inspiration. "I looked at some older movies. I studied Alan Hale Sr.'s larger-than-life performance of Little John in Errol Flynn's *The Adventures of Robin Hood* [1938]. I drew inspiration from Yul Brynner's King Mongkut of Siam in *The King and I* [1956]—his vocal rhythms, movement, and poses. And also, believe it or not, Leonard Nimoy as Spock, because there's a certain stoicism to Drax when he doesn't understand something.

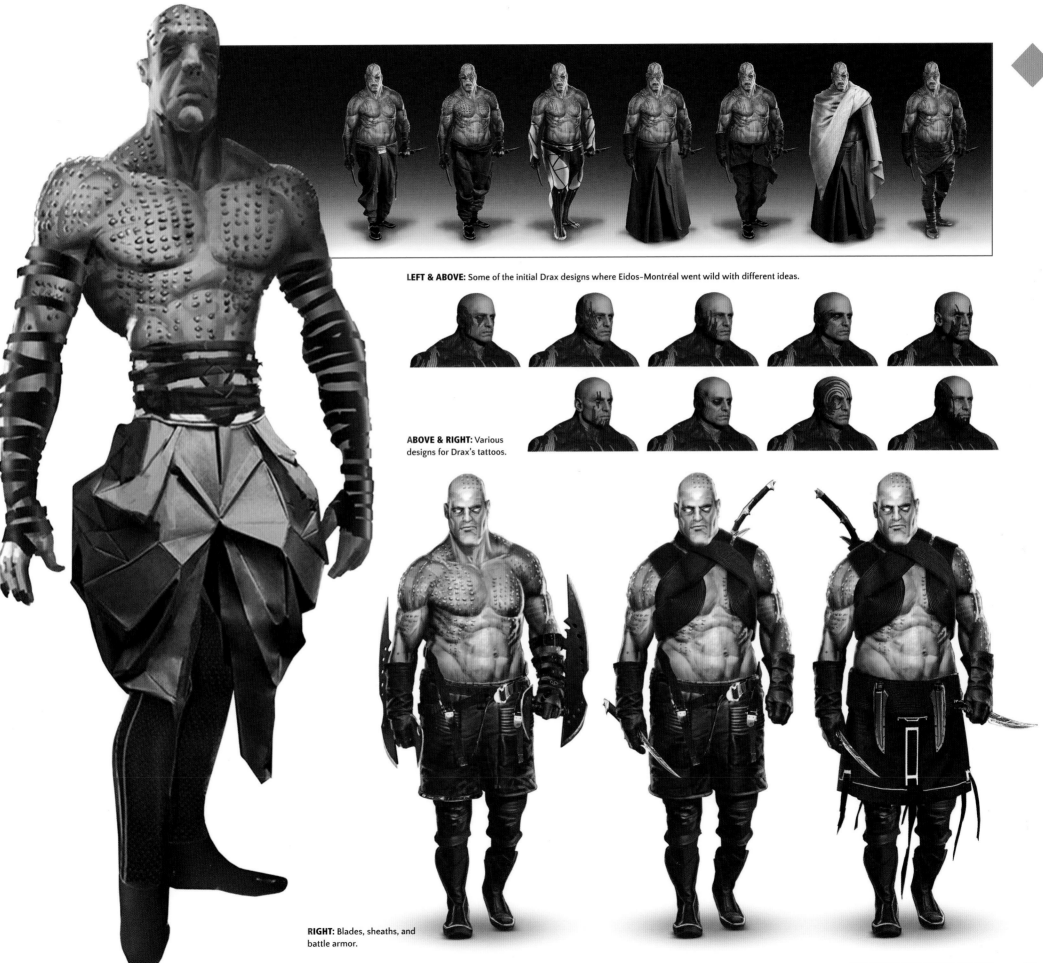

LEFT & ABOVE: Some of the initial Drax designs where Eidos-Montréal went wild with different ideas.

ABOVE & RIGHT: Various designs for Drax's tattoos.

RIGHT: Blades, sheaths, and battle armor.

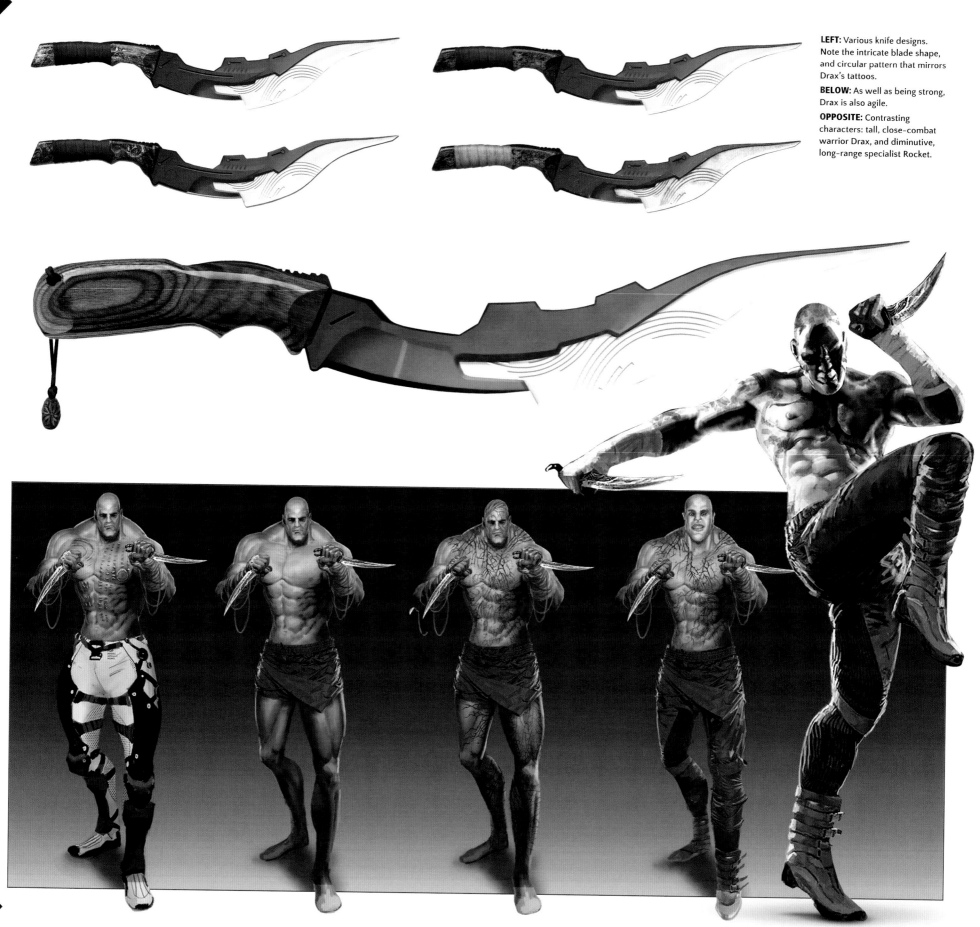

LEFT: Various knife designs. Note the intricate blade shape, and circular pattern that mirrors Drax's tattoos.

BELOW: As well as being strong, Drax is also agile.

OPPOSITE: Contrasting characters: tall, close-combat warrior Drax, and diminutive, long-range specialist Rocket.

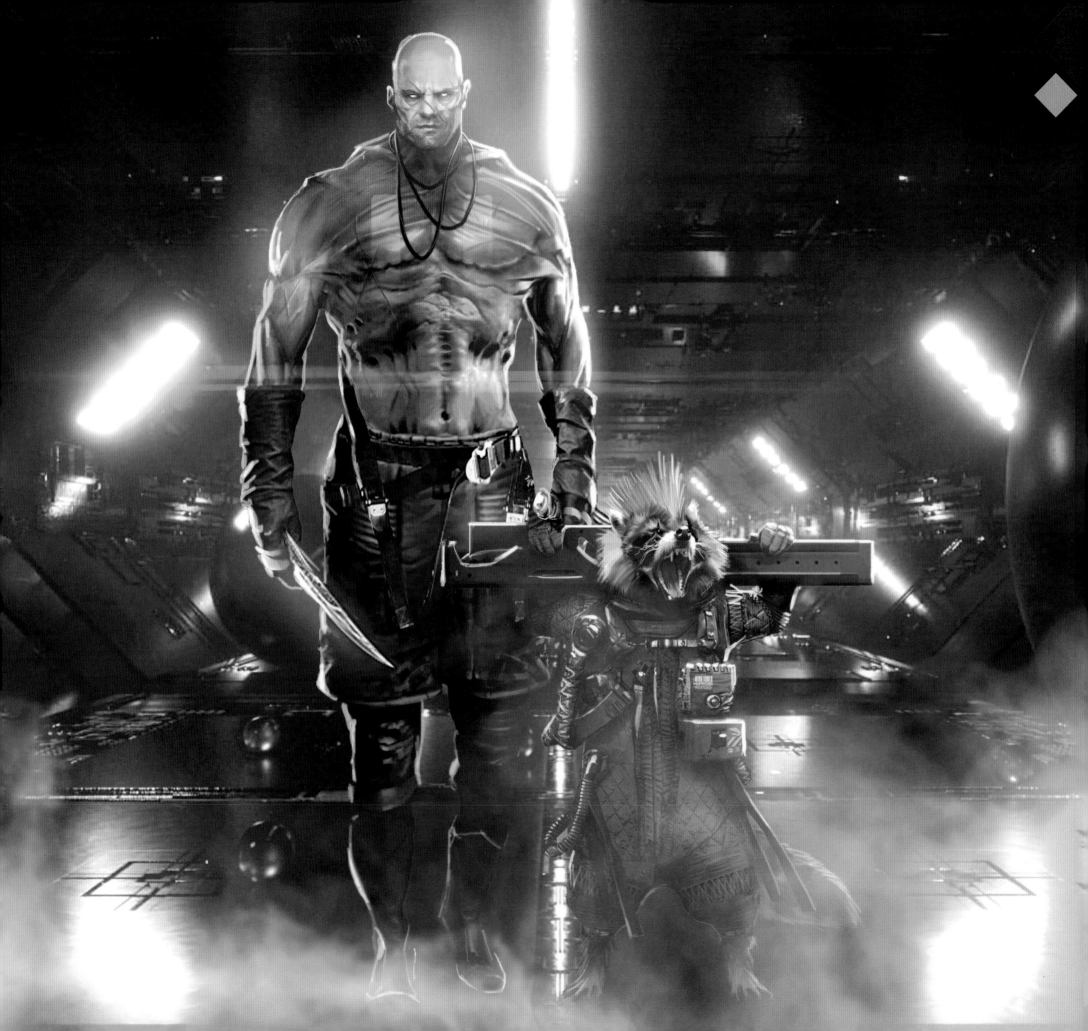

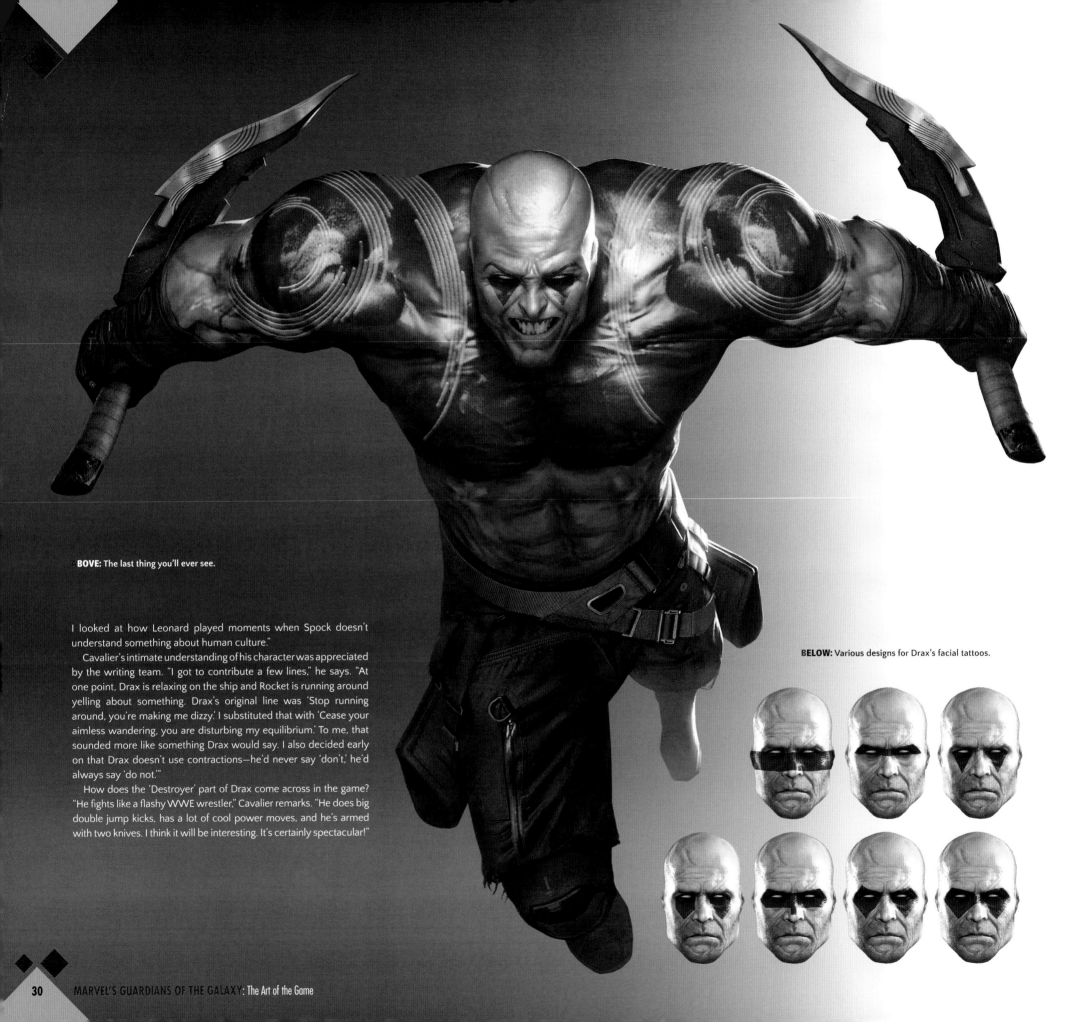

ABOVE: The last thing you'll ever see.

I looked at how Leonard played moments when Spock doesn't understand something about human culture."

Cavalier's intimate understanding of his character was appreciated by the writing team. "I got to contribute a few lines," he says. "At one point, Drax is relaxing on the ship and Rocket is running around yelling about something. Drax's original line was 'Stop running around, you're making me dizzy.' I substituted that with 'Cease your aimless wandering, you are disturbing my equilibrium.' To me, that sounded more like something Drax would say. I also decided early on that Drax doesn't use contractions—he'd never say 'don't,' he'd always say 'do not.'"

How does the 'Destroyer' part of Drax come across in the game? "He fights like a flashy WWE wrestler," Cavalier remarks. "He does big double jump kicks, has a lot of cool power moves, and he's armed with two knives. I think it will be interesting. It's certainly spectacular!"

BELOW: Various designs for Drax's facial tattoos.

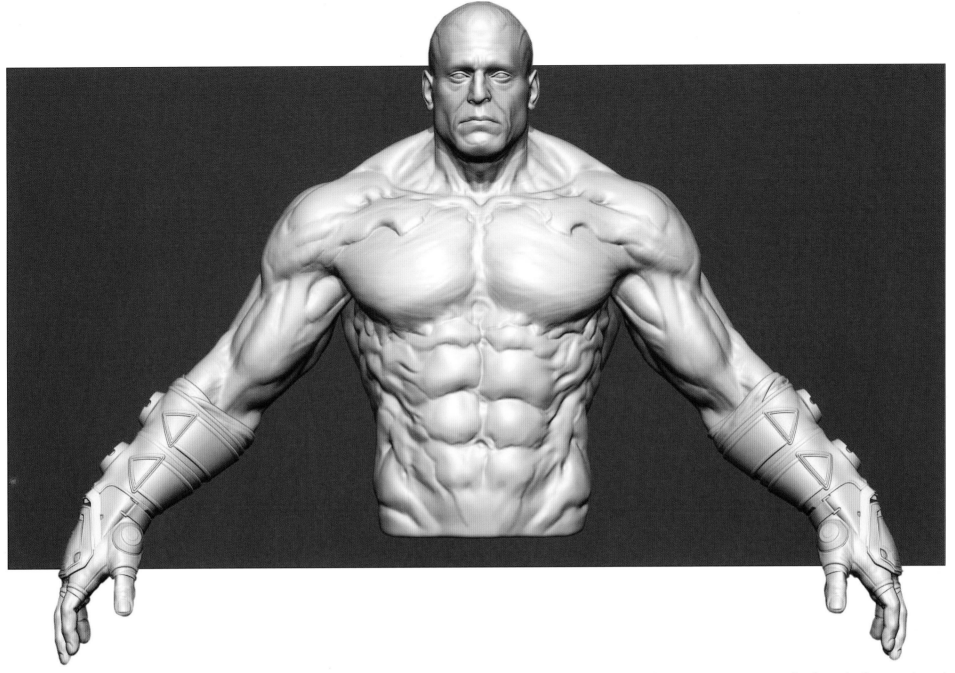

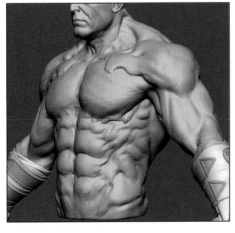

Concept artist Frederic Bennett tells us more, "We had the idea of making Drax look like a heavy wrestler carrying lots of fat. [Legendary French wrestler] Andre the Giant was an inspiration. I developed Drax from there, making him look healthier and more in shape. However, we didn't want him to have a normal Hulk-like physique, so we gave him some alien musculature. Our Drax has a slightly uncanny look—there's something weird about him."

Eidos-Montréal's talented concept artists think deeply about their characters. What sort of society do they come from? What sort of life experiences have brought them to this point in their lives? "I had this idea that teenagers in Drax's warrior society tattoo their bodies red," Bennett explains, "and whenever they make a kill, they deliberately scar their red skin with circles.

Drax is covered in them. The idea was triggered when I saw a piece of art that looked like an alien language."

Drax's history was on Cavalier's mind, too. "We show the love he has for his family and the pain he suffers [due to their deaths]. I wasn't expecting all that when I first took on the role—I was surprised actually. I thought Drax would be more like a supporting character, and his role would mainly be sitting at the ship's controls and saying things like, 'Yes, I will attend to it,' and then doing a lot of yelling and running around. My expectations were blown out of the window."

And finally, how does Cavalier feel about the character he's lived with for so long? "I feel close to Drax, so I'm afraid I'm a bit possessive of him now! But it's the fans who get to decide whether I did a good job or not. I hope I did."

THIS PAGE: These detailed 3D renders show how Eidos-Montréal added unusual musculature to Drax to make him appear more alien and intimidating.

GAMORA

When players first hit 'Start' in *Marvel's Guardians of the Galaxy*, they'll rightfully expect Star-Lord, their playable character, to have a fully realized story arc. But this game is an ensemble piece, and Eidos-Montréal gave the same attention to the stories and backstories of the other Guardians, too. This gave Gamora actor Kimberly-Sue Murray plenty to think about when it came to diving into character.

"Gamora has a beautiful story arc," she enthuses. "We find out that she killed her sister, Nebula—that's Gamora's secret and it weighs on her. She'd been adopted into a family by Thanos (the genocidal Titan super villain) where she was trained to be a killing machine—and then she was torn apart when her father turned her against her own sister. As well as that, Gamora was on the wrong side during the Galactic War. But with the Guardians, she has a chance to redefine herself, to belong to a group, to have a chosen family, and gain redemption for what she's done. Over the course of the game, she changes from being the deadliest woman in the Galaxy to being a loyal member of the Guardians."

THIS SPREAD: Eidos-Montréal wanted their Gamora's outfit to be stylish and practical, as well as highlighting her lethality.

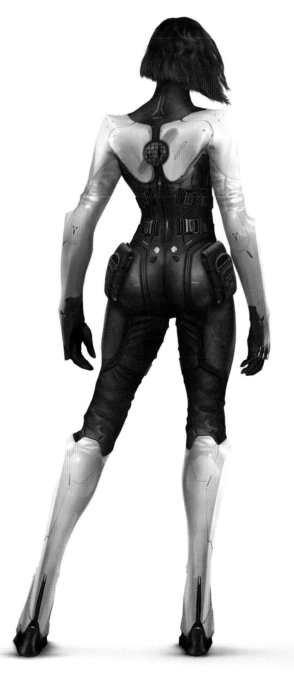

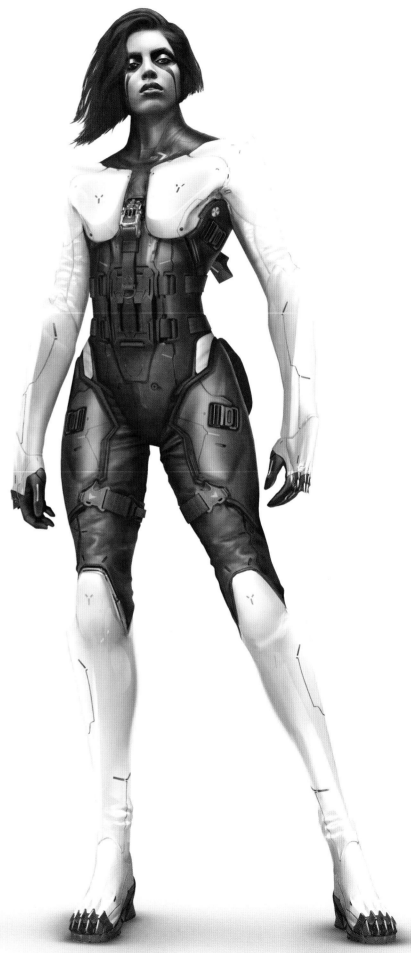

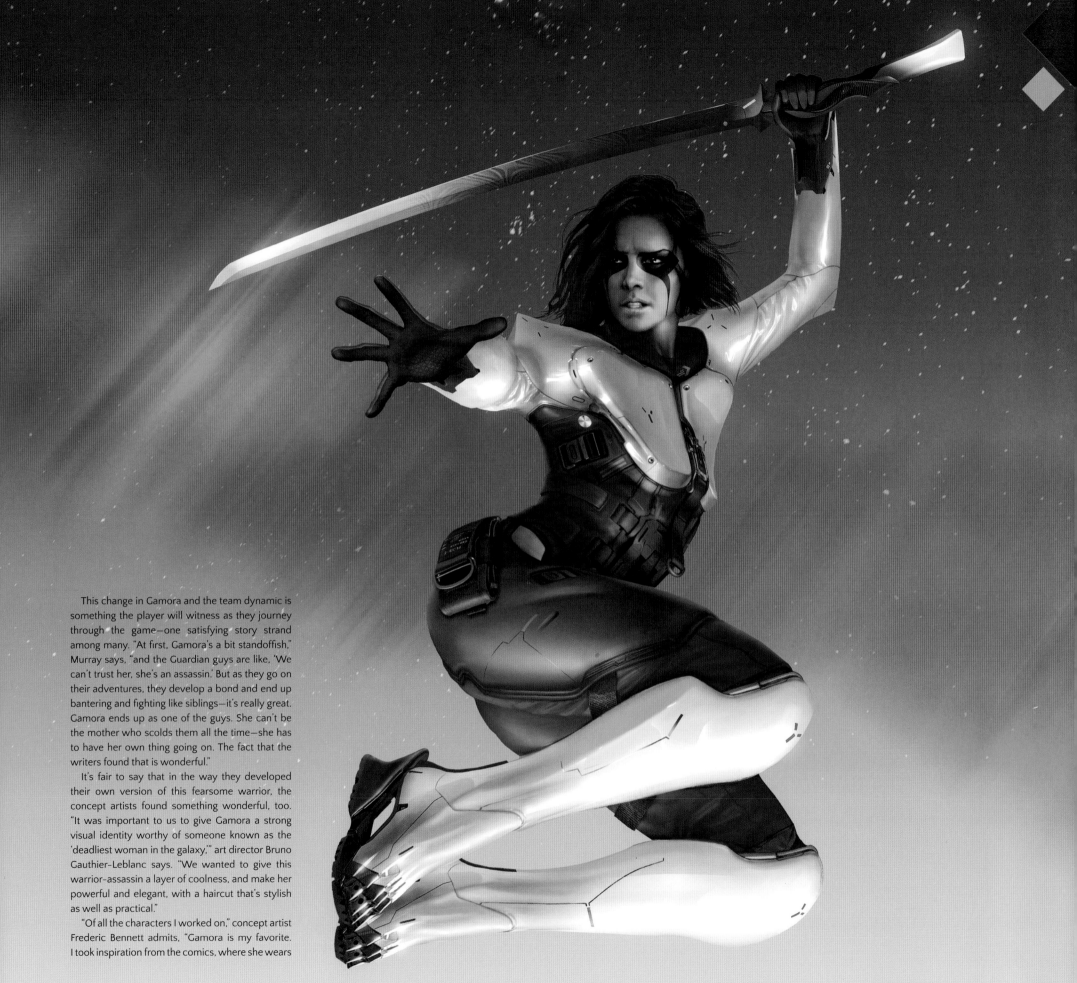

This change in Gamora and the team dynamic is something the player will witness as they journey through the game—one satisfying story strand among many. "At first, Gamora's a bit standoffish," Murray says, "and the Guardian guys are like, 'We can't trust her, she's an assassin.' But as they go on their adventures, they develop a bond and end up bantering and fighting like siblings—it's really great. Gamora ends up as one of the guys. She can't be the mother who scolds them all the time—she has to have her own thing going on. The fact that the writers found that is wonderful."

It's fair to say that in the way they developed their own version of this fearsome warrior, the concept artists found something wonderful, too. "It was important to us to give Gamora a strong visual identity worthy of someone known as the 'deadliest woman in the galaxy,'" art director Bruno Gauthier-Leblanc says. "We wanted to give this warrior-assassin a layer of coolness, and make her powerful and elegant, with a haircut that's stylish as well as practical."

"Of all the characters I worked on," concept artist Frederic Bennett admits, "Gamora is my favorite. I took inspiration from the comics, where she wears

white armor with a black undergarment, almost like a *Star Wars* stormtrooper. I researched a lot of materials, especially images of Apple products, where it looks as if there's a layer of glass on top of the white plastic, and it's all smooth, shiny, and reflective. Gamora was the one character who retained most of the crazy elements we added at the beginning before we landed on her in-game look."

Few understand the Gamora who appears in *Marvel's Guardians of the Galaxy* better than Murray, whose admiration for this character is clear when she speaks of her. "Gamora is fearless and honorable. I love her unwavering determination and the fact that she's willing to sacrifice herself if needs be. I also appreciate her self-awareness: She understands that what happened to her in the past has made her the way she is. She knows that she was groomed by Thanos to be the deadliest woman in the galaxy, to be an assassin. She knows that she was manipulated, used, and abused. But she also has the strength to get herself out of that, and the desire to change and become a better person."

THIS SPREAD: Various iterations of Gamora's look and weapons.

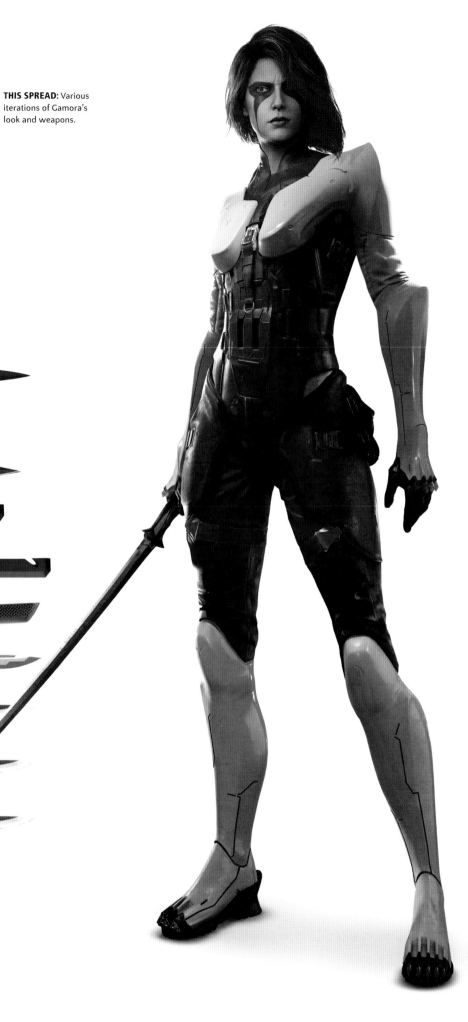

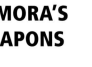

GAMORA'S WEAPONS

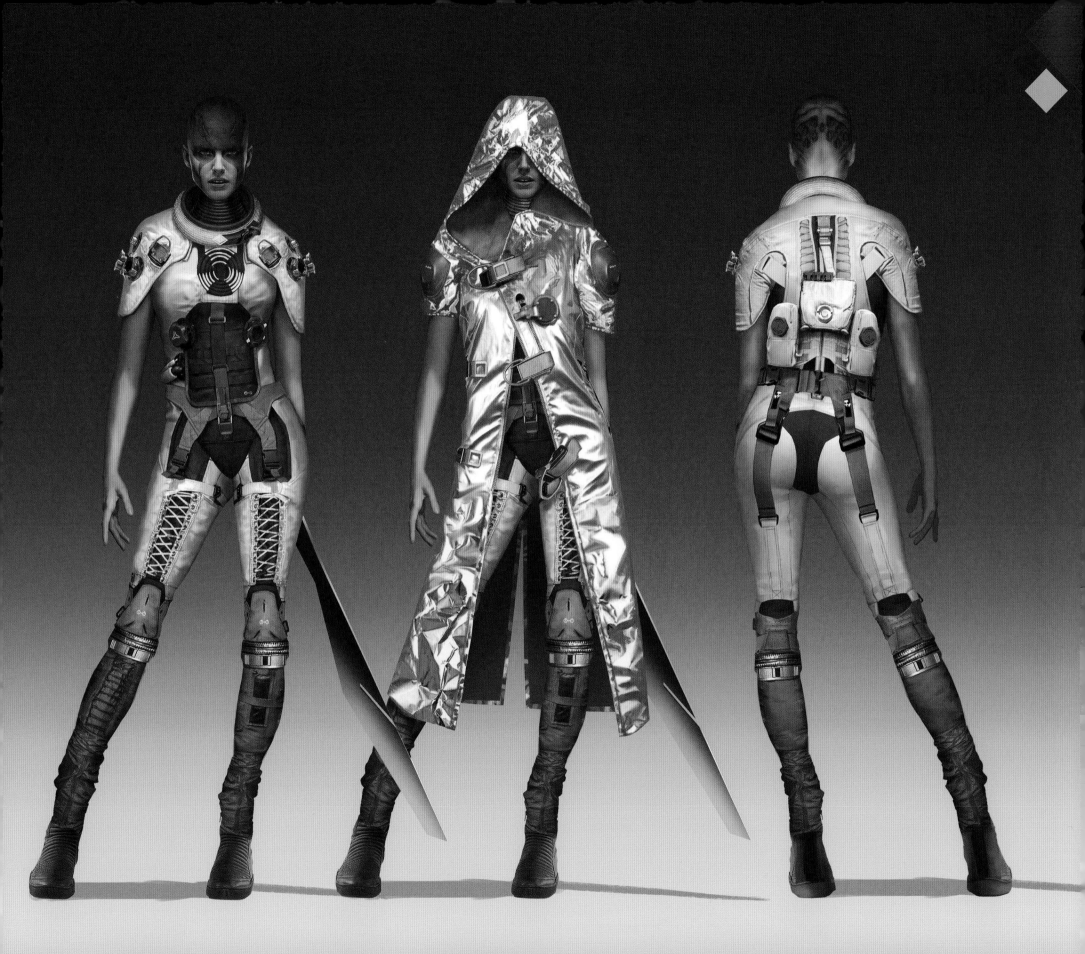

ROCKET

"I knew Rocket from the movies, and I thought that all the Guardians were really interesting characters," says Rocket actor Alex Weiner. "After I got the role, part of my process as an actor was to dive in deep and consume everything I could find about Rocket's backstory."

Playing a character like Rocket demands a certain energy from the performer—an energy that not everyone possesses. You'd be hard pressed to find an actor more suited to the role of Rocket than Weiner. "I think sometimes you get a role because you have part of that character within you—and I share a lot of character traits with Rocket," Weiner says. "I'm quite an intense person who gets passionate and obsessive about

things. I have a lot of energy, too—these things I can transfer into Rocket quite easily."

Weiner may have taken the role in his stride, but there were difficulties when nailing down the 'subtleties' of Rocket's nature. "I think the biggest challenge for me was toning *down* Rocket's energy and anger, because it's very easy with him to project a lot of fury. 'Normal' for Rocket is 'angry' for most people," Weiner laughs. "But we managed to find these glimpses in the game where you see the humanity and gentleness in him, and it's in those moments that I found myself getting closest to Rocket."

Eidos-Montréal crafted their own unique take on the Guardians universe, but the fundamental

THIS SPREAD: He may be small, but he is mighty.

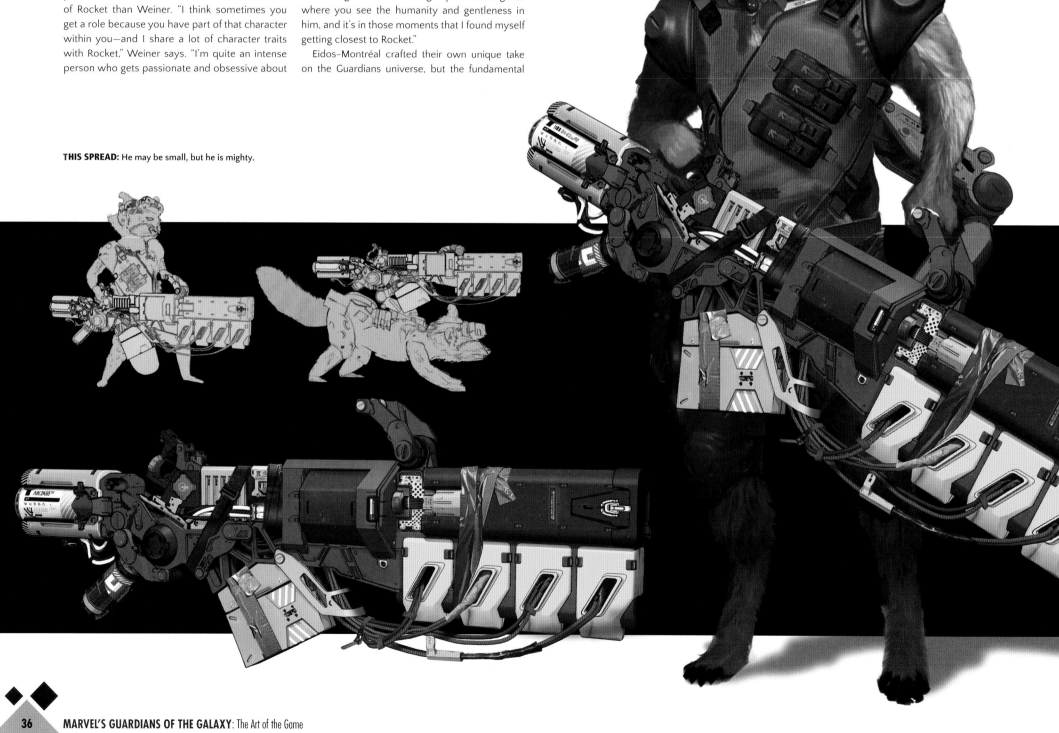

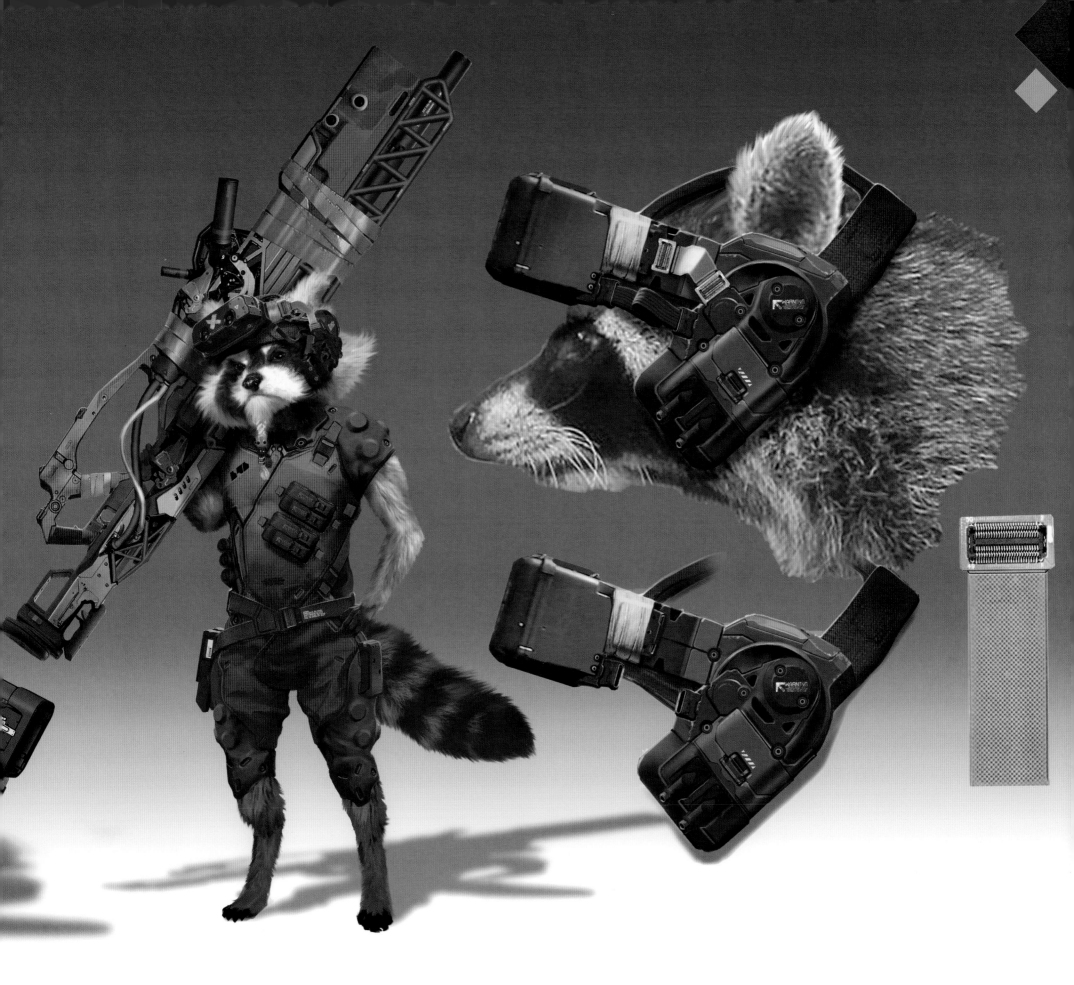

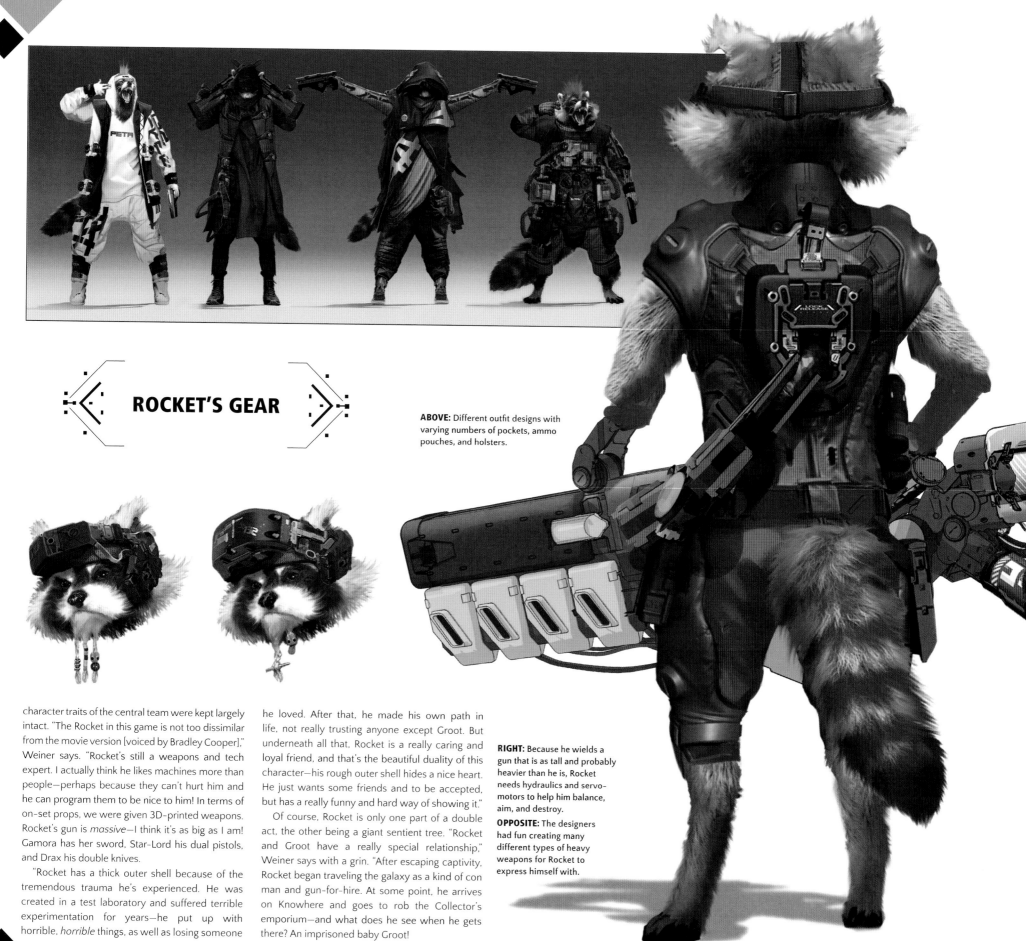

ROCKET'S GEAR

ABOVE: Different outfit designs with varying numbers of pockets, ammo pouches, and holsters.

character traits of the central team were kept largely intact. "The Rocket in this game is not too dissimilar from the movie version [voiced by Bradley Cooper]," Weiner says. "Rocket's still a weapons and tech expert. I actually think he likes machines more than people—perhaps because they can't hurt him and he can program them to be nice to him! In terms of on-set props, we were given 3D-printed weapons. Rocket's gun is *massive*—I think it's as big as I am! Gamora has her sword, Star-Lord his dual pistols, and Drax his double knives.

"Rocket has a thick outer shell because of the tremendous trauma he's experienced. He was created in a test laboratory and suffered terrible experimentation for years—he put up with horrible, *horrible* things, as well as losing someone

he loved. After that, he made his own path in life, not really trusting anyone except Groot. But underneath all that, Rocket is a really caring and loyal friend, and that's the beautiful duality of this character—his rough outer shell hides a nice heart. He just wants some friends and to be accepted, but has a really funny and hard way of showing it."

Of course, Rocket is only one part of a double act, the other being a giant sentient tree. "Rocket and Groot have a really special relationship," Weiner says with a grin. "After escaping captivity, Rocket began traveling the galaxy as a kind of con man and gun-for-hire. At some point, he arrives on Knowhere and goes to rob the Collector's emporium—and what does he see when he gets there? An imprisoned baby Groot!

RIGHT: Because he wields a gun that is as tall and probably heavier than he is, Rocket needs hydraulics and servo-motors to help him balance, aim, and destroy.

OPPOSITE: The designers had fun creating many different types of heavy weapons for Rocket to express himself with.

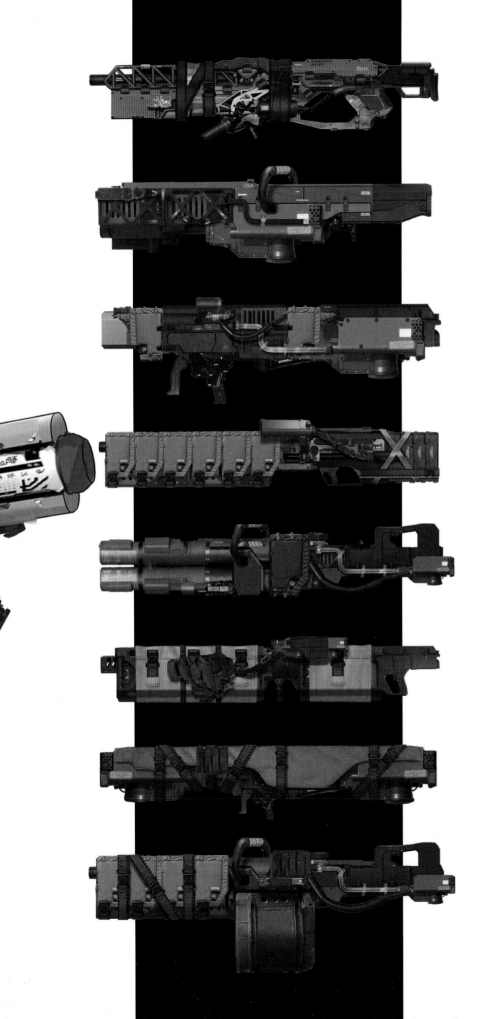

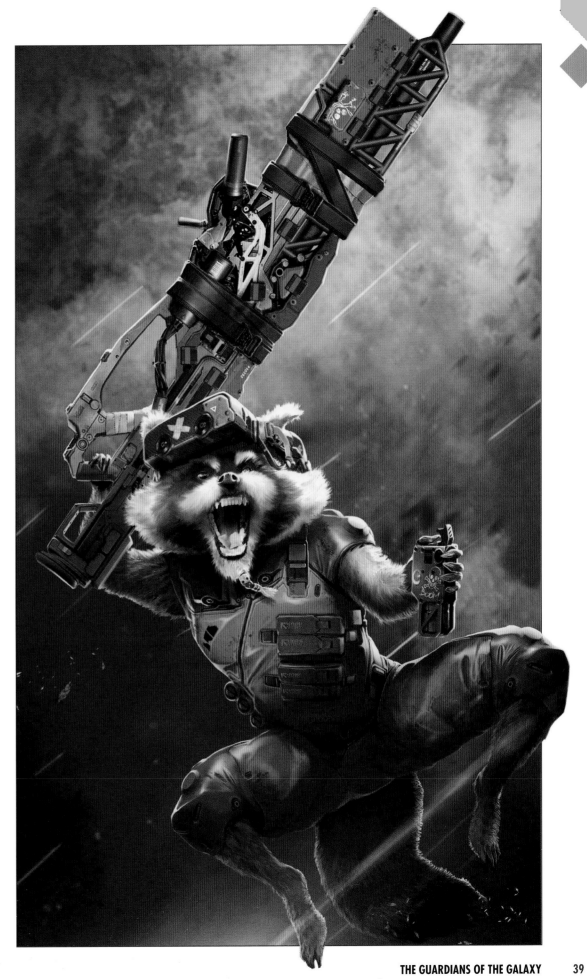

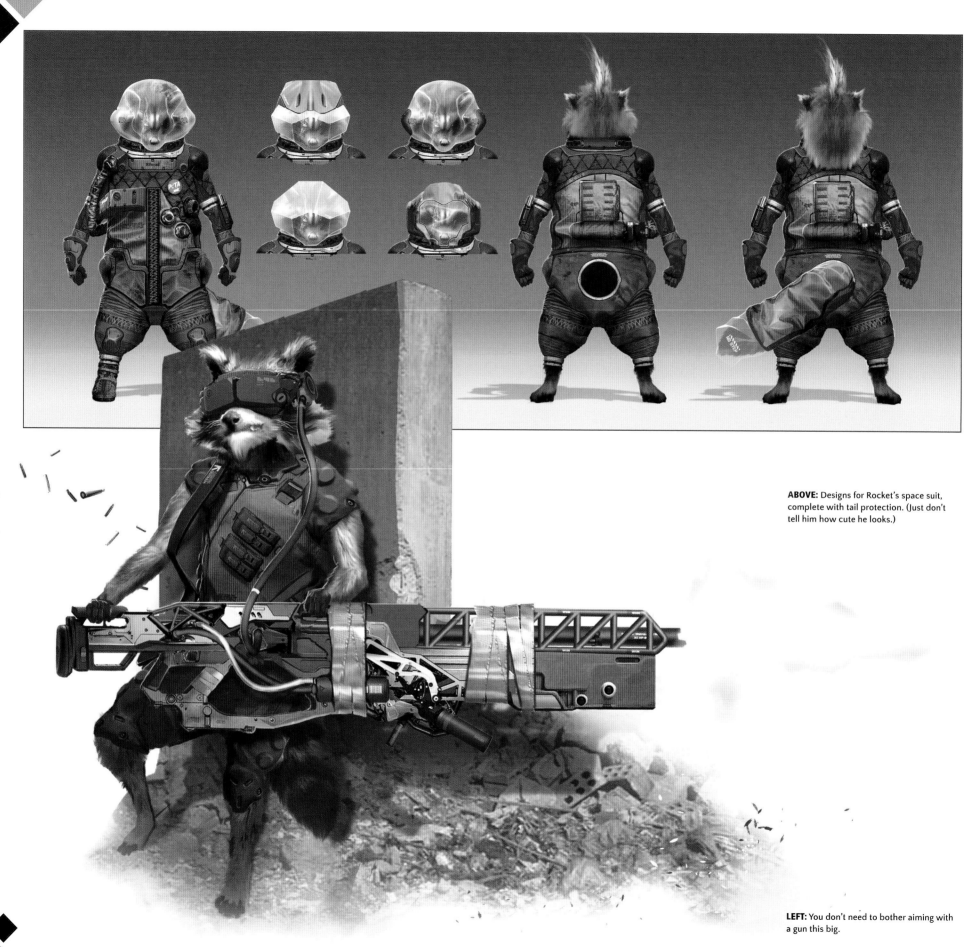

ABOVE: Designs for Rocket's space suit, complete with tail protection. (Just don't tell him how cute he looks.)

LEFT: You don't need to bother aiming with a gun this big.

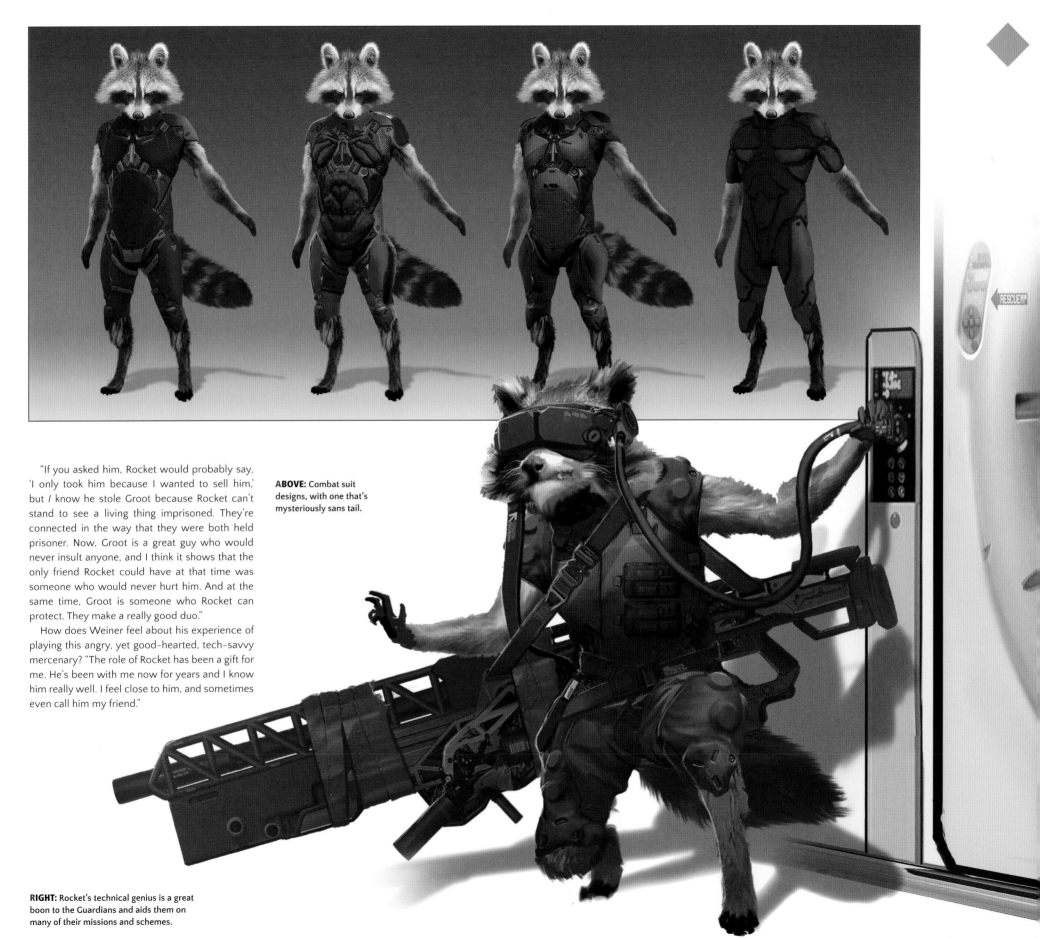

"If you asked him, Rocket would probably say, 'I only took him because I wanted to sell him,' but I know he stole Groot because Rocket can't stand to see a living thing imprisoned. They're connected in the way that they were both held prisoner. Now, Groot is a great guy who would never insult anyone, and I think it shows that the only friend Rocket could have at that time was someone who would never hurt him. And at the same time, Groot is someone who Rocket can protect. They make a really good duo."

How does Weiner feel about his experience of playing this angry, yet good-hearted, tech-savvy mercenary? "The role of Rocket has been a gift for me. He's been with me now for years and I know him really well. I feel close to him, and sometimes even call him my friend."

ABOVE: Combat suit designs, with one that's mysteriously sans tail.

RIGHT: Rocket's technical genius is a great boon to the Guardians and aids them on many of their missions and schemes.

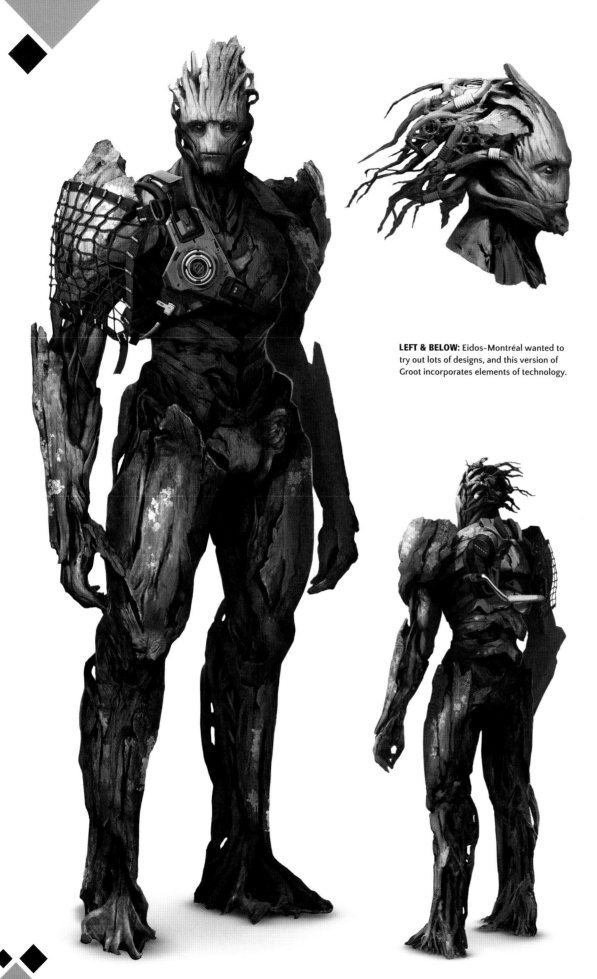

GROOT

Ensuring that a central character in the game exhibits clear emotions, intent, and meaning when all they ever say is "I am Groot" is a massive challenge. It took a combination of great writing and a nuanced physical performance from actor Robert Montcalm to make it work.

"The writers at Eidos-Montréal were fantastic," Rocket actor Alex Weiner says. "They wrote what Groot actually means underneath every 'I am Groot' script line. I really have to commend Rob—oftentimes during a performance he'd say, 'I am Groot' and I'd know exactly what he meant without needing to refer to the script."

"The joke was when I'd turn up to do a session, the team would ask me, 'So are you off-book for the scenes?'" Montcalm laughs. "In theater school, I drifted more toward physical theater. I also certified as a fight instructor, and all that combined into an interest in communicating through body language. What can an actor say without speaking? How can a simple gesture be more effective than a line of dialogue?

"I studied acting under a woman called Jacqueline McClintock before she passed away. She taught me acting is not just about the words, but what's behind them—*how* you're saying them. We'd do this exercise where two actors repeat the same phrase—something like 'You have a blue shirt'—to each other over and over. Even though the phrase is pretty empty, the meaning and emotion behind it changes depending on the performers' facial expressions and how they emphasize the words. So only ever

LEFT & BELOW: Eidos-Montréal wanted to try out lots of designs, and this version of Groot incorporates elements of technology.

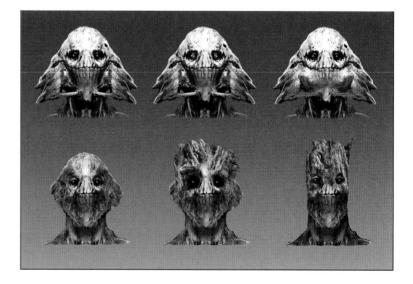

ABOVE & BELOW: It was important to ensure that Groot was as capable of physically expressing emotions as any of the other non-tree characters.

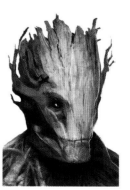
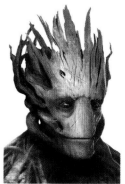

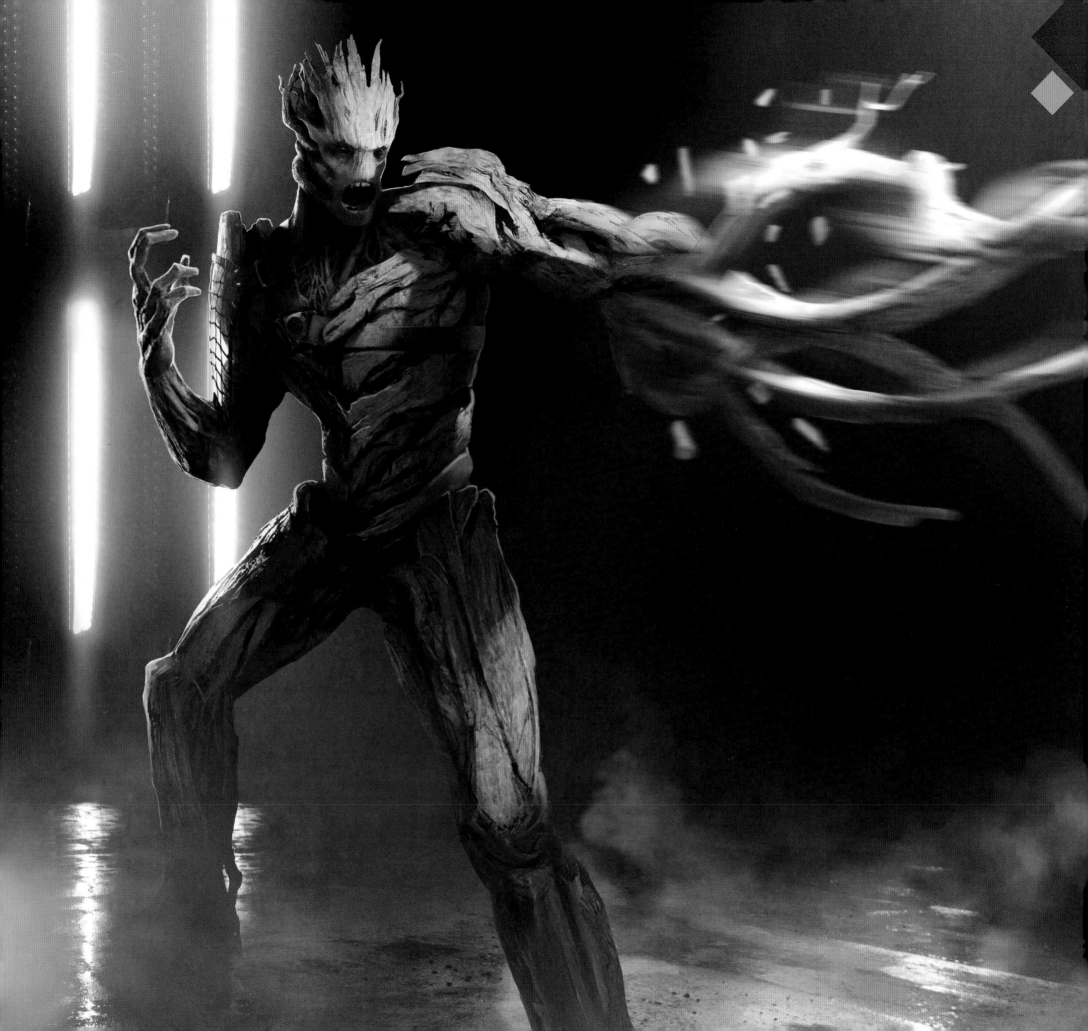

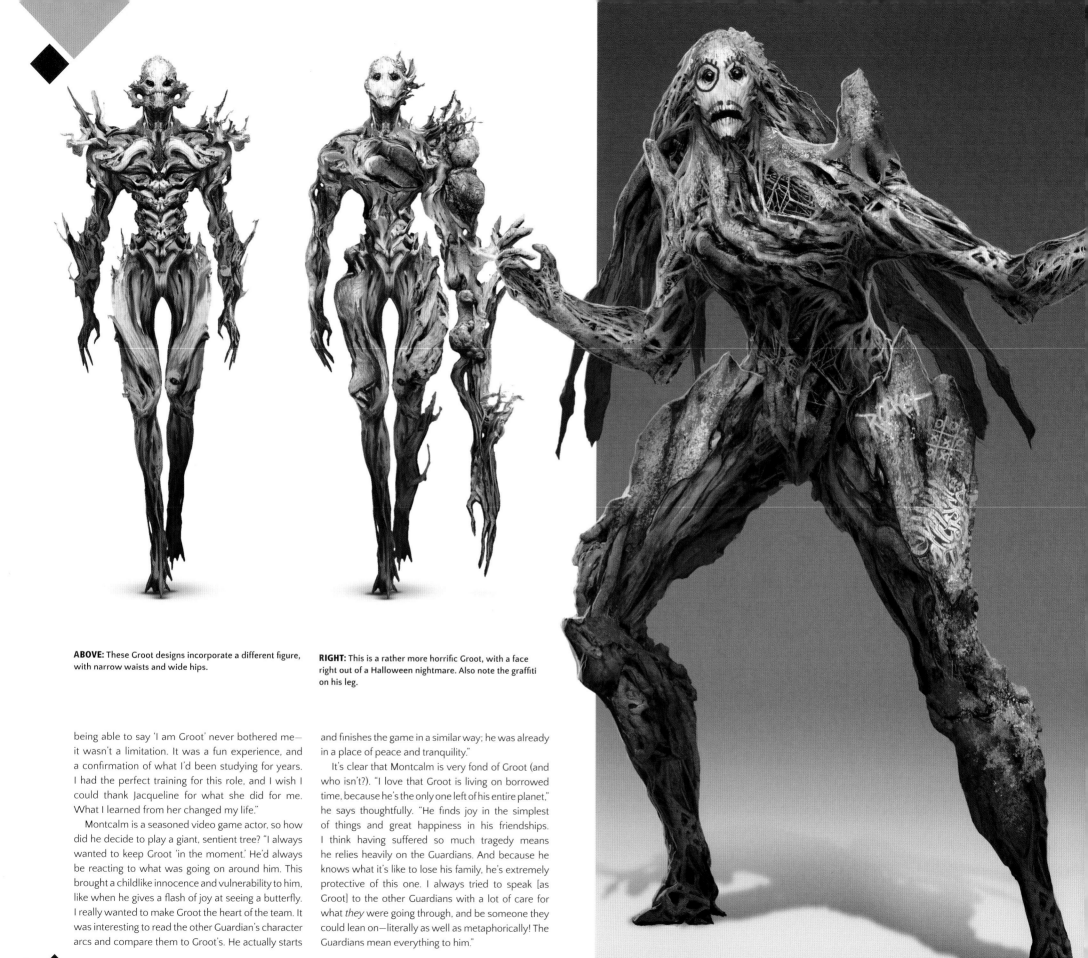

ABOVE: These Groot designs incorporate a different figure, with narrow waists and wide hips.

RIGHT: This is a rather more horrific Groot, with a face right out of a Halloween nightmare. Also note the graffiti on his leg.

being able to say 'I am Groot' never bothered me— it wasn't a limitation. It was a fun experience, and a confirmation of what I'd been studying for years. I had the perfect training for this role, and I wish I could thank Jacqueline for what she did for me. What I learned from her changed my life."

Montcalm is a seasoned video game actor, so how did he decide to play a giant, sentient tree? "I always wanted to keep Groot 'in the moment.' He'd always be reacting to what was going on around him. This brought a childlike innocence and vulnerability to him, like when he gives a flash of joy at seeing a butterfly. I really wanted to make Groot the heart of the team. It was interesting to read the other Guardian's character arcs and compare them to Groot's. He actually starts

and finishes the game in a similar way; he was already in a place of peace and tranquility."

It's clear that Montcalm is very fond of Groot (and who isn't?). "I love that Groot is living on borrowed time, because he's the only one left of his entire planet," he says thoughtfully. "He finds joy in the simplest of things and great happiness in his friendships. I think having suffered so much tragedy means he relies heavily on the Guardians. And because he knows what it's like to lose his family, he's extremely protective of this one. I always tried to speak [as Groot] to the other Guardians with a lot of care for what *they* were going through, and be someone they could lean on—literally as well as metaphorically! The Guardians mean everything to him."

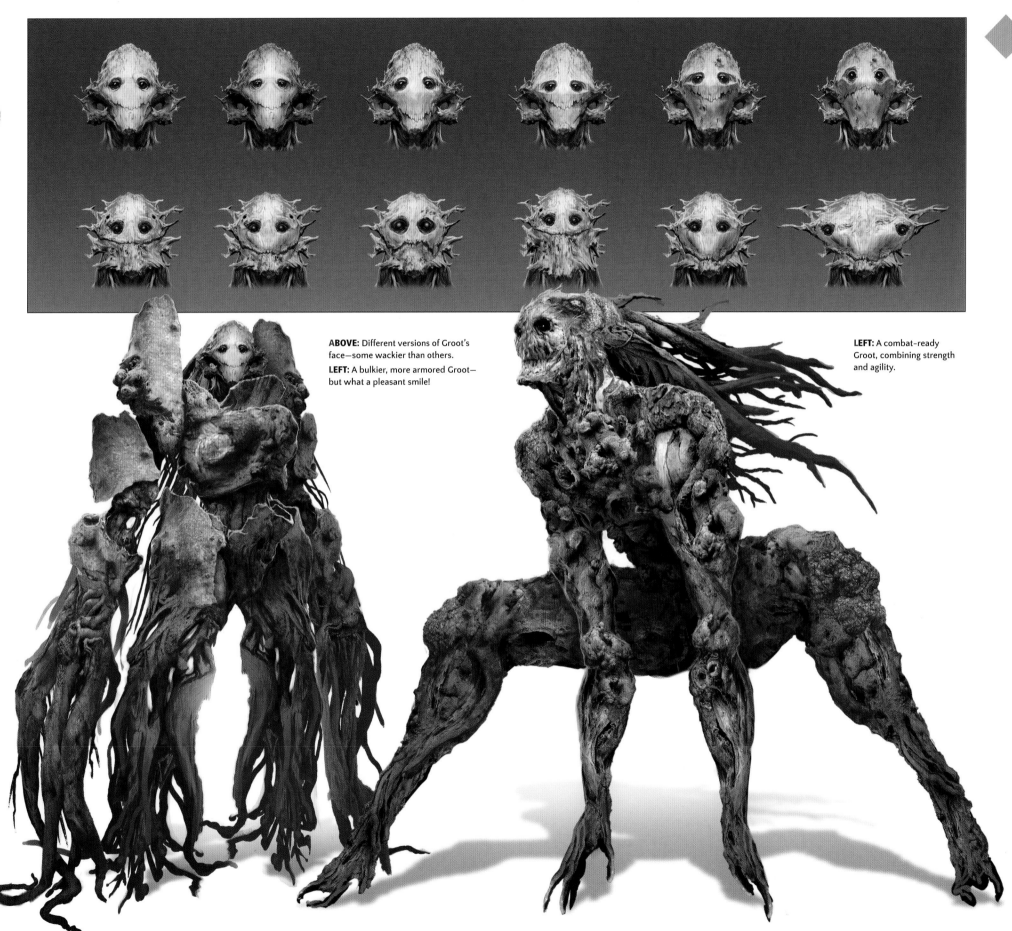

ABOVE: Different versions of Groot's face—some wackier than others.

LEFT: A bulkier, more armored Groot—but what a pleasant smile!

LEFT: A combat-ready Groot, combining strength and agility.

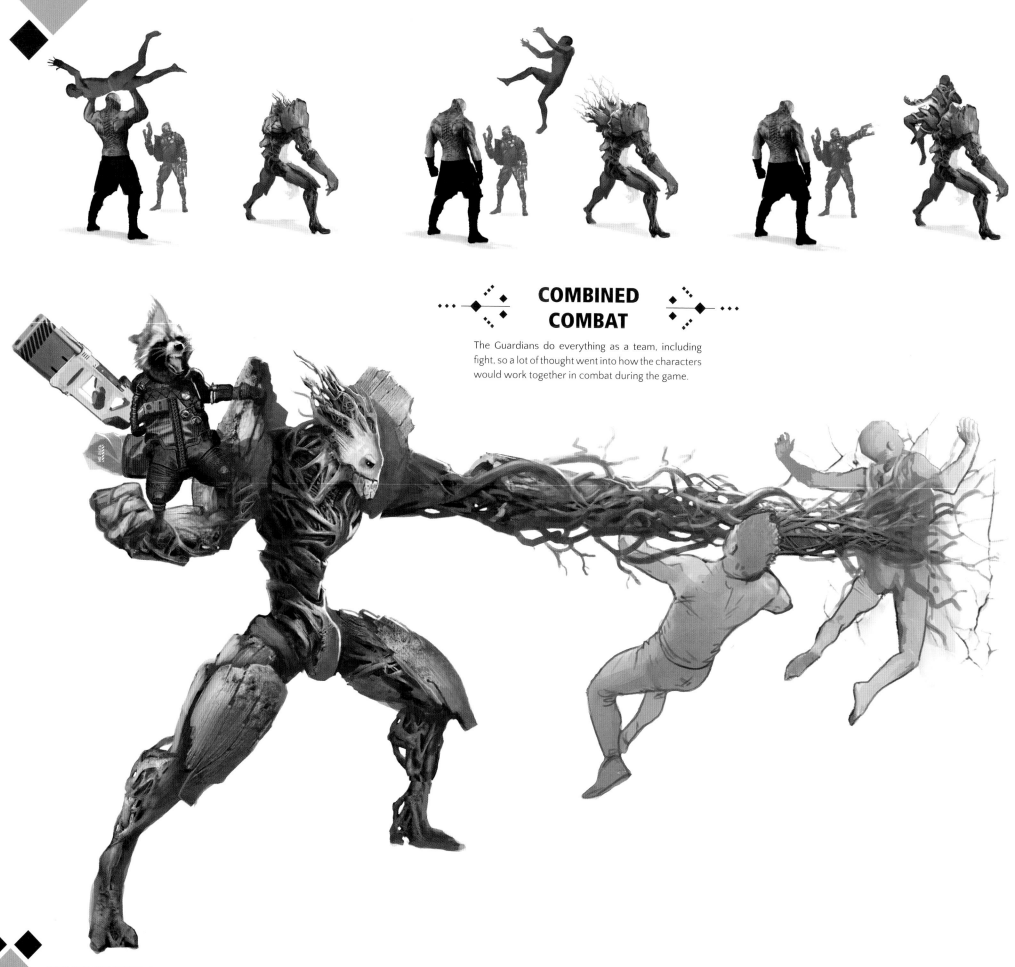

COMBINED COMBAT

The Guardians do everything as a team, including fight, so a lot of thought went into how the characters would work together in combat during the game.

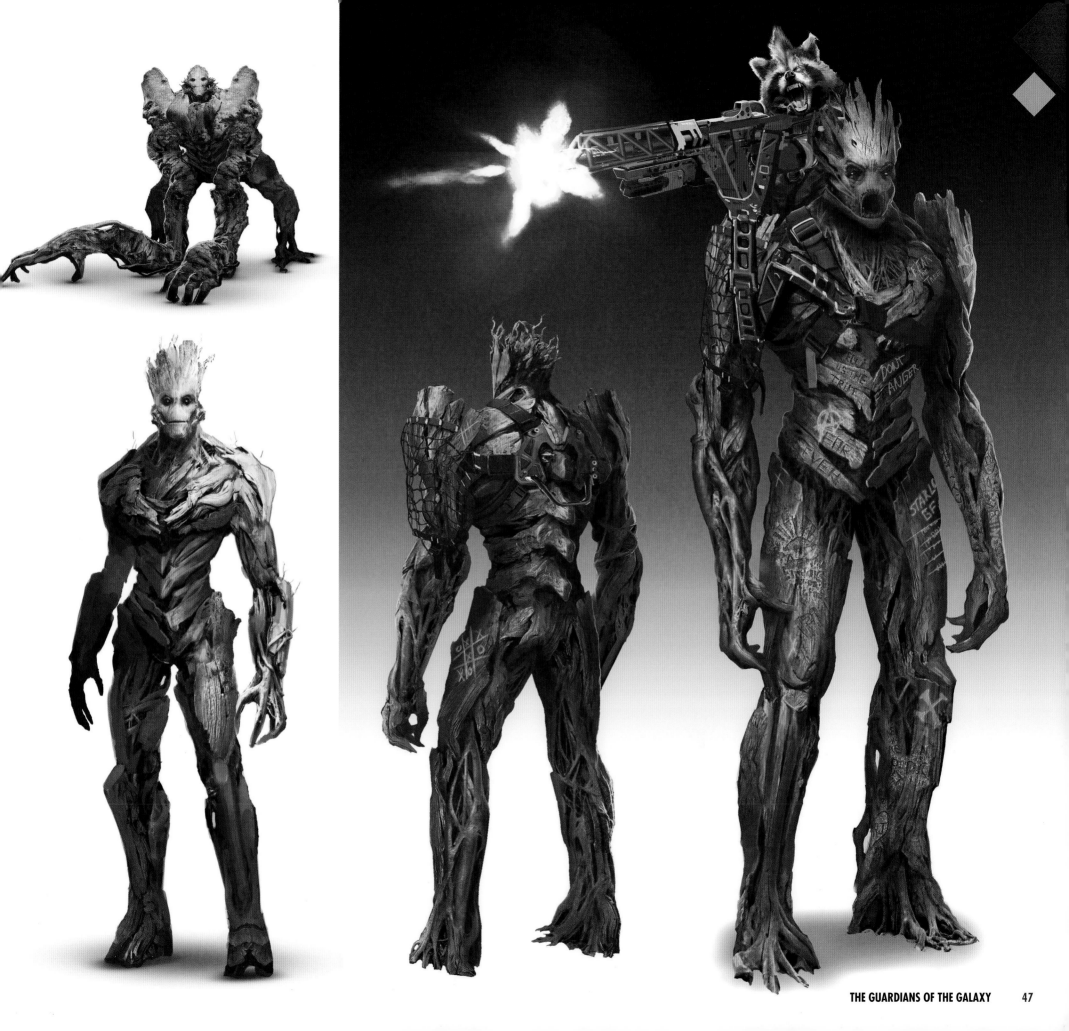

THE MILANO

Eidos-Montréal is grateful for how Marvel gave them the creative freedom to reinterpret existing aspects of the Guardians universe—the locations, characters, creatures, and tech—and add their own unique design spin onto them. As long as new designs were recognizable and remained true to the original's principal elements, they were good to go. However, on occasion, it was decided that only minimal changes were needed. After all, if it ain't broke, don't fix it. Such was the case with Peter Quill's M-class spaceship, the *Milano*.

"In the end, the *Milano*'s design ended up very close to what appears in the Marvel movies and comics, with the winglets and hawk-billed nose," senior concept artist Nicolas Lizotte explains, "although we modified the interior a bit."

In the game, the *Milano* is more than just a spaceship to get the player from one level to the next. It serves as a hub area, and careful examination of the interior details gives insight into each of the Guardians' characters; in *Marvel's Guardians of the Galaxy*, story and character are always front and center. Lizotte says, "You can see a central hub lounge in the *Milano* as well as all the characters' rooms: Groot's growing his plants, Rocket's got a workshop to tinker in and build his tech, and Star Lord's got posters from his childhood on Earth."

Guardians fans may well know how the *Milano* got its name, but for those who don't, here's the reason, courtesy of Lizotte, "Peter Quill named his spaceship the *Milano* after (American actress) Alyssa Milano who starred in the TV sitcom *Who's the Boss?* [1984] because he has a massive crush on her! It's a way for him to use and commemorate all the things he remembers from his childhood on Earth in his new life in space."

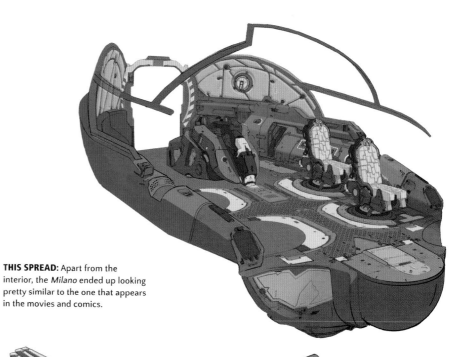

THIS SPREAD: Apart from the interior, the *Milano* ended up looking pretty similar to the one that appears in the movies and comics.

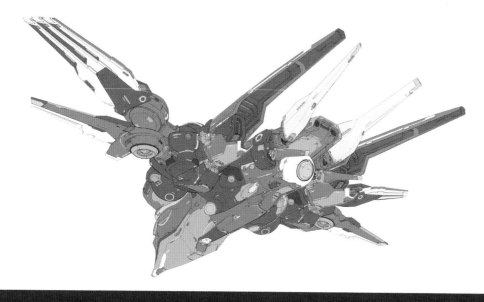

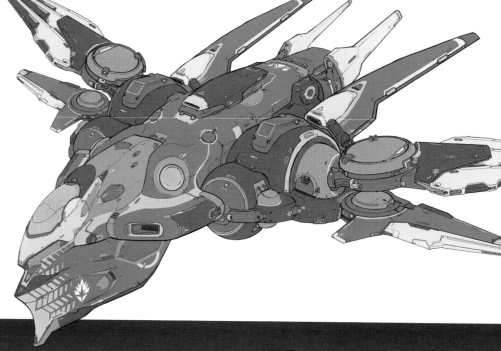

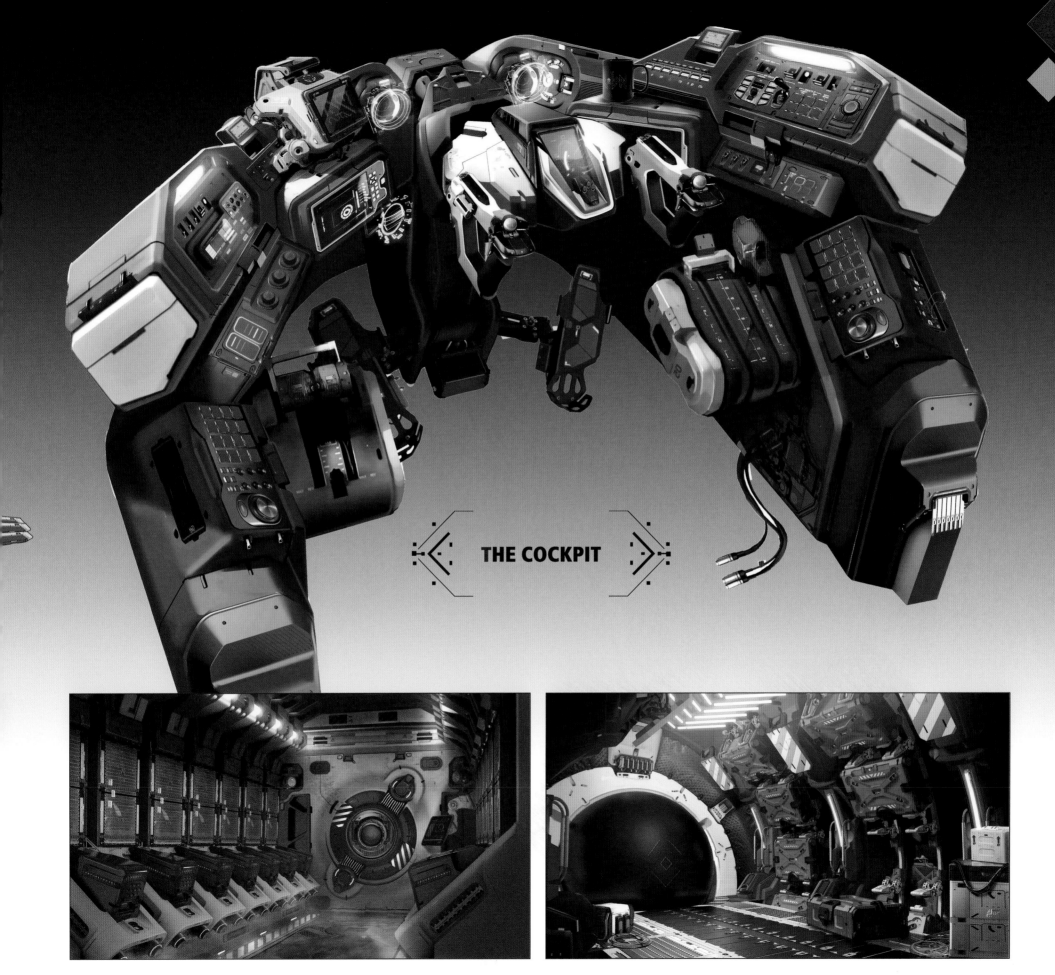

THE COCKPIT

THIS PAGE: The *Milano* serves as a hub, with each character having their own room that the player can explore. Eidos-Montréal packed tons of character detail into the interior, which is the closest thing the Guardians have to a home. Note the hoverboard, band posters, and general messiness of Star-Lord's pit.

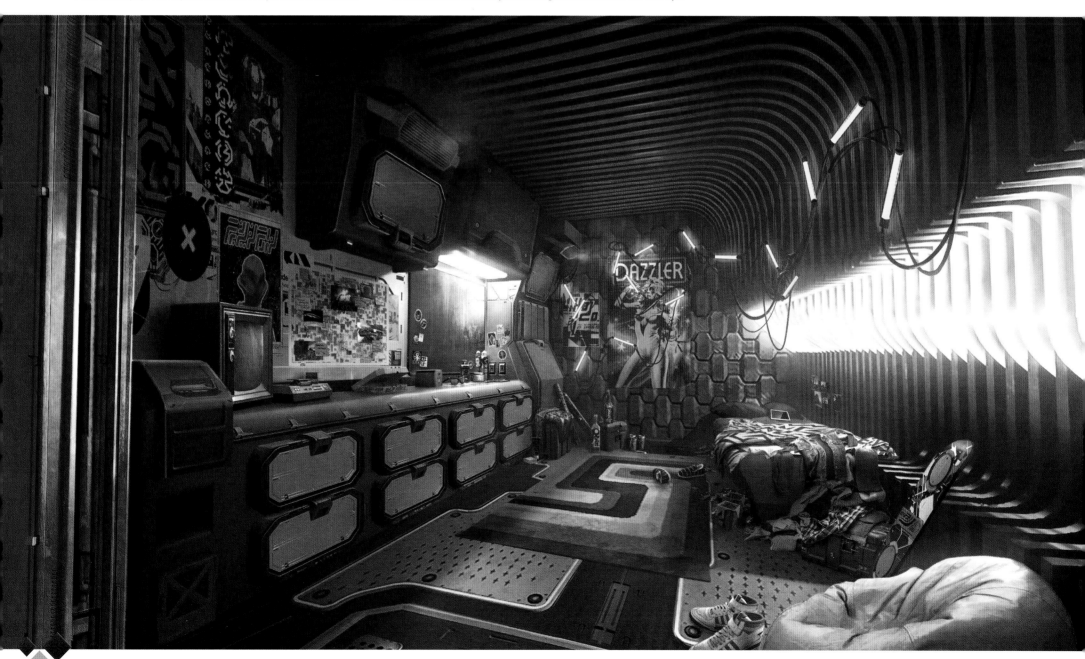

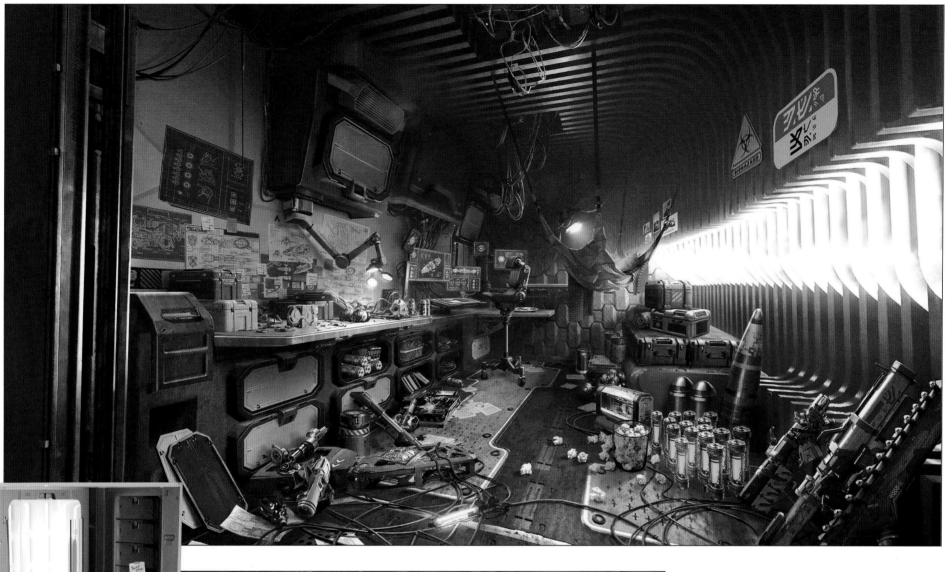

TOP: Filled as it is with guns, bits of guns, more guns, ammo, and bombs, Rocket's room looks more like an arsenal than a bedroom.

ABOVE: Shower facilities.

RIGHT: Groot's chambers are a haven of natural beauty and growth, with all sorts of exotic (and possibly poisonous and/or carnivorous) plants and shrubs.

The philosophy of encouraging people from all departments and at all levels of seniority to share their ideas and inspirations on any given project is taken very seriously at Eidos-Montréal. Suggestions are heard, considered by the creative team leaders—sometimes rejected—and sometimes accepted, developed, and put into the game.

Here's a great example, as told by senior audio director Steve Szczepkowski, "The creative team already had an idea for what design and images they were going to use for the game's menu screen. At some point, I saw a piece of concept art showing the Guardians chilling out together inside the *Milano*, and I noticed how Peter was kicking back and listening to music on his Walkman. I thought, *That's kind of cool*, and an idea clicked in my head. I added a sound loop over the image consisting of short samples of our licensed music tracks, each separated with the noise of the cassette being fast-forwarded by Peter. I showed that around, and the creative team thought it was really cool and chimed perfectly with the game's DNA. So they scrapped their initial idea for the menu screen and developed mine instead. That was a nice moment for me."

EARTH

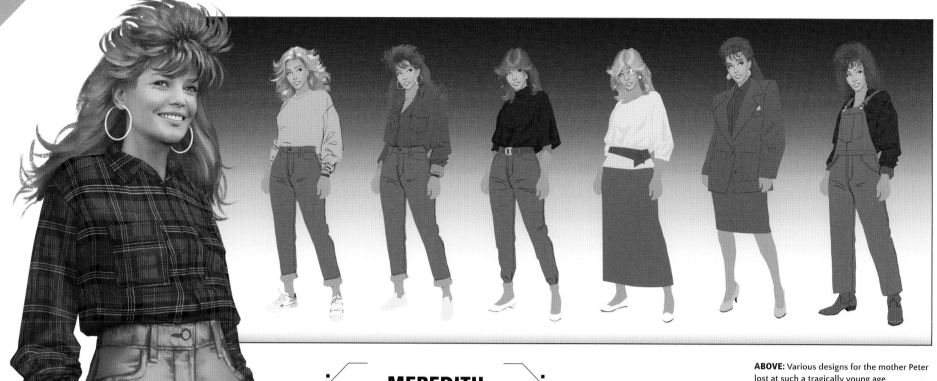

MEREDITH
Peter Quill's mother

ABOVE: Various designs for the mother Peter lost at such a tragically young age.
BELOW: Three earlier designs for the Chitauri.

Just like any story-driven media, video games need engaging and interesting characters—from the main protagonists to the lowliest NPCs. The process of breathing life into the unique characters of *Marvel's Guardians of the Galaxy* began with Eidos-Montréal's creative team.

"This is a Marvel property," senior creative director Jean-François Dugas explains, "so we had to respect certain criteria when designing our characters. However, at the beginning, we decided that instead of being super-conservative, we were going to start at eleven. We

went crazy! Our first version of Star-Lord wore this yellow jacket with puffy bits; Rocket was human-sized and looked *really* psychotic, and Drax was an out-of-shape fifty-year-old. When we revealed them to Marvel, I thought they were going to kill us! Ultimately though, they loved the fact that we were pushing the envelope, but said our designs were not recognizable enough. We've cranked things down to a level where people will be able to recognize the Guardians but also say, 'I haven't seen these versions before.' It was about finding that sweet spot between recognizable and different."

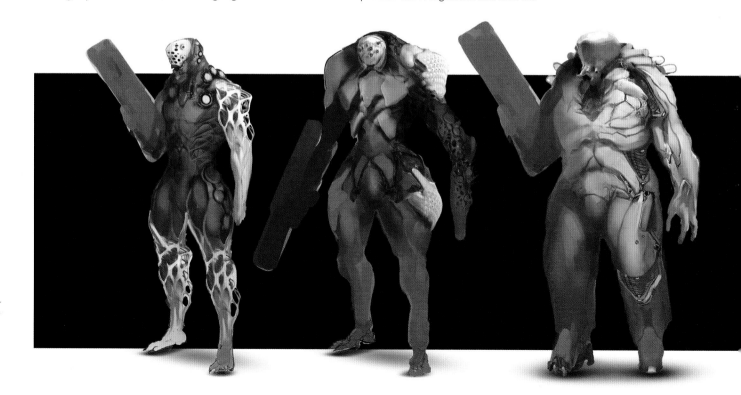

protective of their property, and everything Eidos-Montréal designed for the game had to be approved at each stage. Lead character artist Genci Buxheli says, "Everything we create is sent to the art director [Bruno Gauthier-Leblanc] and Marvel. Only when they've approved our work do we know it's safe to go in the game."

The technical process of creating a character is long and requires a lot of changes and revisions. "Once we've received the concept art, we create a low-polygon model that will run easily [in-game]," Buxheli continues, "then we work on the texturing, sculpting, and shading to create a character that looks good. Characters usually go through quite a lot of small changes; sometimes a character looks great in the concept art and as a 3D model, but doesn't work in-game. For example, a character color palette may look good when viewed on its own, but it might not stand out when placed in the game environment and surrounded by lots of other characters. In that case, we'll revisit

BELOW: Chitauri ship designs. These are gruesomely biological in look, with shades of malevolent coral reef.

CHITAURI
An alien enemy with a hive mind, subservient to Thanos

RIGHT: Heavily armored and with weapon appendages, the player will battle lots of these Chitauri warriors.

the textures, make sure the colors are popping, or add a design element to make the character more noticeable."

And once all that hard work is done and the characters are approved and finished? "It feels good but also terrible when I see my characters in-game," Buxheli says. "It's good to see them interacting, especially when accompanied by the actors' dialogue. The bad part is that, as a creator, I never get to experience it in the same way as the players, who can enjoy everything and become fully immersed in the story and gameplay. I only see the problems and the things I could have done differently. I'm always critical of my work—I don't see the bigger picture, only the details."

THIS SPREAD: Peter's childhood, all-American farmstead home. Note the similarities between Peter's teenager bedroom, and his room on the *Milano*.

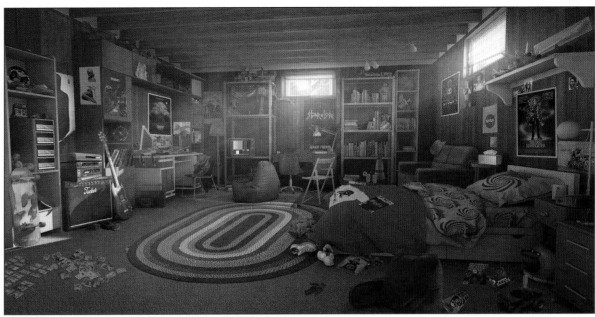

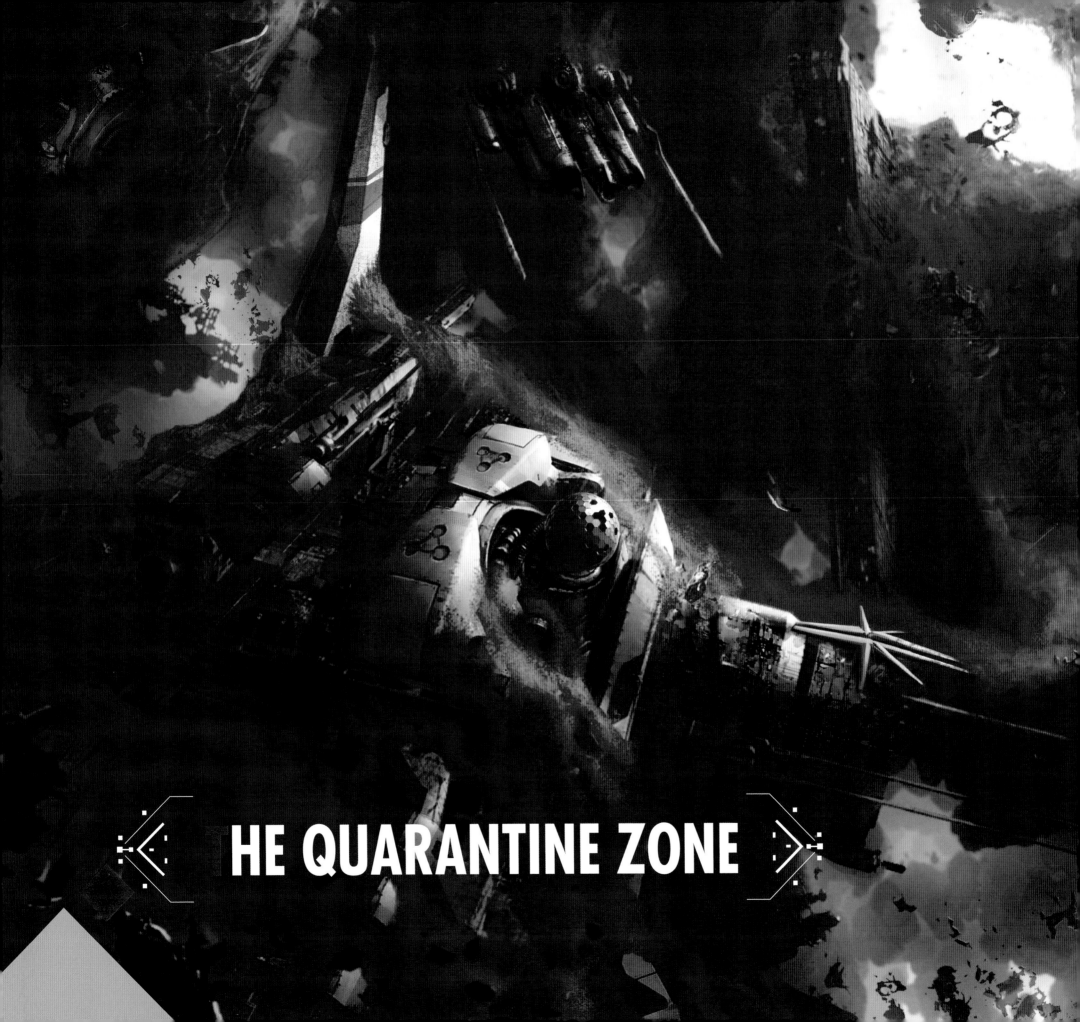

HE QUARANTINE ZONE

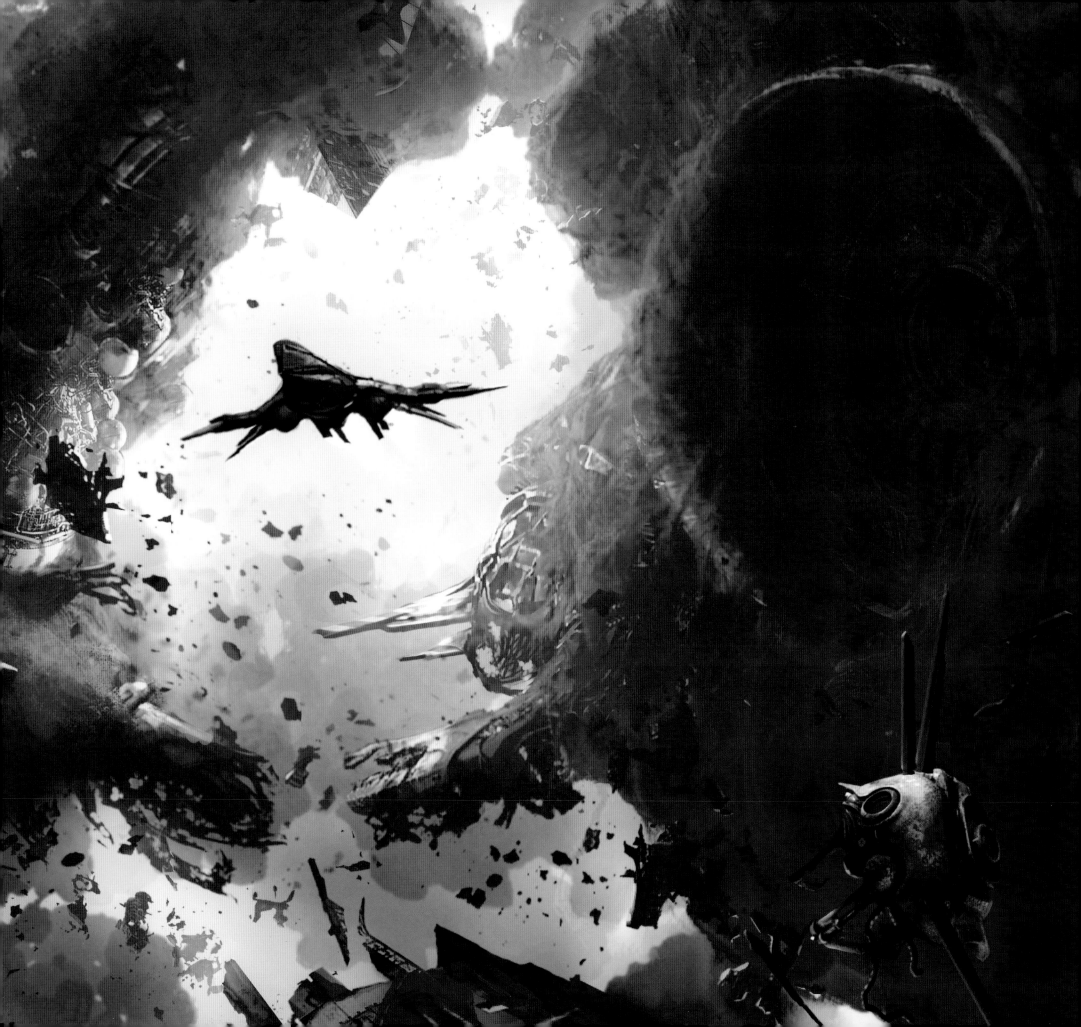

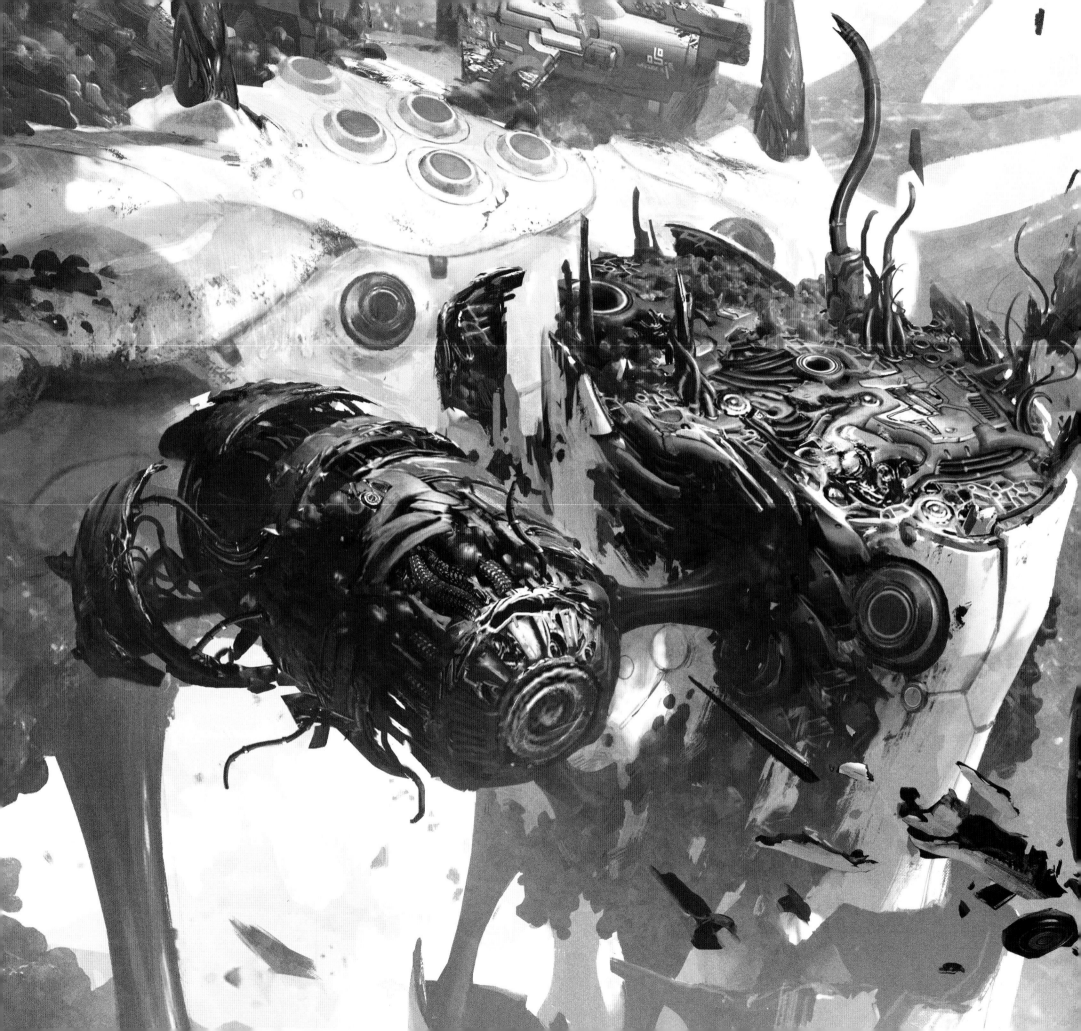

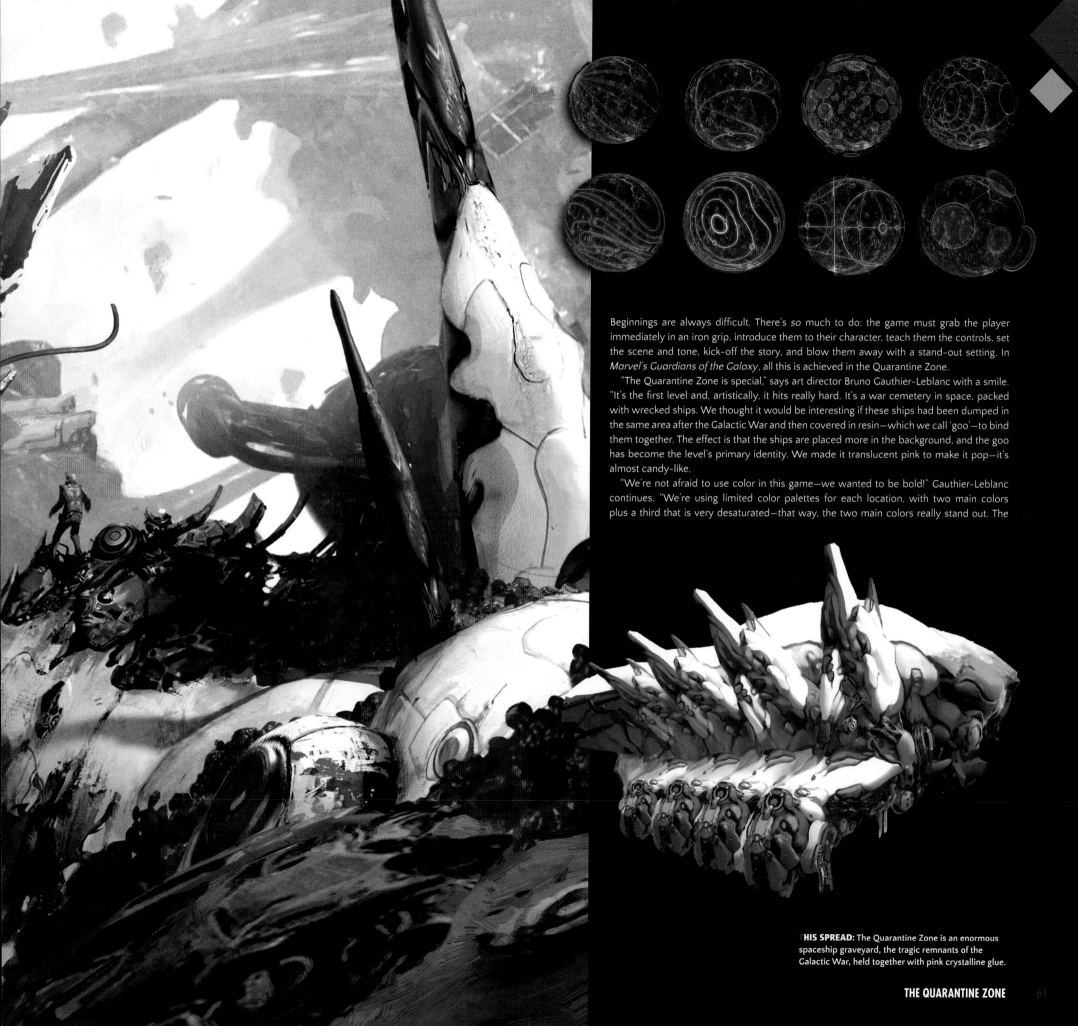

Beginnings are always difficult. There's *so* much to do: the game must grab the player immediately in an iron grip, introduce them to their character, teach them the controls, set the scene and tone, kick-off the story, and blow them away with a stand-out setting. In *Marvel's Guardians of the Galaxy*, all this is achieved in the Quarantine Zone.

"The Quarantine Zone is special," says art director Bruno Gauthier-Leblanc with a smile. "It's the first level and, artistically, it hits really hard. It's a war cemetery in space, packed with wrecked ships. We thought it would be interesting if these ships had been dumped in the same area after the Galactic War and then covered in resin—which we call 'goo'—to bind them together. The effect is that the ships are placed more in the background, and the goo has become the level's primary identity. We made it translucent pink to make it pop—it's almost candy-like.

"We're not afraid to use color in this game—we wanted to be bold!" Gauthier-Leblanc continues. "We're using limited color palettes for each location, with two main colors plus a third that is very desaturated—that way, the two main colors really stand out. The

THIS SPREAD: The Quarantine Zone is an enormous spaceship graveyard, the tragic remnants of the Galactic War, held together with pink crystalline glue.

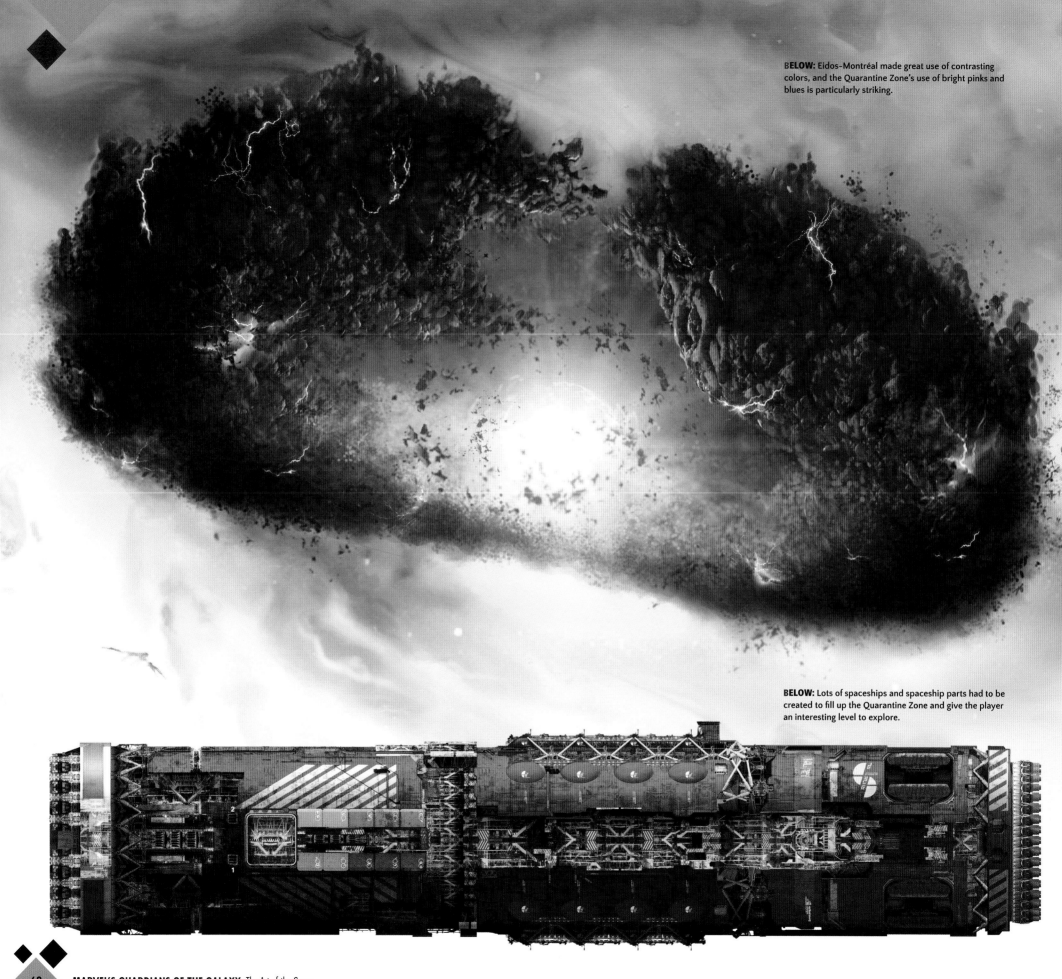

BELOW: Eidos-Montréal made great use of contrasting colors, and the Quarantine Zone's use of bright pinks and blues is particularly striking.

BELOW: Lots of spaceships and spaceship parts had to be created to fill up the Quarantine Zone and give the player an interesting level to explore.

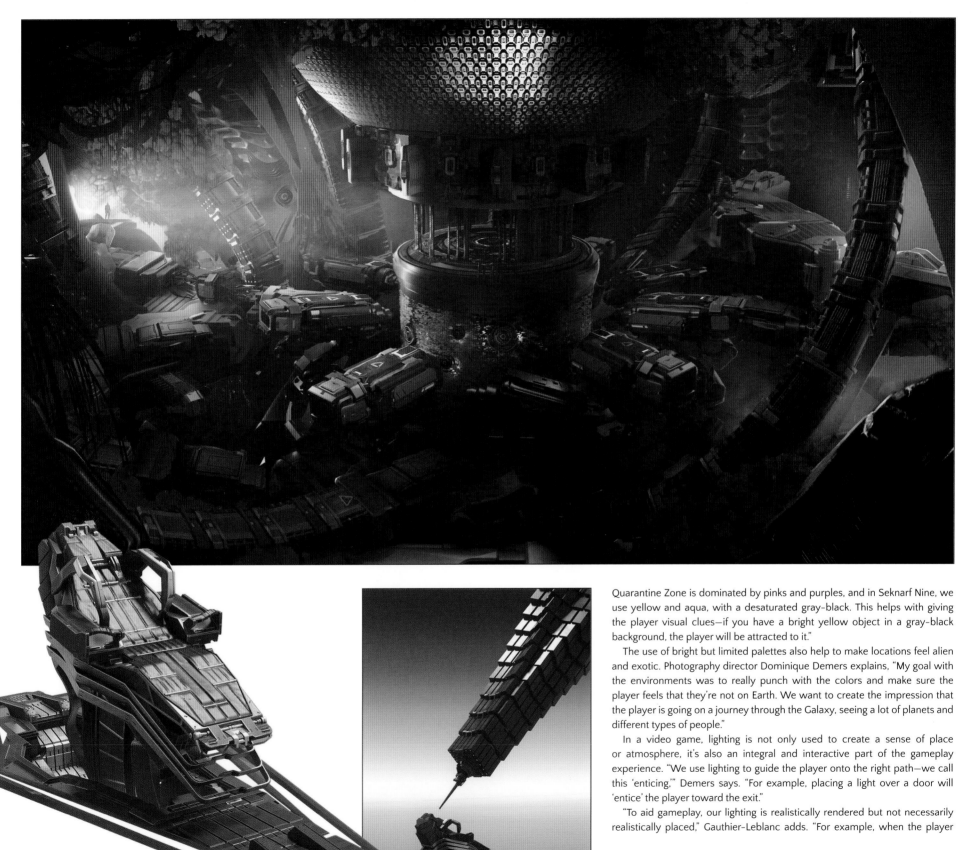

Quarantine Zone is dominated by pinks and purples, and in Seknarf Nine, we use yellow and aqua, with a desaturated gray-black. This helps with giving the player visual clues—if you have a bright yellow object in a gray-black background, the player will be attracted to it."

The use of bright but limited palettes also help to make locations feel alien and exotic. Photography director Dominique Demers explains, "My goal with the environments was to really punch with the colors and make sure the player feels that they're not on Earth. We want to create the impression that the player is going on a journey through the Galaxy, seeing a lot of planets and different types of people."

In a video game, lighting is not only used to create a sense of place or atmosphere, it's also an integral and interactive part of the gameplay experience. "We use lighting to guide the player onto the right path—we call this 'enticing,'" Demers says. "For example, placing a light over a door will 'entice' the player toward the exit."

"To aid gameplay, our lighting is realistically rendered but not necessarily realistically placed," Gauthier-Leblanc adds. "For example, when the player

THIS PAGE: Interior of the Kree Sentry Head.

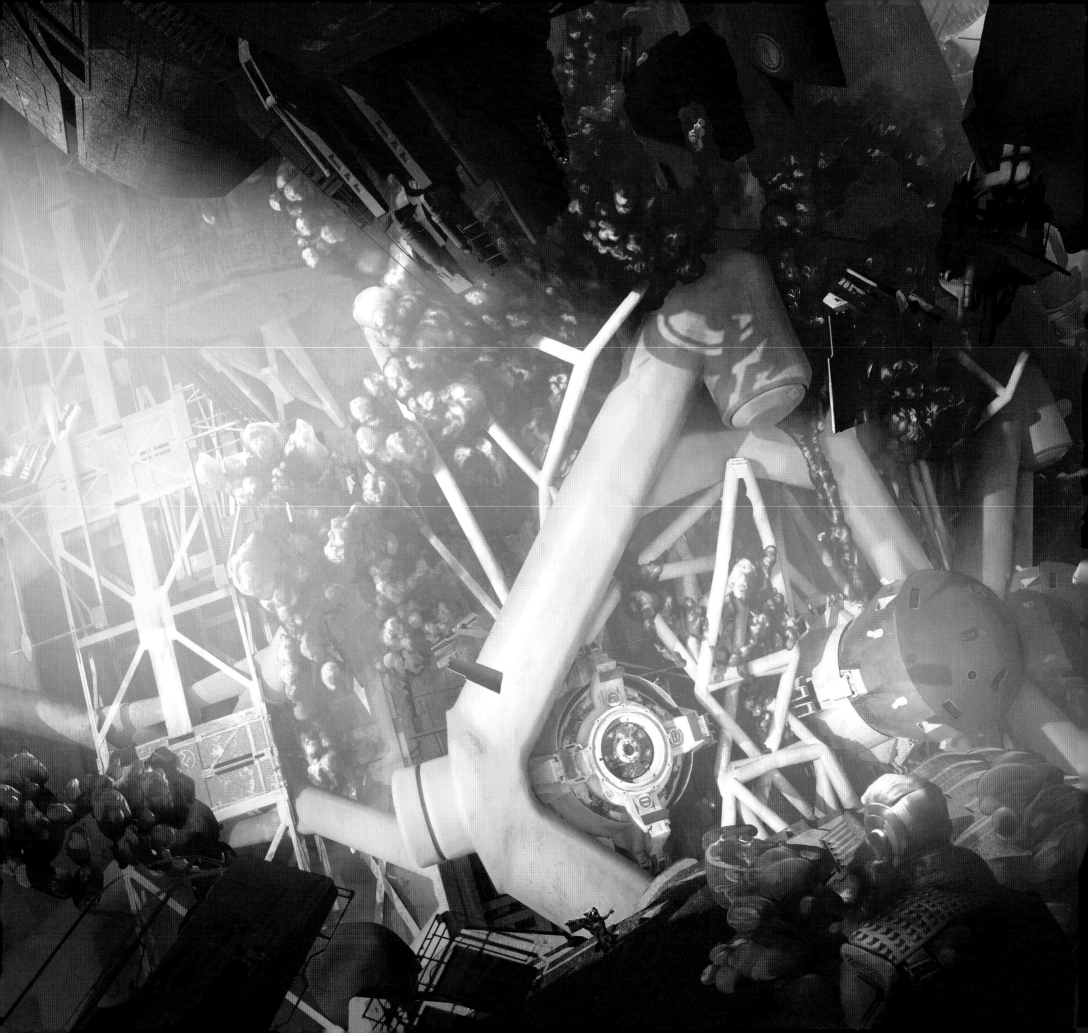

OPPOSITE: The Quarantine Zone is a strange and disorienting place of weird angles, clashing colors and contrasting textures.

THIS PAGE: This is where the story starts—a stupid bet between Star-Lord and Rocket to see who's the best shot. The cost of their rivalry may be higher than anything they could imagine—unless they find a way to save the day.

turns a corner or enters a new area, we can pop new lighting in, and the player won't notice as long as we only move the sun [or other light source] about twenty degrees. We also put in lights to draw the player's attention to particular locations: if we want them to pass through a crack in the wall, we'll blast god-rays through it—but on the other side, the sun might not be that strong."

"We use similar 'enticing' techniques in cutscenes, too," Demers says. "If we want the player to focus on Peter's face, we'll make sure it's lit brighter than everyone else's. When we play-tested the game, we tracked where the play-testers' eyes moved and focused on the screen. This allowed us to see if our lighting cues were working or not, and we could adjust things accordingly."

Creating the lighting for a vast game like *Marvel's Guardians of the Galaxy*, with its multiple levels set in different environments—Earth, alien planets, spaceships, giant floating heads, etc.—is an incredibly complicated job. To put it into some sort of perspective, Demers explains, "A two-hour, big-budget movie will have a lighting team of about sixty to eighty people. They'll work on the project for eighteen months, which gives them time to refine and polish every frame and second of runtime. In comparison, our game is longer, with several hours of cinematics—which is basically a TV miniseries!—and we only have eight lighting artists. It's a big challenge, but I think the work we produce is pretty close to what you'd see in a movie."

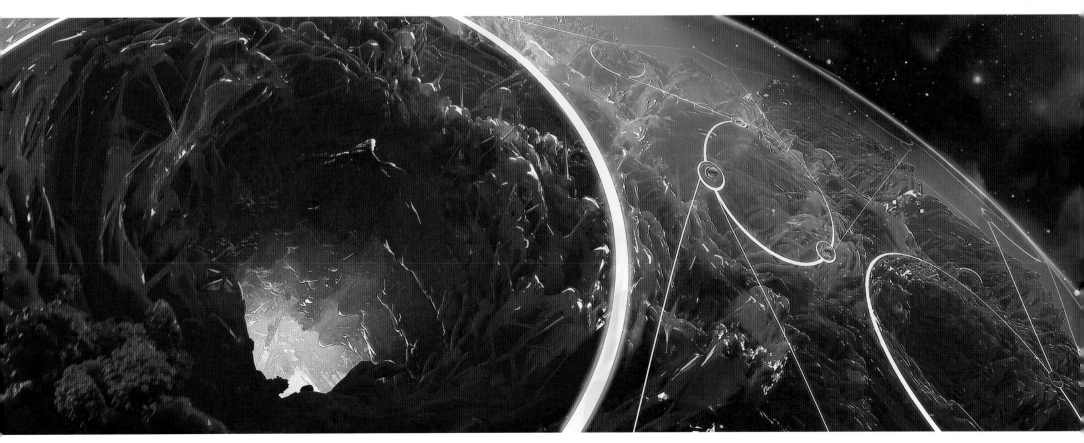

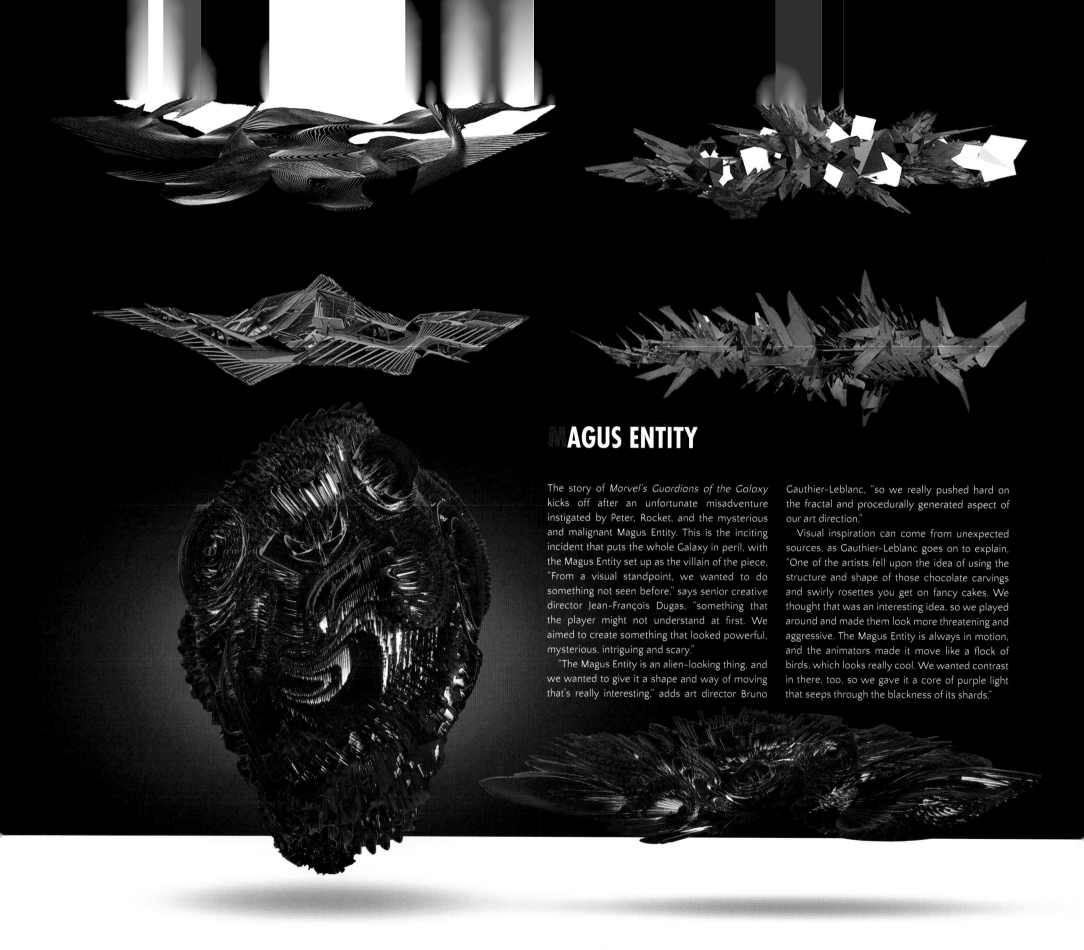

MAGUS ENTITY

The story of *Marvel's Guardians of the Galaxy* kicks off after an unfortunate misadventure instigated by Peter, Rocket, and the mysterious and malignant Magus Entity. This is the inciting incident that puts the whole Galaxy in peril, with the Magus Entity set up as the villain of the piece. "From a visual standpoint, we wanted to do something not seen before," says senior creative director Jean-François Dugas, "something that the player might not understand at first. We aimed to create something that looked powerful, mysterious, intriguing and scary."

"The Magus Entity is an alien-looking thing, and we wanted to give it a shape and way of moving that's really interesting," adds art director Bruno Gauthier-Leblanc, "so we really pushed hard on the fractal and procedurally generated aspect of our art direction."

Visual inspiration can come from unexpected sources, as Gauthier-Leblanc goes on to explain, "One of the artists fell upon the idea of using the structure and shape of those chocolate carvings and swirly rosettes you get on fancy cakes. We thought that was an interesting idea, so we played around and made them look more threatening and aggressive. The Magus Entity is always in motion, and the animators made it move like a flock of birds, which looks really cool. We wanted contrast in there, too, so we gave it a core of purple light that seeps through the blackness of its shards."

THIS PAGE: Eidos-Montréal wanted to create something unique for the Magus Entity. They experimented with fractal shapes and movement to make it appear powerful, ambiguous, and disorienting.

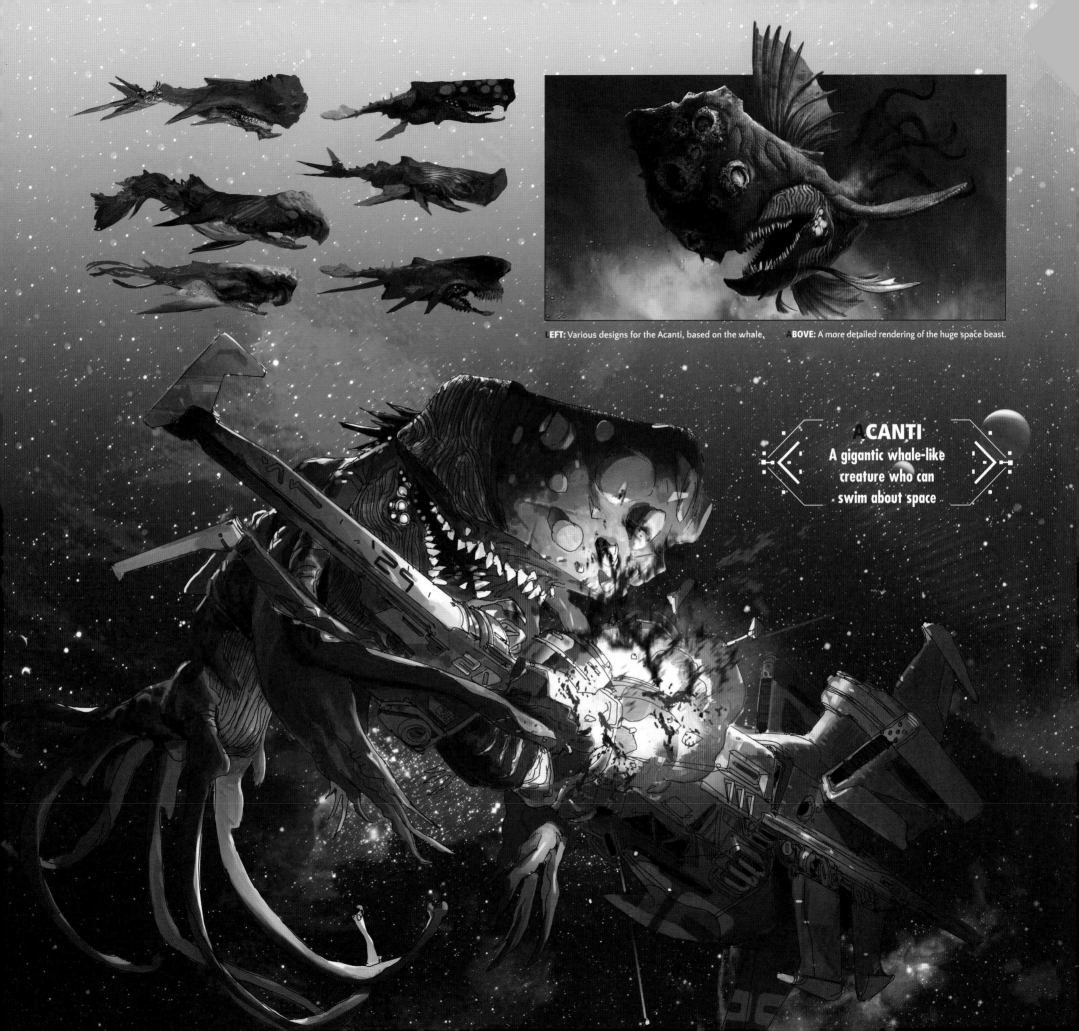

LEFT: Various designs for the Acanti, based on the whale, **ABOVE:** A more detailed rendering of the huge space beast.

ACANTI
A gigantic whale-like creature who can swim about space

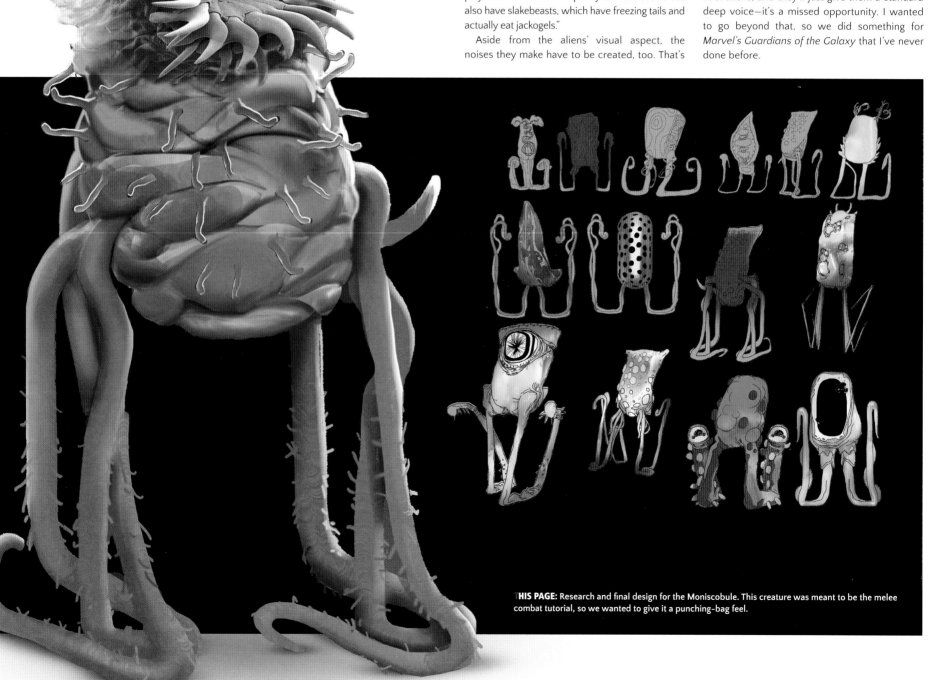

ALIEN CREATURES

Marvel's Guardians of the Galaxy wouldn't be very galactic without an exotic menagerie of alien creatures to meet, greet and shoot at. "The fun part is that all our enemy types look different and require various strategies to defeat," lead character artist Genci Buxheli explains. "We have jackogels, which are funny yet deadly—they're strong, fast, and the player will have to act quickly to beat them. We also have slakebeasts, which have freezing tails and actually eat jackogels."

Aside from the aliens' visual aspect, the noises they make have to be created, too. That's where the creative minds of the sound design team, headed up by senior audio director Steve Szczepkowski, come in. "The alien creature sound effects are quite open to design," Szczepkowski says. "I'm sometimes a bit disappointed in the way some science-fiction games and movies voice alien characters. They'll have these huge, cool aliens, and they'll just give them a standard deep voice—it's a missed opportunity. I wanted to go beyond that, so we did something for Marvel's Guardians of the Galaxy that I've never done before.

THIS PAGE: Research and final design for the Moniscobule. This creature was meant to be the melee combat tutorial, so we wanted to give it a punching-bag feel.

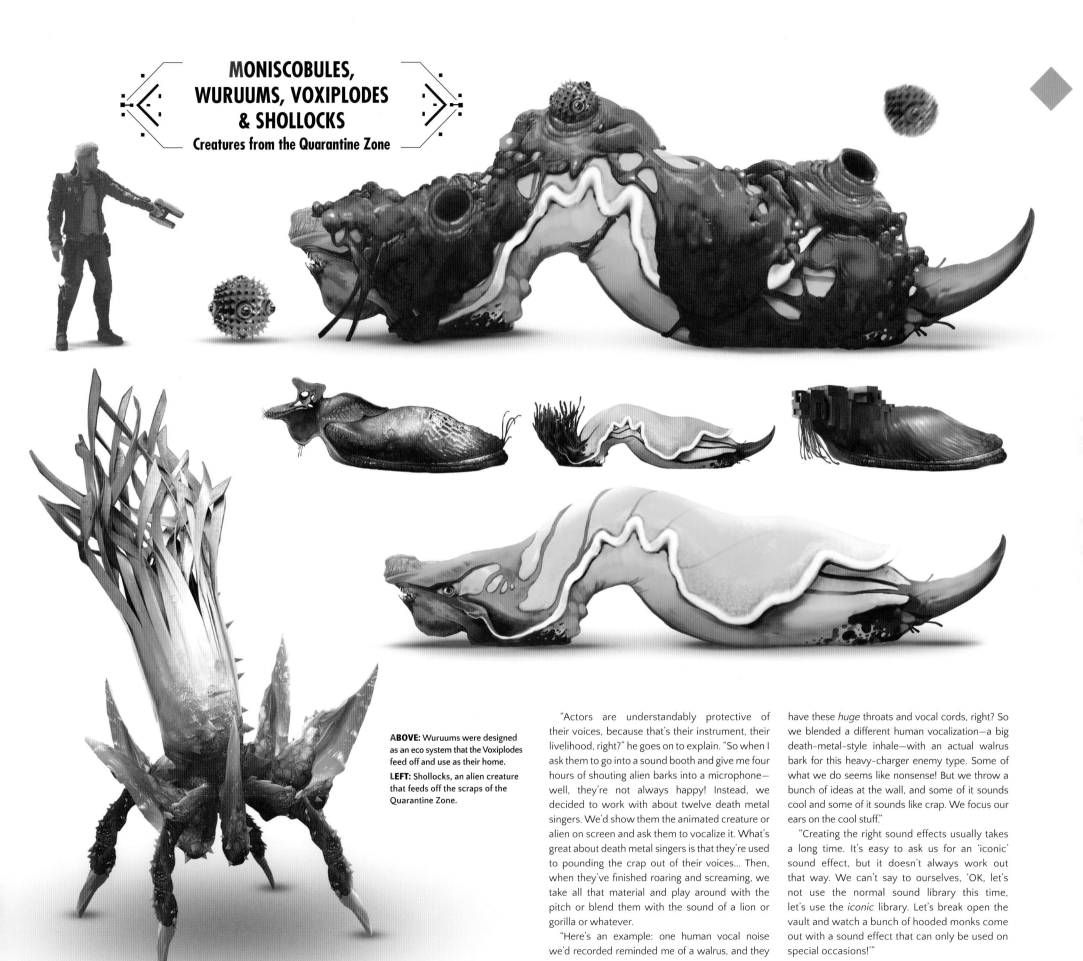

MONISCOBULES, WURUUMS, VOXIPLODES & SHOLLOCKS
Creatures from the Quarantine Zone

ABOVE: Wuruums were designed as an eco system that the Voxiplodes feed off and use as their home.

LEFT: Shollocks, an alien creature that feeds off the scraps of the Quarantine Zone.

"Actors are understandably protective of their voices, because that's their instrument, their livelihood, right?" he goes on to explain. "So when I ask them to go into a sound booth and give me four hours of shouting alien barks into a microphone—well, they're not always happy! Instead, we decided to work with about twelve death metal singers. We'd show them the animated creature or alien on screen and ask them to vocalize it. What's great about death metal singers is that they're used to pounding the crap out of their voices... Then, when they've finished roaring and screaming, we take all that material and play around with the pitch or blend them with the sound of a lion or gorilla or whatever.

"Here's an example: one human vocal noise we'd recorded reminded me of a walrus, and they have these *huge* throats and vocal cords, right? So we blended a different human vocalization—a big death-metal-style inhale—with an actual walrus bark for this heavy-charger enemy type. Some of what we do seems like nonsense! But we throw a bunch of ideas at the wall, and some of it sounds cool and some of it sounds like crap. We focus our ears on the cool stuff."

"Creating the right sound effects usually takes a long time. It's easy to ask us for an 'iconic' sound effect, but it doesn't always work out that way. We can't say to ourselves, 'OK, let's not use the normal sound library this time, let's use the *iconic* library. Let's break open the vault and watch a bunch of hooded monks come out with a sound effect that can only be used on special occasions!'"

KAMMY

Some characters are predestined to become fan favorites, and Kammy is a shoo-in for that title. How do I know this? 1: Because just *look* at her! And 2: Because whenever anyone at Eidos-Montréal talks about Kammy, they always have a smile on their face.

"She's one of my favorite characters!" Groot actor Robert Montcalm laughs. "Groot is very fond of Kammy, too. There's one scene where the rest of the team is really angry with her and are shouting, so Groot comes in, scoops her up, comforts her, and carries her away."

"Kammy was totally our invention," art director Bruno Gauthier-Leblanc says. "She's the comic relief in many scenes. She looks just like a llama, but we gave her some edges—her legs have some geometrical/triangular shapes to them. But really it's her face that's important—it makes her look so innocent, harmless, and oblivious. The bright colors, the hair in front of her

THIS PAGE: Kammy is an original creation from Eidos-Montréal, carefully designed to fit perfectly with the anarchic and slightly absurd world of the Guardians of the Galaxy.

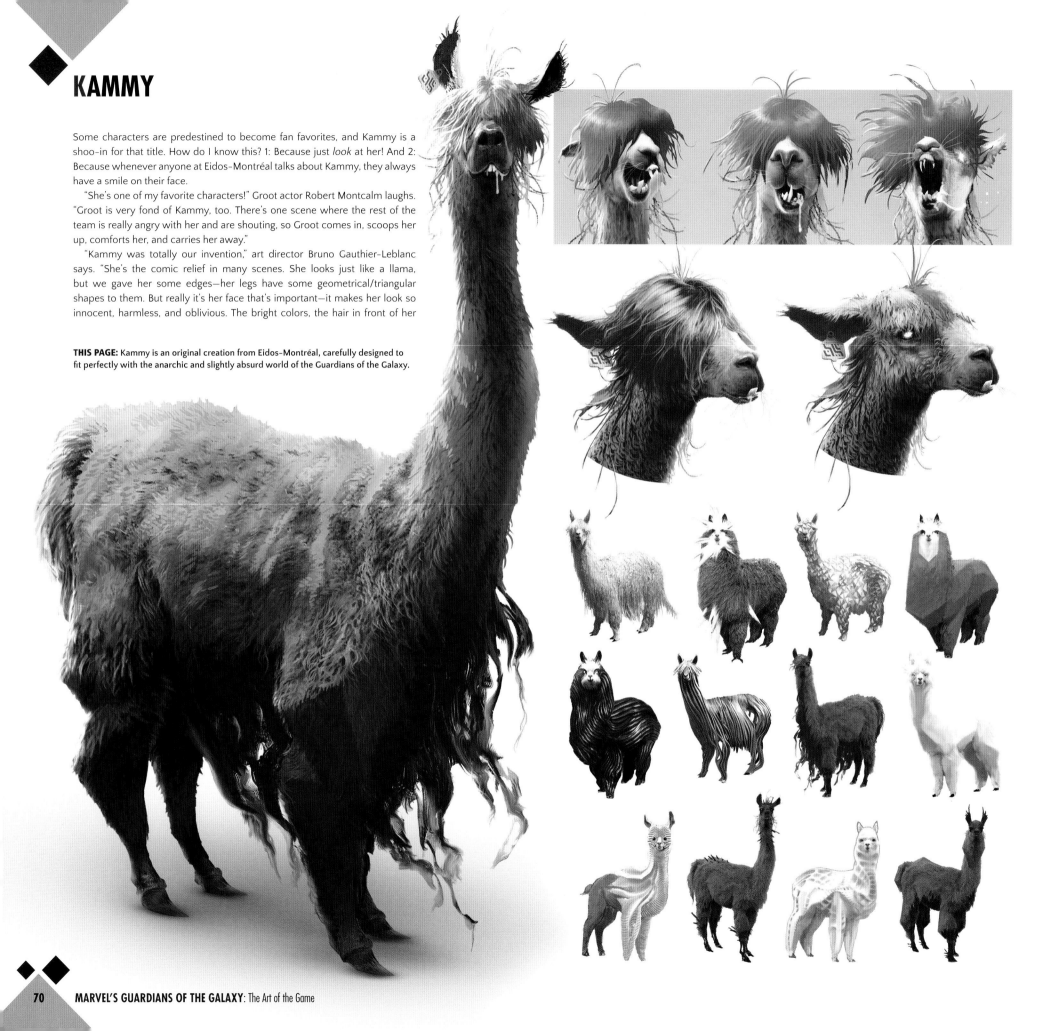

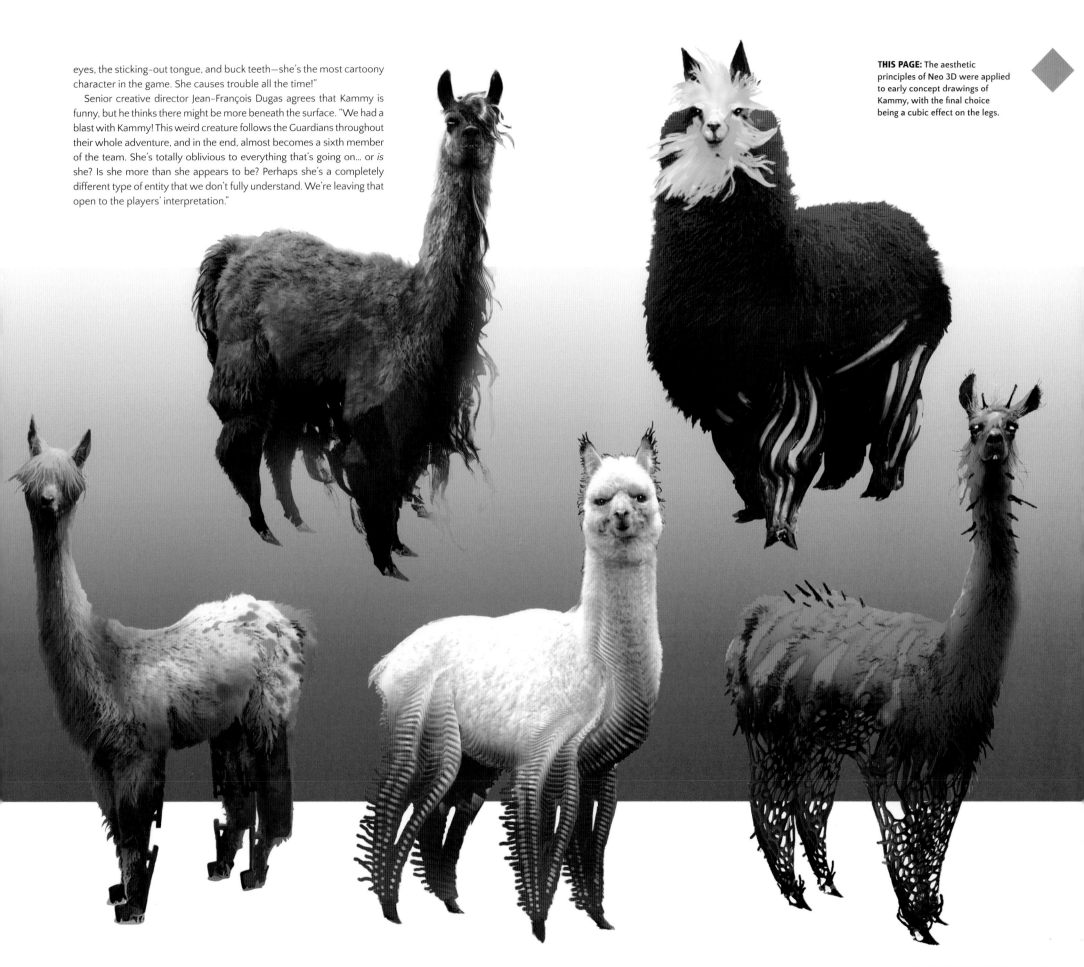

eyes, the sticking-out tongue, and buck teeth—she's the most cartoony character in the game. She causes trouble all the time!"

Senior creative director Jean-François Dugas agrees that Kammy is funny, but he thinks there might be more beneath the surface. "We had a blast with Kammy! This weird creature follows the Guardians throughout their whole adventure, and in the end, almost becomes a sixth member of the team. She's totally oblivious to everything that's going on... or *is* she? Is she more than she appears to be? Perhaps she's a completely different type of entity that we don't fully understand. We're leaving that open to the players' interpretation."

THIS PAGE: The aesthetic principles of Neo 3D were applied to early concept drawings of Kammy, with the final choice being a cubic effect on the legs.

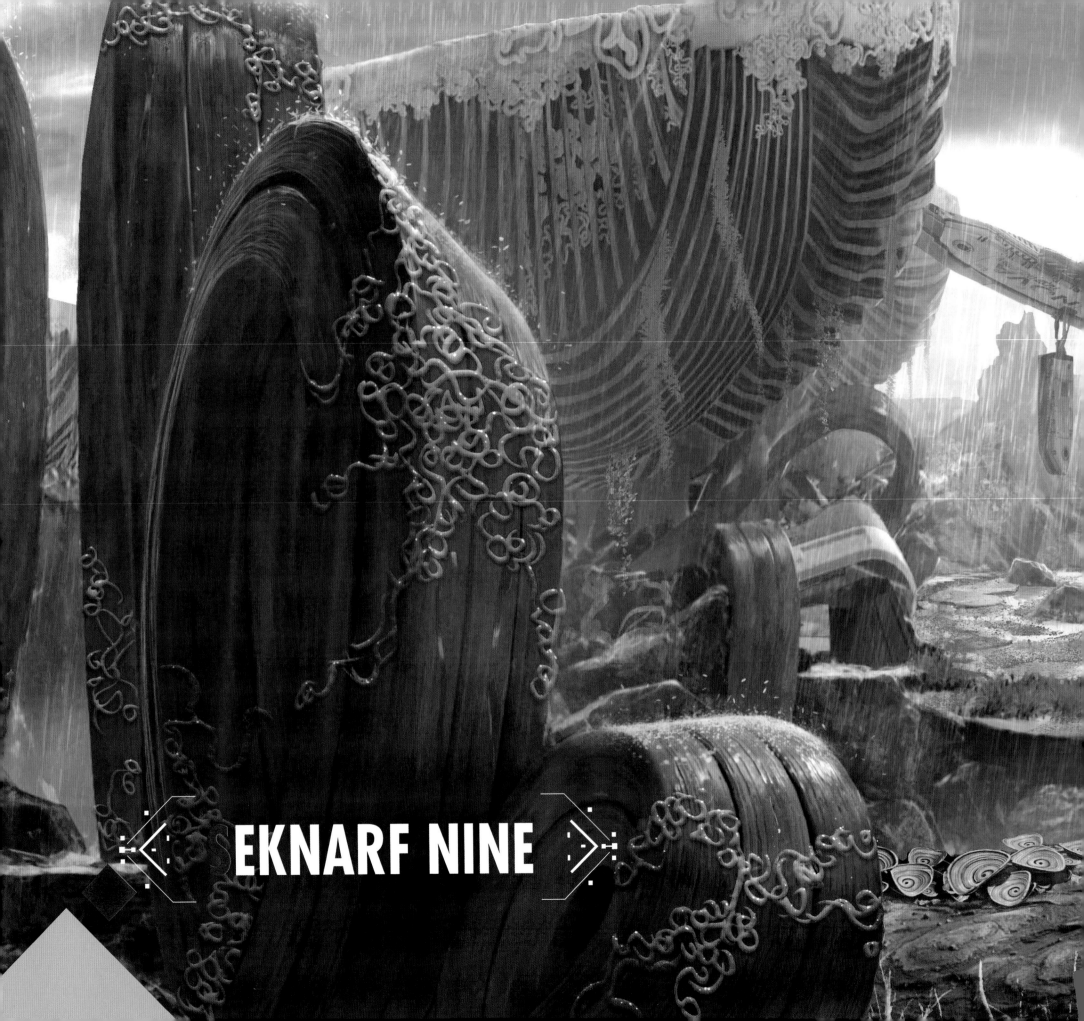

EKNARF NINE

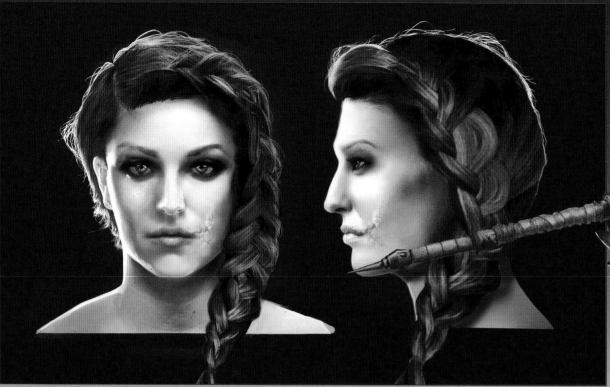

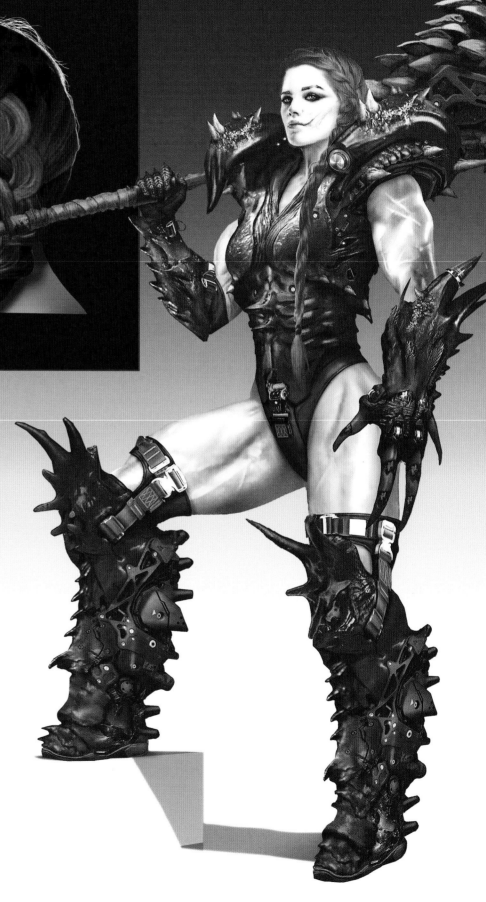

ABOVE: Concept art showing a face-on and profile view of Lady Hellbender.

RIGHT: A fully rendered concept art of Lady Hellbender in all her spikey-armored glory.

LADY HELLBENDER

Every great story needs heroes and villains, but a guaranteed way to add extra spice, surprise, and intrigue to a plot is to include characters who run the gamut between the two. Suffice to say that Lady Hellbender's relationship with the Guardians is fluid... and complicated.

As for her design, that was a complicated process, too, as concept artist Frederic Bennett explains, "My first version of Lady Hellbender was covered in armor made from lots of interlocking shapes—almost like the black thermal tiles on the NASA space shuttle orbiter. I added unique numbers to each tile, the idea being that they'd serve as a reference to show how they should be properly fitted together. However, when we showed the concept to Marvel, they said it looked too much like Iron Man's suit, especially because

it was colored red and gold. Sometimes, we needed Marvel to show us the bigger picture and point out the issues." However, waste not, want not, as they say. "I really liked that tile design idea," Bennett adds, "so I reused it on the Knowhere security guards."

For Bennett and the team, it was back to the drawing board to create a fresh approach. "We wanted to reinterpret the Lady Hellbender design from the comic books [a muscular sword-and-mace-wielding warrior] and make her look more realistic. We drew some inspiration from the Capcom video game, *Monster Hunter* [2004], where the player can reuse parts of the monsters they kill to create new weapons and armor; the creature horn around Lady Hellbender's neck is a little tribute to that game."

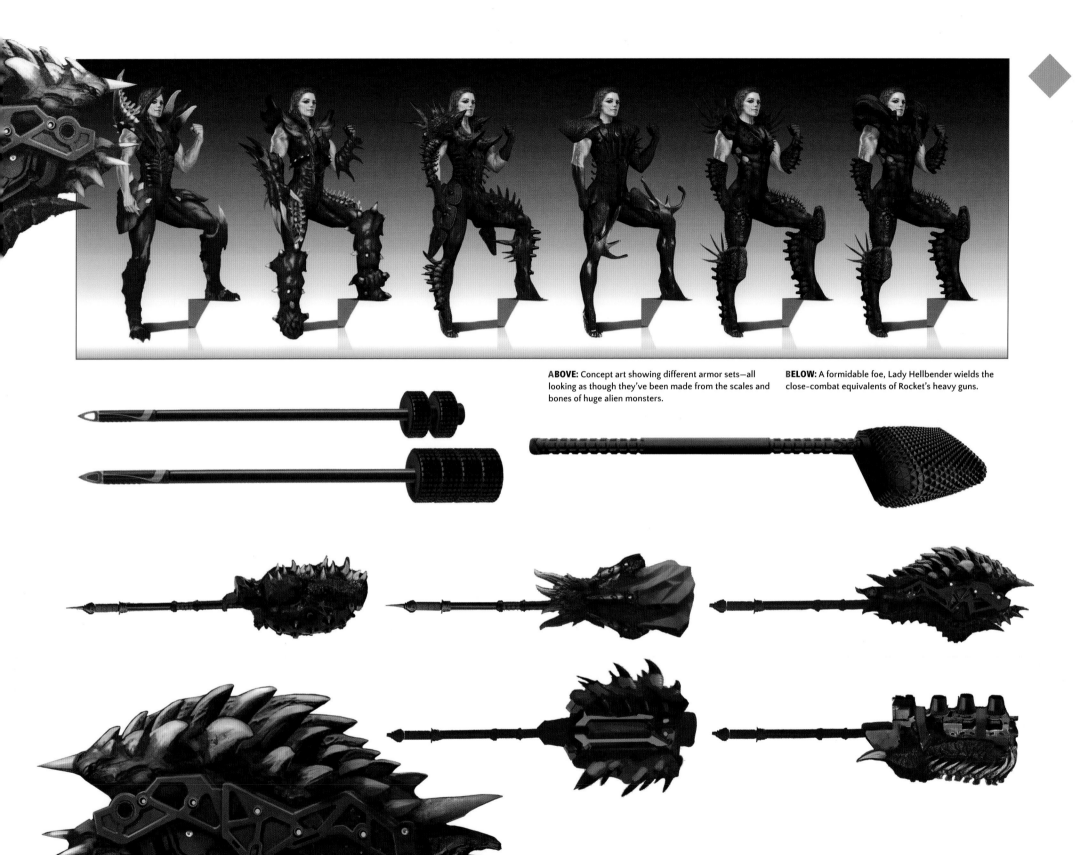

ABOVE: Concept art showing different armor sets—all looking as though they've been made from the scales and bones of huge alien monsters.

BELOW: A formidable foe, Lady Hellbender wields the close-combat equivalents of Rocket's heavy guns.

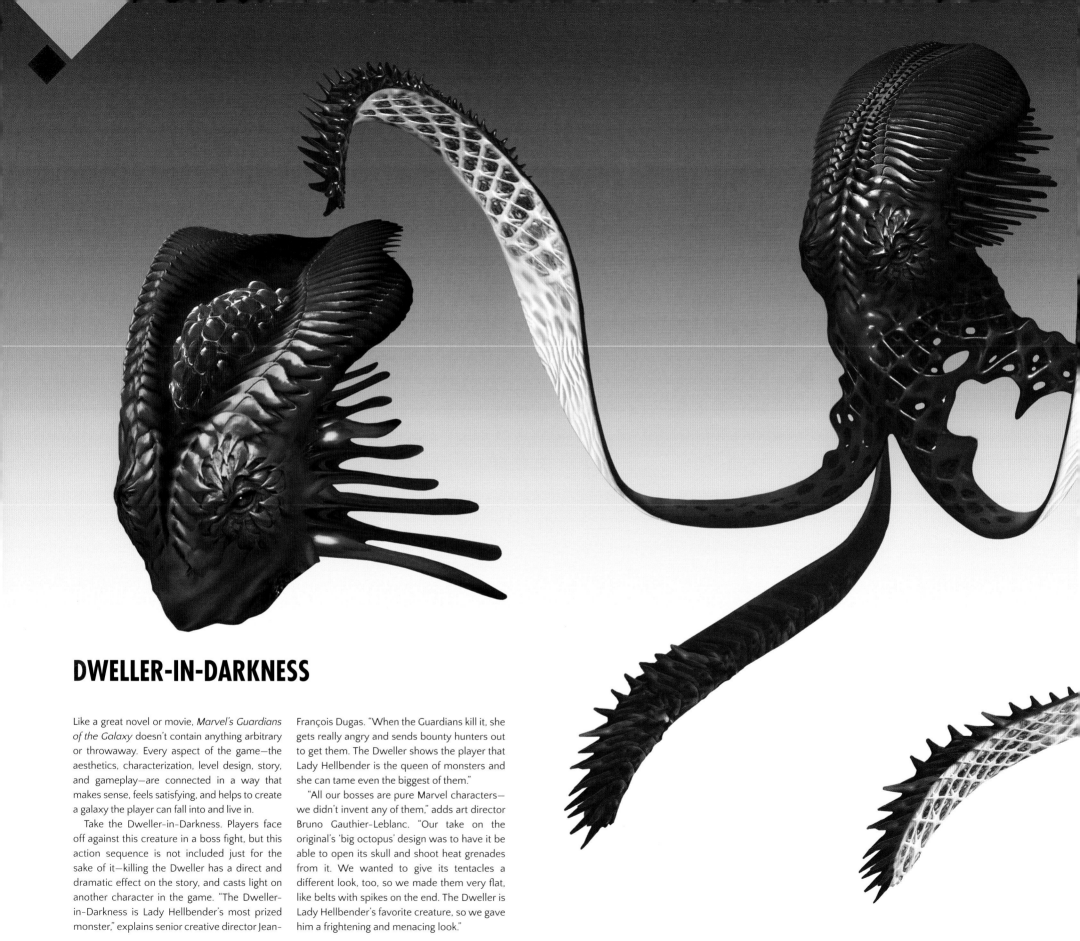

DWELLER-IN-DARKNESS

Like a great novel or movie, *Marvel's Guardians of the Galaxy* doesn't contain anything arbitrary or throwaway. Every aspect of the game—the aesthetics, characterization, level design, story, and gameplay—are connected in a way that makes sense, feels satisfying, and helps to create a galaxy the player can fall into and live in.

Take the Dweller-in-Darkness. Players face off against this creature in a boss fight, but this action sequence is not included just for the sake of it—killing the Dweller has a direct and dramatic effect on the story, and casts light on another character in the game. "The Dweller-in-Darkness is Lady Hellbender's most prized monster," explains senior creative director Jean-

François Dugas. "When the Guardians kill it, she gets really angry and sends bounty hunters out to get them. The Dweller shows the player that Lady Hellbender is the queen of monsters and she can tame even the biggest of them."

"All our bosses are pure Marvel characters—we didn't invent any of them," adds art director Bruno Gauthier-Leblanc. "Our take on the original's 'big octopus' design was to have it be able to open its skull and shoot heat grenades from it. We wanted to give its tentacles a different look, too, so we made them very flat, like belts with spikes on the end. The Dweller is Lady Hellbender's favorite creature, so we gave him a frightening and menacing look."

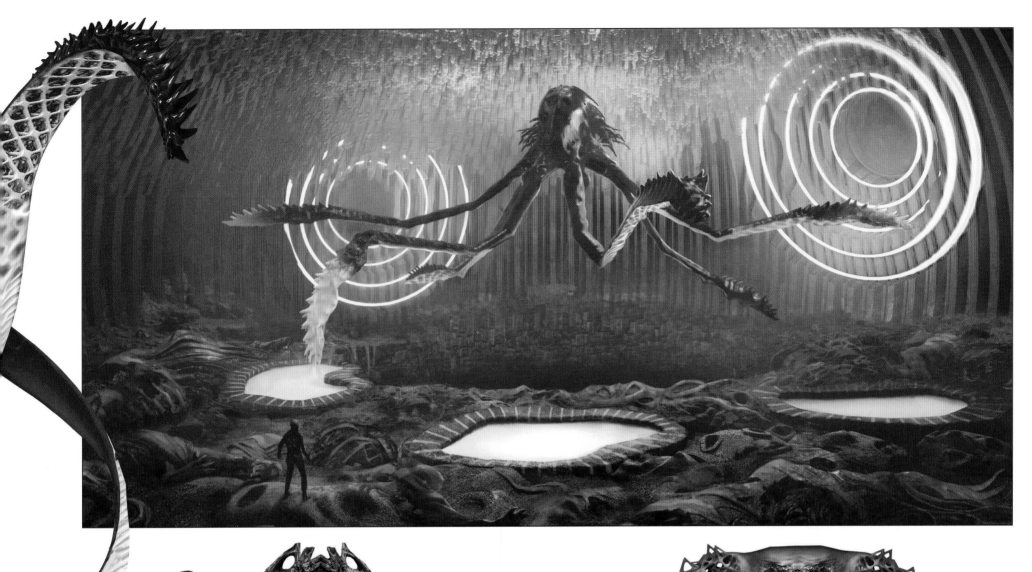

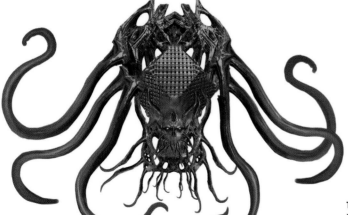

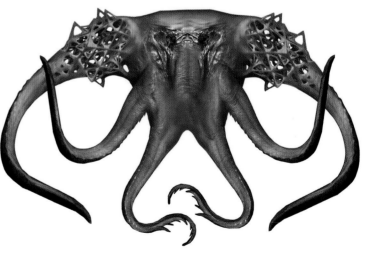

THIS SPREAD: The Dweller-in-Darkness, and some of the strange and malignant fauna found in its shadowy lair.

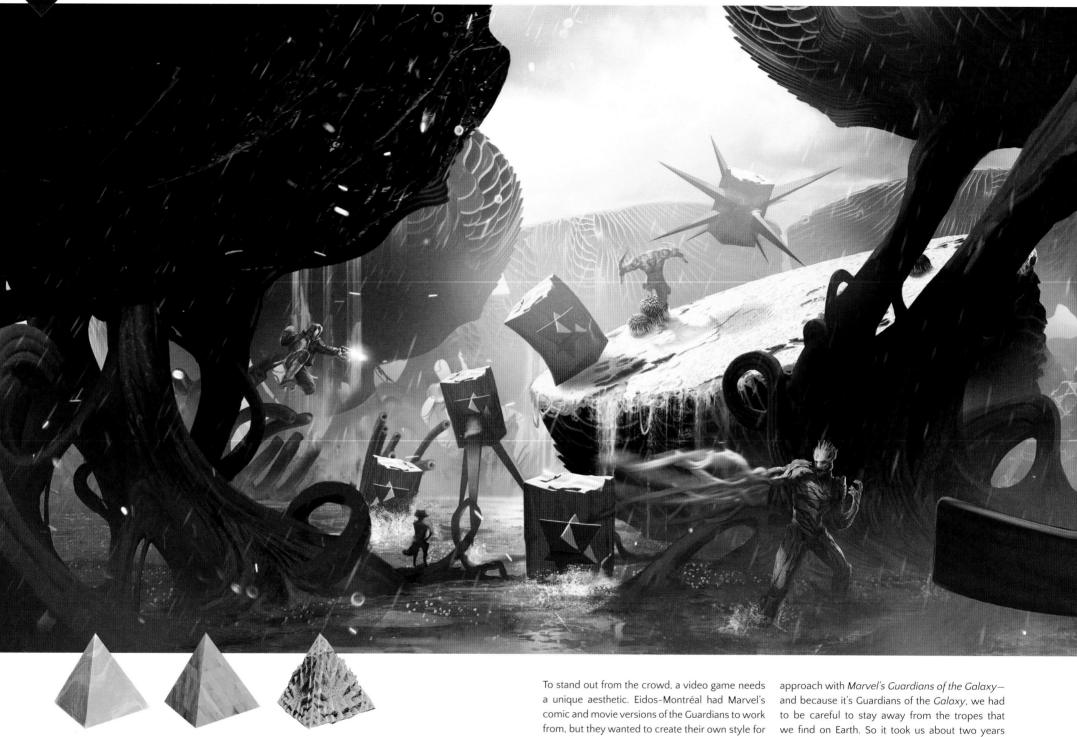

THIS PAGE: Here, we can clearly see how the ingenious Neo 3D infused many aspects of the game world and the alien creatures that inhabit it.

To stand out from the crowd, a video game needs a unique aesthetic. Eidos-Montréal had Marvel's comic and movie versions of the Guardians to work from, but they wanted to create their own style for *Marvel's Guardians of the Galaxy*. Art director Bruno Gauthier-Leblanc explains the process.

"The first big tasks an art director has on a project like this are setting the global vision and establishing a visual identity. This involves a lot of research and trial and error, because you don't often find the right direction on the first attempt. We used a lot of concept artists—our philosophy at Eidos-Montréal is to design *everything*. That's how we create unique worlds like those found in the *Deus Ex* series. We took exactly the same

approach with *Marvel's Guardians of the Galaxy*— and because it's Guardians of the *Galaxy*, we had to be careful to stay away from the tropes that we find on Earth. So it took us about two years of development until we decided that we had something special."

Although proud to be working on such a beloved property, Eidos-Montréal was eager to challenge Marvel with some unusual design choices. "My design philosophy is to break expectations, and I believe there are good ways to shock," explains Gauthier-Leblanc with a smile. "We worked with Marvel closely, of course, but the first thing we did was hit them hard with our most outlandish ideas. We deliberately went to an extreme with

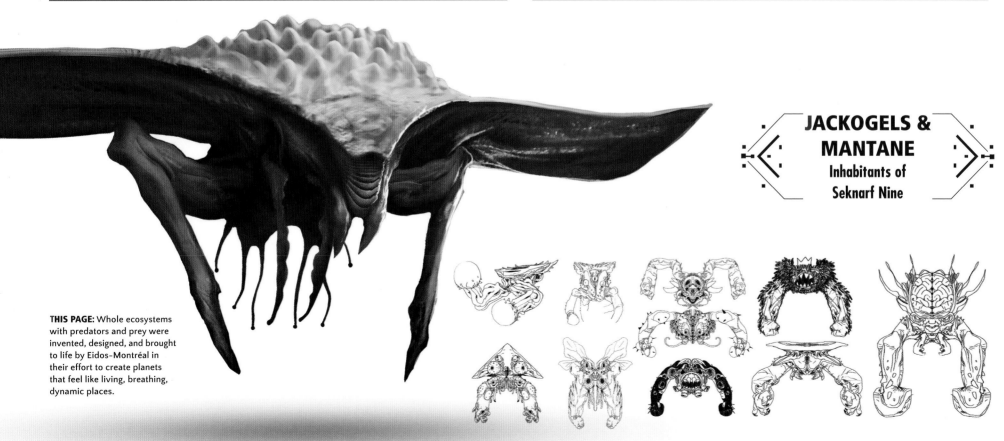

JACKOGELS & MANTANE
Inhabitants of Seknarf Nine

THIS PAGE: Whole ecosystems with predators and prey were invented, designed, and brought to life by Eidos-Montréal in their effort to create planets that feel like living, breathing, dynamic places.

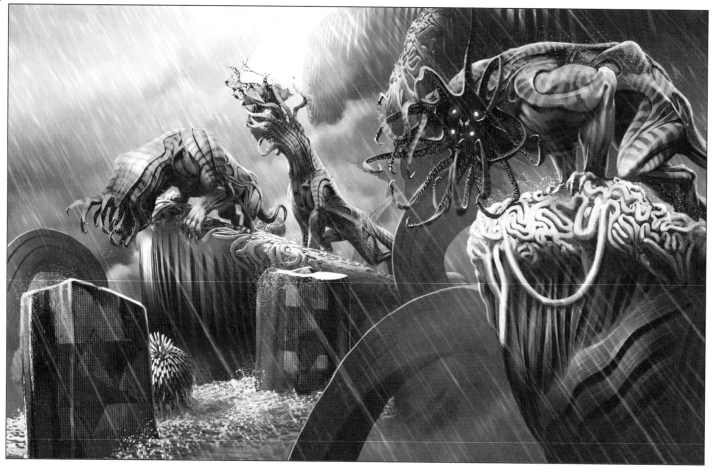

our first character designs: we made a fat Drax, a human-height Rocket, and a Groot who looked like a robot made from wood. This showed Marvel that we didn't want to create a vanilla product and just use designs from the comic books. We wanted to make these Guardians our own and give the characters their own identity. After we hit Marvel with this design hammer, they gave us lots of great feedback and we adjusted accordingly. From then, our relationship with Marvel has been amazing, and sometimes they'd even get back to us and say they didn't think we were pushing things far enough!"

Eidos-Montréal's dogged insistence on creating something original led to the design department coming up with their very own art style. "We were creating a science-fiction game in an era that's saturated with them, and we knew if we weren't careful, we were in danger of blending in with all the others," Gauthier-Leblanc continues. "We wanted to create something with a unique look, so we looked at the sort of 3D-rendered environments created in programs like 3D Studio Max and Bryce in the 1990s—spheres or cubes floating over metallic lakes, that sort of thing."

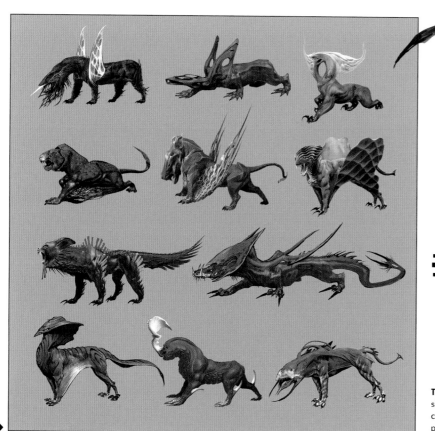

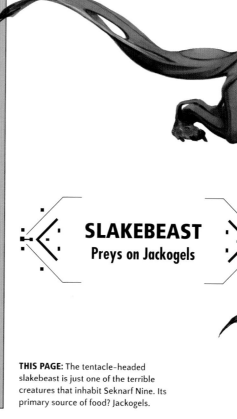

SLAKEBEAST
Preys on Jackogels

THIS PAGE: The tentacle-headed slakebeast is just one of the terrible creatures that inhabit Seknarf Nine. Its primary source of food? Jackogels.

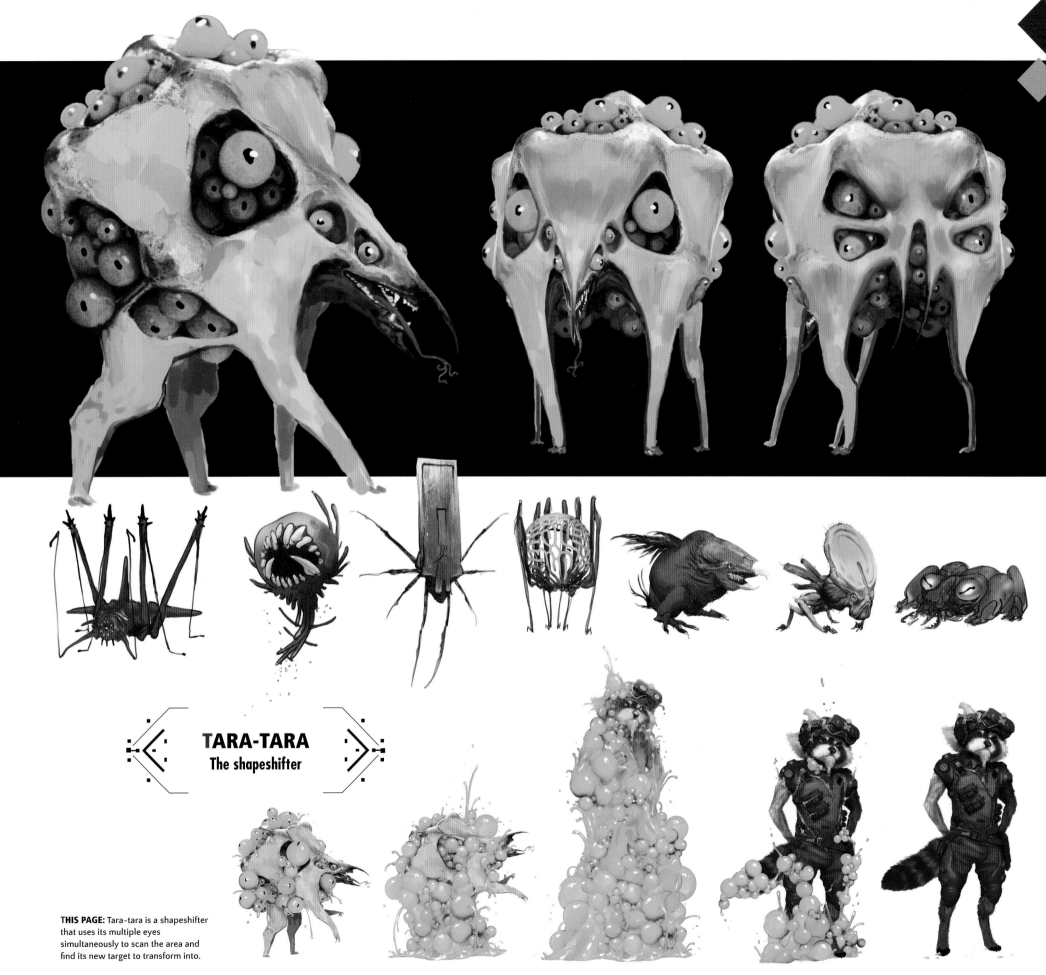

TARA-TARA
The shapeshifter

THIS PAGE: Tara-tara is a shapeshifter that uses its multiple eyes simultaneously to scan the area and find its new target to transform into.

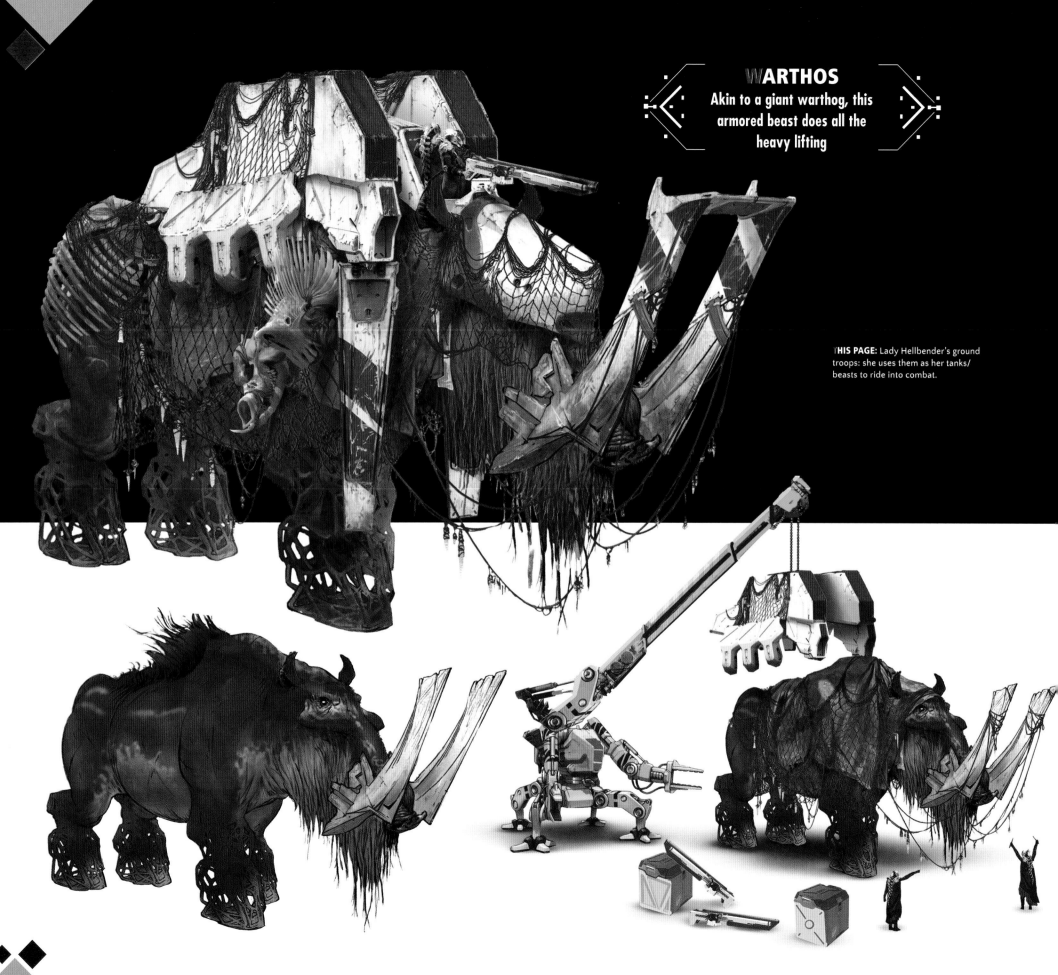

WARTHOS
Akin to a giant warthog, this armored beast does all the heavy lifting

THIS PAGE: Lady Hellbender's ground troops: she uses them as her tanks/ beasts to ride into combat.

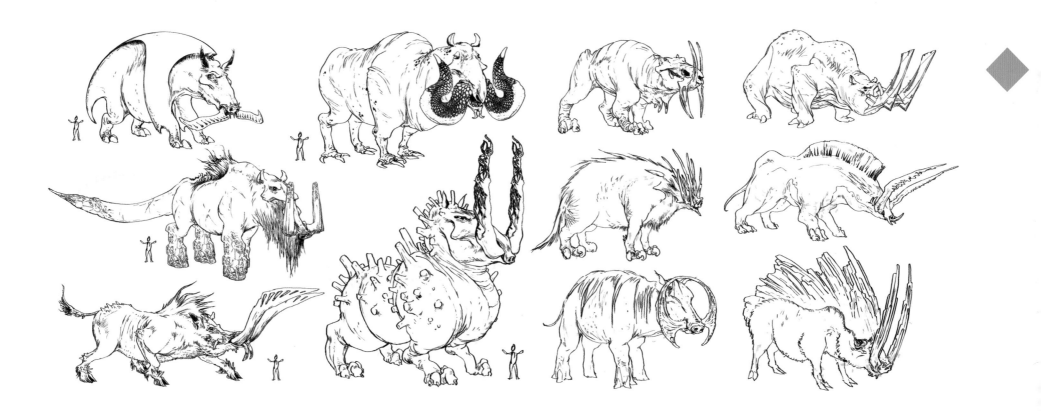

"Although these images haven't aged well," Gauthier-Leblanc continues, "we liked the simplicity of those primitive shapes and we decided to use them for our art direction. We soon realized how much potential this idea had. We named it 'Neo 3D' because 'neo' means 'new,' and it also means to go back to the roots—by taking inspiration and creating new things with 1990s 3D art—and that's exactly what we were doing.

"We discovered that we could create detailed and rich environments by adding fractal shapes on or around simple cubes or spheres. We duplicated and multiplied these shapes to build stacks of cubes, orbs, or cylinders to create really interesting repetitions. The challenge was making sure this repetition didn't become boring. We had to ask ourselves, 'How do we make a sphere interesting in ten different ways?' Luckily, my concept artists came up with lots of funky ideas, and this approach has given our galaxy a

ABOVE: Early sketches for the Warthos.

RIGHT: Designs of the Hellraiser Grunts, part of Lady Hellbender's personal army.

rich and unique look. We also felt it was important to use Neo 3D on the characters as well as the environments—although we push this idea further with the secondary characters and enemy types, rather than the Guardians themselves. For example, we have a character [Raker] who has robotic arms that I made from lots of little cubes."

Once designed, these characters had to be brought to life with smooth, fluid, and convincing animation. Animation director Darryl Purdy explains, "One of the things we like to do at Eidos-Montréal is integrate our cinematics as seamlessly as possible into the gameplay experience. Sometimes, because these projects are so big, we

have separate departments (one for gameplay, another for narrative), and maintaining good communication between them can be challenging. But because my role has one foot in gameplay and one foot in narrative, that makes the experience of making the game more cohesive."

The animation process was made all the more complicated by the early decision to have the player character, Star-Lord, always accompanied and aided in combat by his companions. "One of the biggest challenges the team faced was to create a game with four AI characters [Gamora, Drax, Groot, and Rocket] who must follow the player character, feel alive, don't get in the way, and who don't act like

HELLRAISERS
Lady Hellbender's Army

THIS PAGE: Grenade and Sniper Hellraisers.

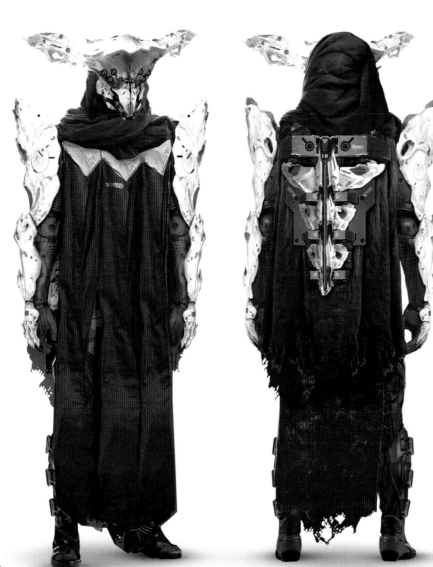

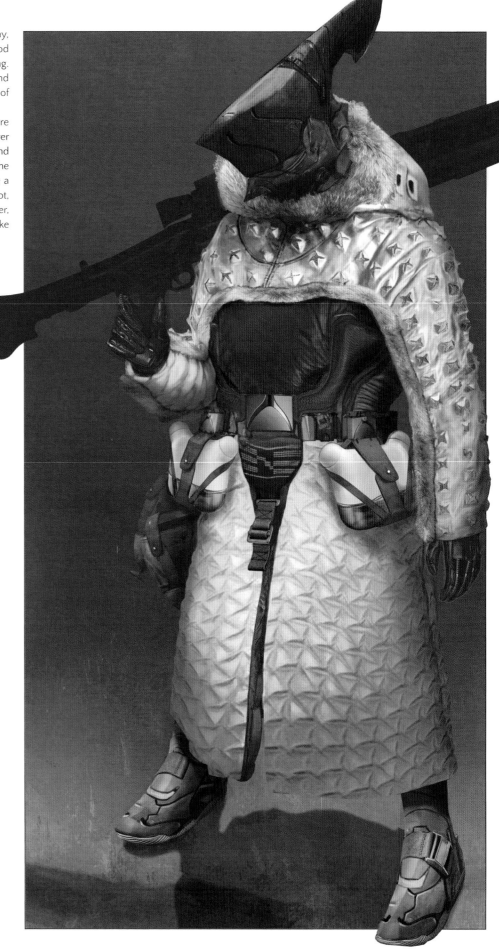

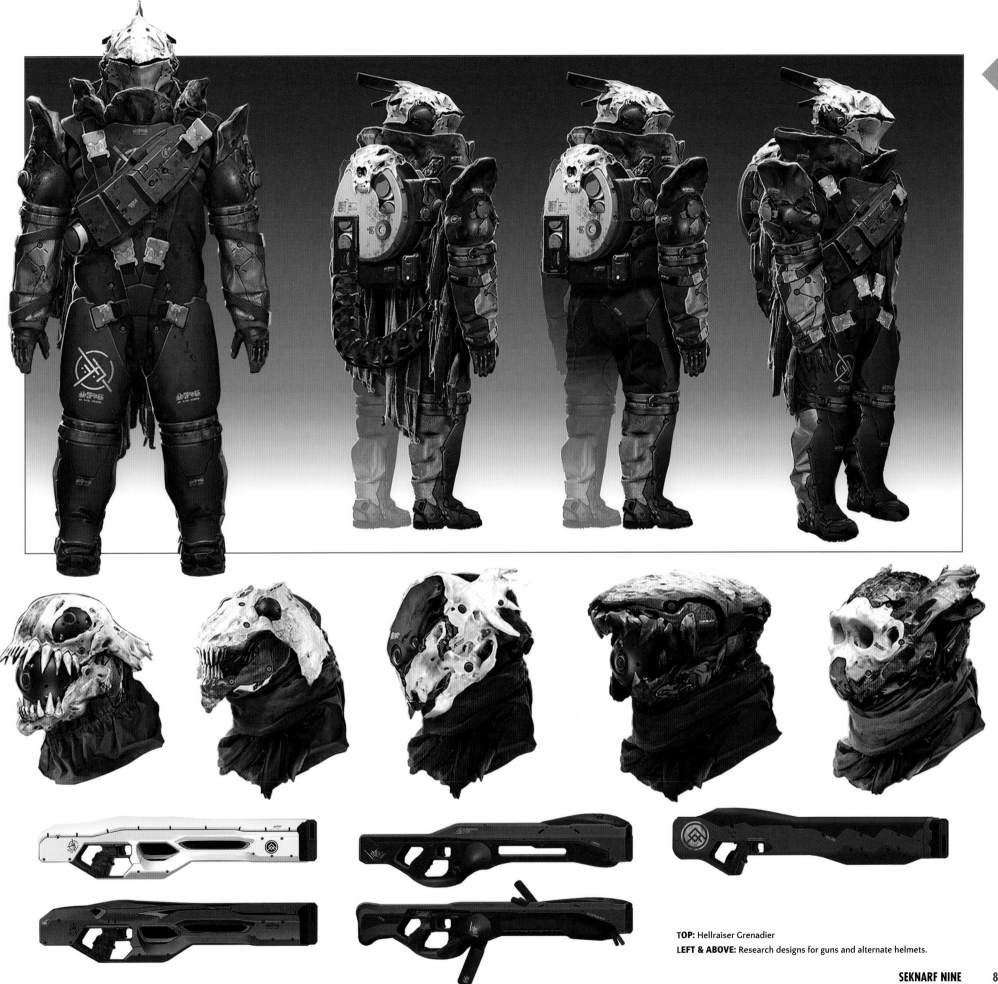

TOP: Hellraiser Grenadier

LEFT & ABOVE: Research designs for guns and alternate helmets.

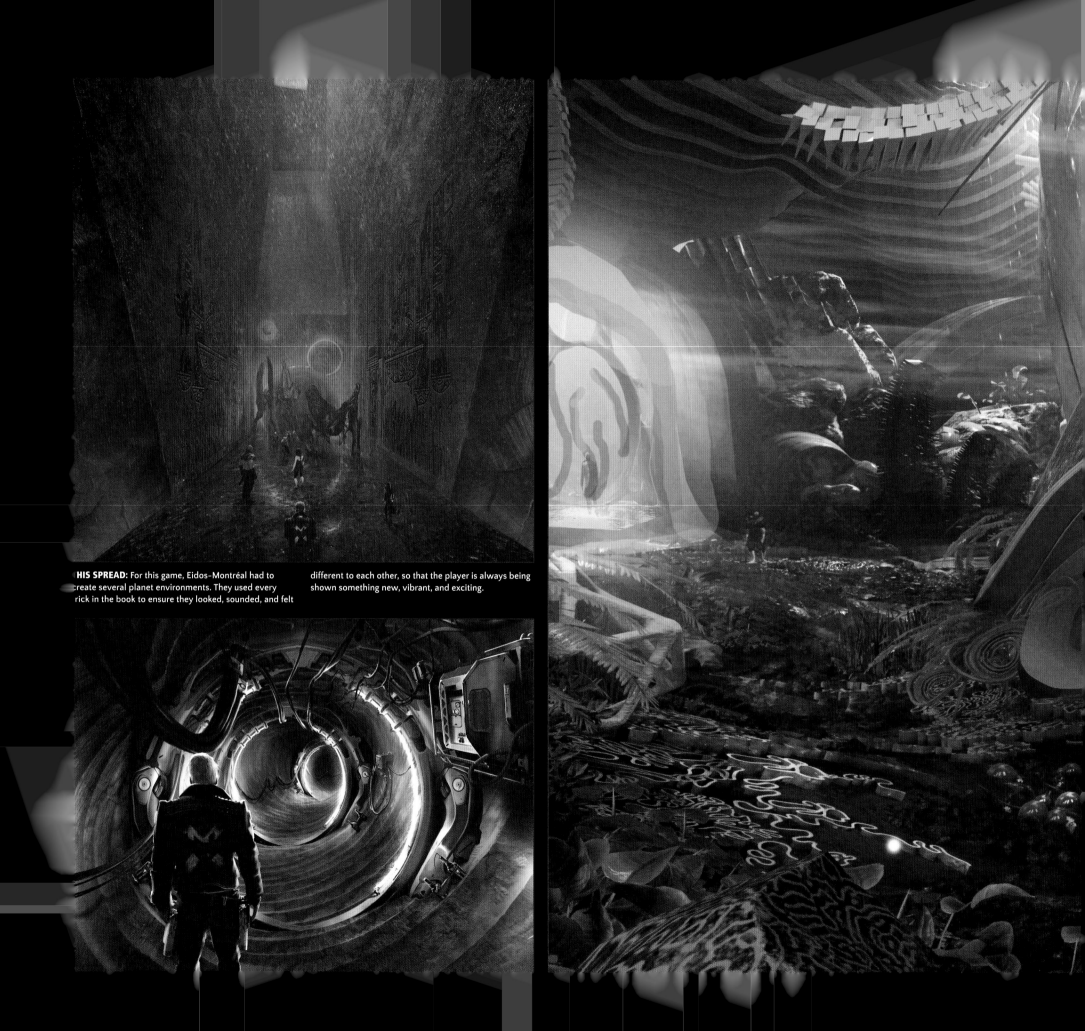

THIS SPREAD: For this game, Eidos-Montréal had to create several planet environments. They used every trick in the book to ensure they looked, sounded, and felt different to each other, so that the player is always being shown something new, vibrant, and exciting.

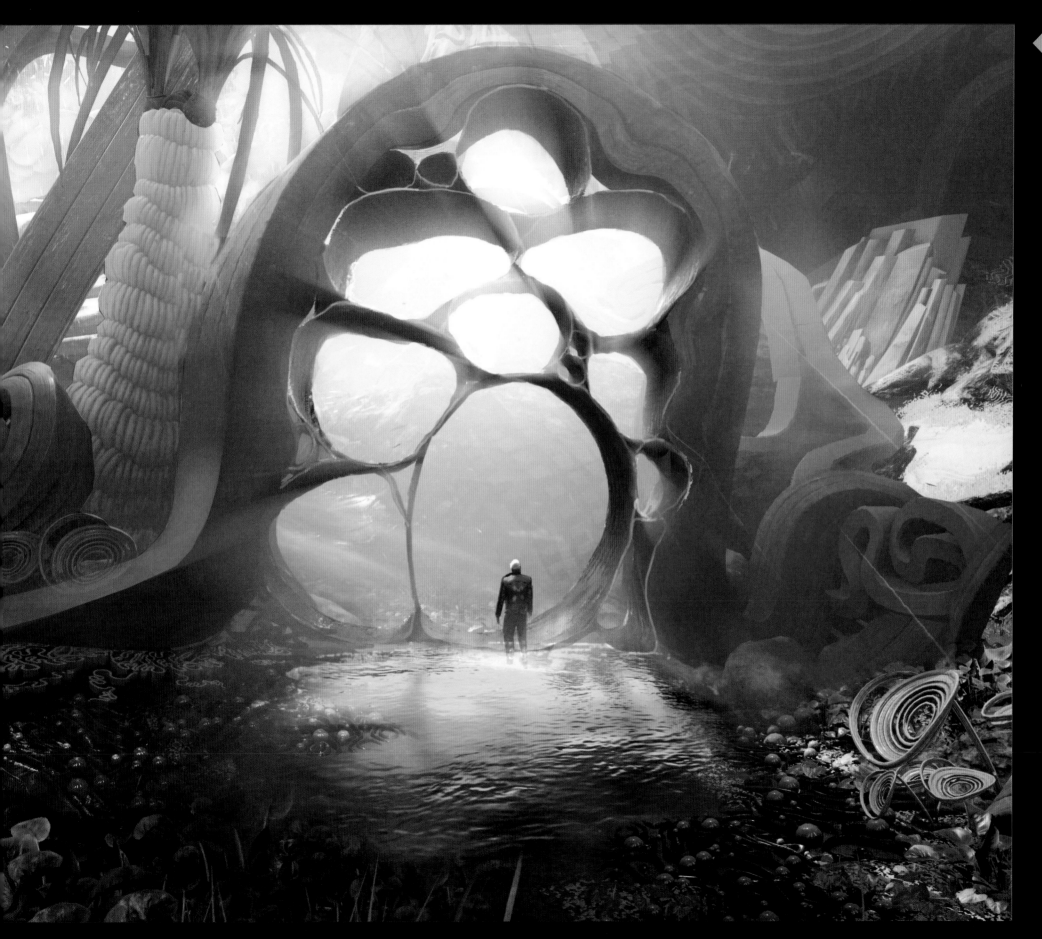

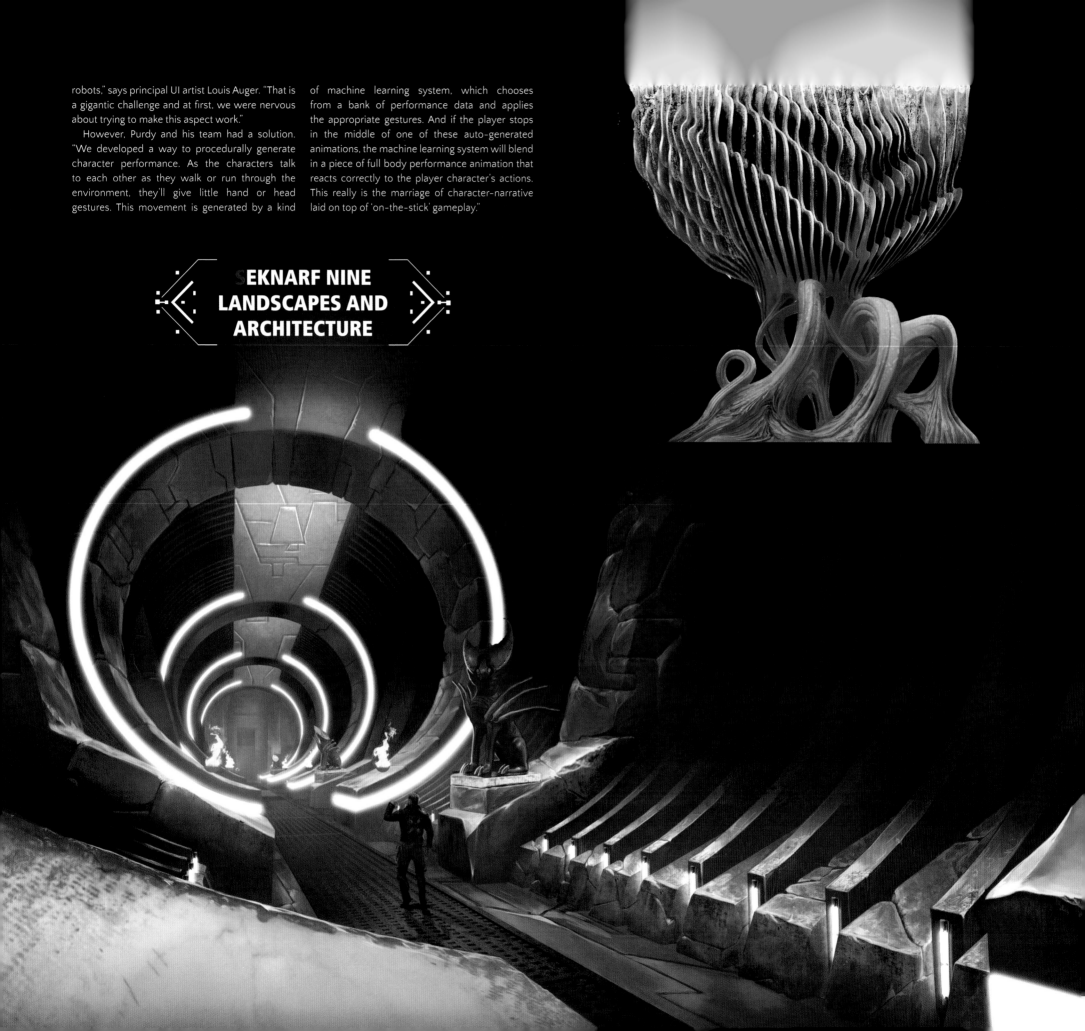

robots," says principal UI artist Louis Auger. "That is a gigantic challenge and at first, we were nervous about trying to make this aspect work."

However, Purdy and his team had a solution. "We developed a way to procedurally generate character performance. As the characters talk to each other as they walk or run through the environment, they'll give little hand or head gestures. This movement is generated by a kind of machine learning system, which chooses from a bank of performance data and applies the appropriate gestures. And if the player stops in the middle of one of these auto-generated animations, the machine learning system will blend in a piece of full body performance animation that reacts correctly to the player character's actions. This really is the marriage of character-narrative laid on top of 'on-the-stick' gameplay."

SEKNARF NINE LANDSCAPES AND ARCHITECTURE

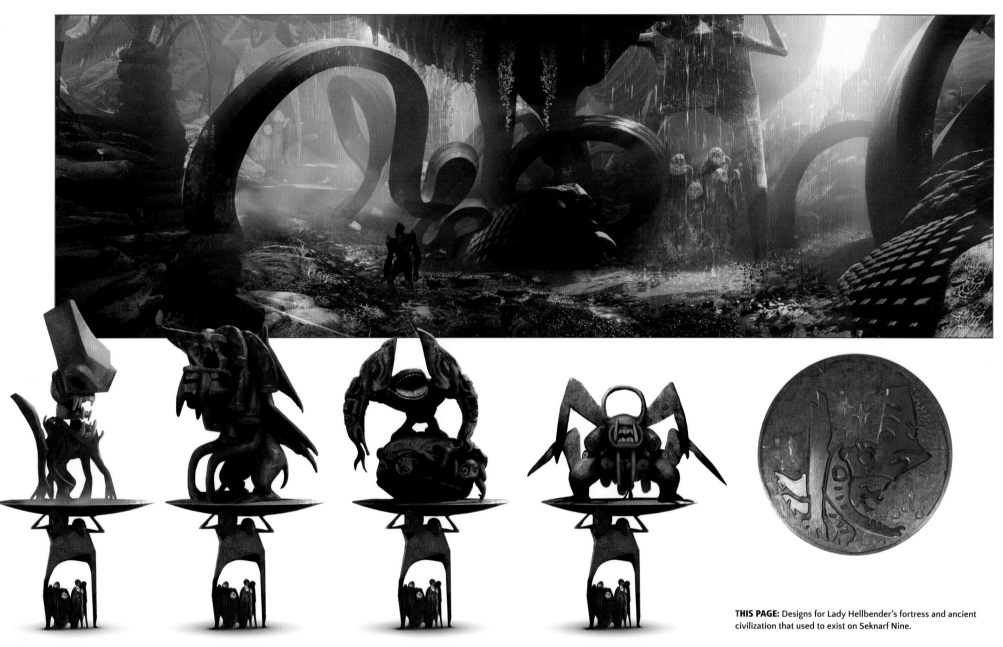

THIS PAGE: Designs for Lady Hellbender's fortress and ancient civilization that used to exist on Seknarf Nine.

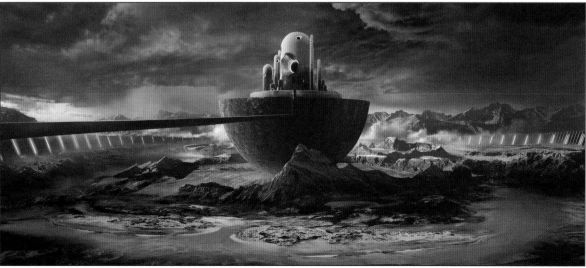

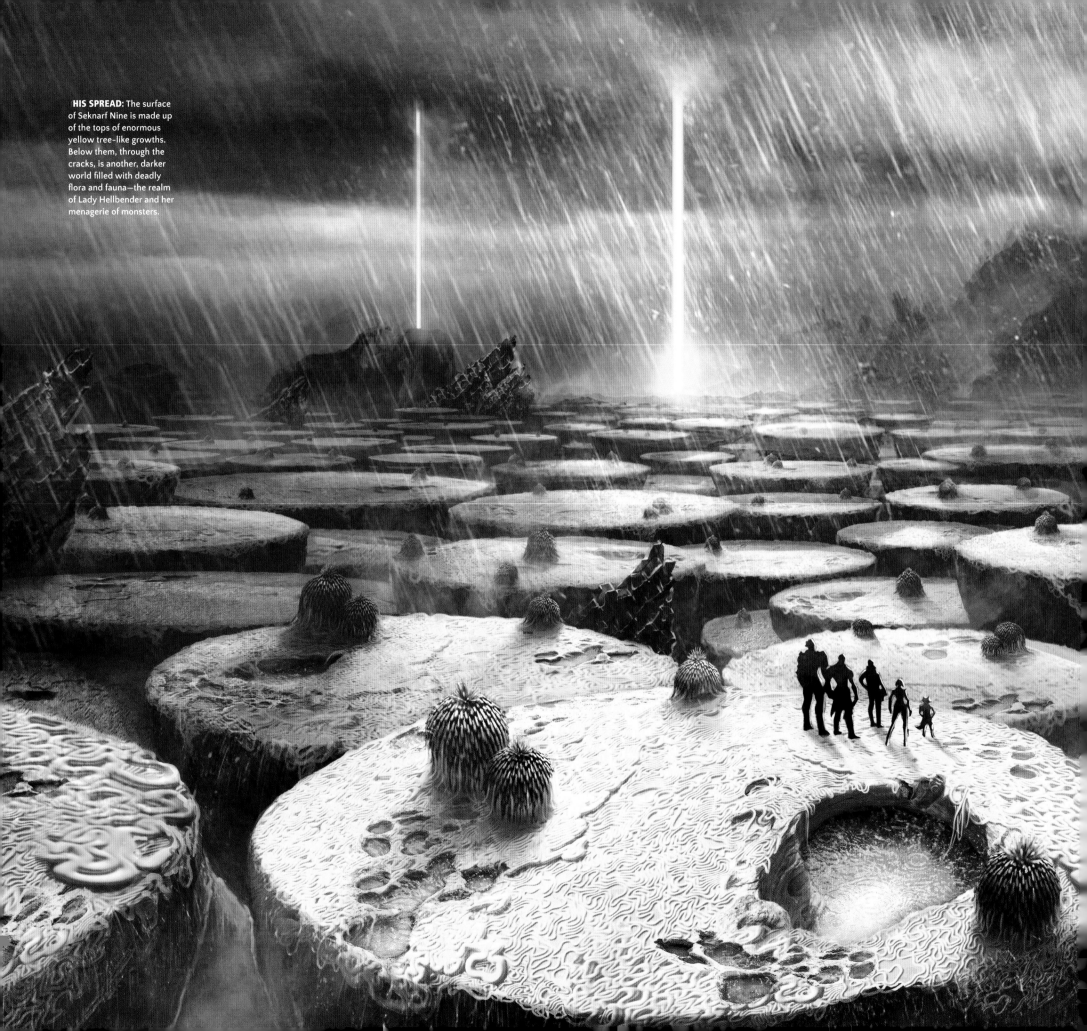

THIS SPREAD: The surface of Seknarf Nine is made up of the tops of enormous yellow tree-like growths. Below them, through the cracks, is another, darker world filled with deadly flora and fauna—the realm of Lady Hellbender and her menagerie of monsters.

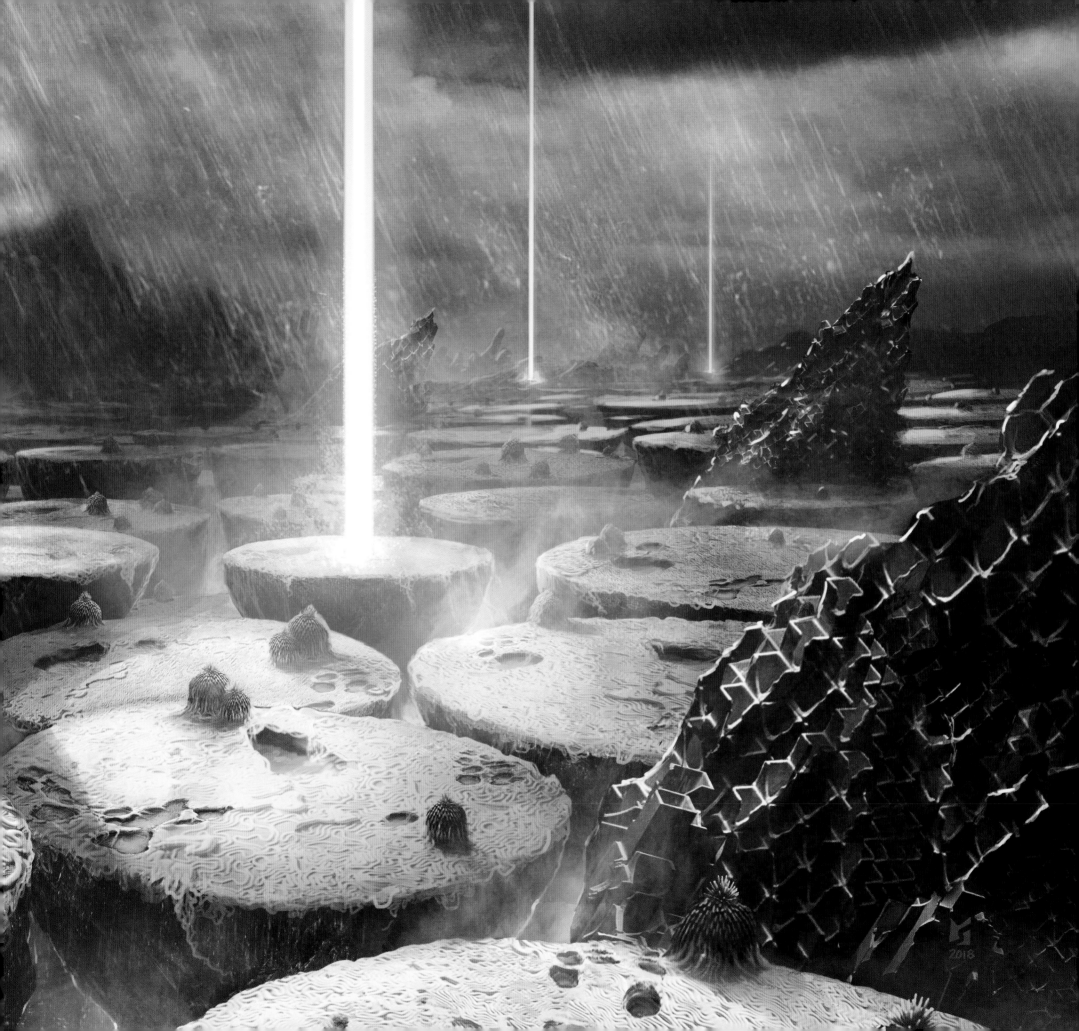

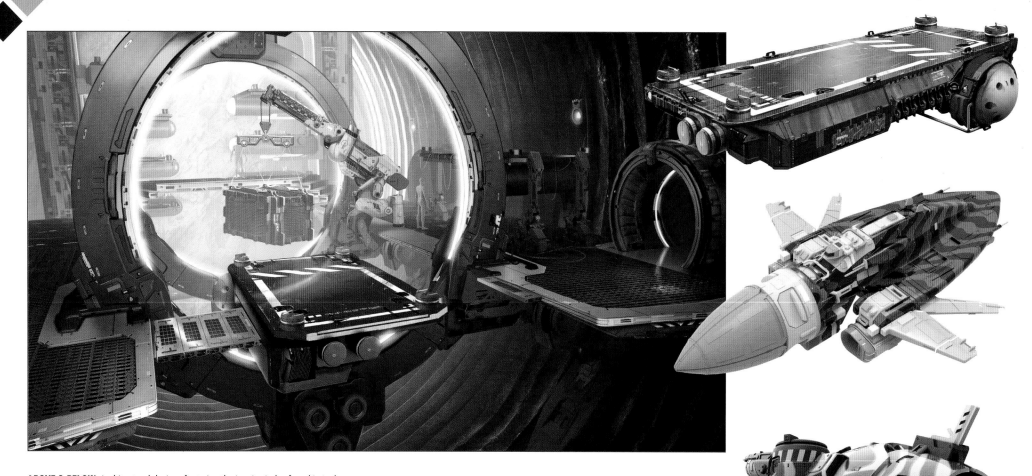

ABOVE & BELOW: Architectural designs featuring the iconic circles found in Lady Hellbender's fortress.

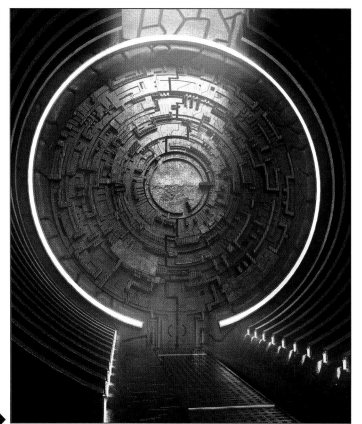

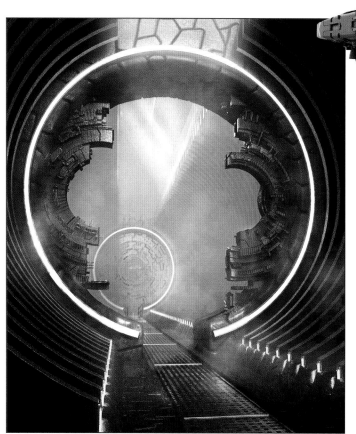

ABOVE: The *Hull Piercer* and the *Fighter*, ships from Lady Hellbender's fleet.

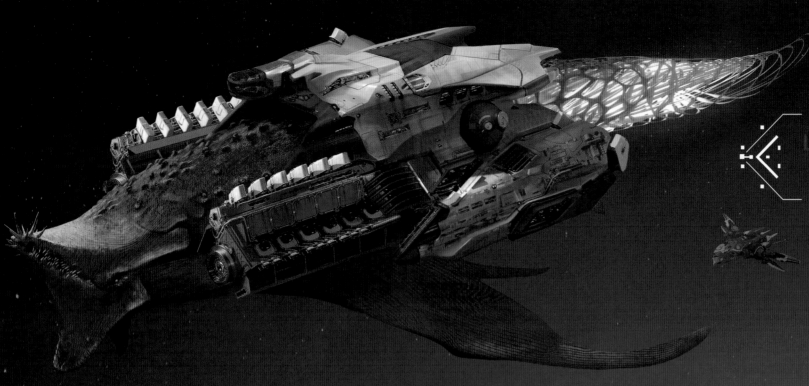

HIS PAGE: Lady Hellbender's capital ship and her throne room, where the Guardians meet her for the first time.

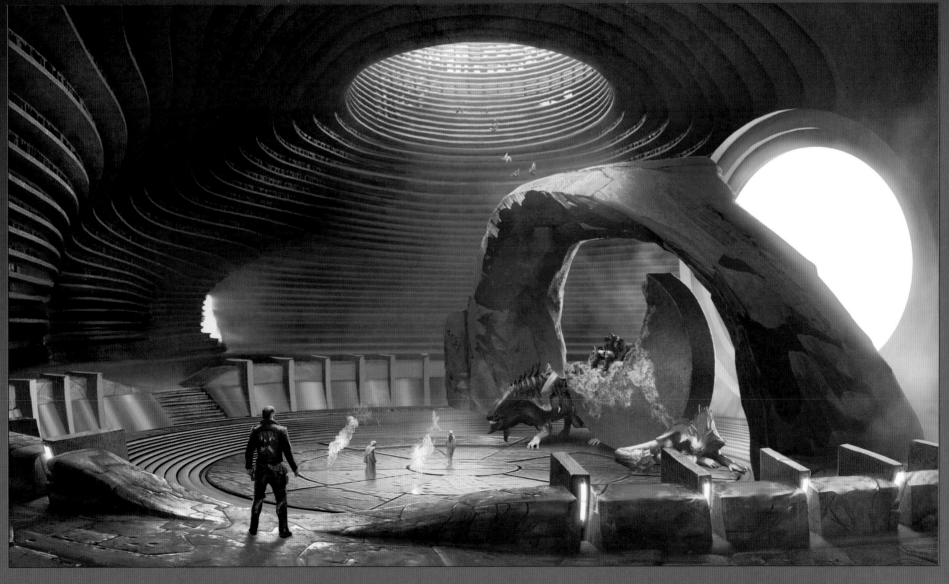

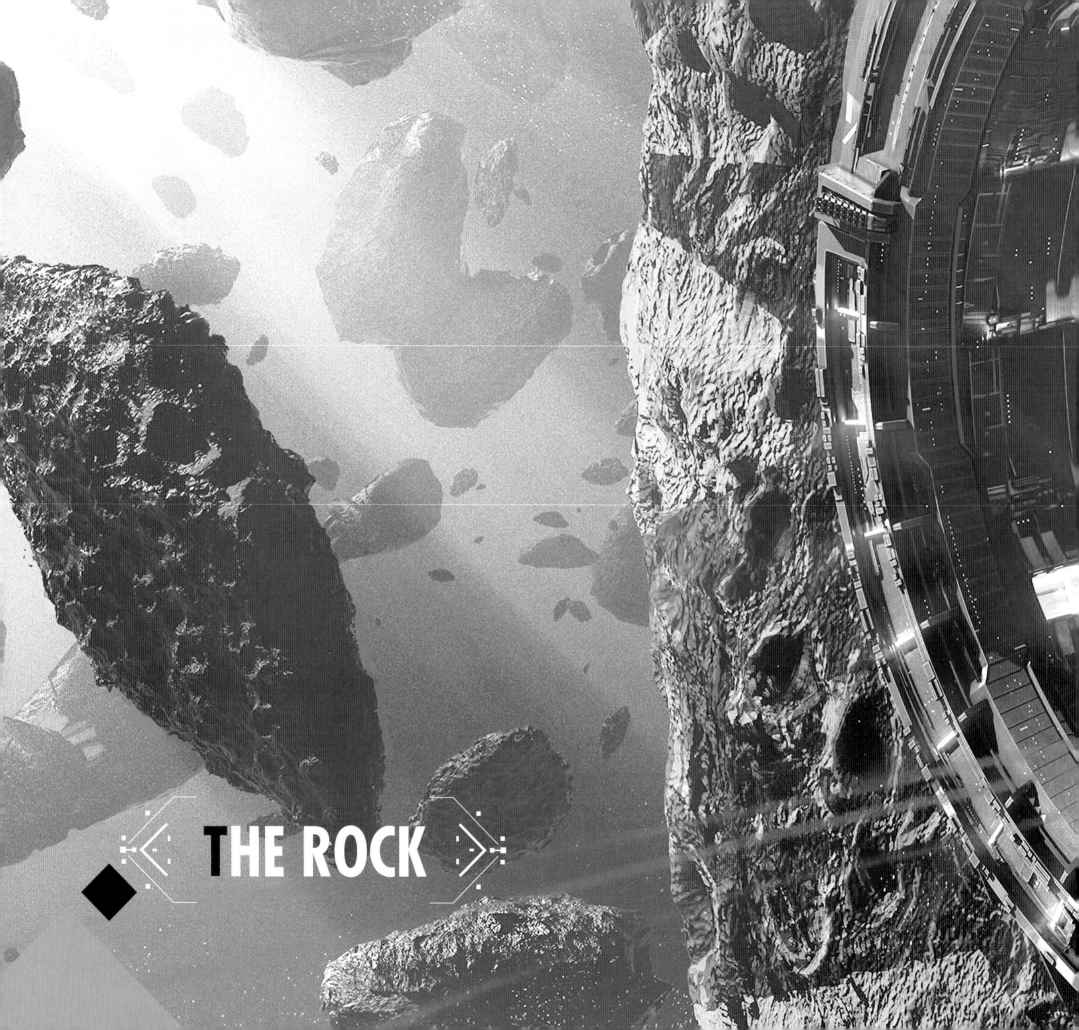

THE ROCK

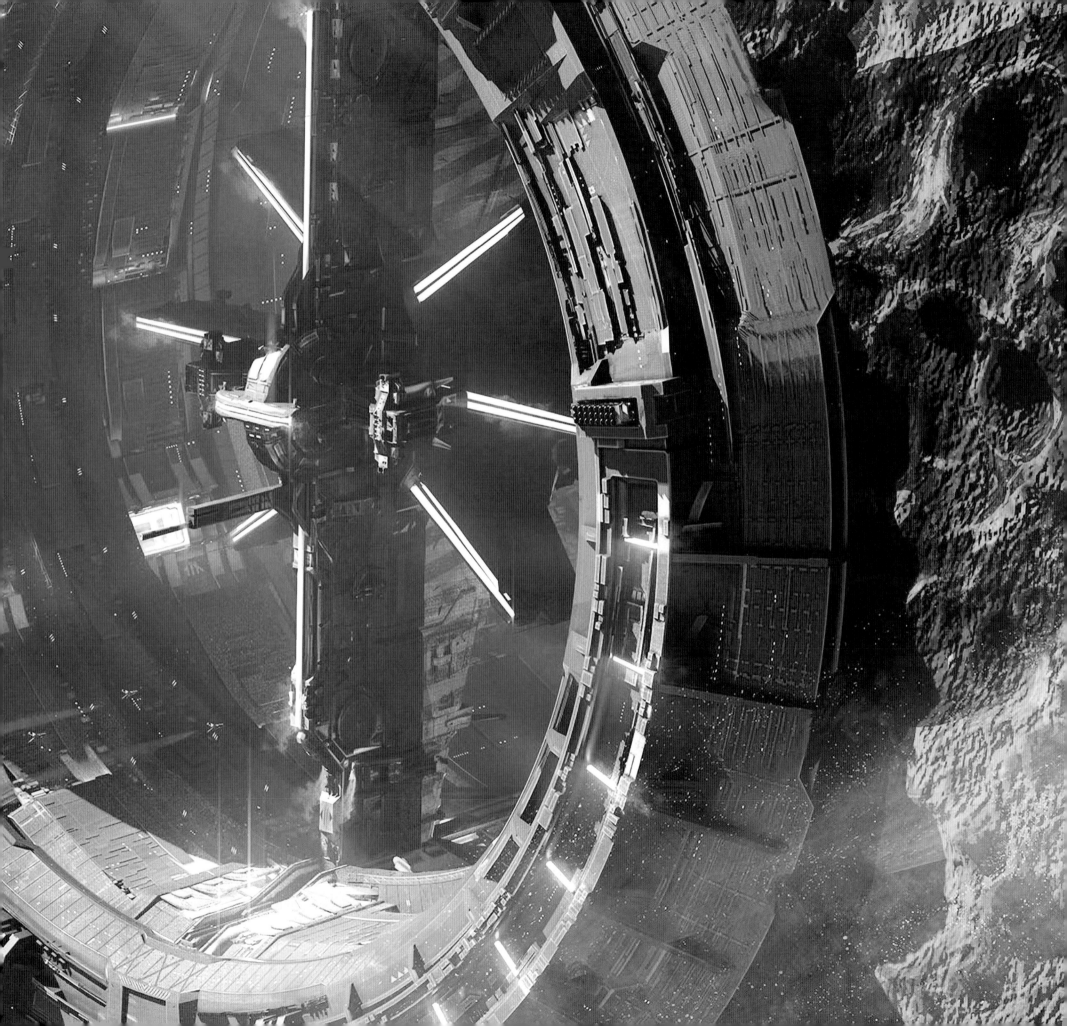

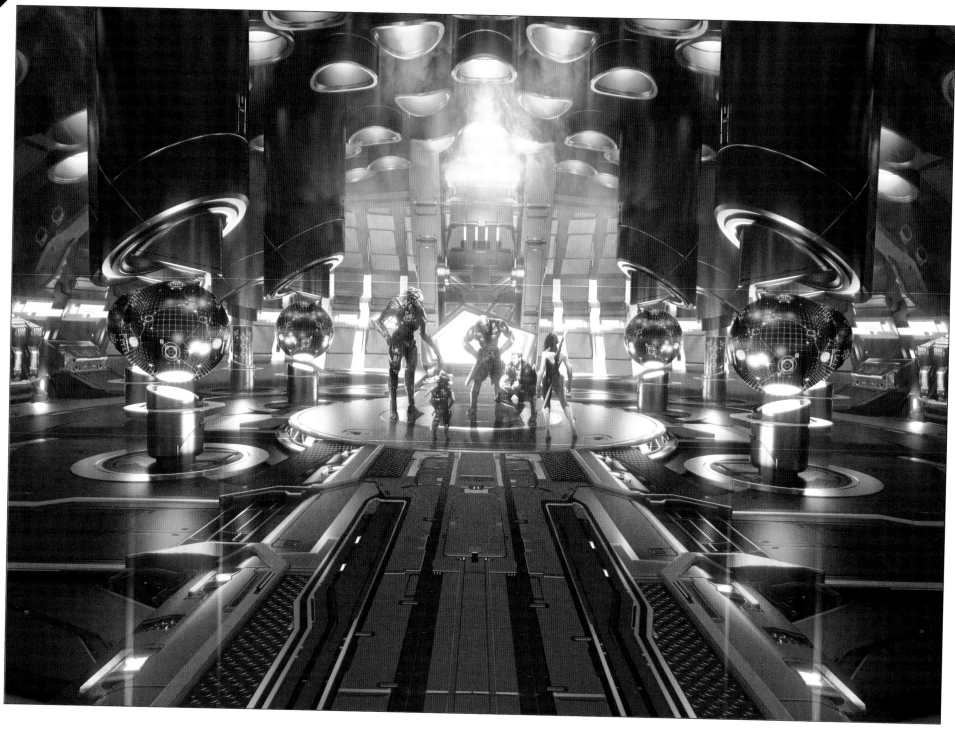

There is a fact that many of the unfortunate people who don't play video games—or think video games are not a proper art form—don't understand: video games are a brilliant way to tell amazing stories. From the first interactive text adventures back in the 1970s to the sophisticated graphical feats of the new console generation, the most memorable, compelling, and emotive games are built on great stories. This is something Marvel and Eidos-Montréal know well and strive for in their games.

Mary DeMarle is executive narrative director for *Marvel's Guardians of the Galaxy*. Responsible for generating and developing the story, she was involved in the project right from the start. "Creating a game like this is a collaboration, and I work closely with the senior creative director, art director, level design director, and gameplay director. My aim was to write a story that matched the game director's vision, so I developed the plot closely with Jean-François Dugas, who's very narratively driven—we did a lot of brainstorming together.

ABOVE: The austere, symmetrical, and rather unwelcoming interiors of the Rock are in sharp contrast to the more personal and anarchic interiors of the Guardian's home on the *Milano*.

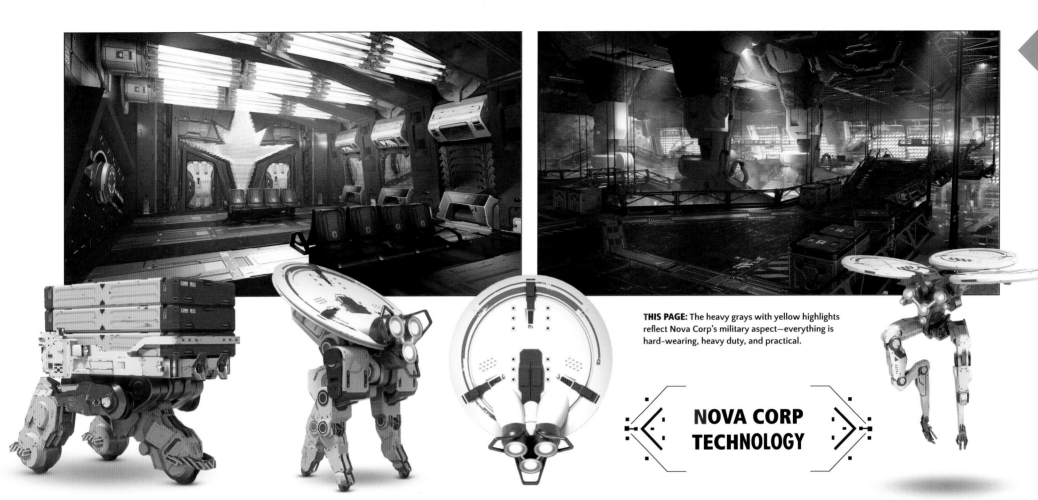

THIS PAGE: The heavy grays with yellow highlights reflect Nova Corp's military aspect—everything is hard-wearing, heavy duty, and practical.

< **NOVA CORP TECHNOLOGY** >

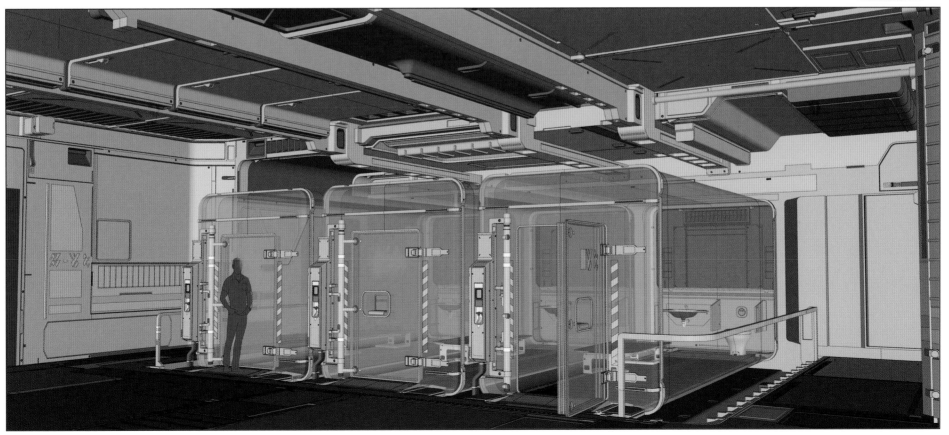

"At the beginning, we had to decide what we wanted this game to be. What's the experience we want the player to live? What's the player fantasy? We also talk about the gameplay mechanics and the themes that we wish to explore through both gameplay and story. There are usually things that come from these discussions that spark ideas in me and get me excited—they'll be the first plot seeds.

"Then I'll go off and develop that story with the writing team. When that's done, we split the story up into gameplay levels and write the character dialogue and the in-game text [written material that the player can find in the game world]. As well as writing my own material, I'm also reviewing my team's work, helping them to create and craft scenes, and pushing everything up to the next level."

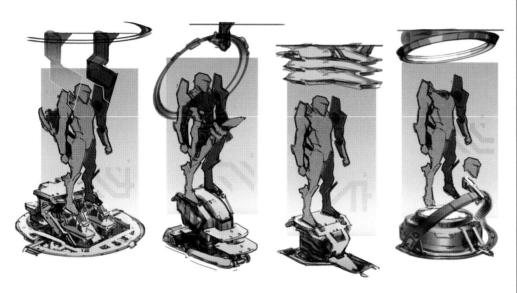

THIS SPREAD: Concept sketches and fully rendered art showing various ways to house and repair this Nova Corp tech.

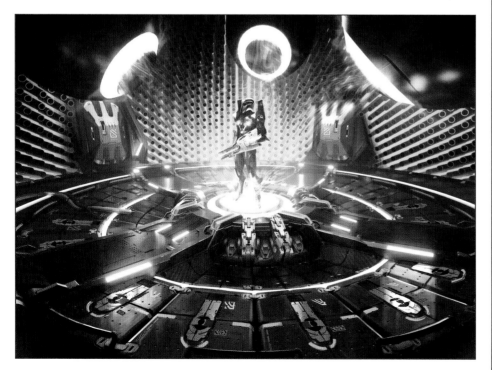

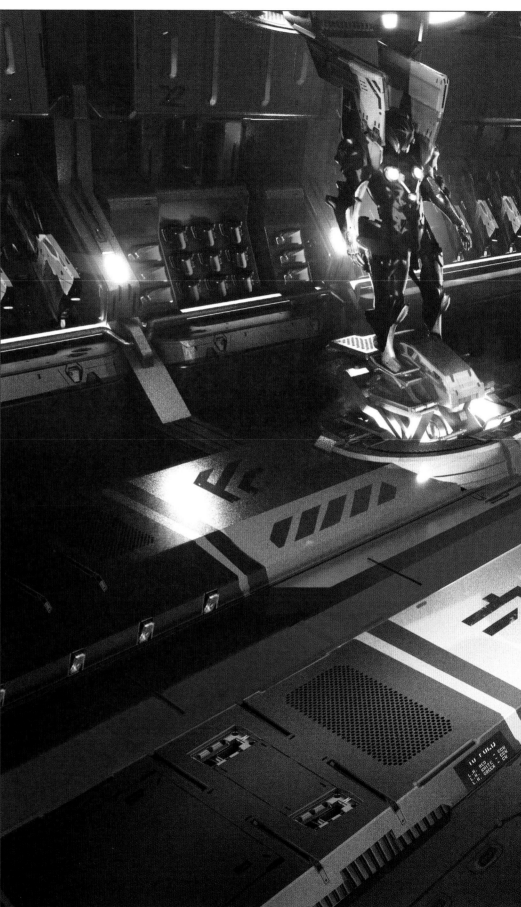

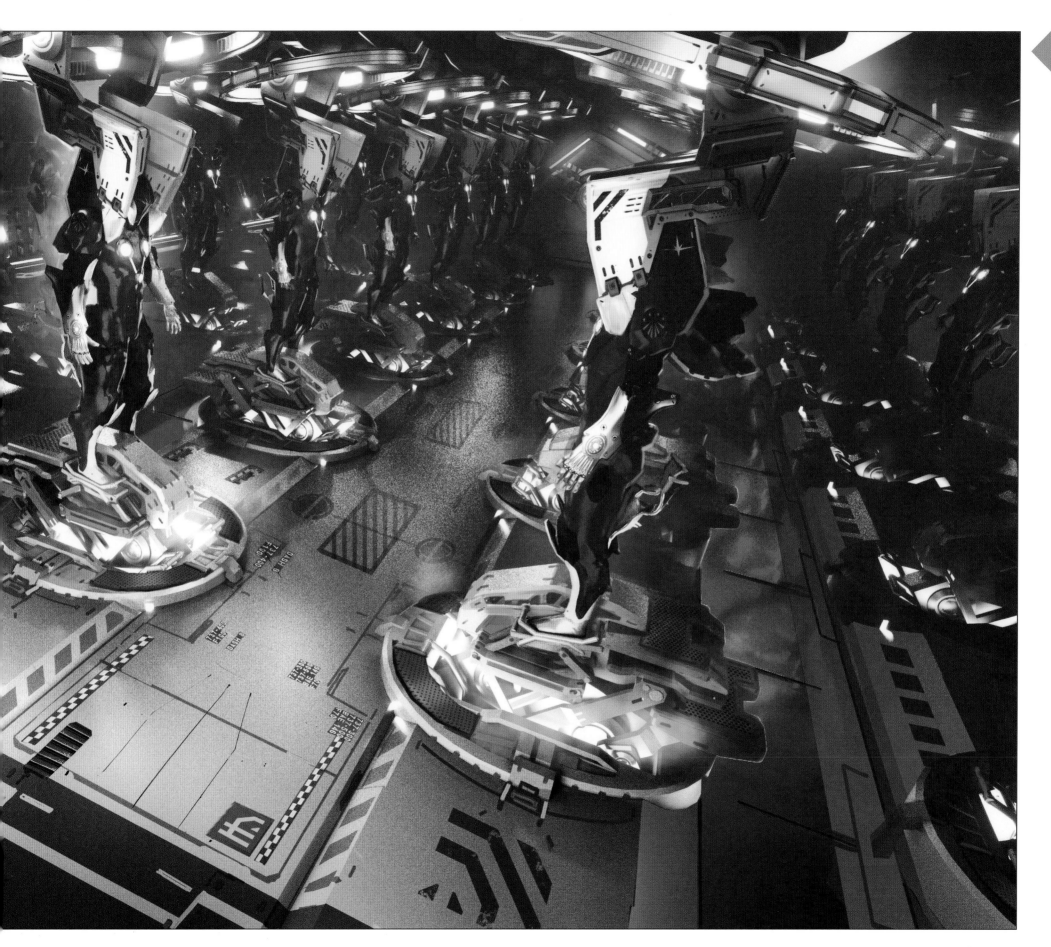

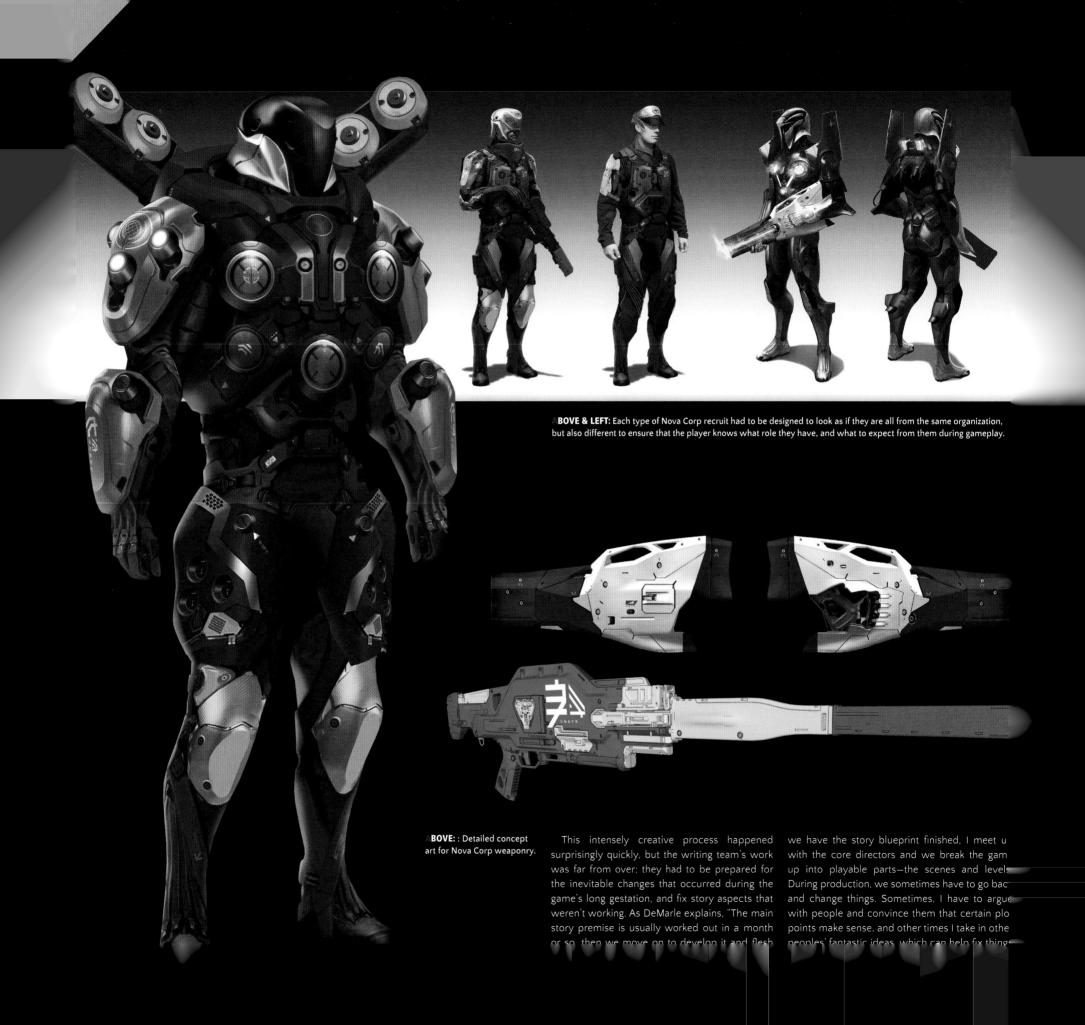

ABOVE & LEFT: Each type of Nova Corp recruit had to be designed to look as if they are all from the same organization, but also different to ensure that the player knows what role they have, and what to expect from them during gameplay.

ABOVE: : Detailed concept art for Nova Corp weaponry.

This intensely creative process happened surprisingly quickly, but the writing team's work was far from over; they had to be prepared for the inevitable changes that occurred during the game's long gestation, and fix story aspects that weren't working. As DeMarle explains, "The main story premise is usually worked out in a month or so, then we move on to develop it and flesh

we have the story blueprint finished, I meet u with the core directors and we break the gam up into playable parts—the scenes and level During production, we sometimes have to go bac and change things. Sometimes, I have to argue with people and convince them that certain plo points make sense, and other times I take in othe peoples' fantastic ideas, which can help fix thing

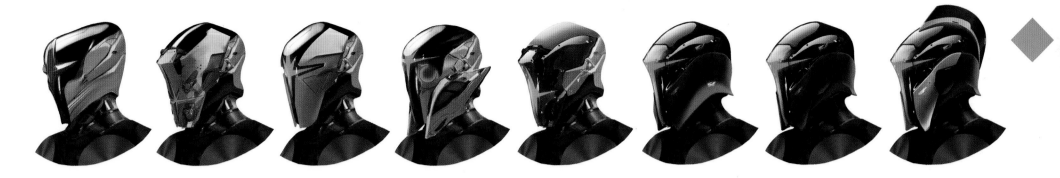

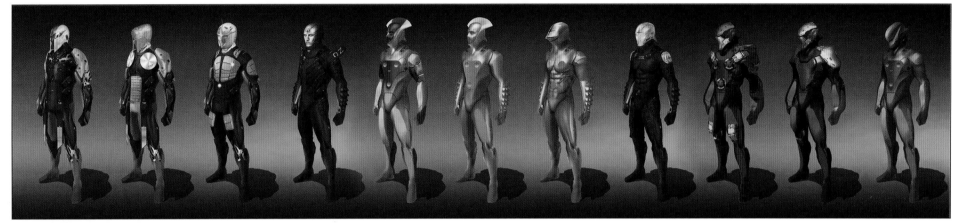

ABOVE: Eidos-Montréal created many versions of Nova Corp troops, both outfits and helmets, using various color combinations and stylistic motifs, before settling on the smartly militaristic blue and gold.

BELOW: More concepts for Nova Corp firearms.

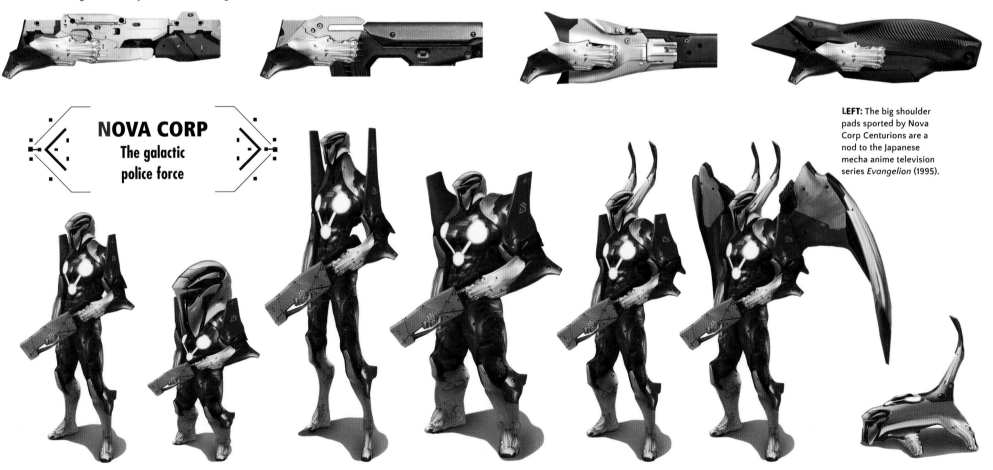

NOVA CORP
The galactic
police force

LEFT: The big shoulder pads sported by Nova Corp Centurions are a nod to the Japanese mecha anime television series *Evangelion* (1995).

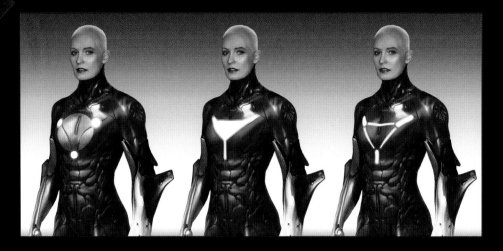

KO-REL

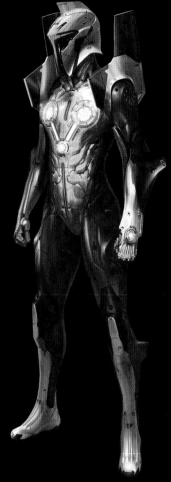

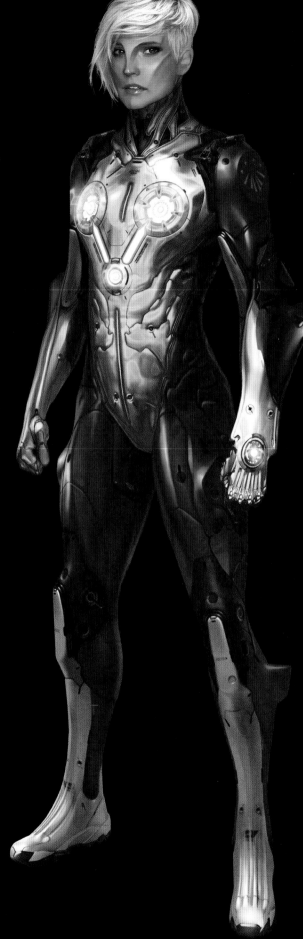

Ko-Rel has been through a lot. After her husband and son were killed during the Galactic War, she fought hard against the Chitauri, desperate for revenge. During her epic—and ultimately victorious—struggle, she met two people who would greatly impact her life: Peter Quill and, more importantly, a half-Kree, half-human child named Nicholette Gold.

"Ko-Rel is the Kree commander of a Nova Corp ship," senior creative director Jean-François Dugas explains, "and Nikki is her adopted daughter. At the start of the story, Nikki doesn't know she's adopted. She's half-Kree and half-human. According to Kree law, half-breeds are considered impure and should be terminated. Ko-Rel protects Nikki by dying her hair blue so she looks full-Kree and providing her with forged ID papers."

As always, Eidos-Montréal put a lot of thought into the design. "Ko-Rel is a commanding officer, so we added gold decorations to her Centurion suit to give her presence, authority, and make her stand out from the lower ranks," says art director Bruno Gauthier-Leblanc. "Most of the work went into her face. We wanted her to look elegant and strong. Her face is alien, but we included defined human features so it's easier for players to connect with her. We added sharp edges: hard cheekbones, pointy ears, and a rigid nose that has a slightly feline look. And, of course, the blue skin comes from the comic books."

THIS PAGE: Eidos-Montréal wanted Ko-Rel to look human, so that the player would more readily empathize with her, but with physical aspects showing that she's an alien.

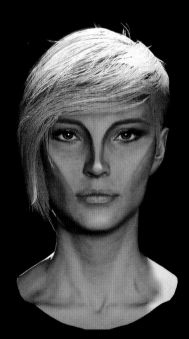
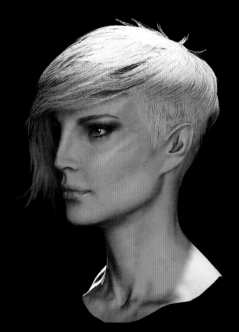
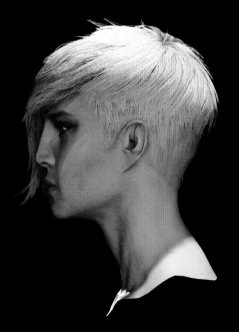

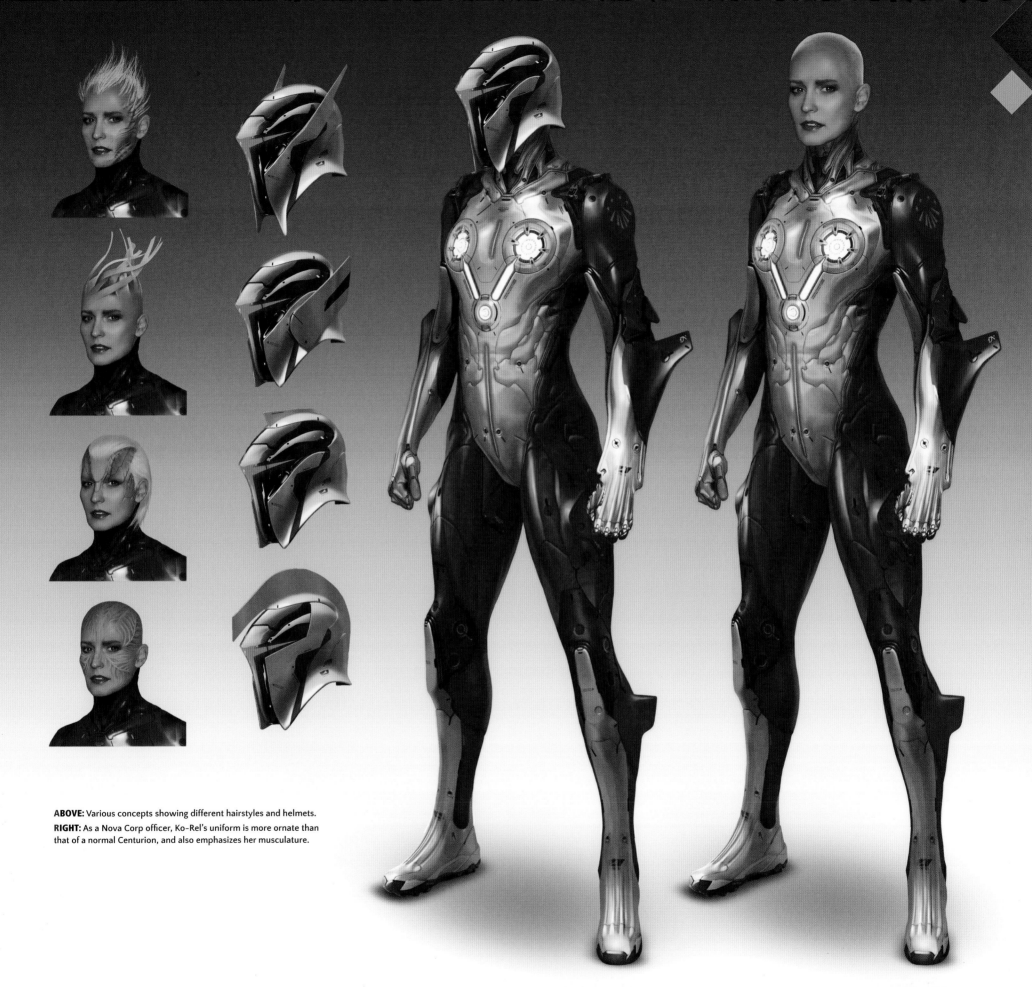

ABOVE: Various concepts showing different hairstyles and helmets.

RIGHT: As a Nova Corp officer, Ko-Rel's uniform is more ornate than that of a normal Centurion, and also emphasizes her musculature.

NIKKI

Nicholette Gold, nicknamed 'Nikki,' has spent her entire life on a Nova Corp warship. Clever, stubborn, and imaginative, she wants more than anything to join her mother in the Nova Corp officer cadre. She's memorized all the protocols and regulations, and can even operate some of the ship's basic systems.

Nikki is also a curious girl who loves to sneak into places she shouldn't go, and it's during one of these clandestine adventures that she's taken over by the malignant and insidious Magus Entity. Possessed with strange new powers of insight and healing, she's destined to change from a plucky Nova Corp cadet into something else entirely...

"Nikki begins as a cadet on a Nova Corp ship," senior creative director Jean-François Dugas says. "But she's more than that—she has powers that she doesn't understand. She only discovers the full potential of her strange powers after going through the stressful events toward the end of the game, when she joins the Guardians to fight the Magus."

Nikki is a dynamic character who undergoes enormous changes throughout the game. But what about the design of her first iteration as a Nova Corp cadet? "Nikki is half human, so her skin is less blue and more blue-gray, her hair is a different color, and she doesn't have the

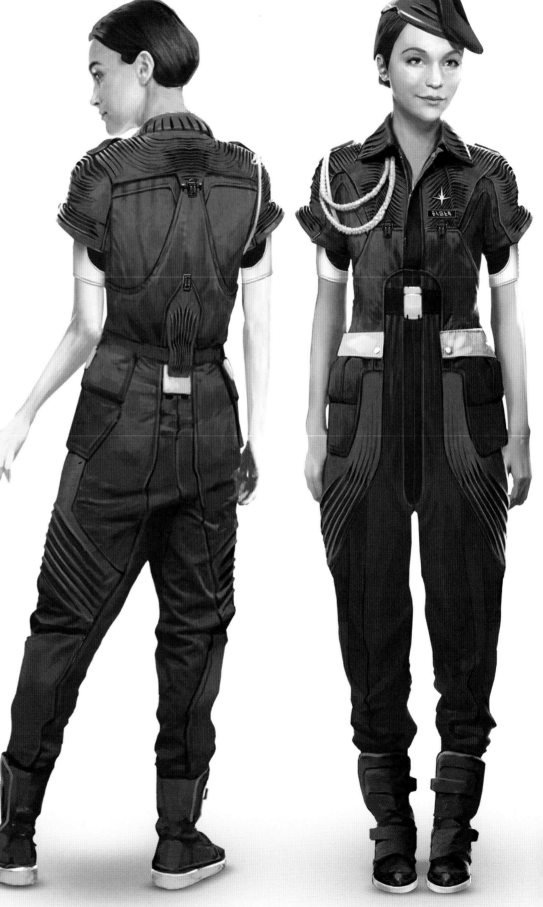

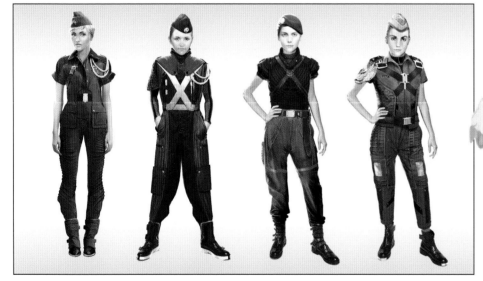

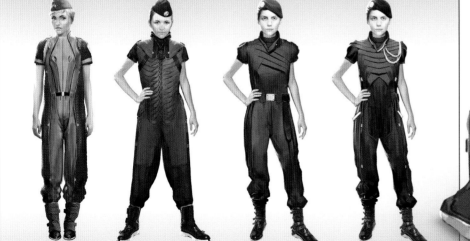

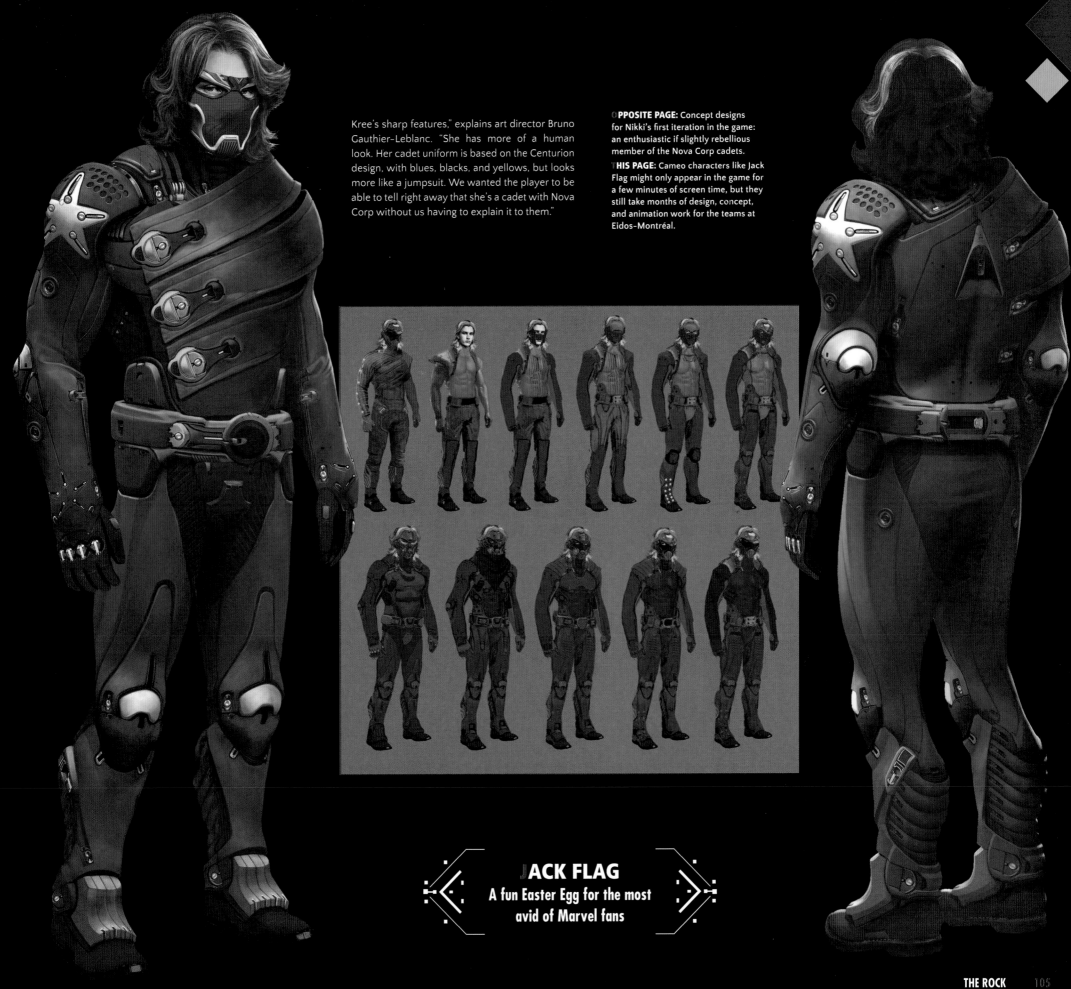

Kree's sharp features," explains art director Bruno Gauthier-Leblanc. "She has more of a human look. Her cadet uniform is based on the Centurion design, with blues, blacks, and yellows, but looks more like a jumpsuit. We wanted the player to be able to tell right away that she's a cadet with Nova Corp without us having to explain it to them."

OPPOSITE PAGE: Concept designs for Nikki's first iteration in the game: an enthusiastic if slightly rebellious member of the Nova Corp cadets.

THIS PAGE: Cameo characters like Jack Flag might only appear in the game for a few minutes of screen time, but they still take months of design, concept, and animation work for the teams at Eidos-Montréal.

JACK FLAG
A fun Easter Egg for the most avid of Marvel fans

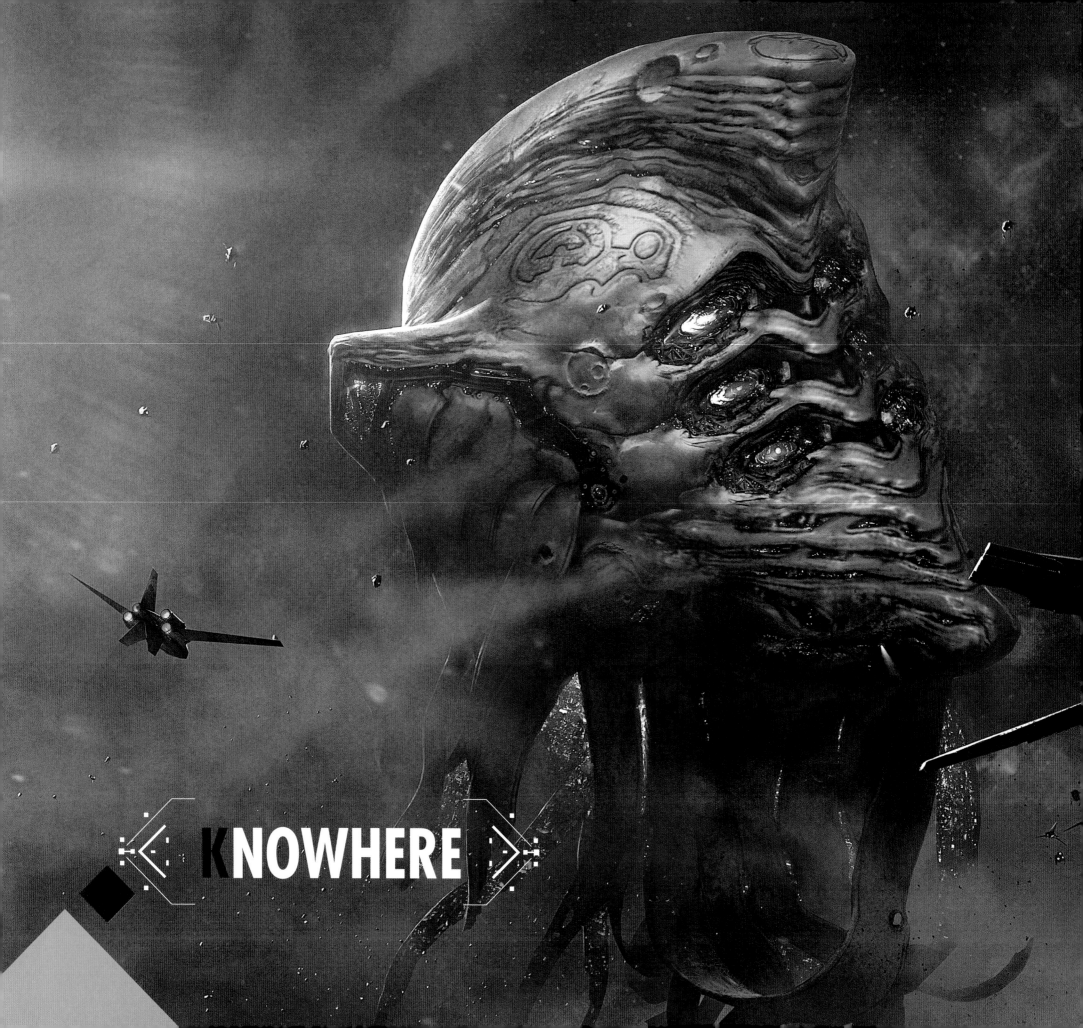

KNOWHERE

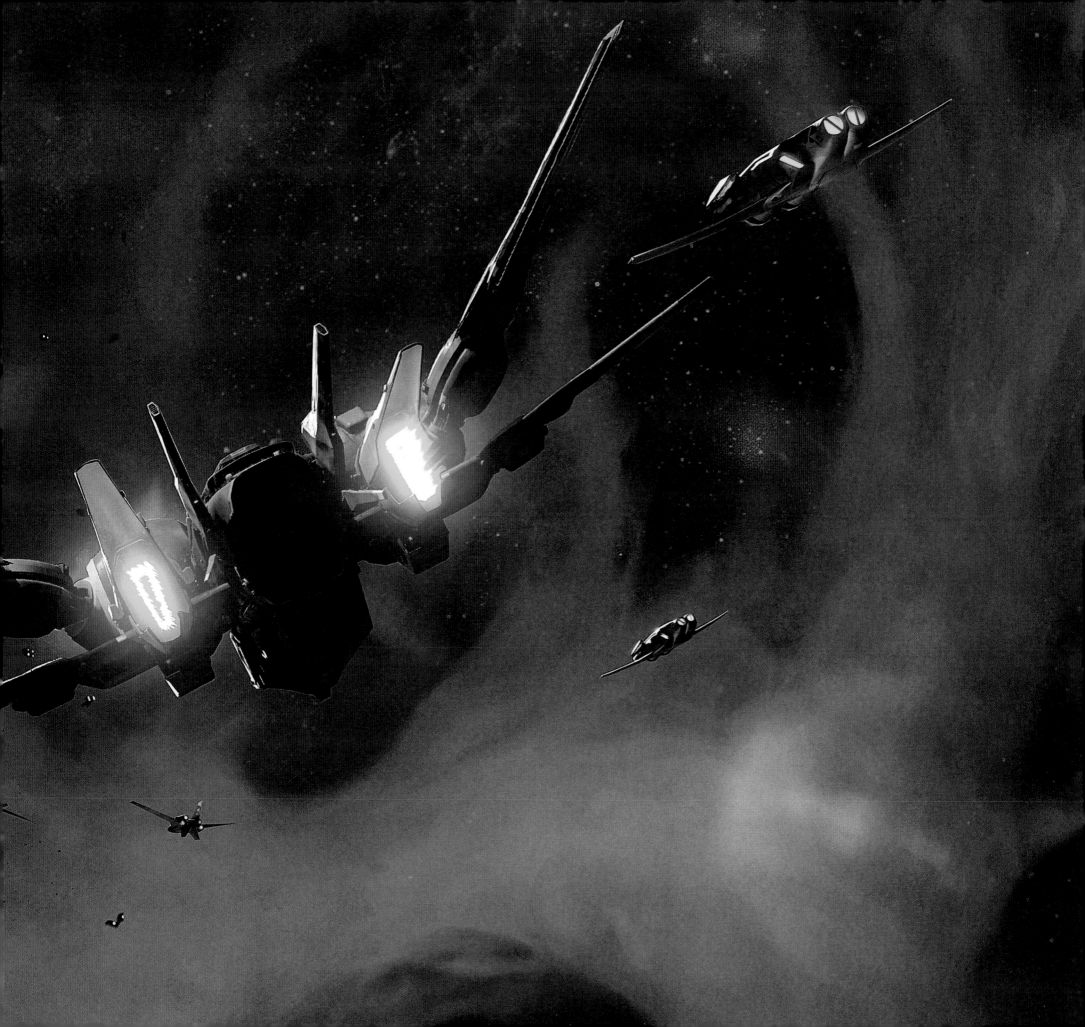

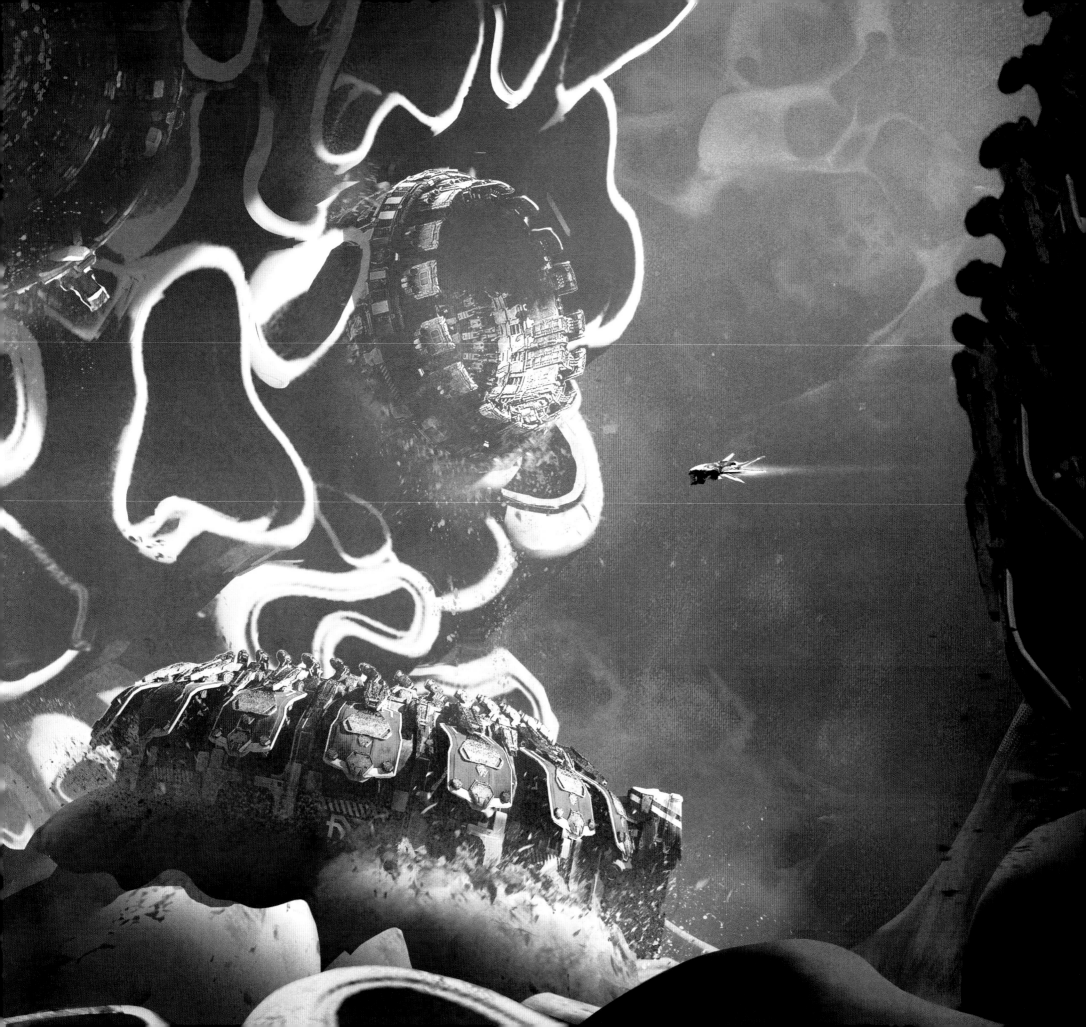

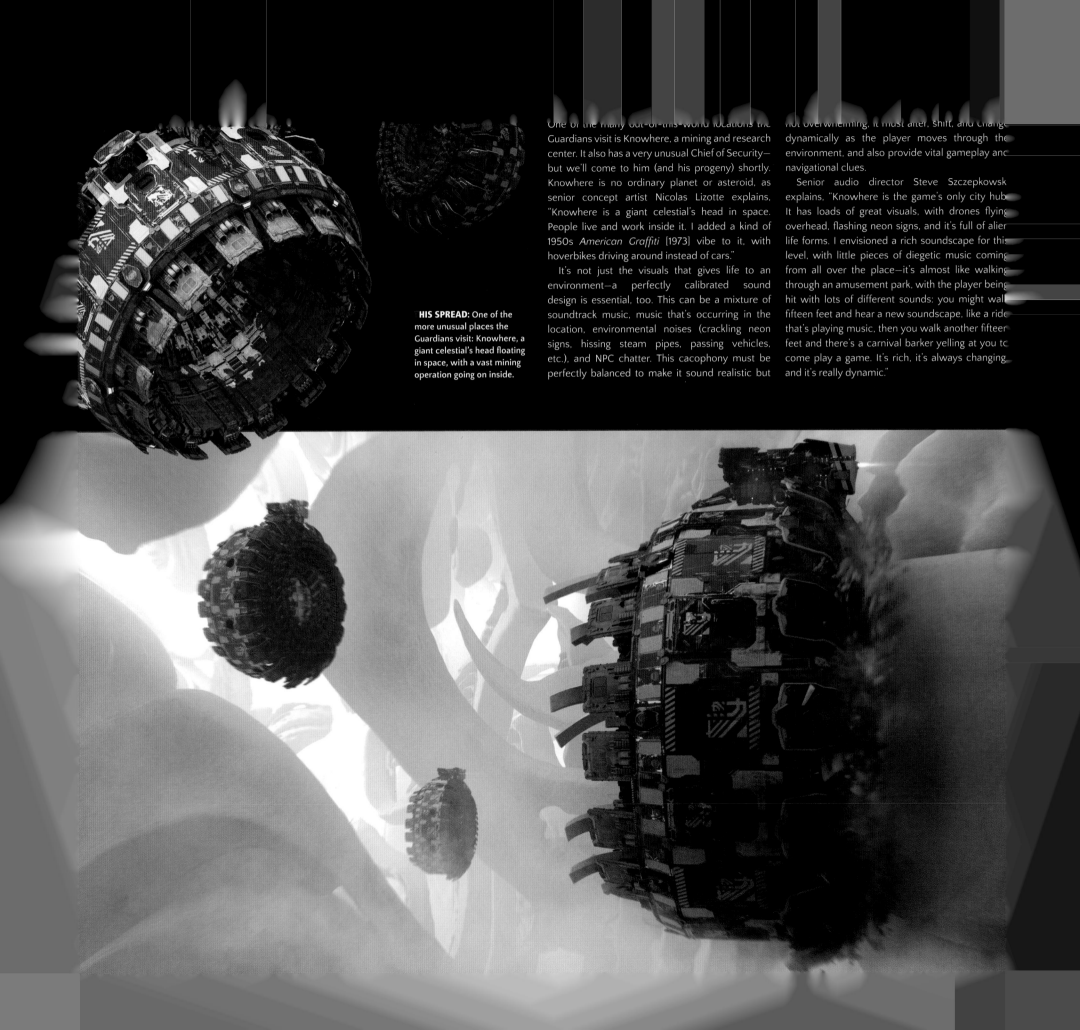

One of the many out-of-this-world locations the Guardians visit is Knowhere, a mining and research center. It also has a very unusual Chief of Security—but we'll come to him (and his progeny) shortly. Knowhere is no ordinary planet or asteroid, as senior concept artist Nicolas Lizotte explains, "Knowhere is a giant celestial's head in space. People live and work inside it. I added a kind of 1950s *American Graffiti* [1973] vibe to it, with hoverbikes driving around instead of cars."

It's not just the visuals that gives life to an environment—a perfectly calibrated sound design is essential, too. This can be a mixture of soundtrack music, music that's occurring in the location, environmental noises (crackling neon signs, hissing steam pipes, passing vehicles, etc.), and NPC chatter. This cacophony must be perfectly balanced to make it sound realistic but not overwhelming. It must alter, shift, and change dynamically as the player moves through the environment, and also provide vital gameplay and navigational clues.

Senior audio director Steve Szczepkowski explains, "Knowhere is the game's only city hub. It has loads of great visuals, with drones flying overhead, flashing neon signs, and it's full of alien life forms. I envisioned a rich soundscape for this level, with little pieces of diegetic music coming from all over the place—it's almost like walking through an amusement park, with the player being hit with lots of different sounds: you might walk fifteen feet and hear a new soundscape, like a ride that's playing music, then you walk another fifteen feet and there's a carnival barker yelling at you to come play a game. It's rich, it's always changing, and it's really dynamic."

HIS SPREAD: One of the more unusual places the Guardians visit: Knowhere, a giant celestial's head floating in space, with a vast mining operation going on inside.

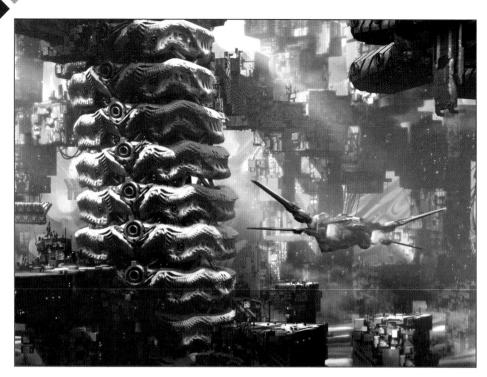

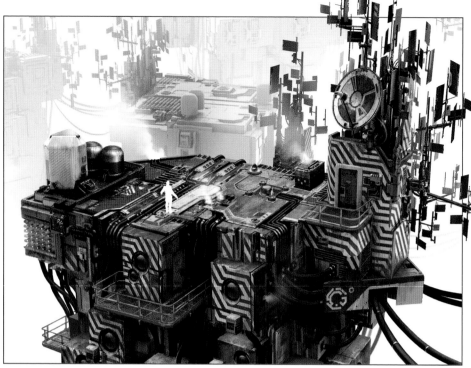

ABOVE & BELOW: Knowhere is a busy place, with people of all kinds coming and going on a wide variety of spaceships.

ABOVE: Like many great games, it's to the player's advantage to take time off from combat and the main story to go explore. You never know what you'll find.

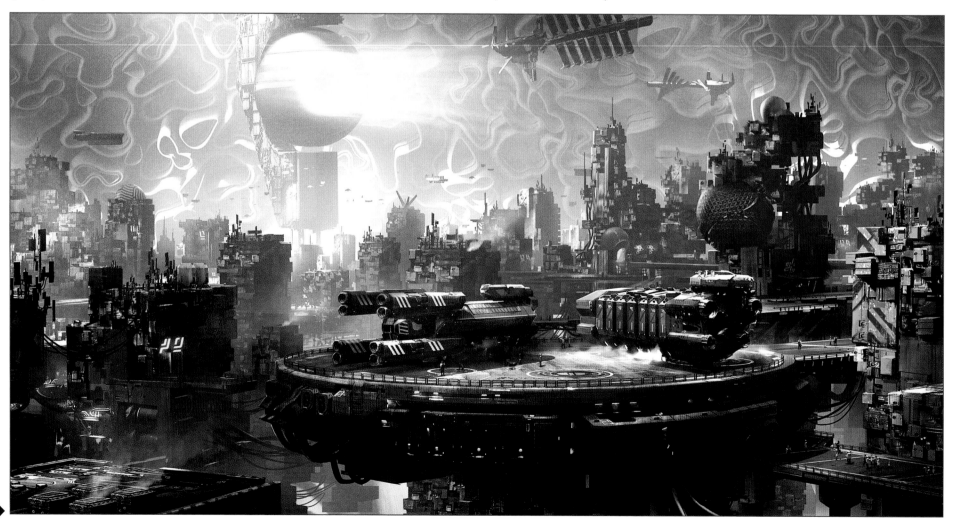

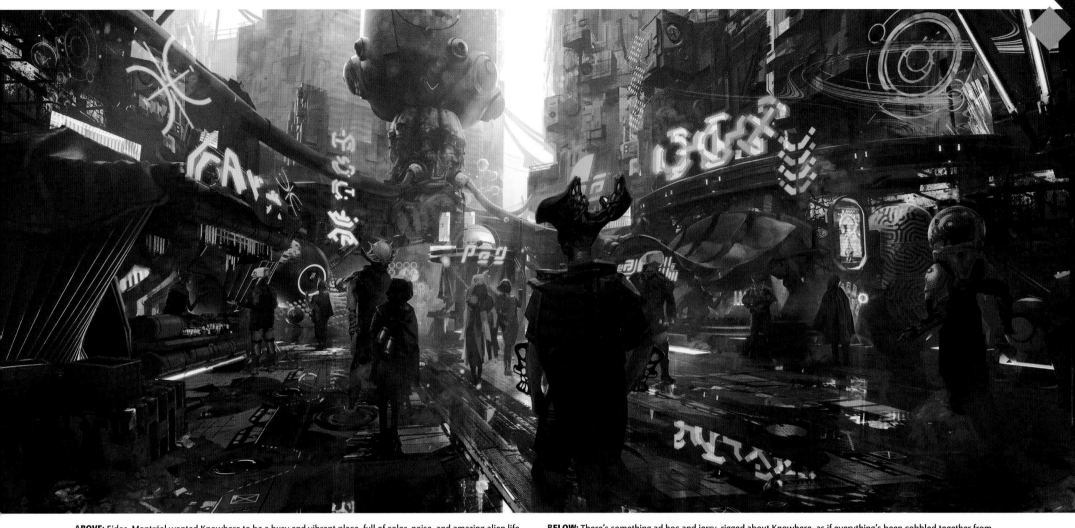

ABOVE: Eidos-Montréal wanted Knowhere to be a busy and vibrant place, full of color, noise, and amazing alien life.

BELOW: There's something ad hoc and jerry-rigged about Knowhere, as if everything's been cobbled together from whatever was found lying around—a far cry from the order and discipline of the Rock.

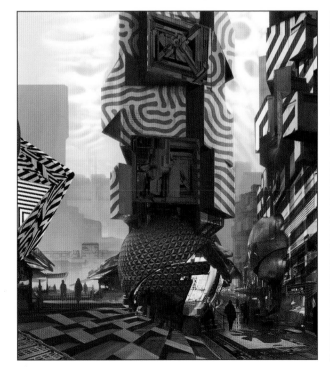

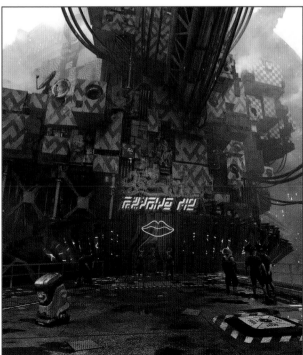

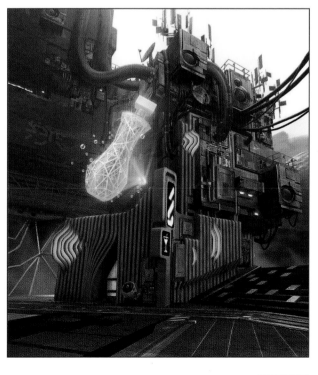

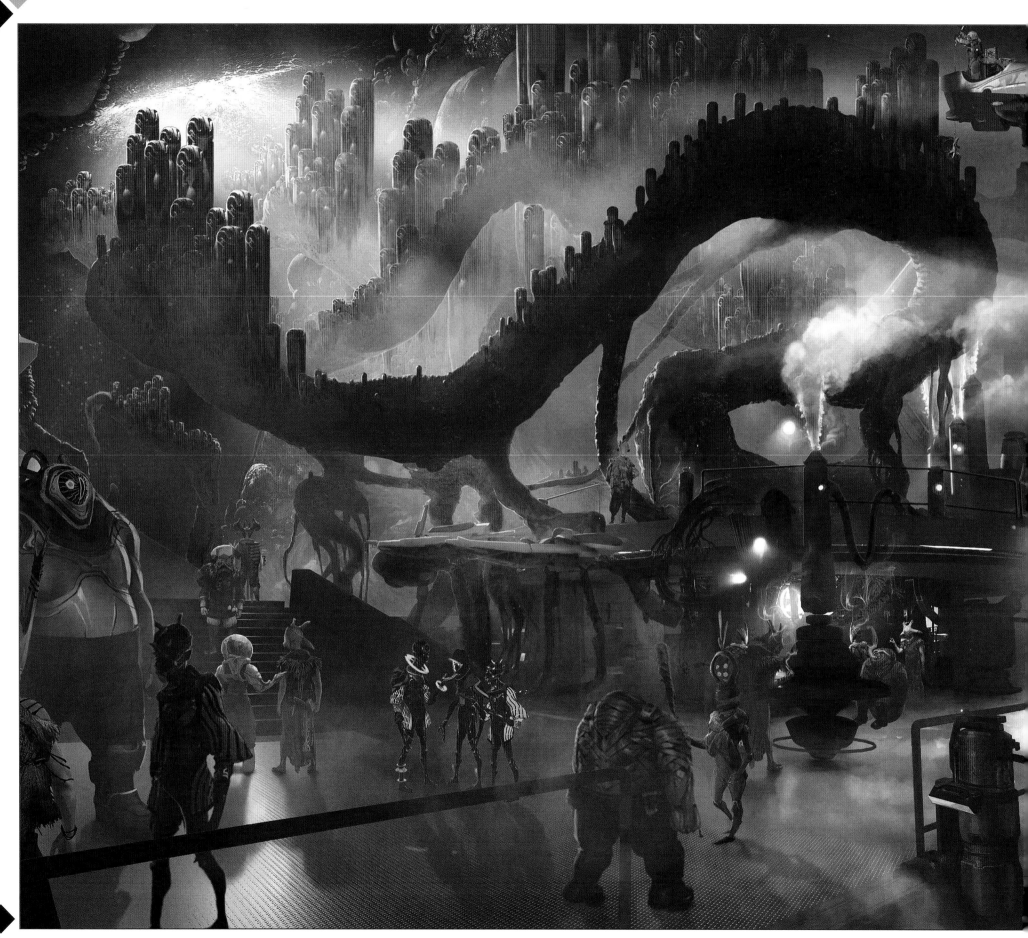

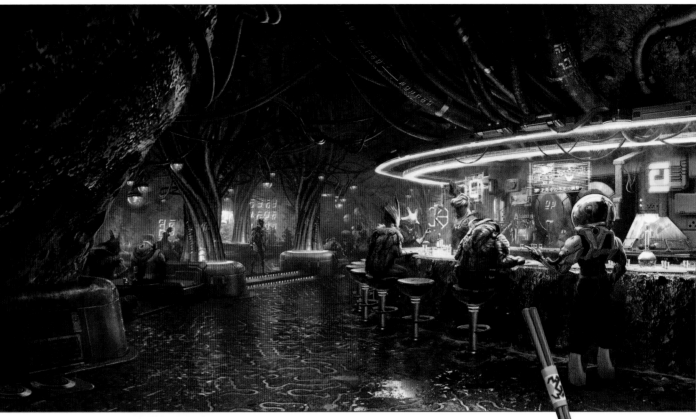

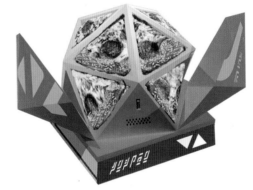

LEFT: The dominant red gives this place a menacing, dangerous aspect.

THIS PAGE: To create a totally immersive world, everything needs to be considered. For example, where food is eaten; adverts for the food; the food itself.

At the start of this project, the hopeful actors were not told what they were auditioning for—although some worked it out from an often-repeated line of dialogue.

"When I first auditioned, the production only had the code name 'Project 9,'" says Gamora actor Kimberly-Sue Murray. "Everything was highly confidential and I didn't actually know what the project was, or even who the character I was reading for was. Luckily, the script they provided was well written, and I just gave it my best shot. About two years later, I got a call and they asked if I was available to do a screen test. I said, 'Yes, and also, what's the role?' That's when I found out it was Gamora, and I was like, 'Are you *kidding* me?' I'm a huge fan of the Marvel movies, so to be playing this fantastic character is like winning the lottery—it feels as if I'm in a dream and someone needs to pinch me awake!"

"I also got this super-confidential script called 'Project 9,'" says Rocket actor Alex Weiner. "They'd given Rocket the name Calvin Glow. There was also a character breakdown of the other roles, including one described as a 'sentient vegetative being' and all it ever said was, 'I love celery.' And I thought, *Yeah, this is probably a Guardians script!* So I did an audition tape and sent that in, fairly certain—but not sure—that I was trying out for Rocket. And I was cast, and the first reading probably happened about three months later."

"I actually did know what the project was when I read the script, even though it was all in code names," says Star-Lord actor Jon McLaren. "I think I was called Captain Jones. It was 'I love celery' that gave it away as a Guardian game. I put together an audition tape and sent it in. At first, I was disappointed because I thought I hadn't got the role. But about two months later, I received

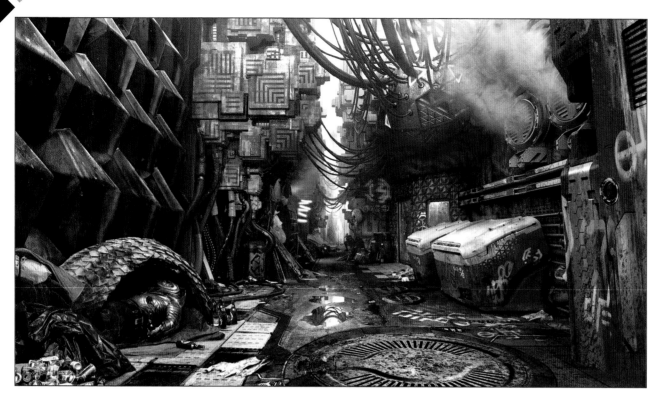

the good news from my agent that I was going to be Star-Lord. I'm not going to lie—I cried. I was so happy! It was a moment of pure excitement because I wanted it so badly."

"I originally auditioned for Star-Lord, and it hurt when I didn't hear anything for a while," confides Groot actor Robert Montcalm. "When I eventually met Jon [McLaren], I thought, *Oh, so that's why I didn't land the role of Star-Lord. This man is literally Star-Lord!*' Anyway, then the studio held audio auditions for Groot—or Quiet Joe as he was called then. After studying every time Groot [voiced by Vin Diesel] says, 'I am Groot' in the movies, I submitted my tape. I met [senior audio director] Steve Szczepkowski and he had me perform the line many different ways. At the end of that day, Steve said he liked what I'd done, and when the elevator door closed, I pretty much burst into tears of happiness because it looked like I was going to get the part."

"When I heard I'd got the role of Drax, I didn't quite believe it," actor and stuntman John Cavalier says with a shake of his head. "I had to pinch myself. Playing a Super Hero has been on my bucket list for a long time. When you audition for a video game, you often have no idea what it is you're auditioning for... although I had an inkling with this project. The giveaway was one of the characters in the script. They'd called him Quiet Joe and he just kept saying, 'Celery is good.' So I thought, *could this be? Is it possible...?* Drax also speaks in a very distinctive way; despite the fact that he's kind of brutish, he's also pretty eloquent and articulate. I started to suspect that this was a Guardians project, and I attacked the material with the feel of the movies in mind."

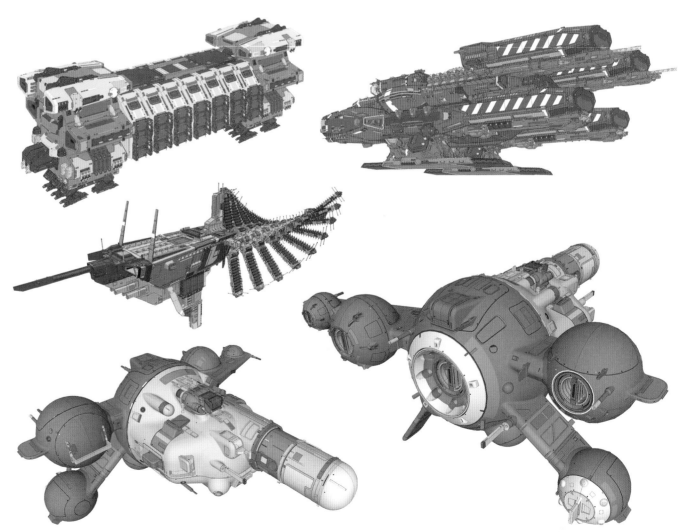

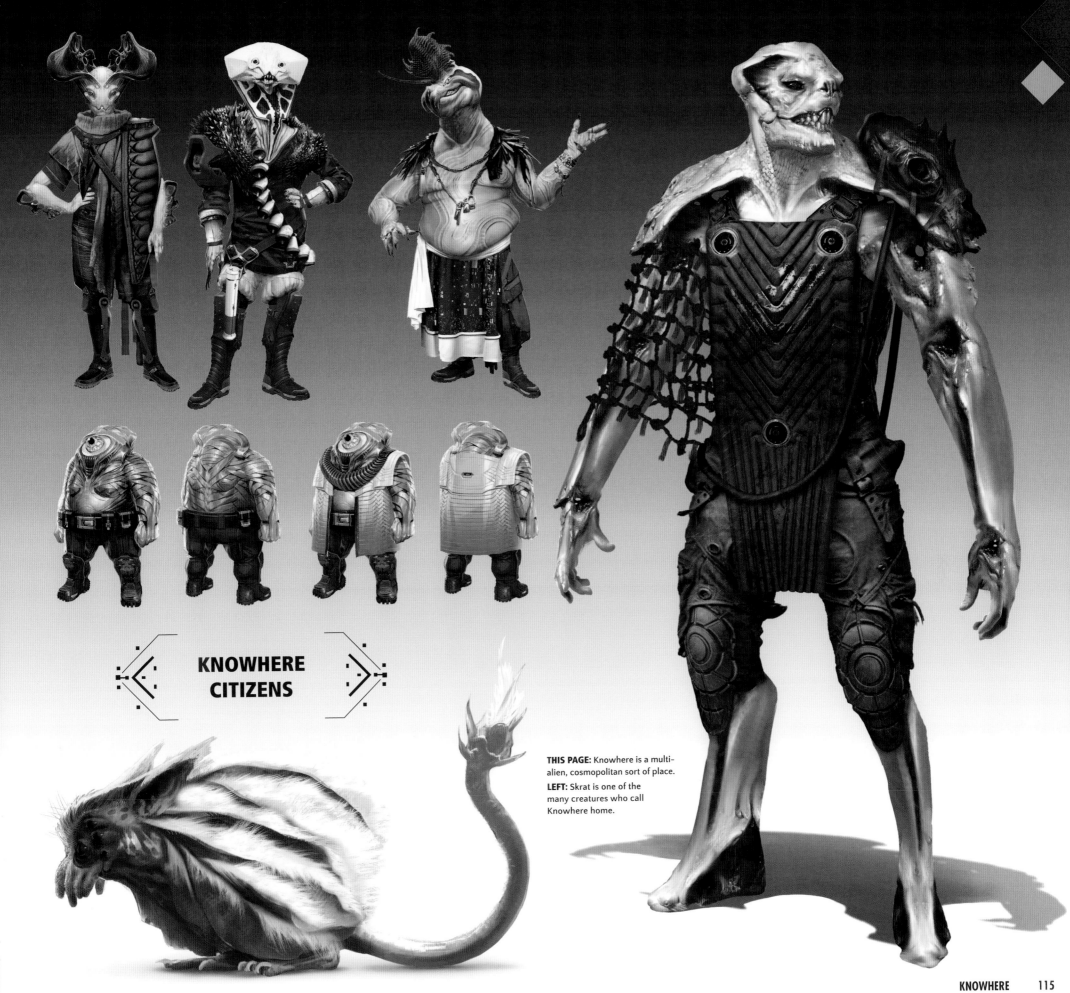

KNOWHERE
CITIZENS

THIS PAGE: Knowhere is a multi-alien, cosmopolitan sort of place.

LEFT: Skrat is one of the many creatures who call Knowhere home.

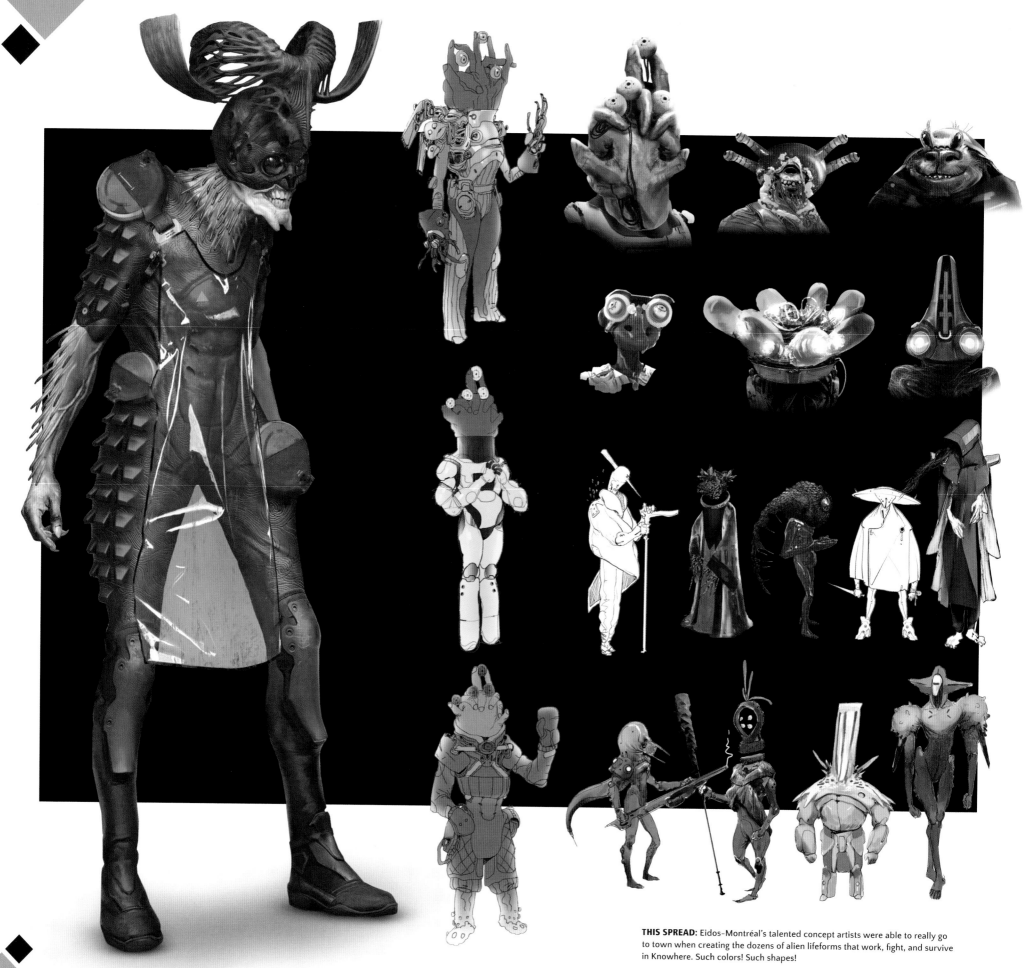

THIS SPREAD: Eidos-Montréal's talented concept artists were able to really go to town when creating the dozens of alien lifeforms that work, fight, and survive in Knowhere. Such colors! Such shapes!

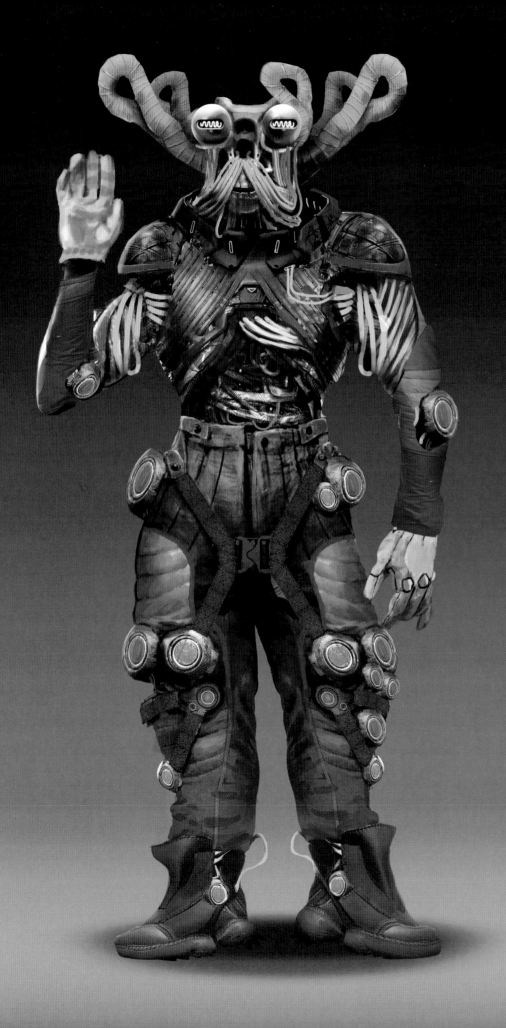
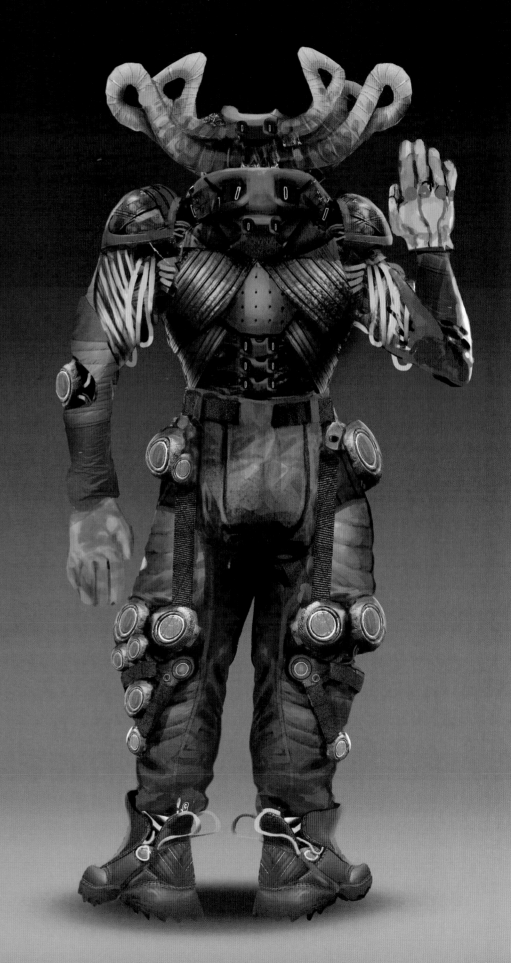

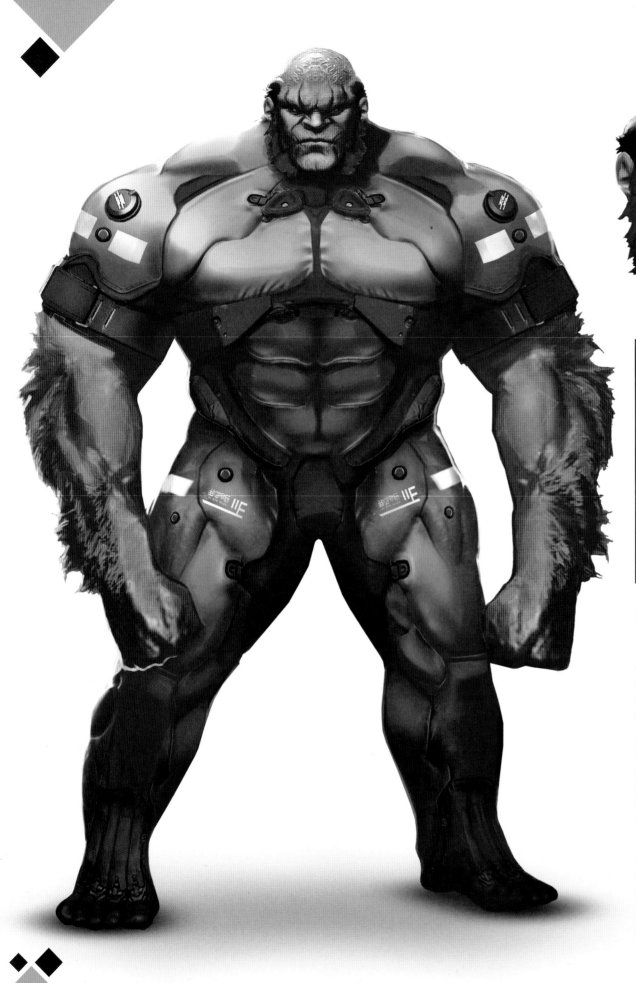

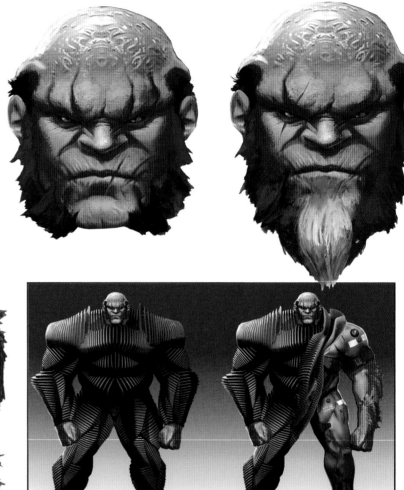

BLOOD BROTHERS

The Guardians of the Galaxy universe includes a rich plethora of supporting characters, and Eidos-Montréal was spoilt for choice as to who to include. It was important to the creative team to ensure as wide a variety as possible, especially when it came to boss battles—they wanted each encounter to present the player with fresh challenges and ways to experiment and make full use of the combat system.

"The Blood Brothers—oh yes!" says art director Bruno Gauthier-Leblanc. "We really love these characters from the comics. They're these big, red cosmic mercenaries—we tried to follow this design and experimented with different proportions. They're twins, so they look the same, with the

only difference being their beards."

Aside from their look, another reason Eidos-Montréal included the Blood Brothers was because of the unique way that they fight together. "The Blood Brothers are stronger when they're together and weaker when they're apart," Gauthier-Leblanc continues. "This is something we needed the player to instantly understand when they have to face them in a boss fight. This aspect of the Blood Brothers' combat relationship is not visualized in the comic books, so we came up with a shield system that they use, that the player can actually see. The closer the Brothers are to each other, the more shield power is generated, which offers them more protection."

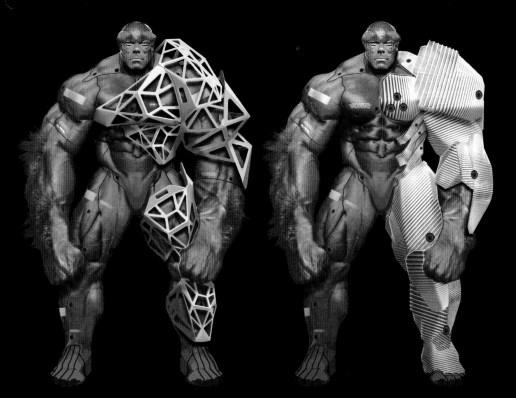

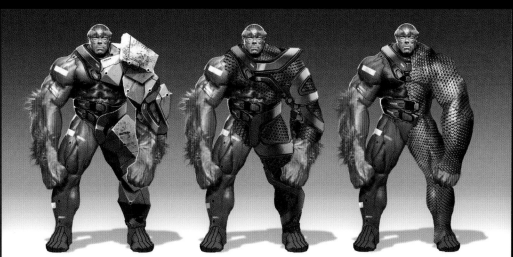

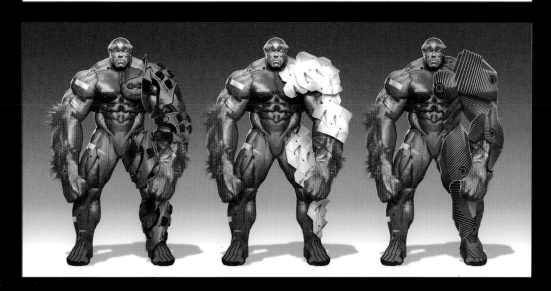

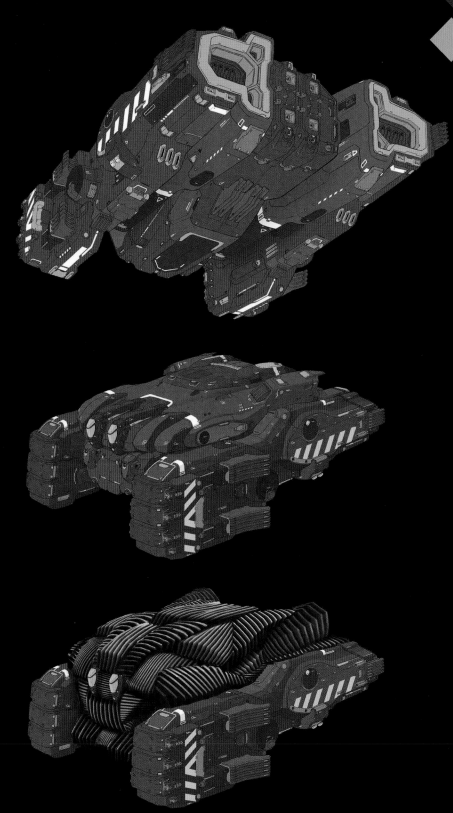

LEFT: Eidos-Montréal worked hard on the look and function of the Blood Brothers' shared shield; the player needs to separate the Brothers to weaken it.

ABOVE: Concept art for the Blood Brothers' spaceship.

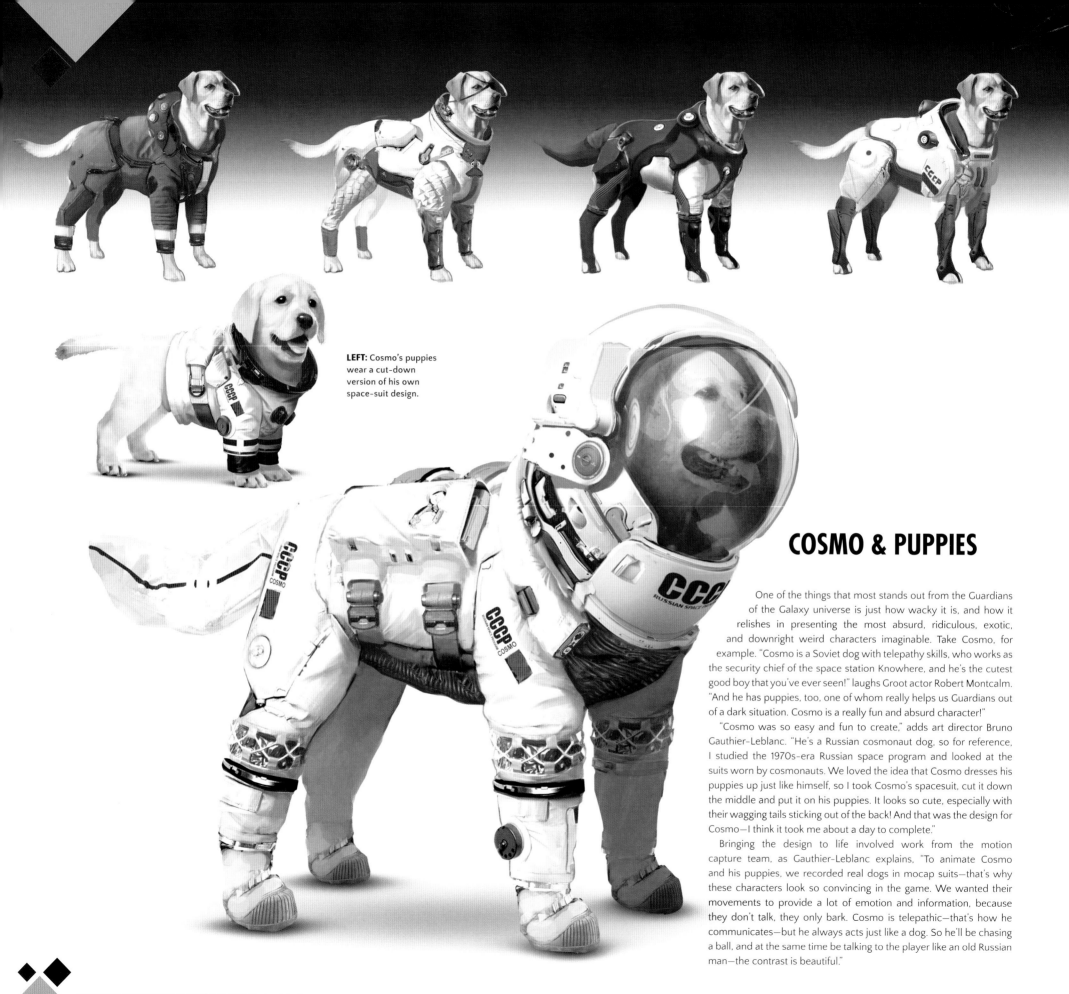

LEFT: Cosmo's puppies wear a cut-down version of his own space-suit design.

COSMO & PUPPIES

One of the things that most stands out from the Guardians of the Galaxy universe is just how wacky it is, and how it relishes in presenting the most absurd, ridiculous, exotic, and downright weird characters imaginable. Take Cosmo, for example. "Cosmo is a Soviet dog with telepathy skills, who works as the security chief of the space station Knowhere, and he's the cutest good boy that you've ever seen!" laughs Groot actor Robert Montcalm. "And he has puppies, too, one of whom really helps us Guardians out of a dark situation. Cosmo is a really fun and absurd character!"

"Cosmo was so easy and fun to create," adds art director Bruno Gauthier-Leblanc. "He's a Russian cosmonaut dog, so for reference, I studied the 1970s-era Russian space program and looked at the suits worn by cosmonauts. We loved the idea that Cosmo dresses his puppies up just like himself, so I took Cosmo's spacesuit, cut it down the middle and put it on his puppies. It looks so cute, especially with their wagging tails sticking out of the back! And that was the design for Cosmo—I think it took me about a day to complete."

Bringing the design to life involved work from the motion capture team, as Gauthier-Leblanc explains, "To animate Cosmo and his puppies, we recorded real dogs in mocap suits—that's why these characters look so convincing in the game. We wanted their movements to provide a lot of emotion and information, because they don't talk, they only bark. Cosmo is telepathic—that's how he communicates—but he always acts just like a dog. So he'll be chasing a ball, and at the same time be talking to the player like an old Russian man—the contrast is beautiful."

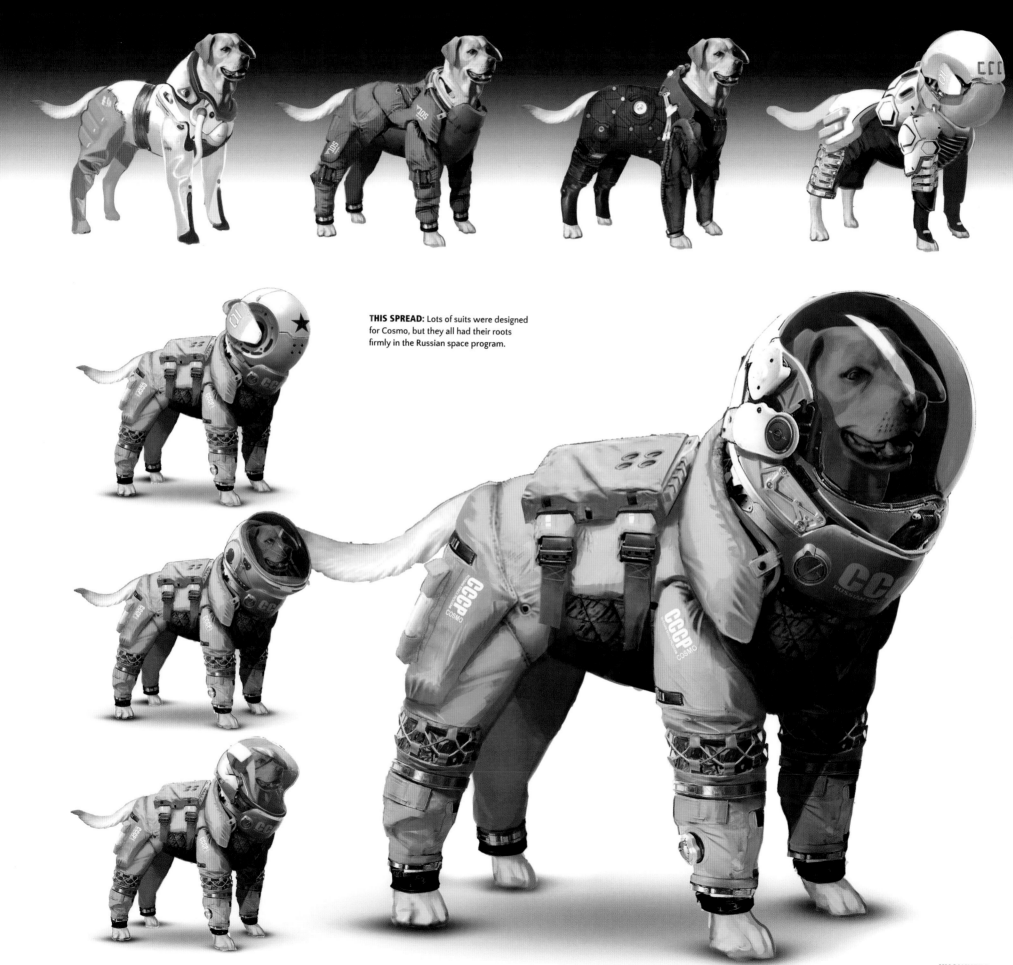

THIS SPREAD: Lots of suits were designed for Cosmo, but they all had their roots firmly in the Russian space program.

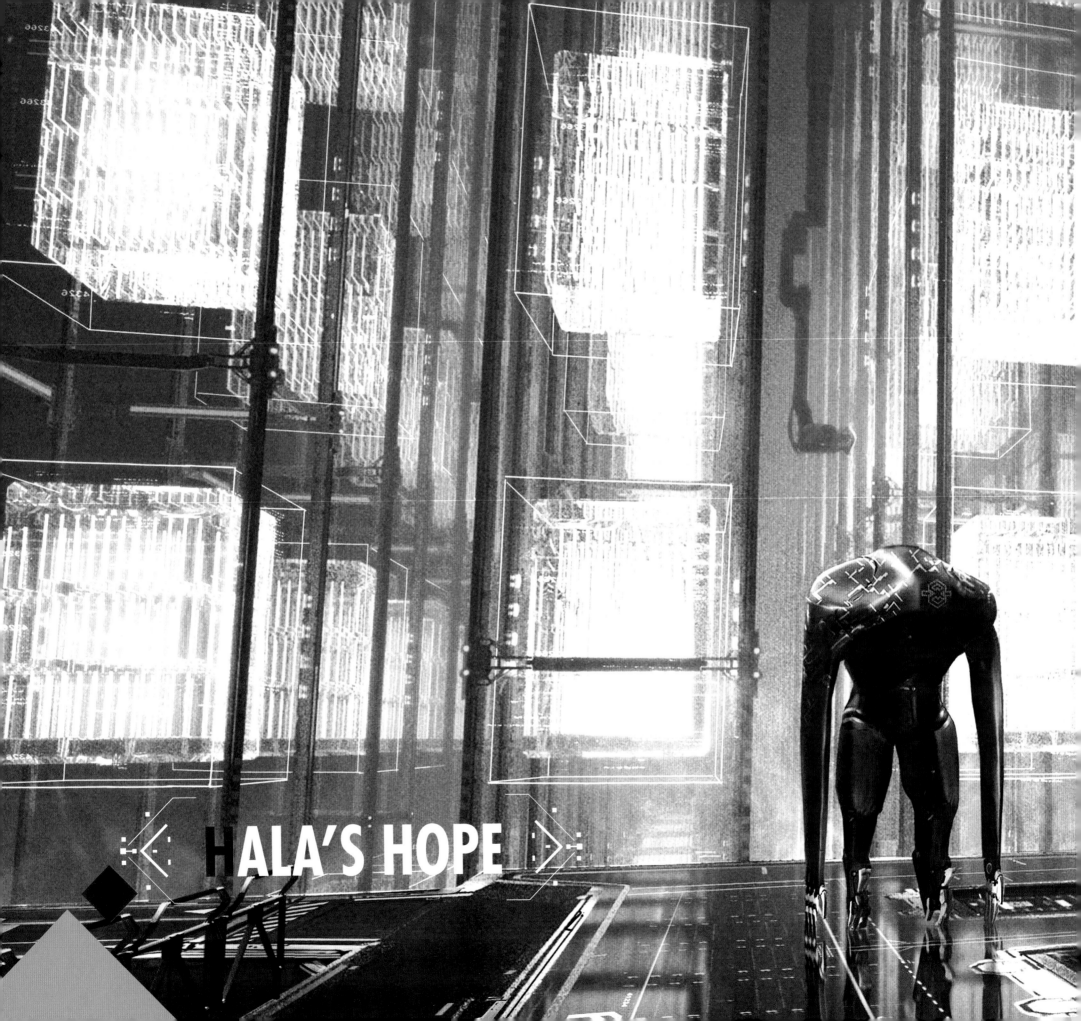

HALA'S HOPE

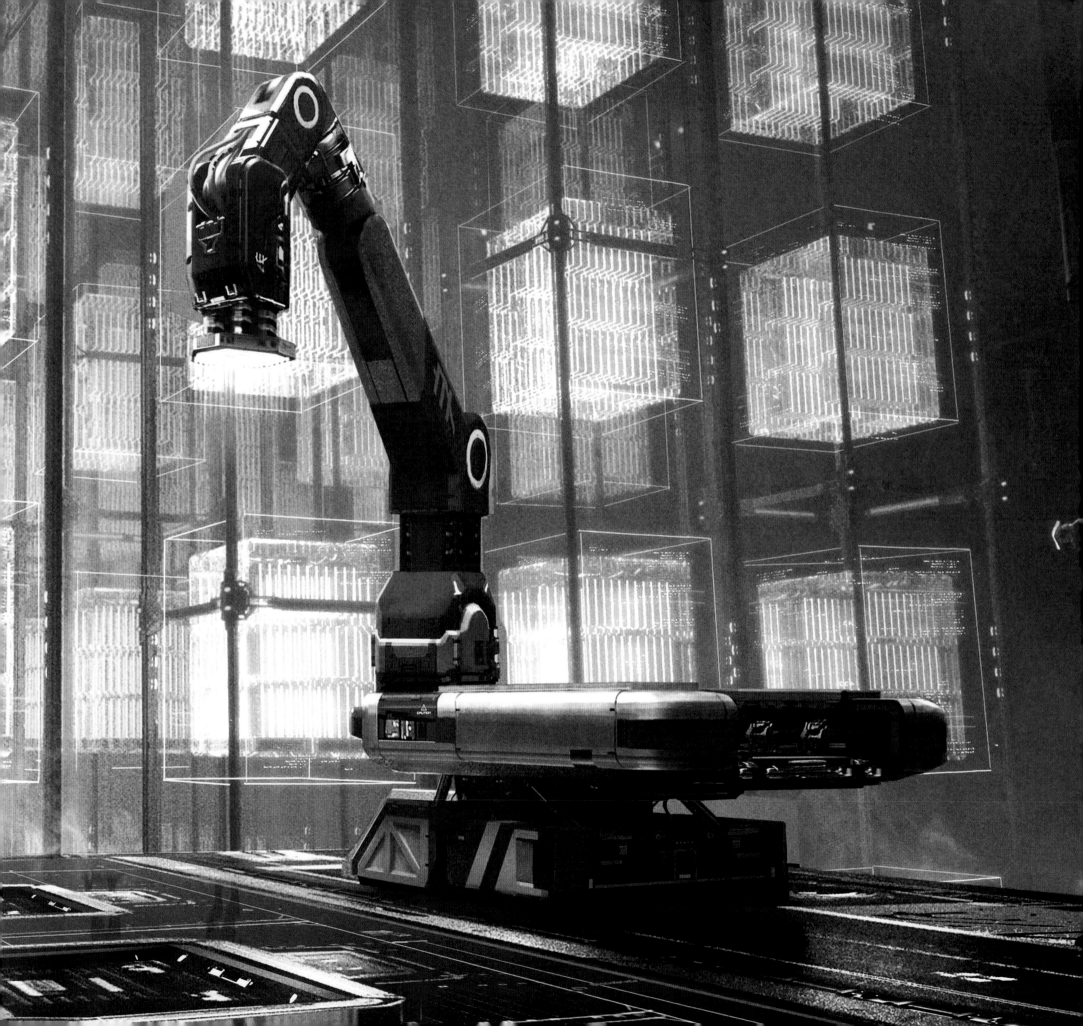

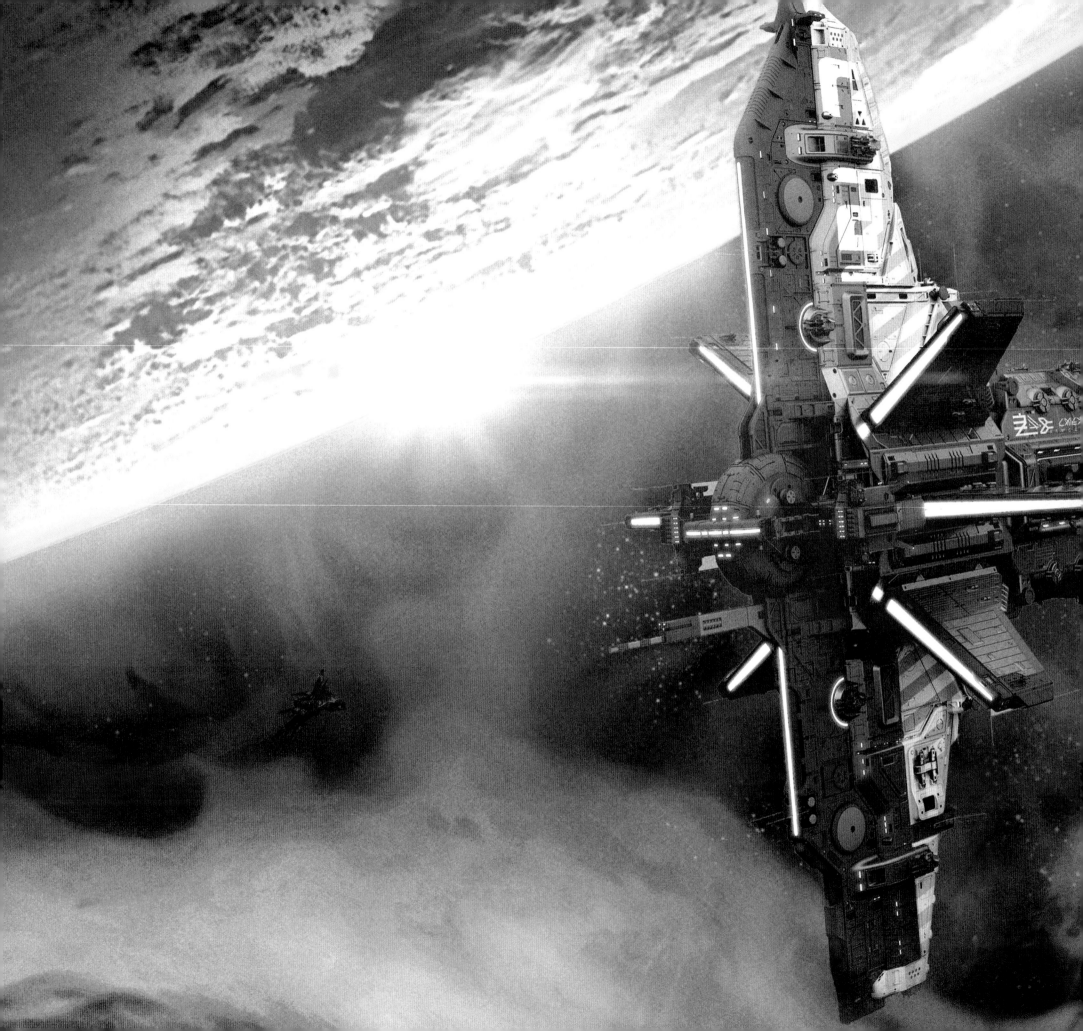

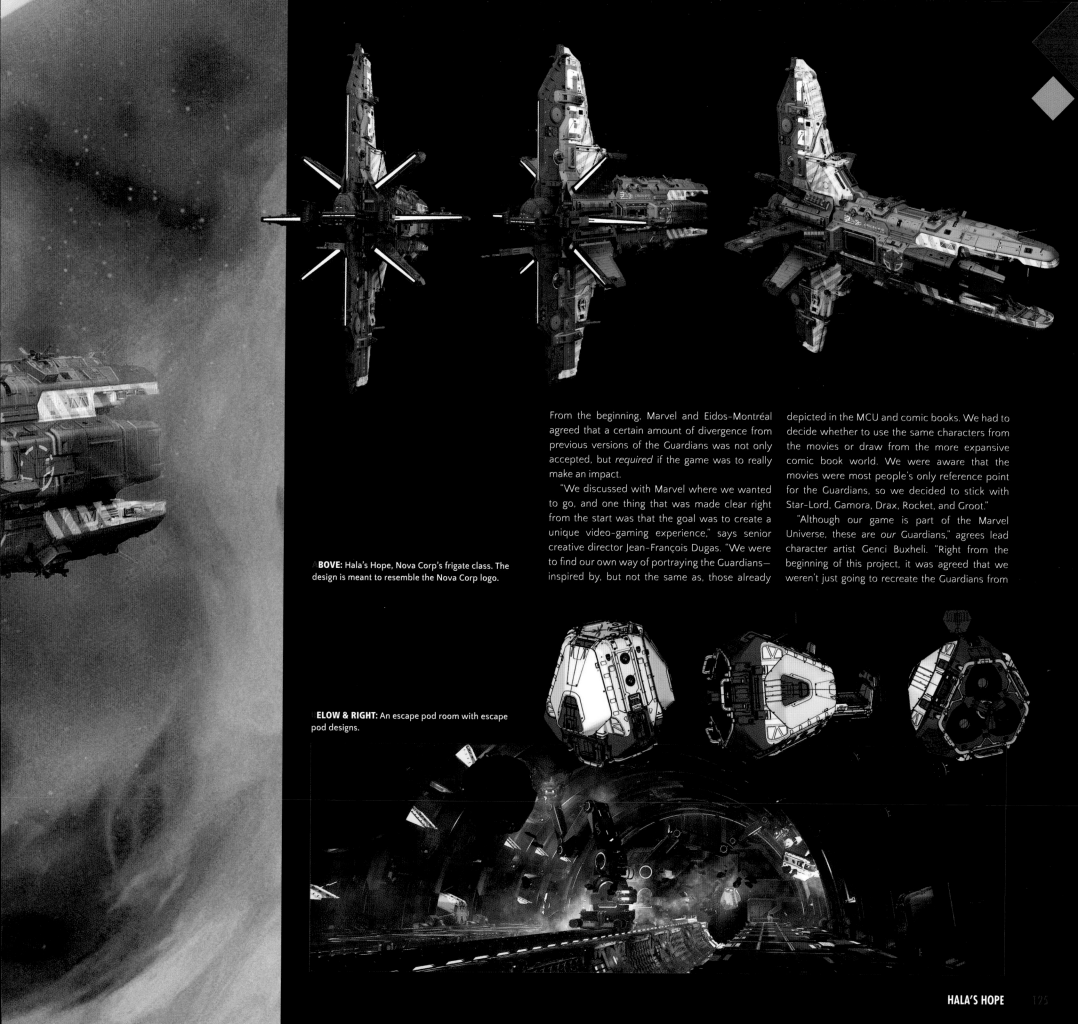

ABOVE: Hala's Hope, Nova Corp's frigate class. The design is meant to resemble the Nova Corp logo.

BELOW & RIGHT: An escape pod room with escape pod designs.

From the beginning, Marvel and Eidos-Montréal agreed that a certain amount of divergence from previous versions of the Guardians was not only accepted, but *required* if the game was to really make an impact.

"We discussed with Marvel where we wanted to go, and one thing that was made clear right from the start was that the goal was to create a unique video-gaming experience," says senior creative director Jean-François Dugas. "We were to find our own way of portraying the Guardians— inspired by, but not the same as, those already

depicted in the MCU and comic books. We had to decide whether to use the same characters from the movies or draw from the more expansive comic book world. We were aware that the movies were most people's only reference point for the Guardians, so we decided to stick with Star-Lord, Gamora, Drax, Rocket, and Groot."

"Although our game is part of the Marvel Universe, these are *our* Guardians," agrees lead character artist Genci Buxheli. "Right from the beginning of this project, it was agreed that we weren't just going to recreate the Guardians from

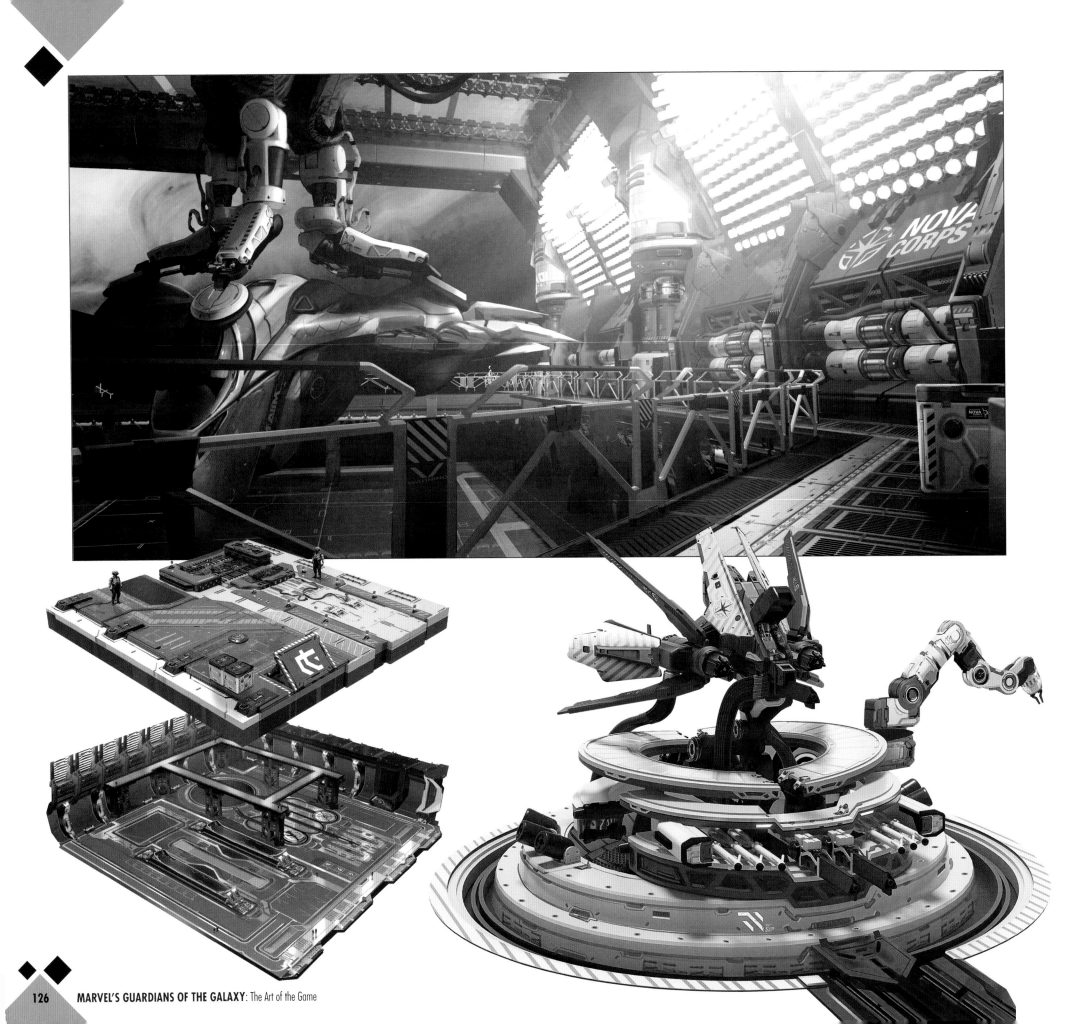

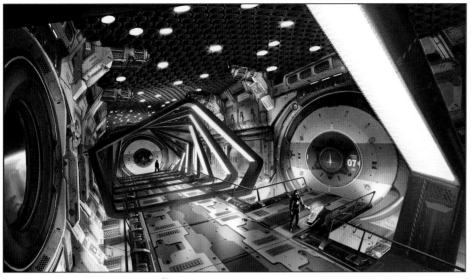

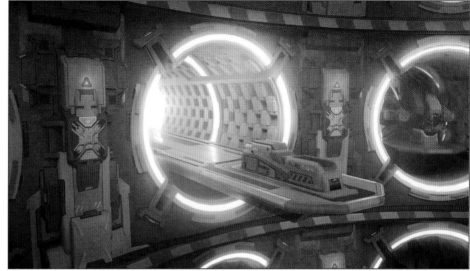

OPPOSITE PAGE: Hangar bay and ships docking into Hala's Hope.

ABOVE & RIGHT: Corridor and fighter bay design, as well as Nova Corps fighters.

BELOW: Hala's Hope hangar taken over by the church and used as a faith-harvesting vessel.

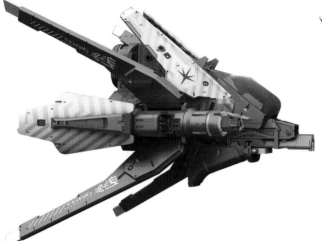

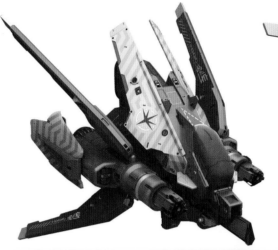

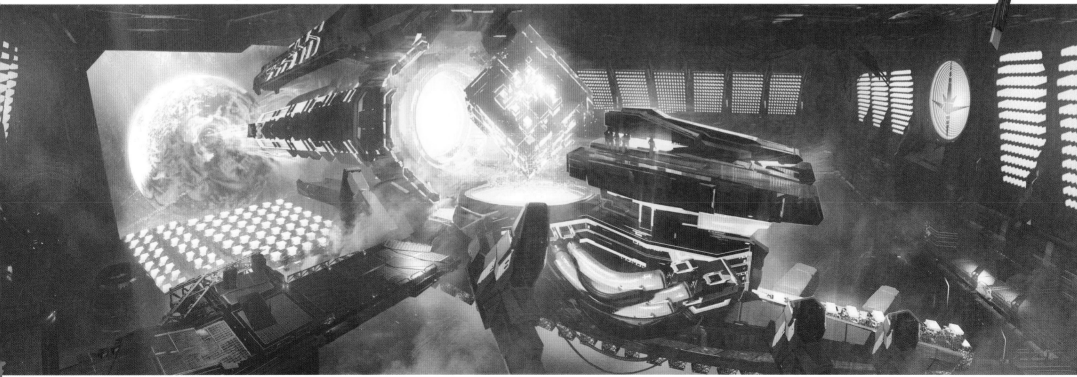

RIGHT: Nexus, the command center of Hala's Hope.
BELOW: Nikki's lair/secret hideout.
OPPOSITE PAGE: Ko-Rel and Nikki's official quarters on Hala's Hope.

the movies and comics. We wanted to keep their personalities, of course, because that's what makes them the Guardians, but design-wise we wanted something that fitted more closely to the style of game we were making."

This idea also extended to the performers playing the Guardians, as Gamora actor Kimberly-Sue Murray explains, "Darryl [Purdy, animation director] didn't want us to replicate what the actors who starred in the movie franchise did—he wanted something different. We trusted the writing, which is where the character voices are defined, and we were encouraged to bring our own interpretation of their personalities."

"We really wanted to stand out and make this our own iteration of the Guardians of the Galaxy," Purdy adds. "It's not the movie or comic book version—and Marvel agreed that they didn't want us to replicate what had gone before."

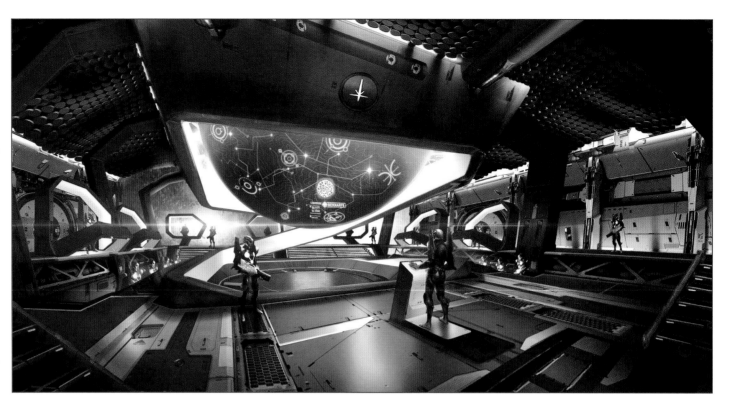

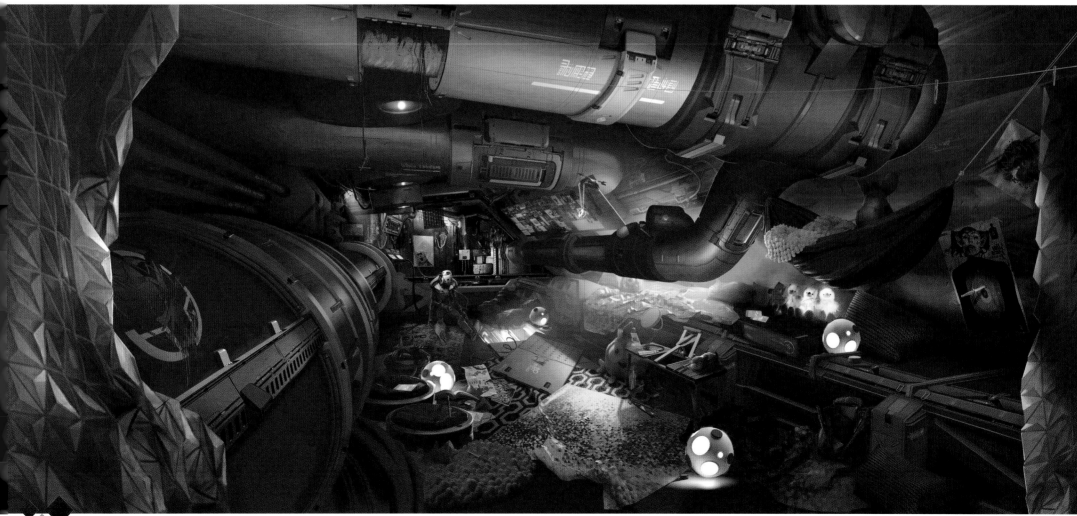

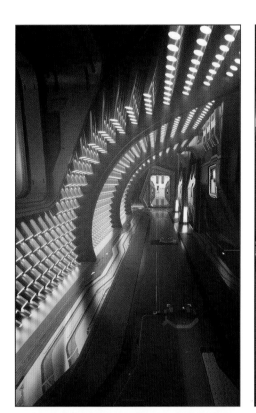
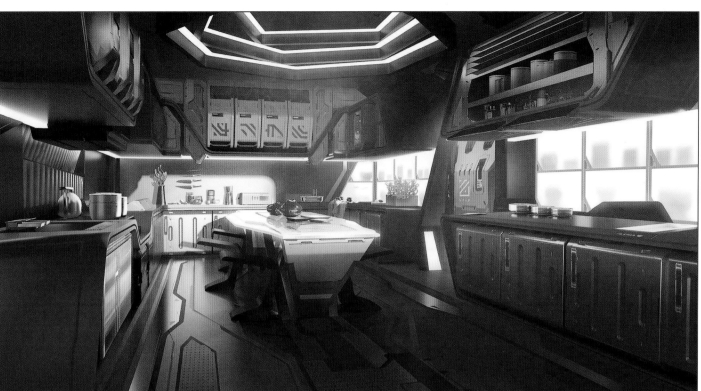
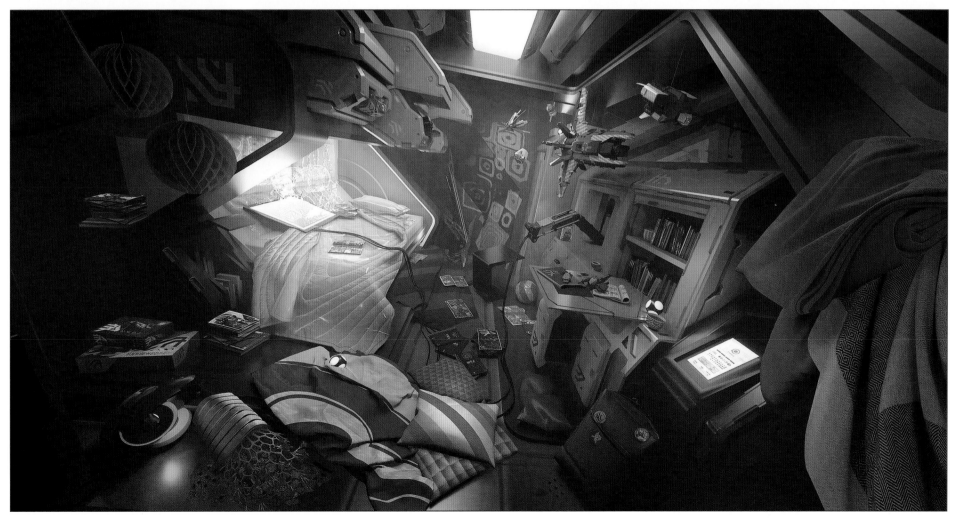

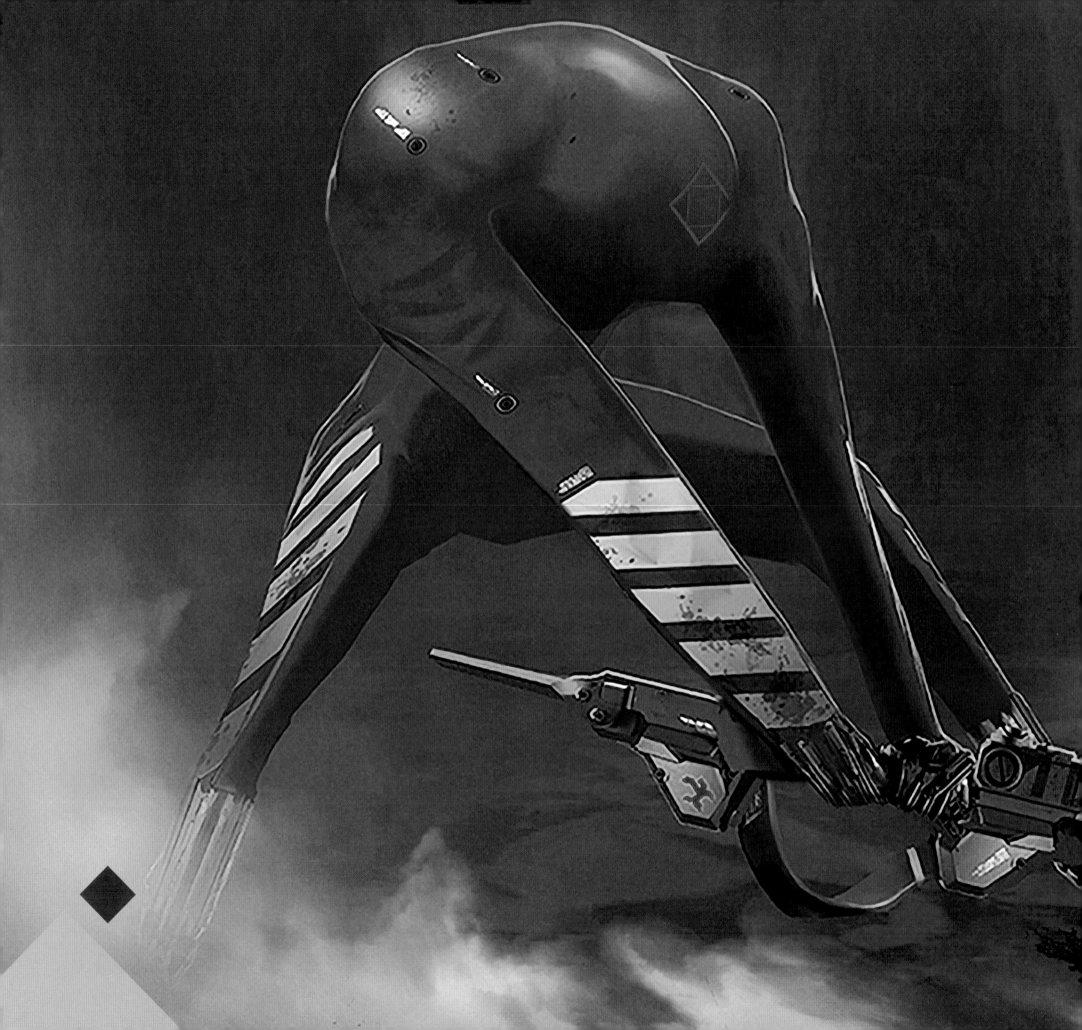

THE CHURCH OF
UNIVERSAL TRUTH

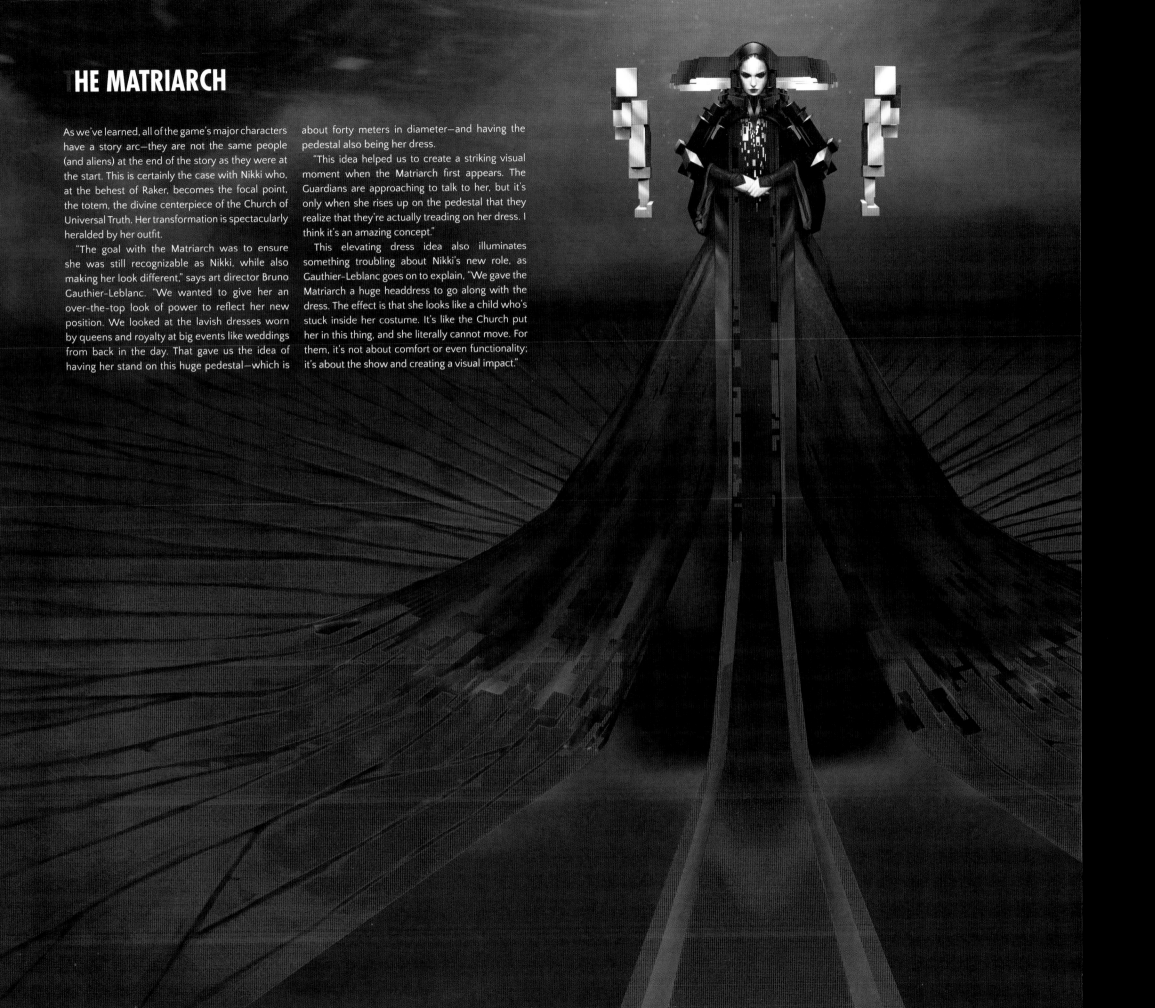

HE MATRIARCH

As we've learned, all of the game's major characters have a story arc—they are not the same people (and aliens) at the end of the story as they were at the start. This is certainly the case with Nikki who, at the behest of Raker, becomes the focal point, the totem, the divine centerpiece of the Church of Universal Truth. Her transformation is spectacularly heralded by her outfit.

"The goal with the Matriarch was to ensure she was still recognizable as Nikki, while also making her look different," says art director Bruno Gauthier-Leblanc. "We wanted to give her an over-the-top look of power to reflect her new position. We looked at the lavish dresses worn by queens and royalty at big events like weddings from back in the day. That gave us the idea of having her stand on this huge pedestal—which is

about forty meters in diameter—and having the pedestal also being her dress.

"This idea helped us to create a striking visual moment when the Matriarch first appears. The Guardians are approaching to talk to her, but it's only when she rises up on the pedestal that they realize that they're actually treading on her dress. I think it's an amazing concept."

This elevating dress idea also illuminates something troubling about Nikki's new role, as Gauthier-Leblanc goes on to explain, "We gave the Matriarch a huge headdress to go along with the dress. The effect is that she looks like a child who's stuck inside her costume. It's like the Church put her in this thing, and she literally cannot move. For them, it's not about comfort or even functionality; it's about the show and creating a visual impact."

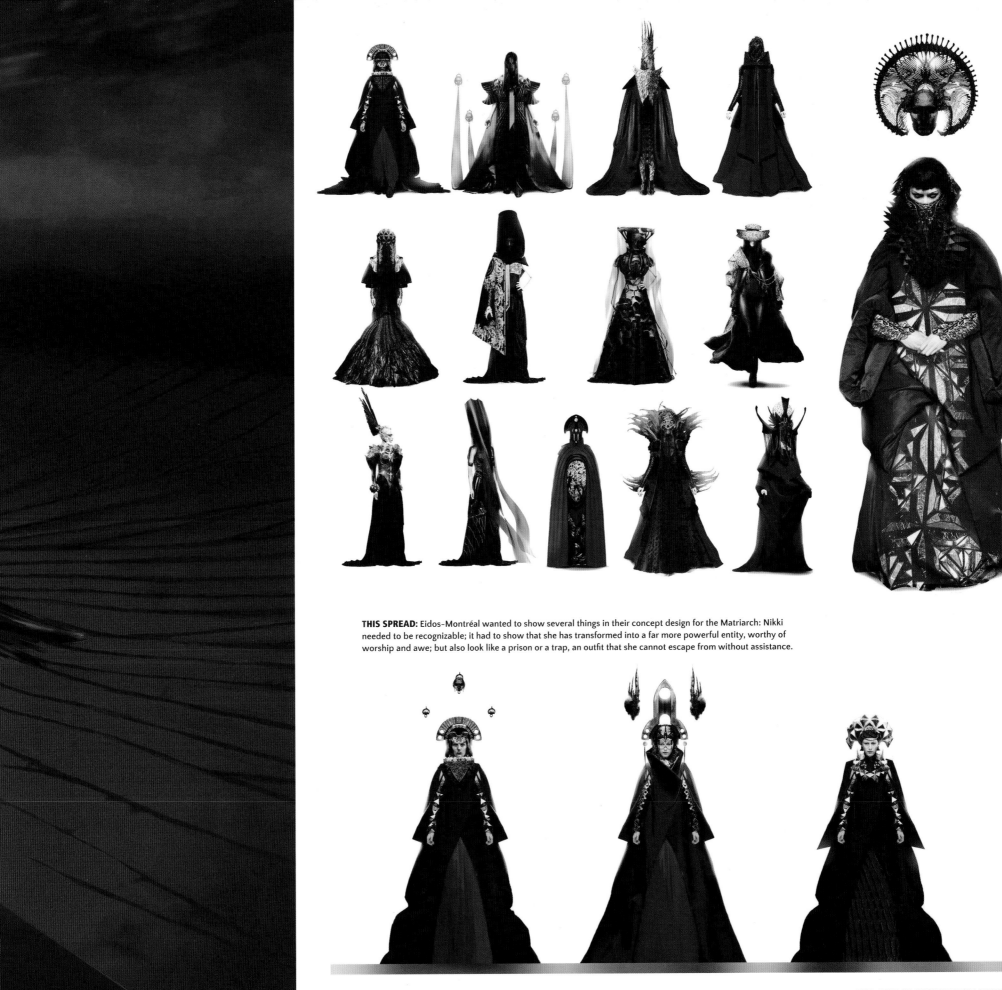

THIS SPREAD: Eidos-Montréal wanted to show several things in their concept design for the Matriarch: Nikki needed to be recognizable; it had to show that she has transformed into a far more powerful entity, worthy of worship and awe; but also look like a prison or a trap, an outfit that she cannot escape from without assistance.

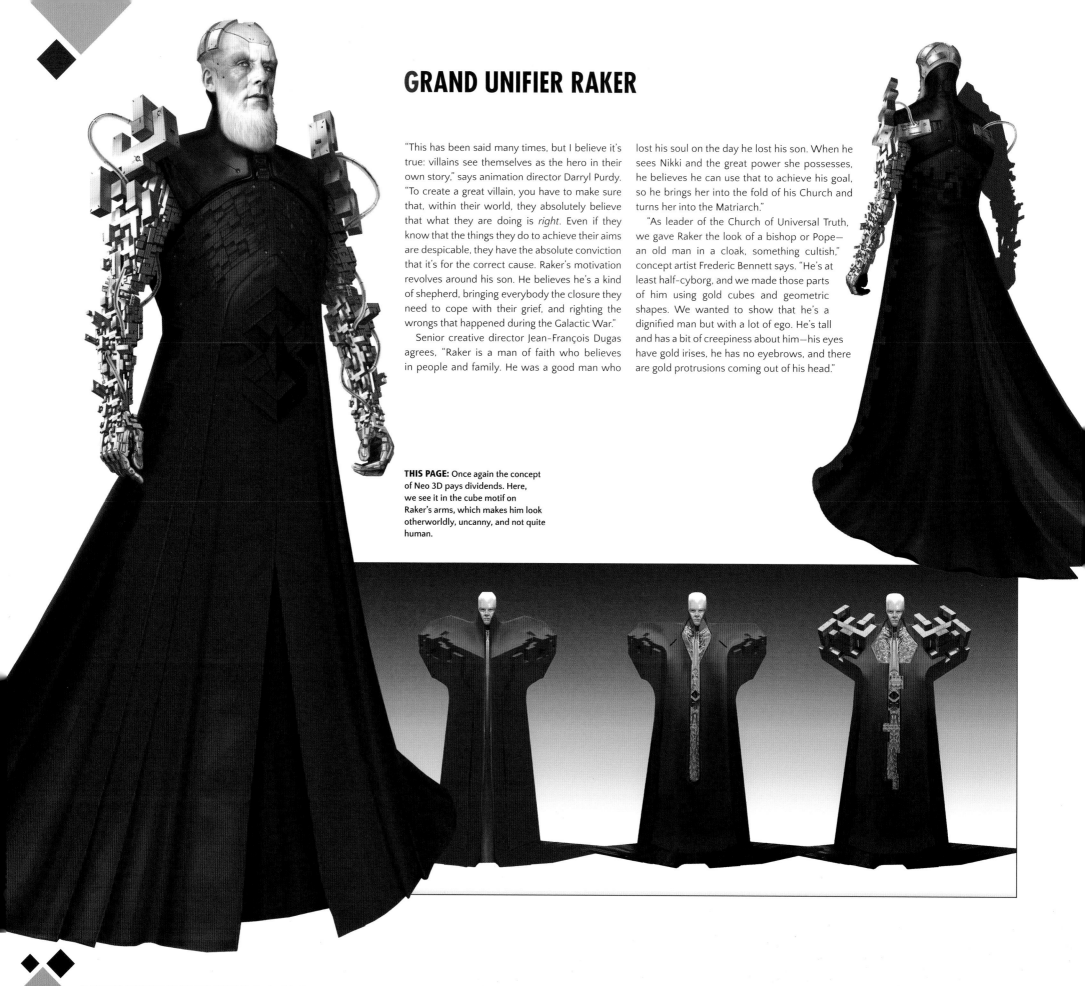

GRAND UNIFIER RAKER

"This has been said many times, but I believe it's true: villains see themselves as the hero in their own story," says animation director Darryl Purdy. "To create a great villain, you have to make sure that, within their world, they absolutely believe that what they are doing is *right*. Even if they know that the things they do to achieve their aims are despicable, they have the absolute conviction that it's for the correct cause. Raker's motivation revolves around his son. He believes he's a kind of shepherd, bringing everybody the closure they need to cope with their grief, and righting the wrongs that happened during the Galactic War."

Senior creative director Jean-François Dugas agrees, "Raker is a man of faith who believes in people and family. He was a good man who lost his soul on the day he lost his son. When he sees Nikki and the great power she possesses, he believes he can use that to achieve his goal, so he brings her into the fold of his Church and turns her into the Matriarch."

"As leader of the Church of Universal Truth, we gave Raker the look of a bishop or Pope—an old man in a cloak, something cultish," concept artist Frederic Bennett says. "He's at least half-cyborg, and we made those parts of him using gold cubes and geometric shapes. We wanted to show that he's a dignified man but with a lot of ego. He's tall and has a bit of creepiness about him—his eyes have gold irises, he has no eyebrows, and there are gold protrusions coming out of his head."

THIS PAGE: Once again the concept of Neo 3D pays dividends. Here, we see it in the cube motif on Raker's arms, which makes him look otherworldly, uncanny, and not quite human.

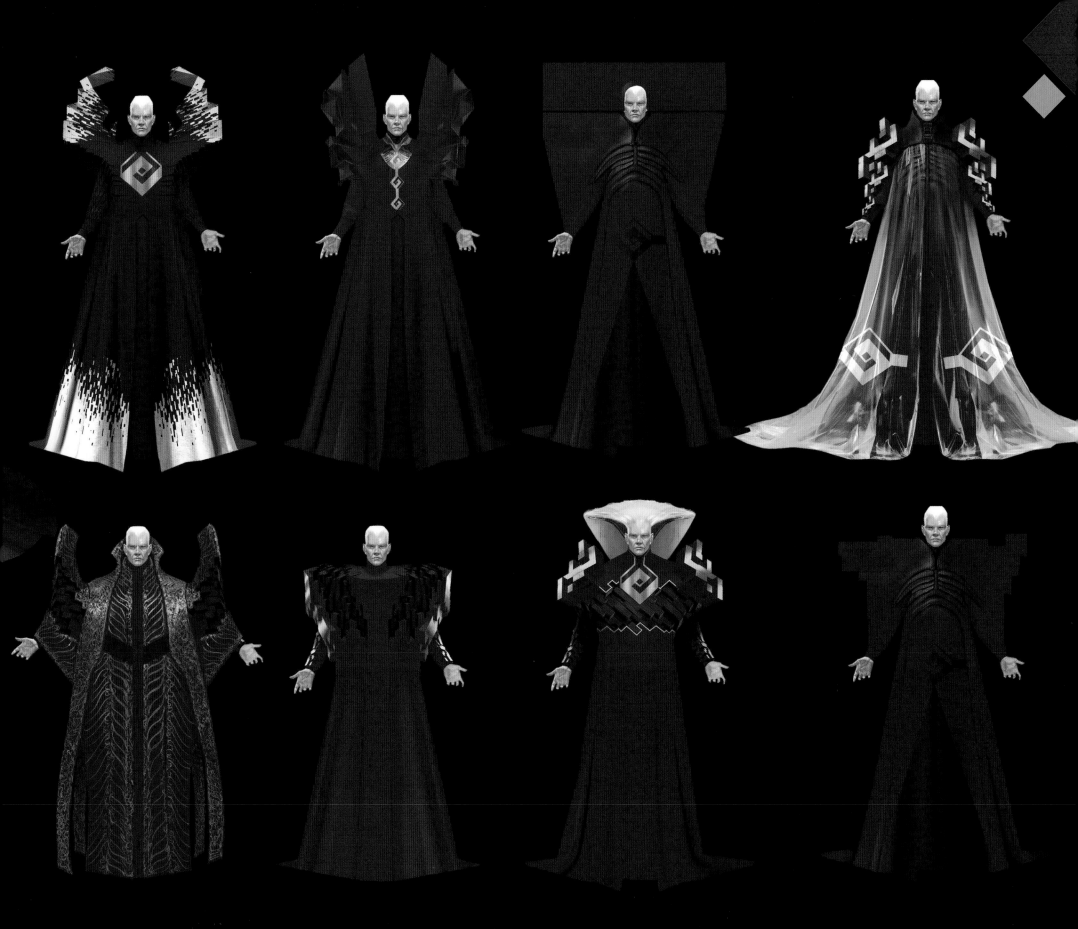

THIS PAGE: A lot of work was done on Raker's outfit. Being a man of great ego, the main aim was to make it reflect his overbearing personality and desire to inspire awe. The regal golds and reds work perfectly, and much inspiration came from the robes worn by senior religious officials.

Acting in an ambitious and big-budget video game such as *Marvel's Guardians of the Galaxy* demands flexible thinking and a large skill set from the actors. The final performance that gamers see on-screen is a mixture of work from the cast, mocap stunt performers, animators, and sound designers.

"Part of the challenge was the fact that we shot scenes out of sequence," explains Gamora actor Kimberly-Sue Murray. "Say we have twelve chapters total—we might start off by performing scenes from chapter three, and then jump forward to chapter seven, and then back to chapter one. It came down to us completely trusting our animation director, Darryl Purdy. He knew all the story arcs and it was up to him to fill us in and guide us if we didn't know what was going on. As the months went by, we actors were able to connect the story dots and say, 'Ah, *now* it makes sense!'"

THE CHURCH FACTION
The Guardian's main antagonist, with strong motives to succeed

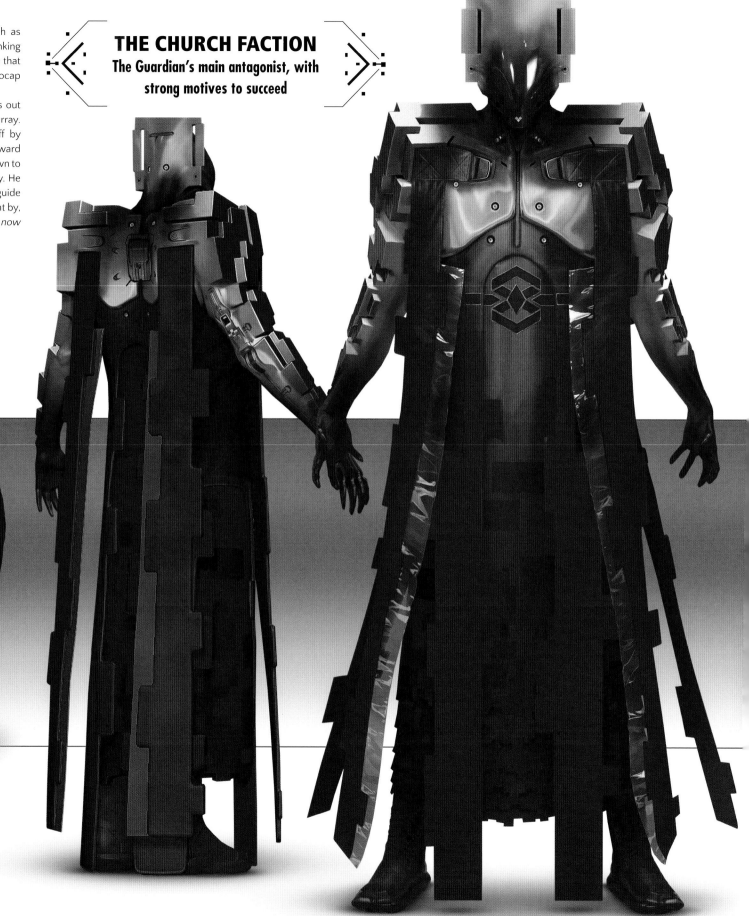

THIS PAGE: The design motifs of Raker's outfit are clearly reflected in those who fight for him and his cause: deep red complemented by gold, and the cubic motif for the arms, shoulders, and head.

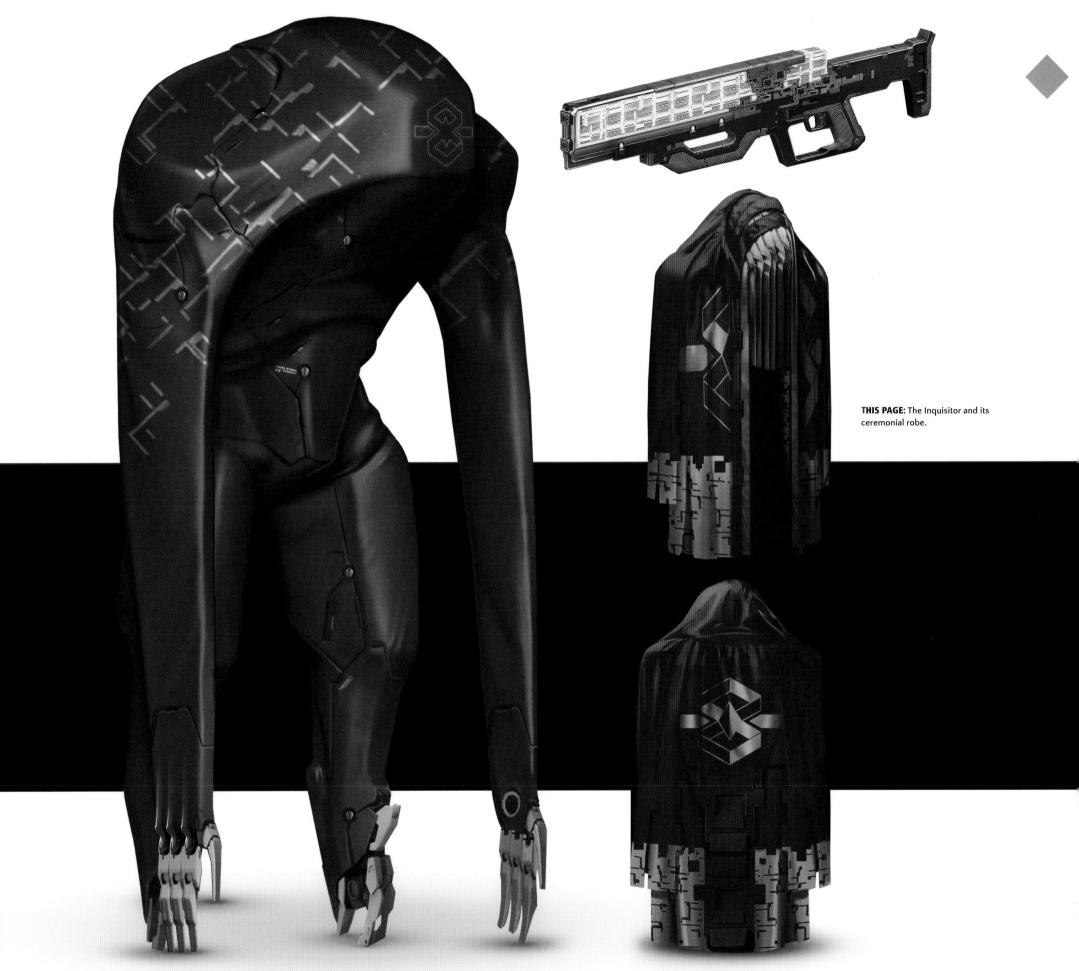

THIS PAGE: The Inquisitor and its ceremonial robe.

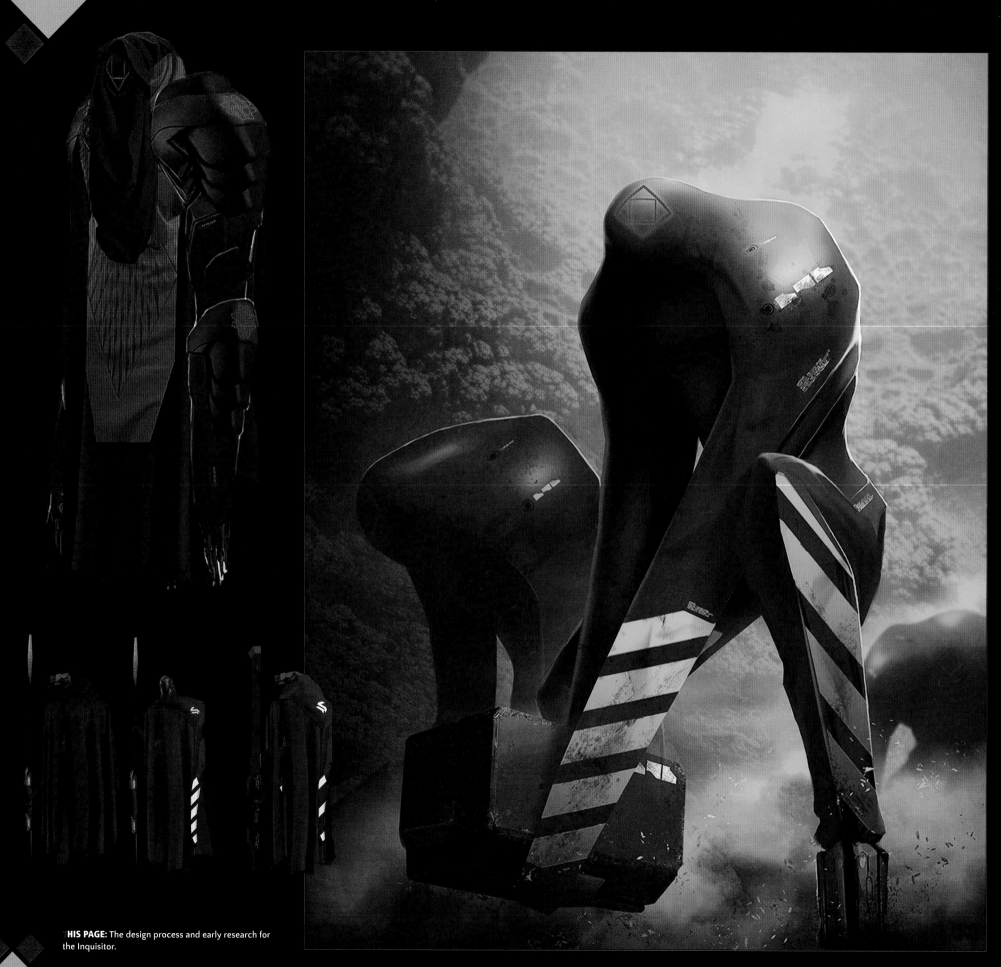

THIS PAGE: The design process and early research for the Inquisitor.

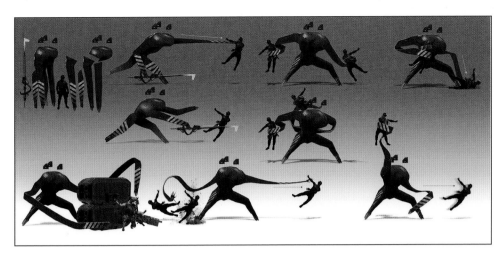

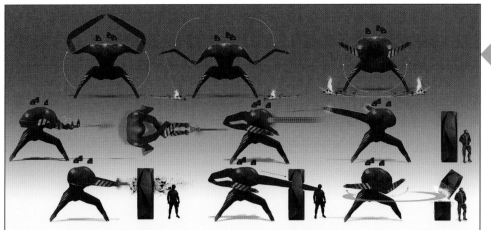

INQUISITORS

ABOVE: Combat designs for the inquisitors.

BELOW: Various designs for the menacing inquisitors of the Church Faction.

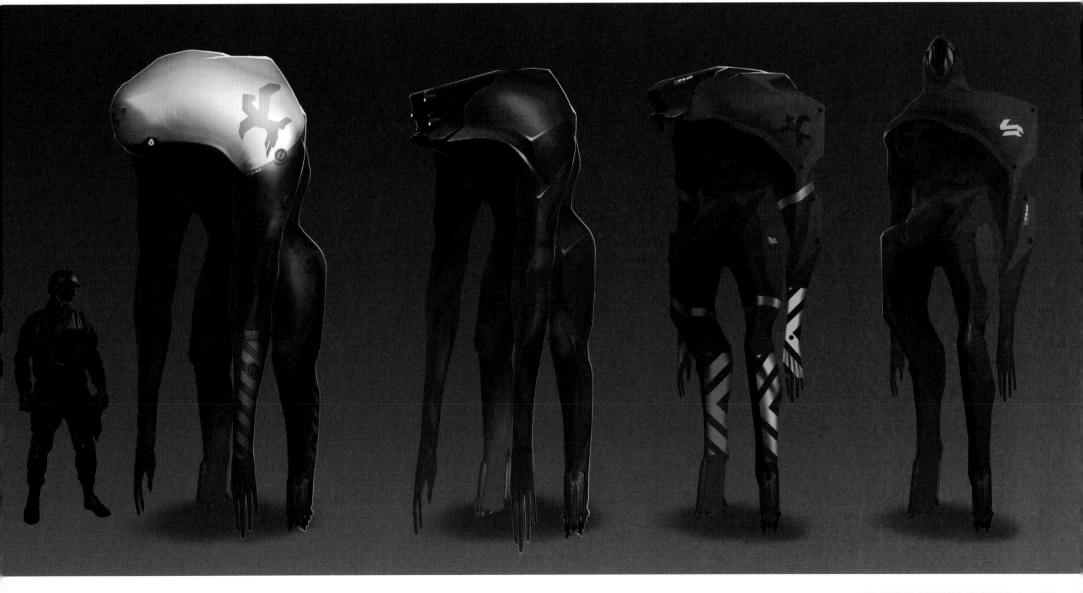

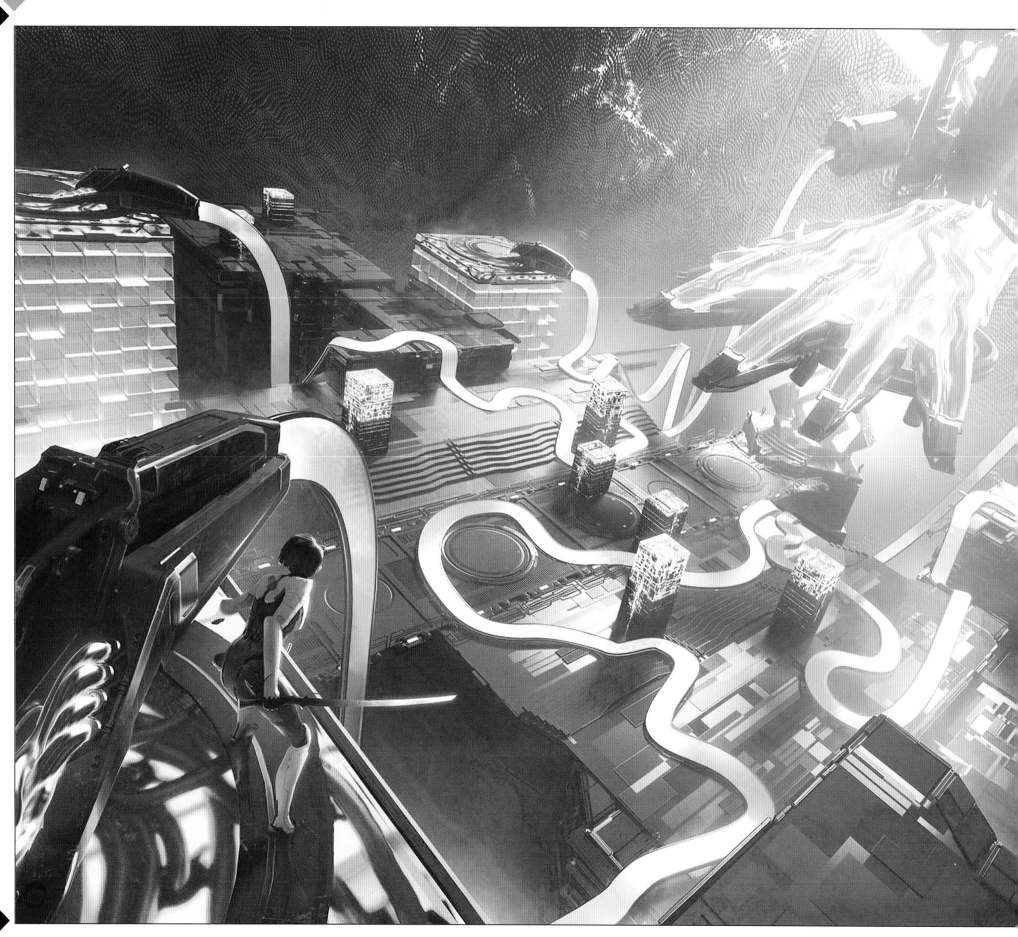

THE FULFILLMENT RITUAL
The end of one way of being, and the beginning of a new

THIS SPREAD: Eidos-Montréal created combat arenas using vast alien architecture and shape combinations to ensure each environment was unique, novel, and fun to fight in.

"What I like about acting in a video game," continues Kimberly-Sue Murray, "is that it's like if film and theater had a baby: it's a discipline that requires the physical and emotional range of theater, as well as the nuances and subtleties of human expression in film. I always want to give a heartfelt performance, and acting in a video game allows me to embody my character. Performing in *Marvel's Guardians of the Galaxy* was a wholesome experience. It was physical and emotional; you're using your entire instrument."

Murray talks enthusiastically about the practicality of her task, as well as the hard work it required. "Before we shot a scene, Darryl showed us storyboards and told us what was going to happen. So for example, if an enemy was going to be flying in to attack us, he'd explain where it was coming from, so we could act and react accordingly. We rehearsed a *lot* and shot a lot until we got it right. Darryl is so great with actors—he knows how to speak to us and is so precise. He's passionate and has great ideas. Working on *Guardians* was fun!"

The full-body mocap suits and facial performance mocap (sometimes called 'facial tracking') are standard fare for video game actors, and some adjust to wearing them faster than others. "Some actors get comfortable fairly quickly working in mocap suits," says Darryl Purdy. "Others take a little bit longer to adjust because there's no tangible feeling of wearing a costume and make-up, or being on a set with lots of props."

"I try to keep a light, fun, and creative atmosphere on set. I also tell the actors that it might take a while to get used to having all the cameras around them and being in a spandex suit, and not to worry about it. I don't put any time pressure on them, especially when it's their first day. I want them to get past the physical weirdness of being on set so they can find their character and perform."

Murray needed no such reassurance. "I like wearing the mocap suit," she laughs, "it makes me feel like a ninja! They're black, skin-tight outfits covered with sensors. The helmet has a light—which Jon [McLaren, Star-Lord actor] always forgot to switch on!—and a camera on the front to capture facial expressions, and a microphone to pick up our dialogue. And there are cameras all over the studio. They capture our full performance: face, body, and voice, and all that data is sent off to the animators to work their magic on."

"Here's something about video game acting," says Rocket actor Alex Weiner, "sometimes you hear actors say, 'Yes, that's my performance on screen.' And yes, they did the motion capture and the voice lines, but an animator is going to go in there afterward and do, I would say, about fifty percent of the work to make the character that appears in the game."

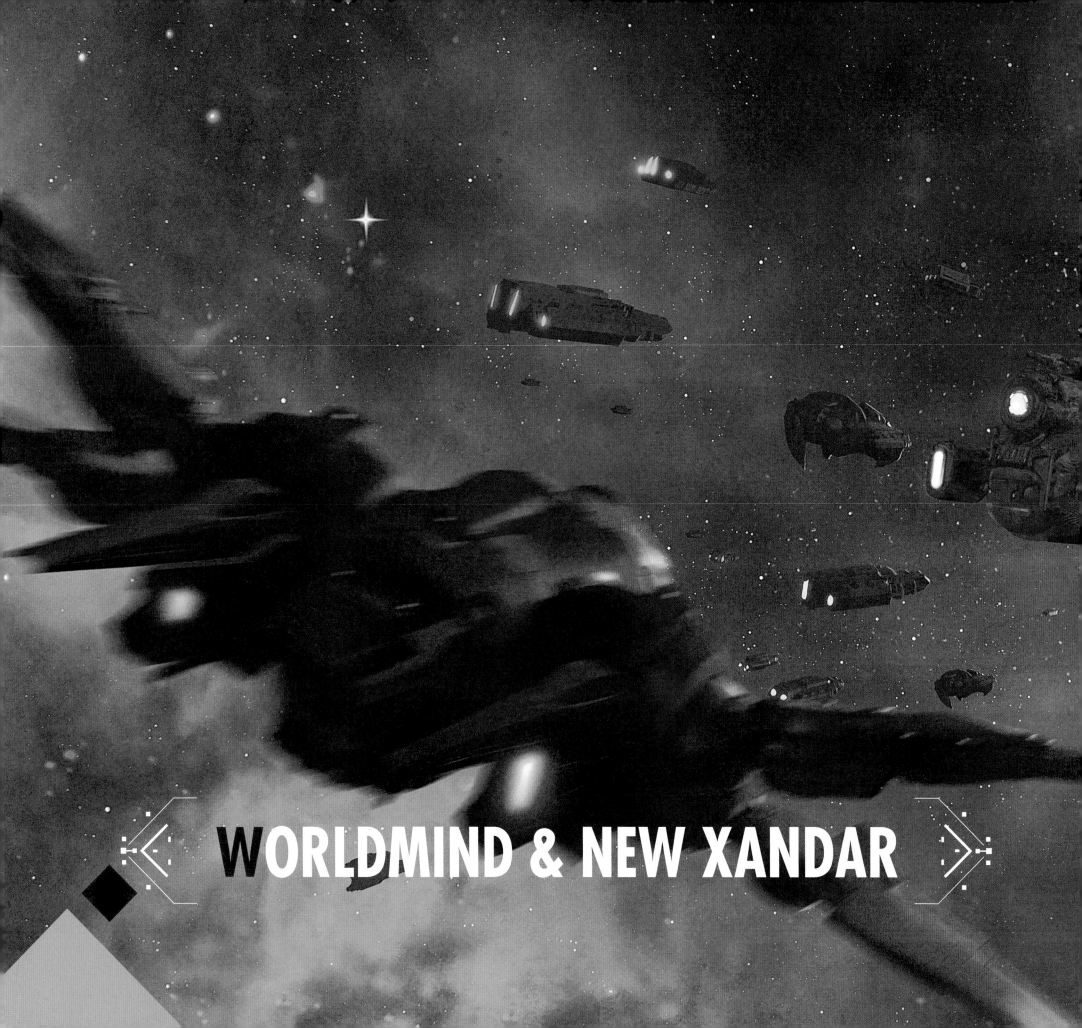

WORLDMIND & NEW XANDAR

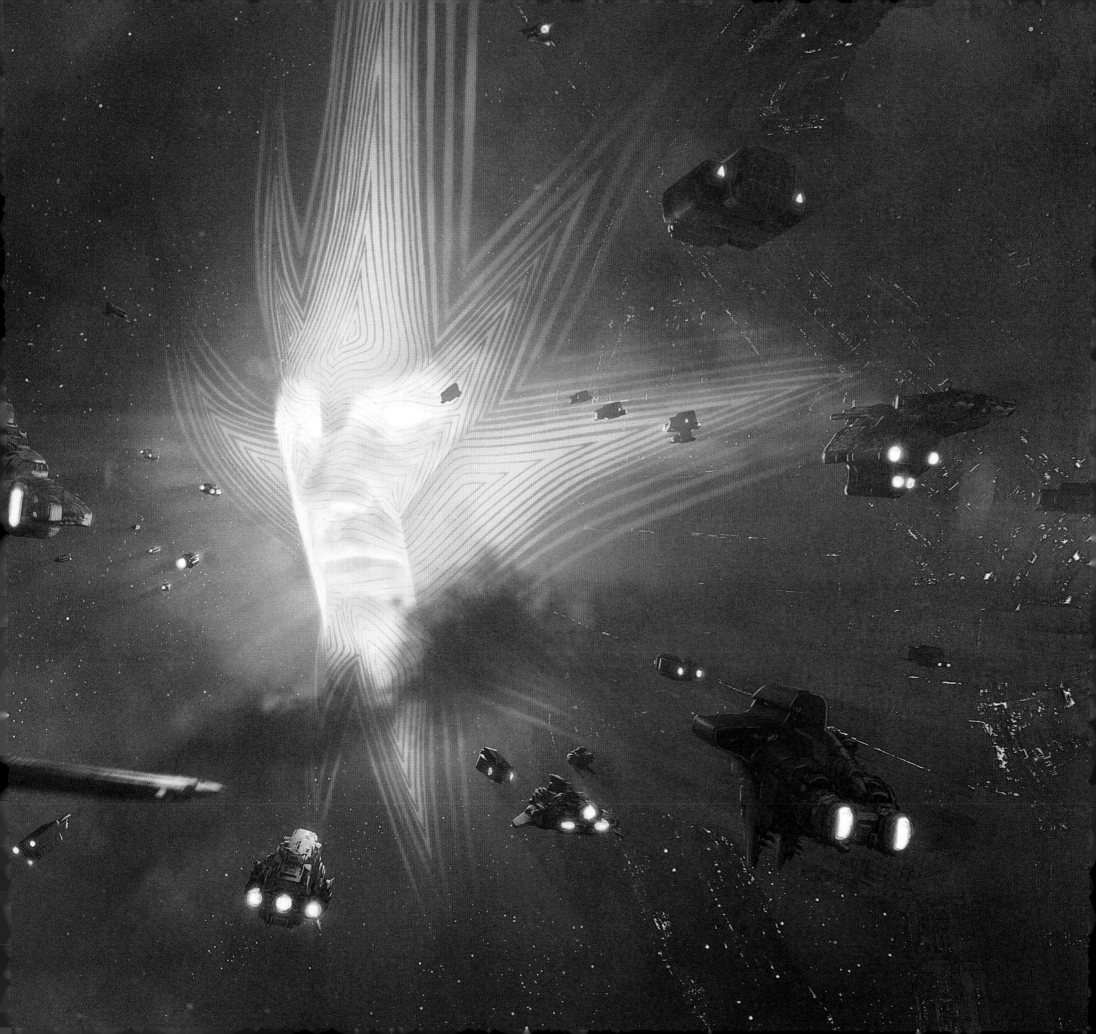

The Guardians are scrappy, capable, and expert at getting themselves out of trouble, one way or another. But sometimes, they know that the odds stacked against them are so high, they need to ask for help. The problem is, they don't always receive it.

Faced with the deceitful Promise, the ever-growing Church of Universal Truth, and the homicidal Grand Unifier Raker who wants them dead, the Guardians battle their way through the Lethal Legion to reach New Xandar and the Worldmind—leader and custodian of the Nova Force. But how do you give voice to such an entity?

Senior audio director Steve Szczepkowski explains, "The Worldmind is Nova Corp's collective consciousness, it's basically this giant head in space. I had an actress in mind for the voice of the Worldmind, but then I thought it would be really cool if we could hear a *collection* of voices, so at times, the Worldmind sounds female and at others, it sounds male. As a test to see if this would work, I recorded the seventy-five lines of dialogue using my voice, being careful to match the actress's cadence. I then blended them together, so we had them running parallel with each other. That way, we got the effect of our two voices weaving in and out of each other."

THIS SPREAD: When Nova Corp realize the sheer size of the forces ranged against them, they cut their losses and run—exposing to all that they were never all that powerful in the first place.

RIGHT: Another Easter Egg for avid Marvel fans in the form of Captain Glory.

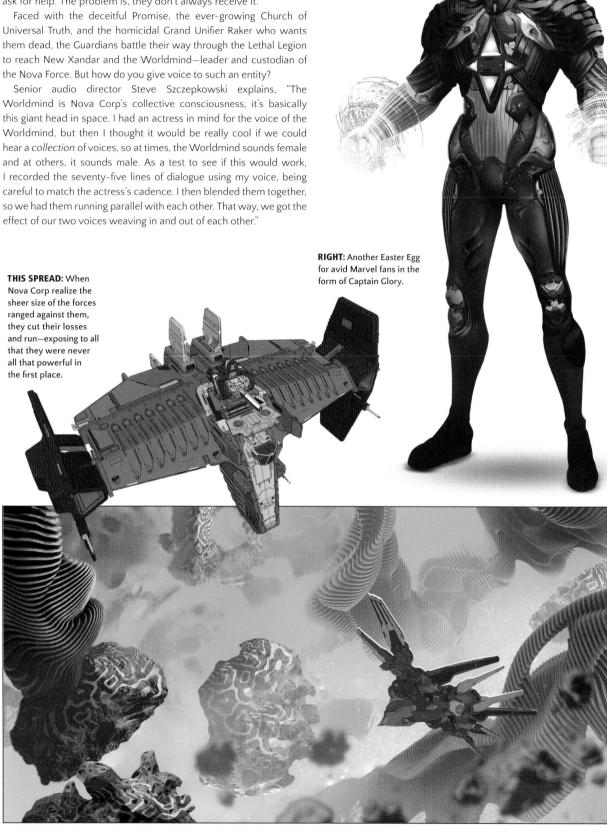

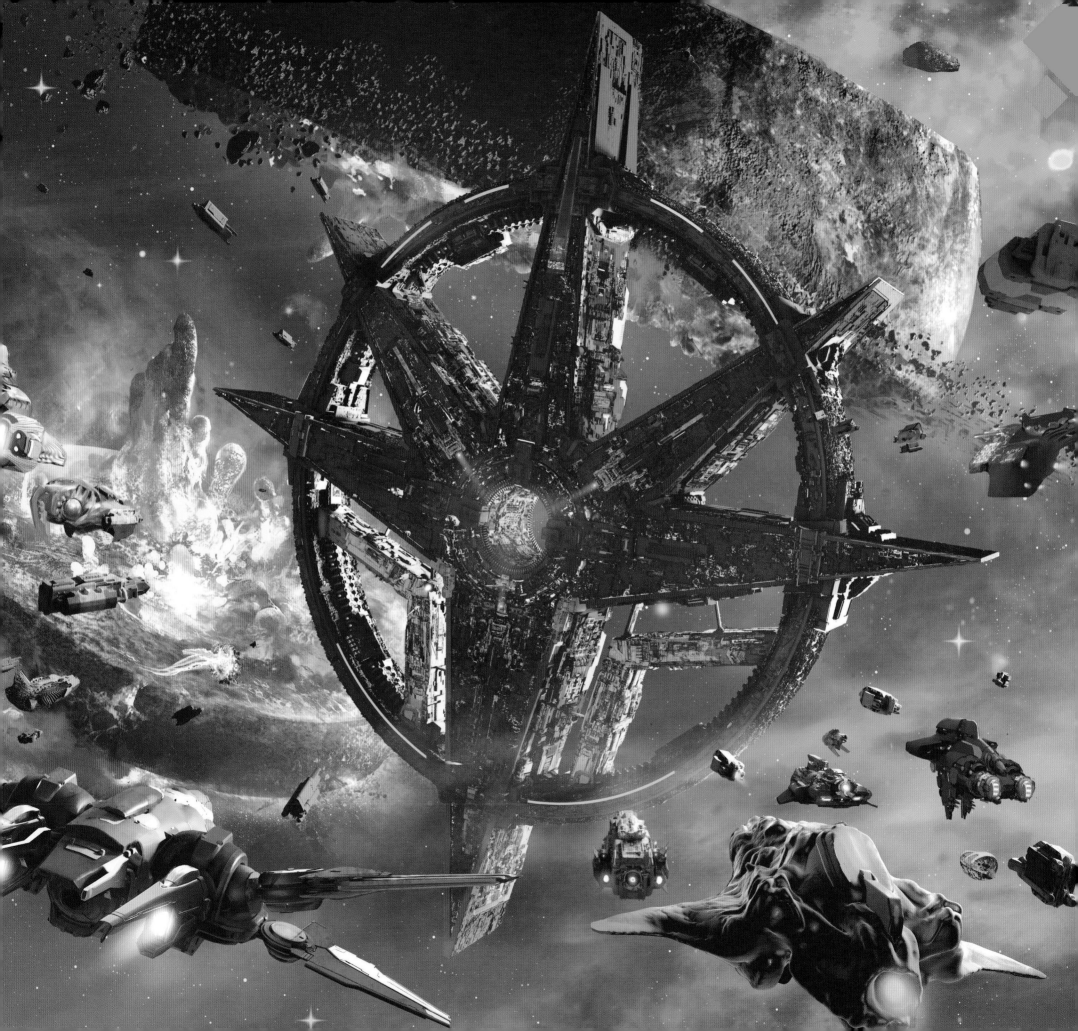

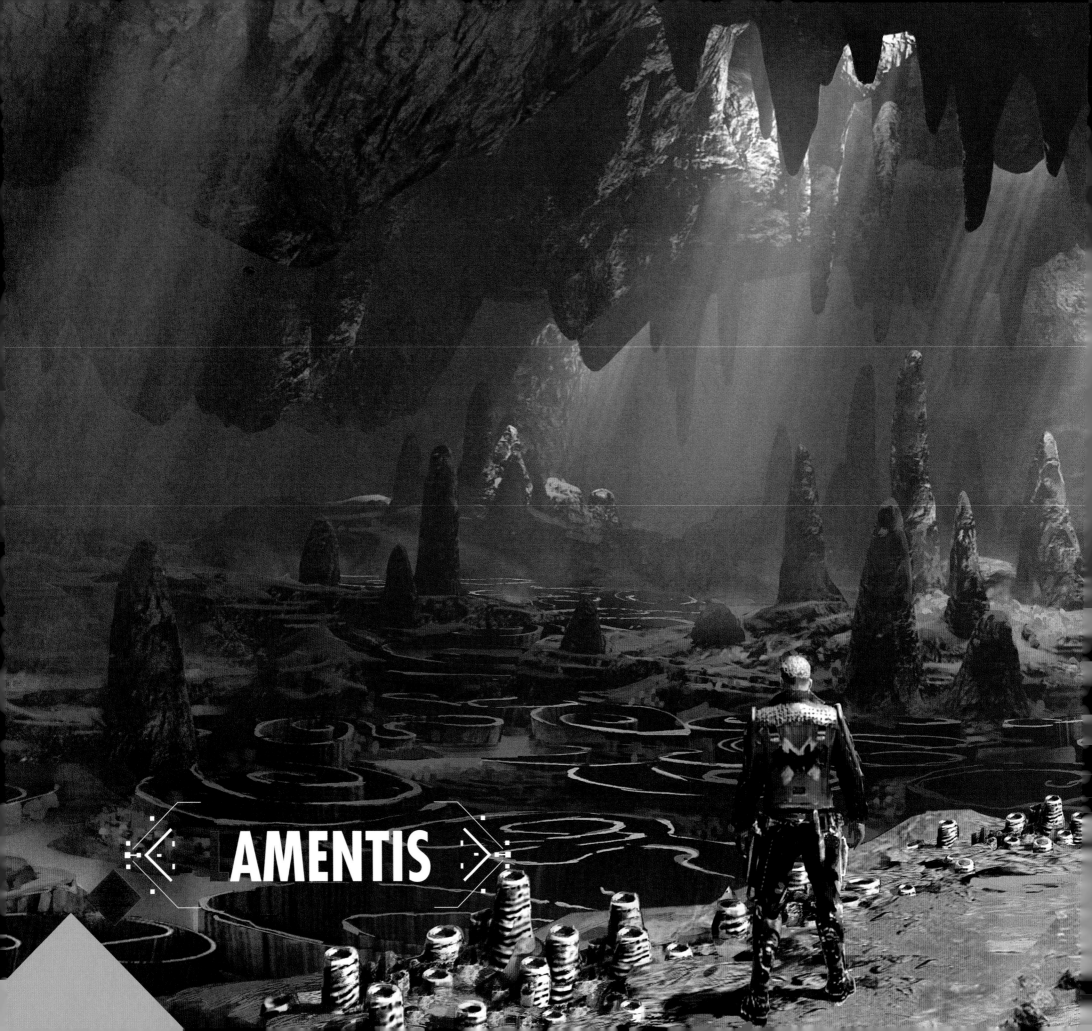

AMENTIS

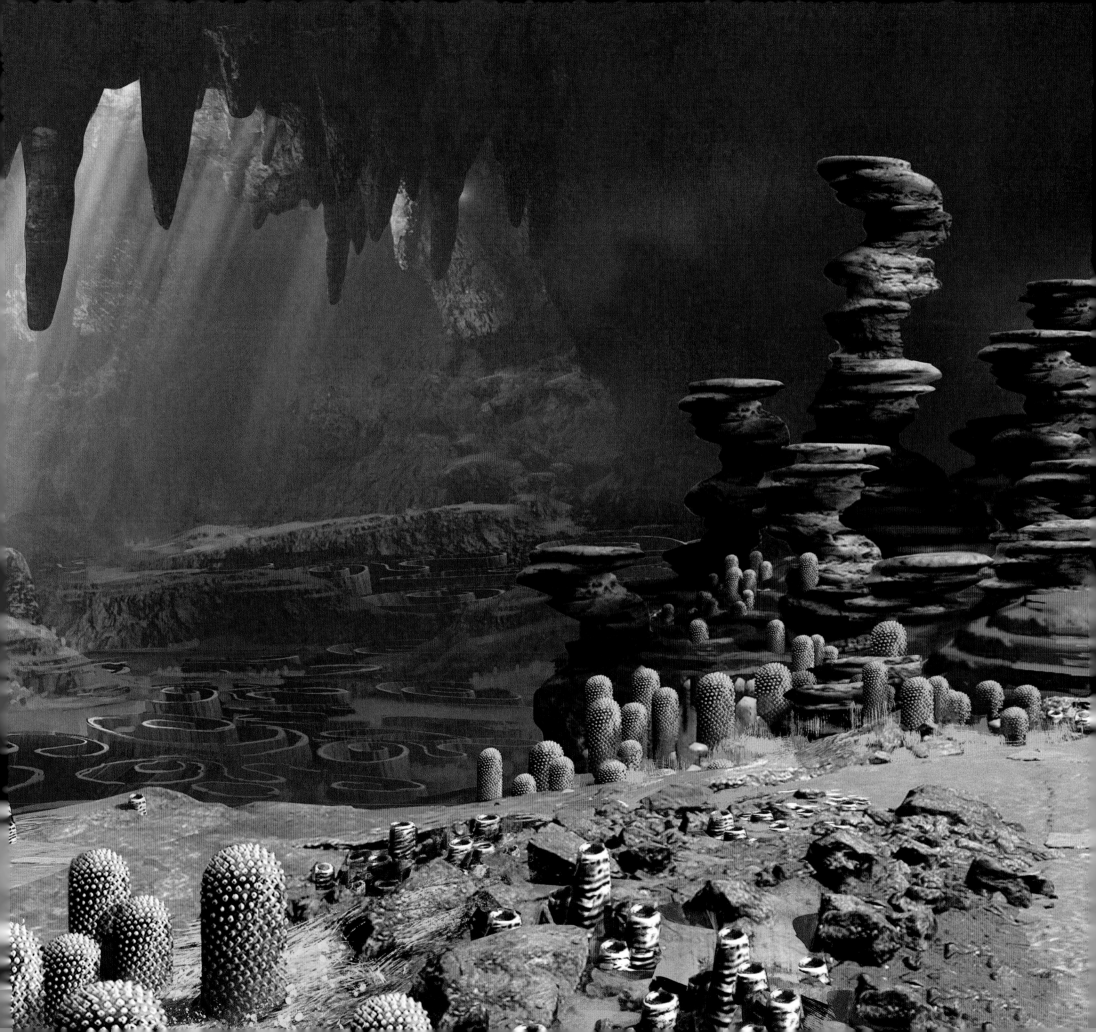

MANTIS

The Guardians of the Galaxy made their first comic book appearance in *Marvel Super-Heroes* #18 in 1969, but the team most people recognize as the Guardians today first appeared in *Annihilation: Conquest* #6 in 2008. The Guardians comics have many fans, but it's fair to say that before the MCU movies, they were not as well known in popular culture as, say, Iron Man, the Hulk, or Spider-Man.

Eidos-Montréal was aware of this and wanted to include some characters in their game that most people would recognize—aside from the Guardians themselves. Mantis, who appears in *Guardians of the Galaxy: Vol 2* (2017), was an obvious choice. "Mantis is a beloved MCU character," senior creative director Jean-François Dugas says. "We wanted to include her because we have quite a lot of obscure characters that most people may never have heard of, but she's well known and recognizable."

However, it was decided not to follow the Mantis character who stars in the movie. "We wanted to go back to how she is in the comic books: smart, confused, scary, a bit like a punky teenager," Dugas continues. "She sees the universe through different lenses than the rest of us, so when she speaks, it might sound like she's crazy, but it actually makes a lot of sense. We wanted the character's charisma and humor to come from this. She brings light to the game—she's smart, full of energy and spirit, hard to understand yet lovable."

Gamora actor Kimberly-Sue Murray concurs, "Mantis can see the futures as they could potentially happen, but she never knows *which* one will happen. So she has a gift of knowing the futures, but also an uncertainty of *Yeah, but which one?* She's like the sixth member of the Guardians. She's so different to us and she brings a lot of levity."

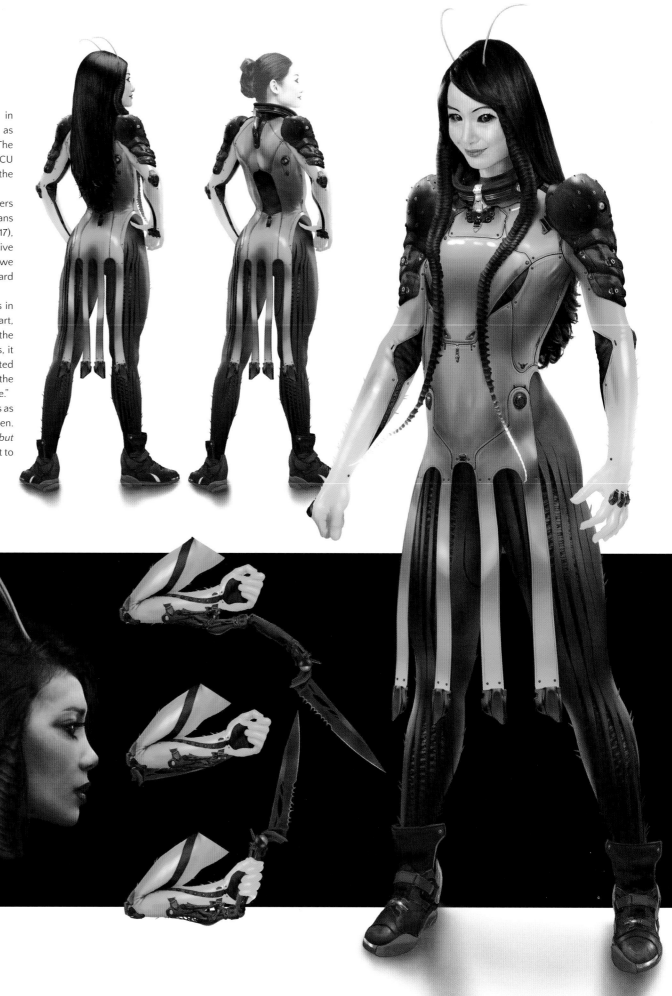

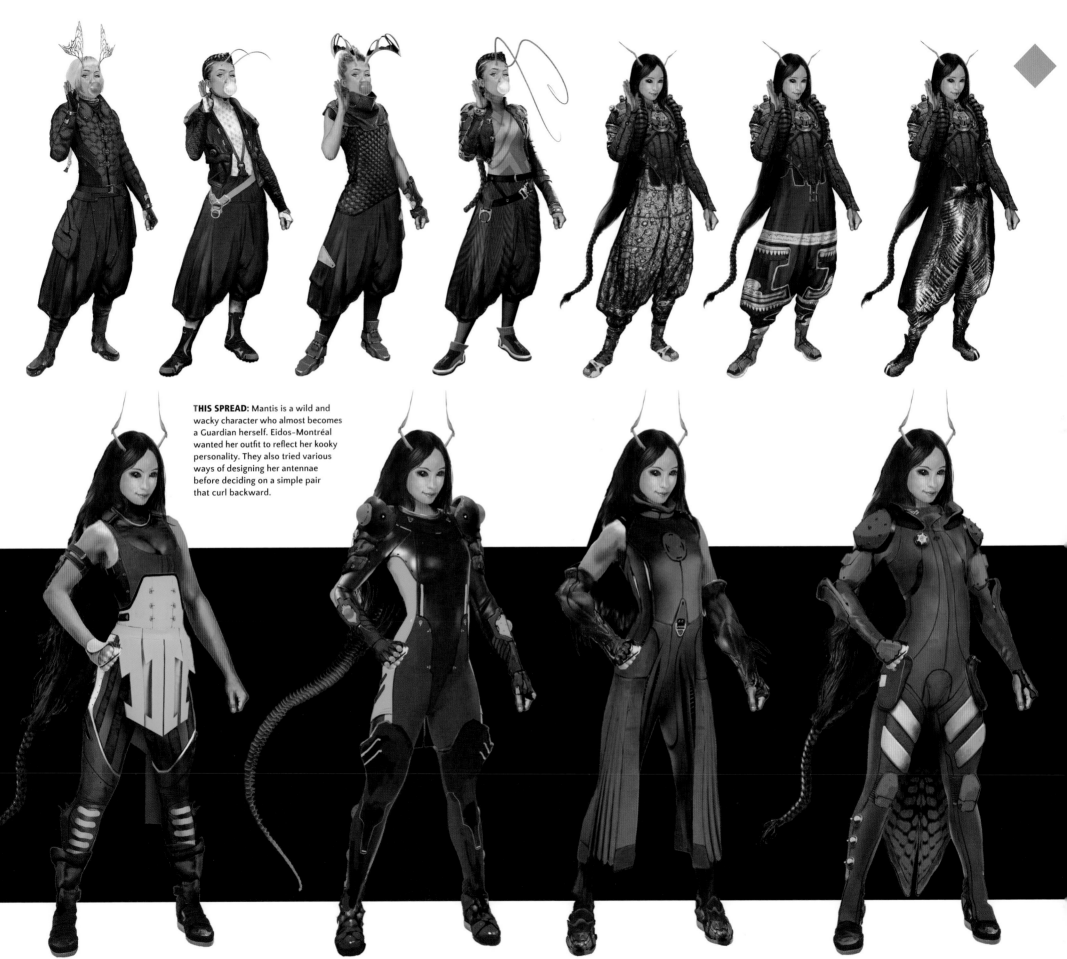

THIS SPREAD: Mantis is a wild and wacky character who almost becomes a Guardian herself. Eidos-Montréal wanted her outfit to reflect her kooky personality. They also tried various ways of designing her antennae before deciding on a simple pair that curl backward.

ADAM WARLOCK

Adam Warlock sits at the center of the story and is an essential part of Grand Unifier Raker's infernal plan, but it would be wrong to call him a villain. He is a man (or a god?) of mysterious origins who, during the height of the Galactic War, drew on the power of the soul stone embedded in his forehead to remove people's suffering and pain, and literally take away their grief. Raker, who was himself suffering from the devastating loss of his son, recognized the value of what Warlock could do and forged a quasi-religious organization around him.

"Adam Warlock is considered to be almost a god from another dimension," concept artist Frederic Bennett explains of this most mysterious and ambiguous character. "He has golden skin and hair, which has influenced the look of the Church of Universal Truth. Our main design goal was to make him look like something out of Norse or Greek mythology, but with a science-fiction twist."

ELOW: Adam Warlock's golden skin makes him look like he's stepped right from the pantheon of a race of ancient gods.

IGHT: The primary black color of Warlock's outfits allows the gold and red to really pop from the screen.

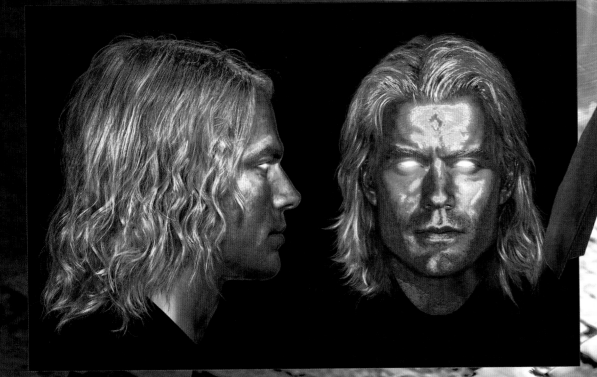

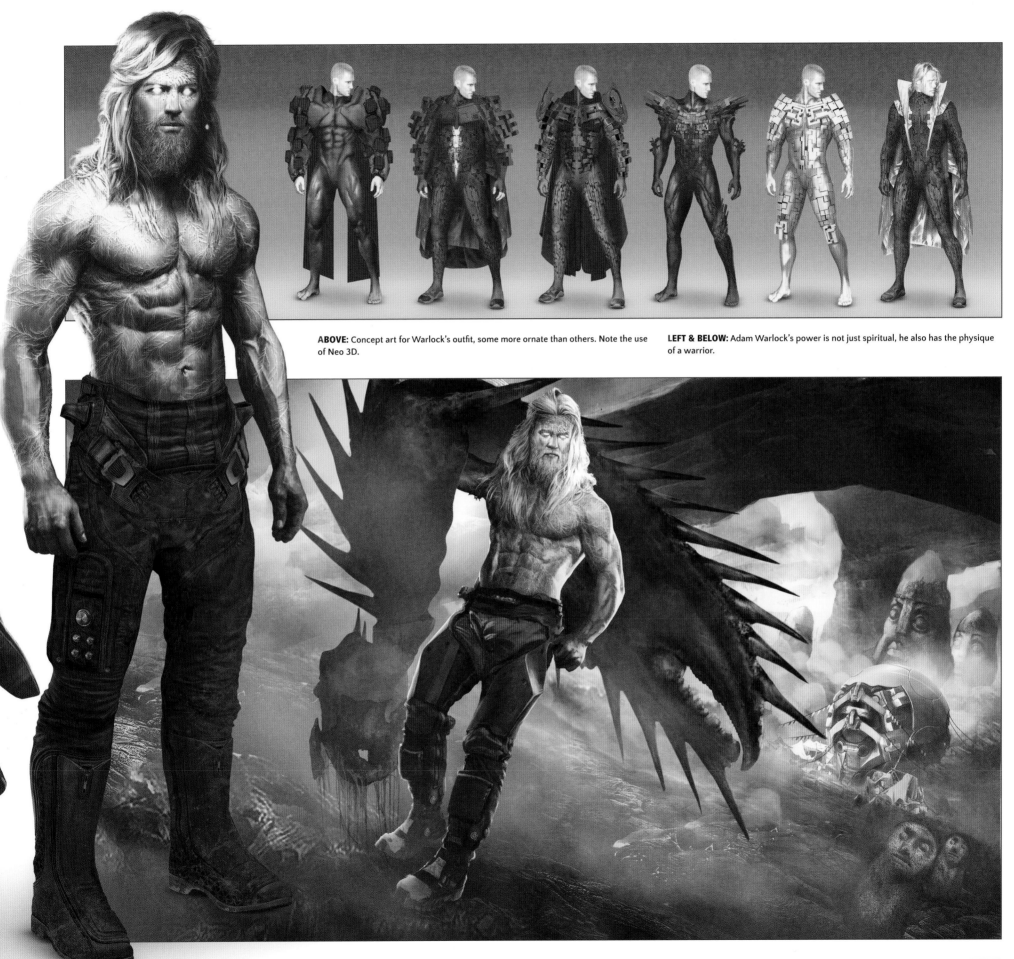

ABOVE: Concept art for Warlock's outfit, some more ornate than others. Note the use of Neo 3D.

LEFT & BELOW: Adam Warlock's power is not just spiritual, he also has the physique of a warrior.

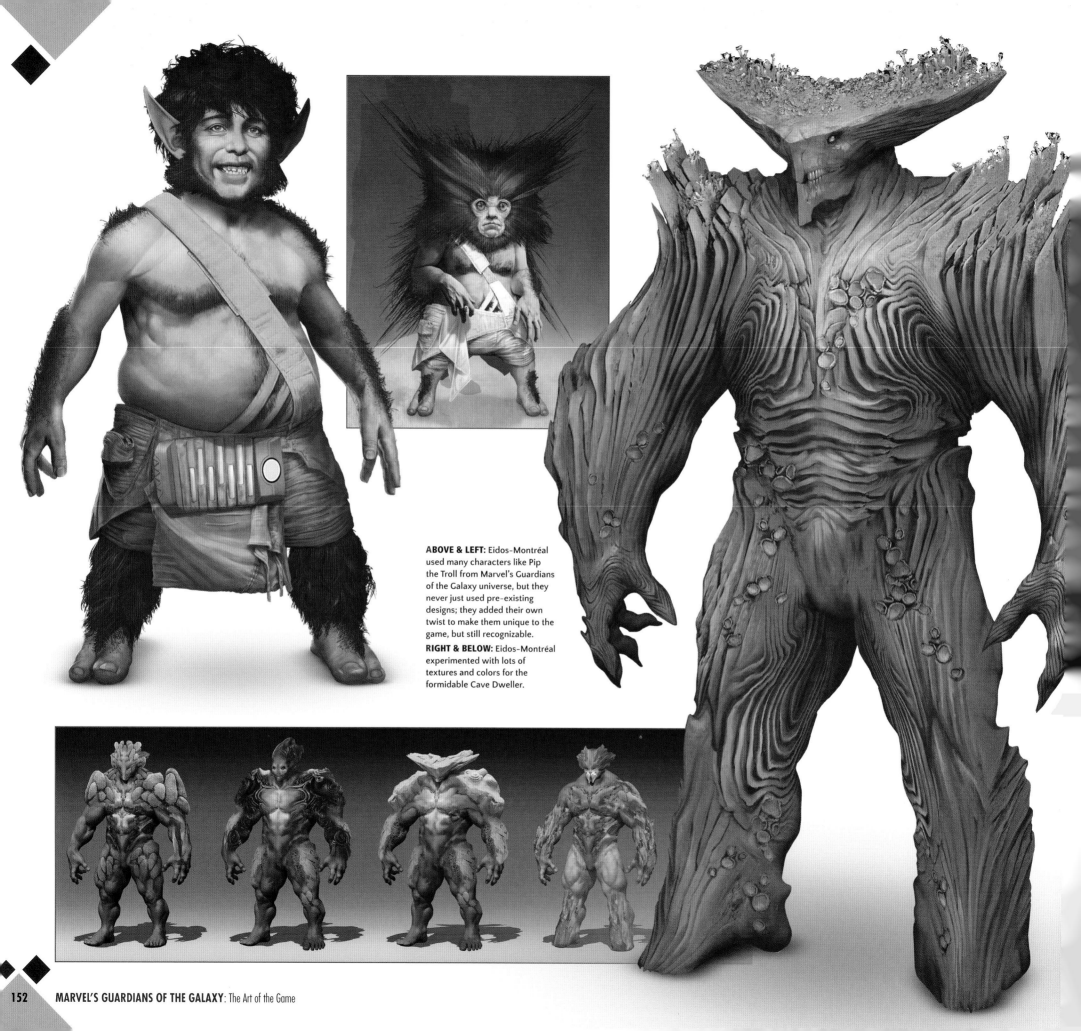

ABOVE & LEFT: Eidos-Montréal used many characters like Pip the Troll from Marvel's Guardians of the Galaxy universe, but they never just used pre-existing designs; they added their own twist to make them unique to the game, but still recognizable.

RIGHT & BELOW: Eidos-Montréal experimented with lots of textures and colors for the formidable Cave Dweller.

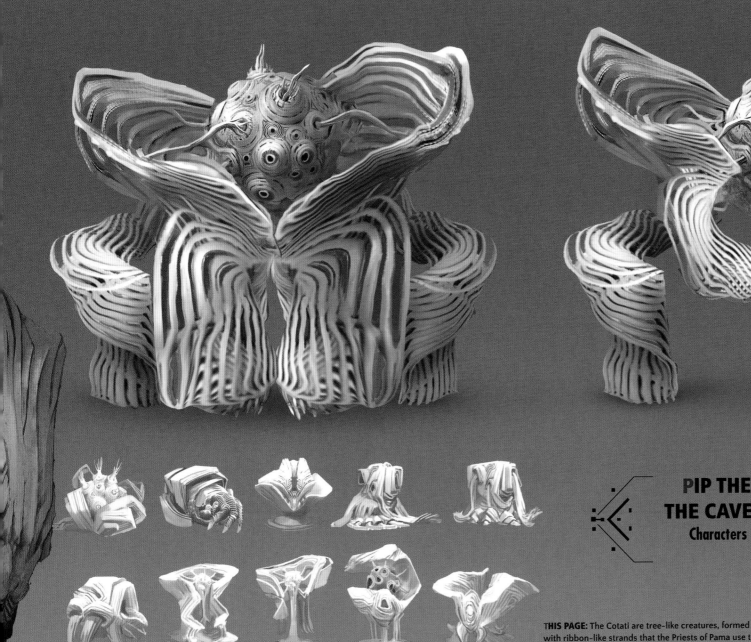

PIP THE TROLL, LAMENTIS
THE CAVE DWELLER & COTATI
Characters and semi-plant lifeforms that
live on Lamentis

THIS PAGE: The Cotati are tree-like creatures, formed with ribbon-like strands that the Priests of Pama use to make their clothes.

Strong stories—ones that stick with the audience—always have an underlying theme. "We explore parenthood," says executive narrative director Mary DeMarle. "Peter has to grow up and become a parent to his team, as well as the child [Nikki] who might be his. It's a story about what families can be. Is it our biological family? Or the family we make along our way through life? And how do we cope with family relationships, especially in the wake of tragedy? How do we learn how to heal, and how much of a role does family have in that healing process? When I consider all this stuff, I think, *Wow, that's huge—I can't believe we tried that!*"

Animation director Darryl Purdy considers how this theme relates directly to Peter, "In the early part of the game, Peter is reckless and constantly doing things by the seat of his pants. Now, this is fun and entertaining, but it also has consequences. This

game is something of a coming-of-age story for him, in that he has to learn how to be a responsible leader to the four other members in his team.

"What's interesting is that our story's themes of parenthood, responsibility, and growing up haven't changed much since the game's conception—they were all there from the start. Certain scenes and nuances have changed, yes, but those themes remained as a touchstone throughout the whole project. This doesn't surprise me because the idea of being responsible for somebody else's life is a powerful and universal human experience, and a great foundation for any story."

Growing up and parenthood were not the only themes, as DeMarle thoughtfully explains, "Another big theme is grief. Some of that came from my personal life—several years ago, both my parents died within a month of each other. I really wanted to explore grief, while remembering

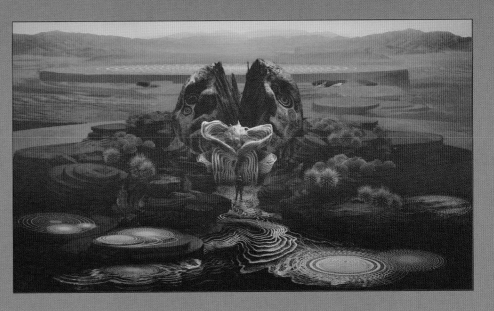

that this is a Guardians of the Galaxy game and it should also be lighthearted."

"We explore that hard subject in ways that are sometimes fun, and other times emotional," senior creative director Jean-François Dugas agrees. "How do we cope when we lose someone we love? How do we find new friends or family? Mary lost both parents in quick succession, so this theme spoke to her emotionally. Our challenge at Eidos-Montréal was to talk about serious things with sensitivity, while keeping the tone fun, lighthearted, and part of a great big adventure.

"All of our Guardians are trying to deal with grief. Peter lost his mother and never really had a family; Gamora was kidnapped and subjected to psychological and physical violence; Drax lost his daughter and wife; Rocket is a lost soul created in a lab; and Groot is the sole survivor of a destroyed planet. These grieving characters are all looking for a family."

All this gave the actors plenty to work with. "I went through something similar [to Drax's loss]," Jason Cavalier says. "I lost my father in 2009, and we were very close. I thank the stars that I had that kind of relationship with my father—he was my

THIS PAGE: The Priests of Pama wear simple clothing to reflect their life of quiet reflection. The white tubes that make up their outfits are taken from the trees found on Lamentis. This shows yet again, how much care and attention Eidos-Montréal took in making sure there are lots of logical connections between characters, their outfits, and their environments.

PRIESTS OF PAMA
An offshoot of the Kree civilization who settled on Lamentis to become monks

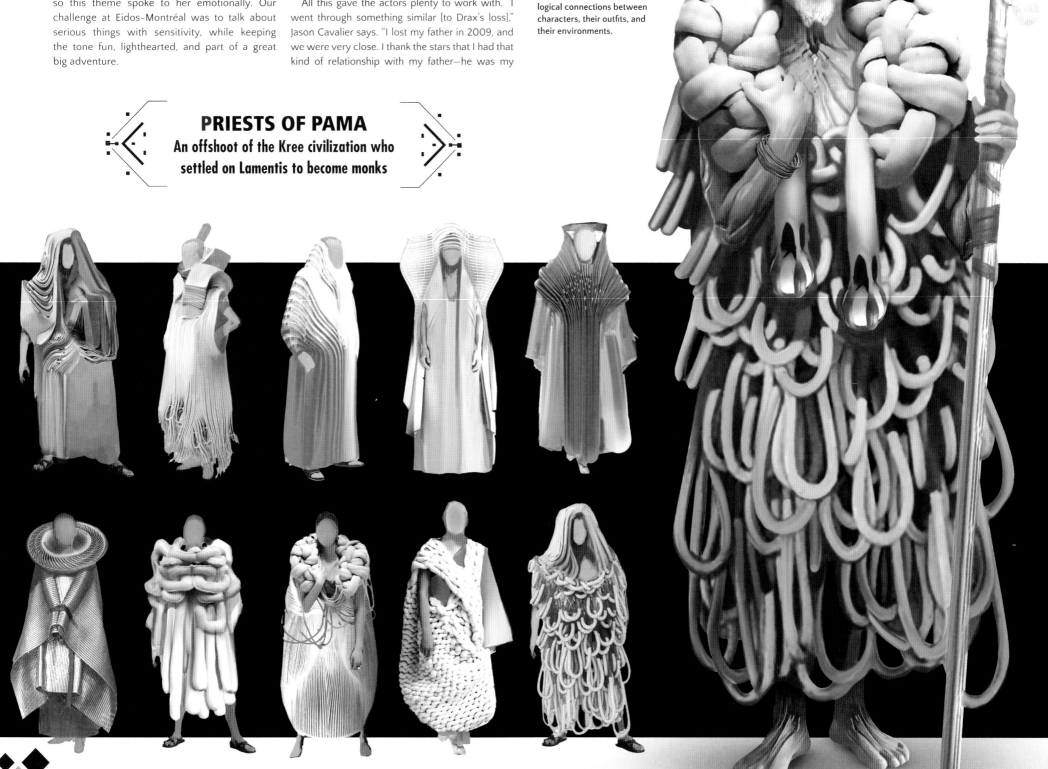

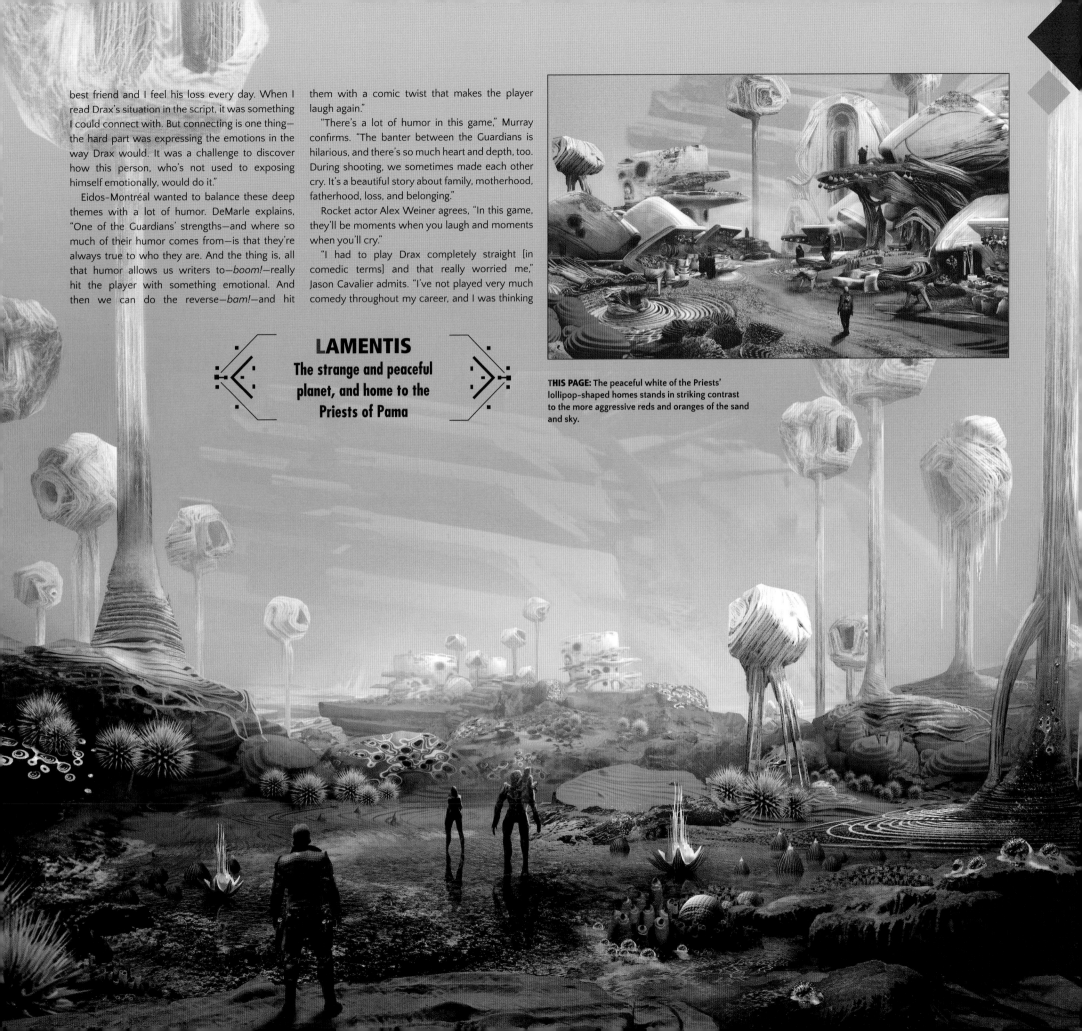

best friend and I feel his loss every day. When I read Drax's situation in the script, it was something I could connect with. But connecting is one thing—the hard part was expressing the emotions in the way Drax would. It was a challenge to discover how this person, who's not used to exposing himself emotionally, would do it."

Eidos-Montréal wanted to balance these deep themes with a lot of humor. DeMarle explains, "One of the Guardians' strengths—and where so much of their humor comes from—is that they're always true to who they are. And the thing is, all that humor allows us writers to—boom!—really hit the player with something emotional. And then we can do the reverse—bam!—and hit

them with a comic twist that makes the player laugh again."

"There's a lot of humor in this game," Murray confirms. "The banter between the Guardians is hilarious, and there's so much heart and depth, too. During shooting, we sometimes made each other cry. It's a beautiful story about family, motherhood, fatherhood, loss, and belonging."

Rocket actor Alex Weiner agrees, "In this game, they'll be moments when you laugh and moments when you'll cry."

"I had to play Drax completely straight [in comedic terms] and that really worried me," Jason Cavalier admits. "I've not played very much comedy throughout my career, and I was thinking

LAMENTIS
The strange and peaceful planet, and home to the Priests of Pama

THIS PAGE: The peaceful white of the Priests' lollipop-shaped homes stands in striking contrast to the more aggressive reds and oranges of the sand and sky.

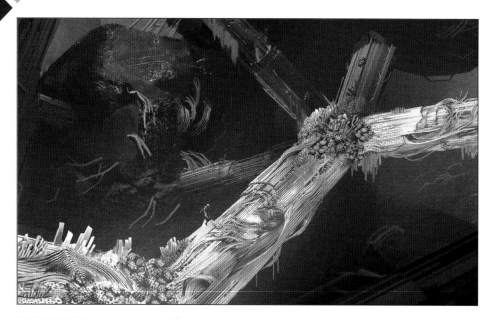

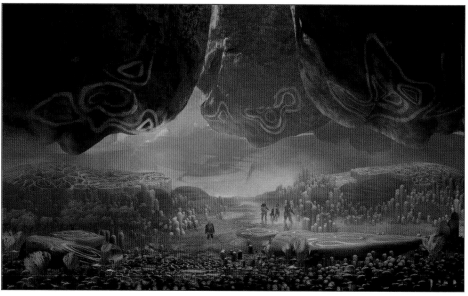

ABOVE & BELOW: There's another world beneath the surface of Lamentis, formed from rock and crystal, and cut through with foaming rivers.

ABOVE: The fiery orange atmosphere and epic natural architecture give this space an awesome aspect.

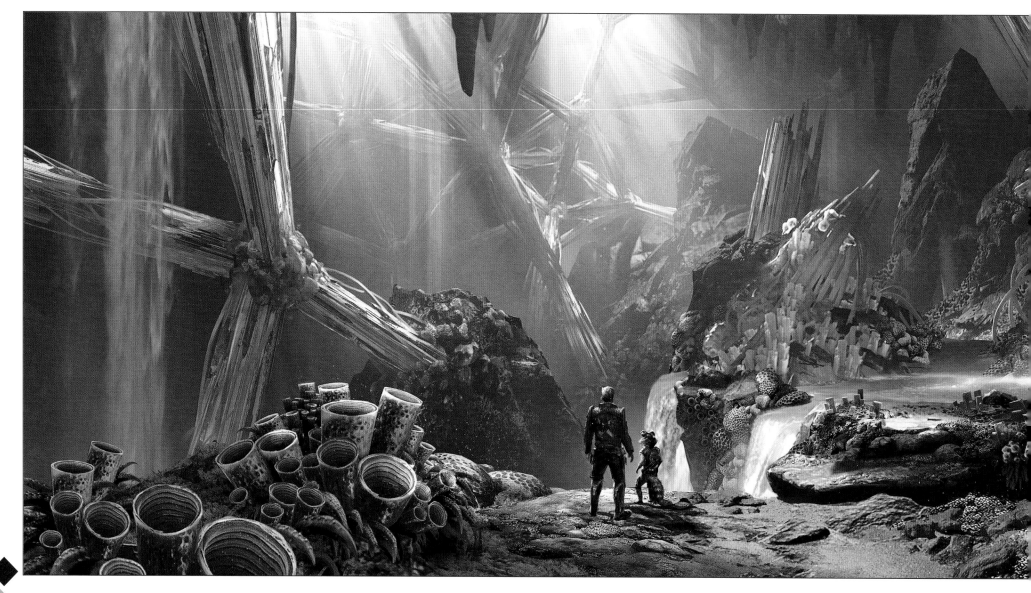

about how my character has to get laughs. The only thing I knew for sure was that I couldn't *look* for the laugh—it had to happen naturally. It was often the timing that determined whether a line was funny or not, and sometimes getting a laugh came down to how long it took Drax to respond [to a situation or question]. I can't say that I always hit the mark—better comic actors than I am might have nailed every single one—but I hit a few of them."

"If I was to sum up our game in one word," says Purdy, "I would choose 'wacky.' I believe we've found the sweet spot for the tone. There's such a lot of humor—I don't know if players are going to be prepared for just how funny the game is and how *weird* it gets. I really hope it resonates with the audience."

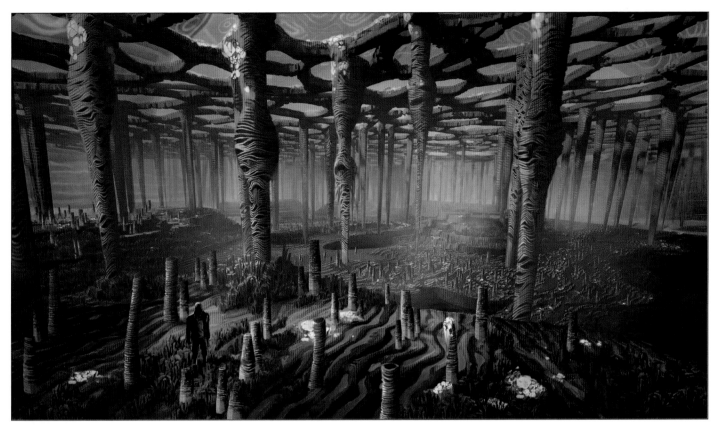

THIS PAGE: Remnants of the first Kree-inspired civilization are visible beneath the surface of Lamentis, before its citizens changed their outlook centuries ago and became the Priests of Pama.

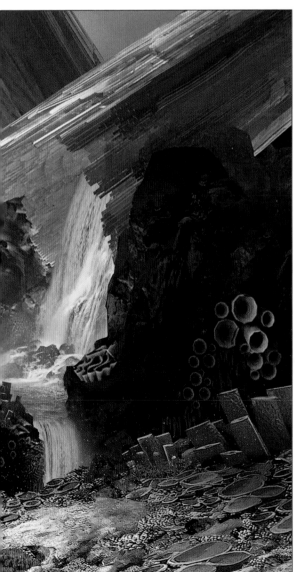

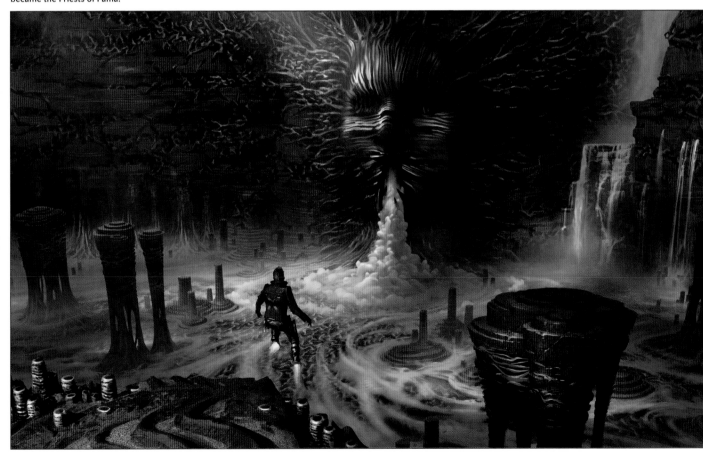

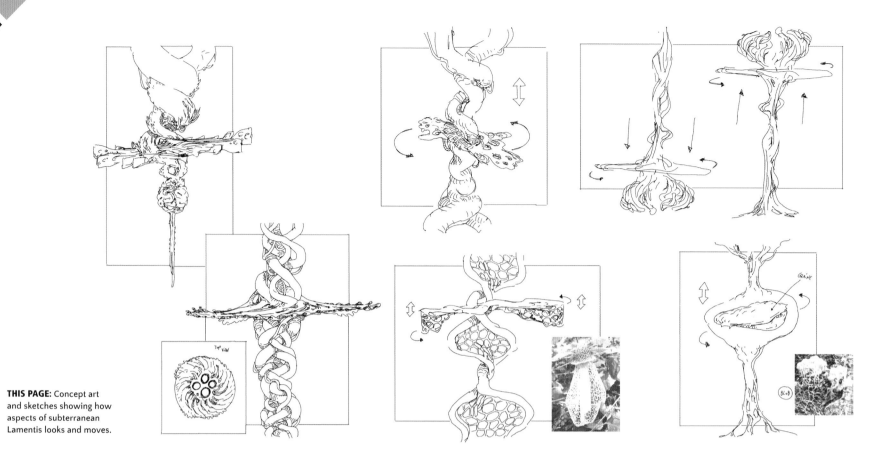

THIS PAGE: Concept art and sketches showing how aspects of subterranean Lamentis looks and moves.

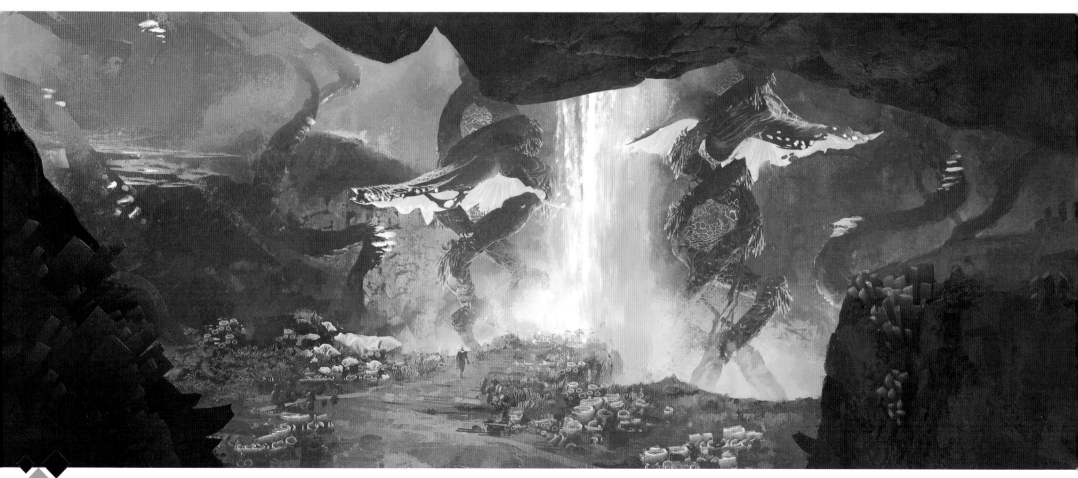

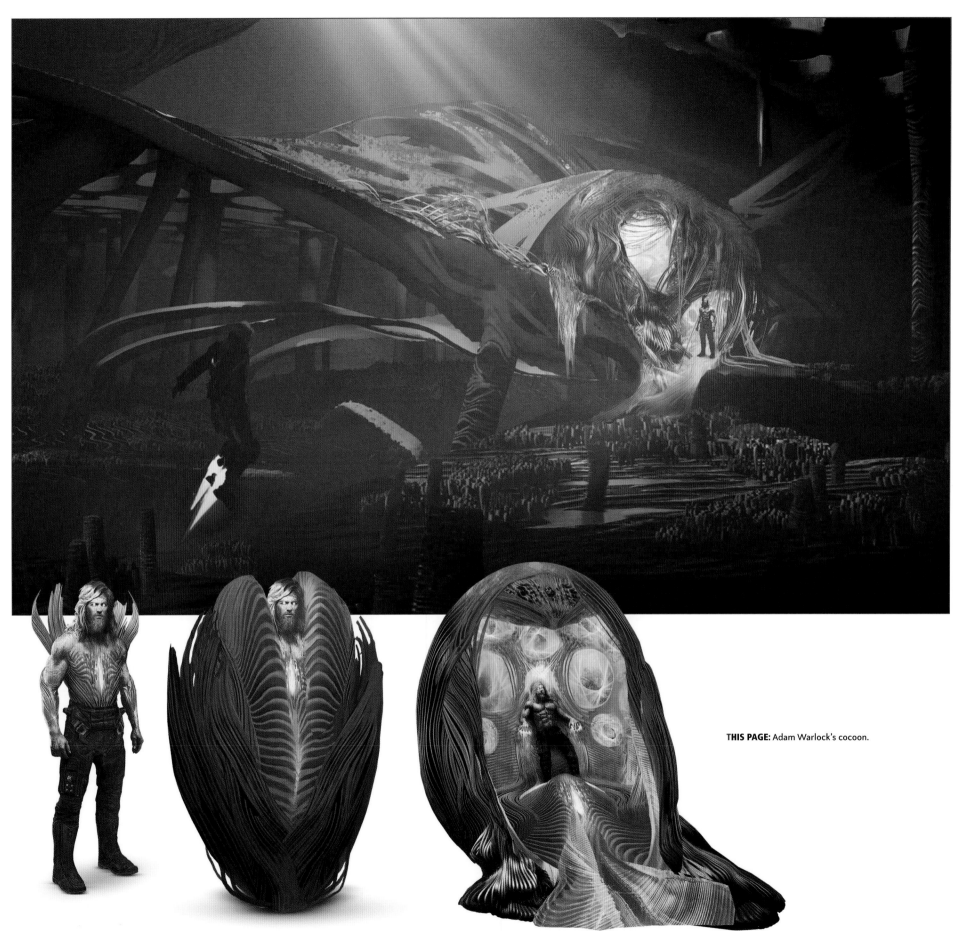

THIS PAGE: Adam Warlock's cocoon.

ATATH

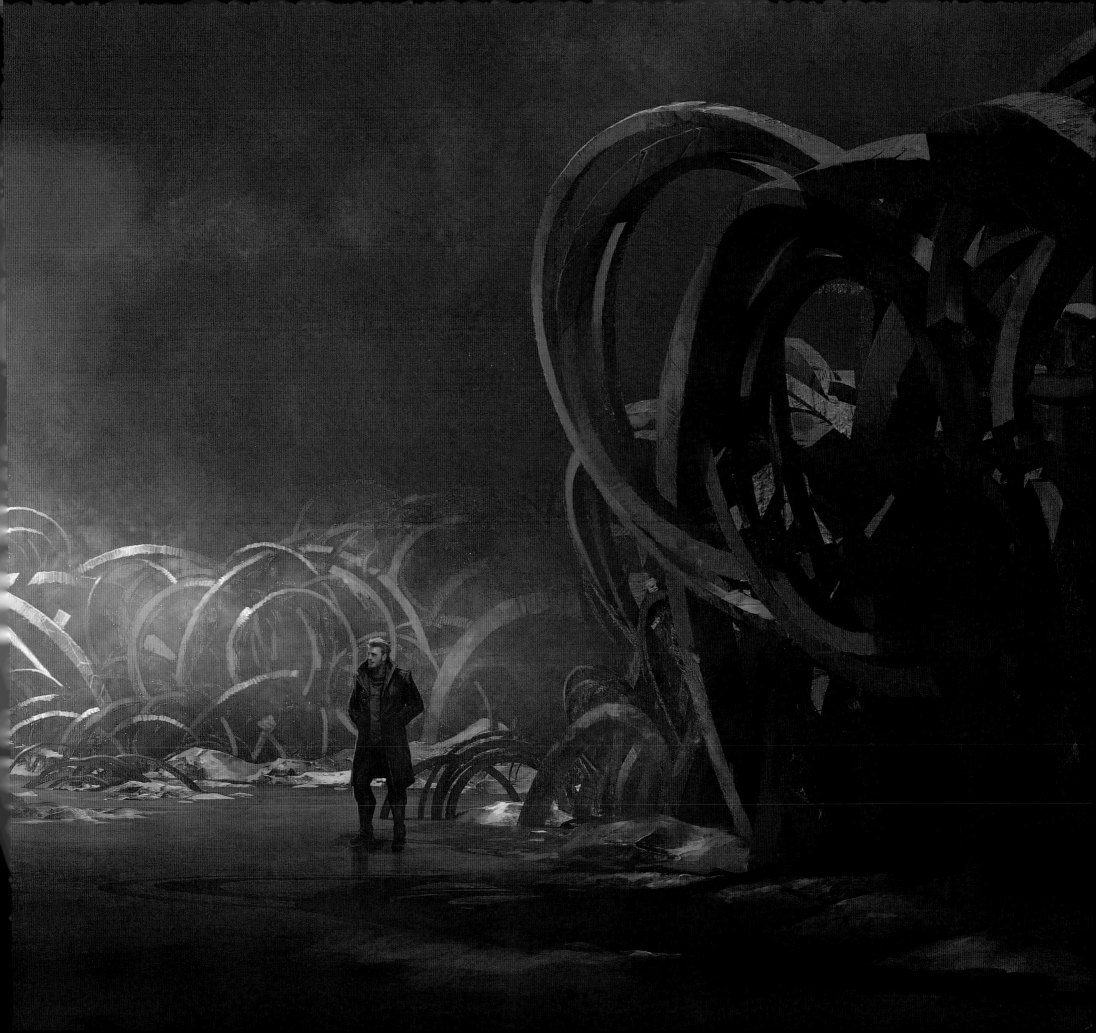

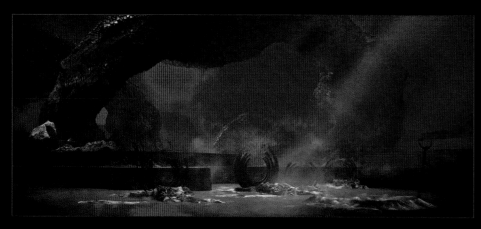

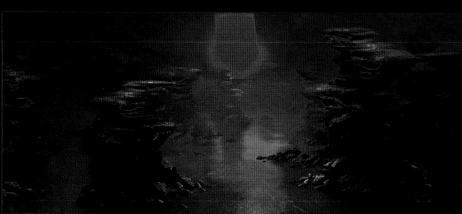

It was important to Marvel and Eidos-Montréal to ensure that each Guardian had a strong role in the game and their own story arc. This led to some very special scenes. "During the game, an entity possesses Drax and offers him a chance to be with his family again—but it's just an illusion," Drax actor Jason Cavalier says. "In the end, Drax decides to stay with the Guardians because he discovers that they're his new family. This enables him to deal with his grief—it was a challenge to play that scene and I had to rise to the occasion."

"There are so many touching scenes," Star-Lord actor Jon McLaren says. "There's a moment that Star-Lord shares with Drax. We're both looking off into space and he speaks about the loss of his family, and how it felt when they were murdered

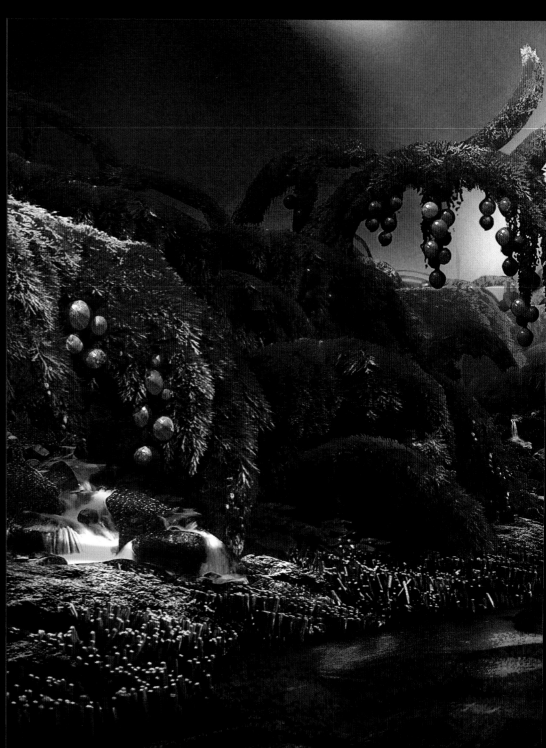

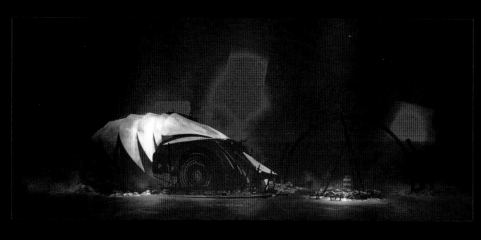

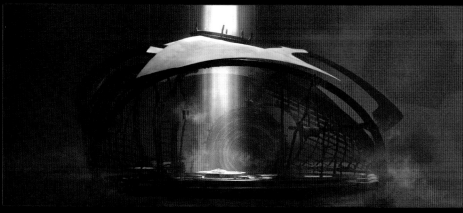

by Thanos. When performing heavy scenes like this, I'd often look around the studio and see that everyone was crying. People might assume that a game like *Marvel's Guardians of the Galaxy* is all jokes and tomfoolery, but we're also hitting the opposite end of the dramatic spectrum."

Gamora actor Kimberly-Sue Murray also remembers a dramatic moment, "There's a pivotal scene I love; it's the moment when Gamora breaks emotionally. She's fighting someone and is *really* raging, so afterward, Peter confronts her, and she basically snaps. She comes clean about Thanos, killing her sister and how it feels to be part of the Guardians after spending so long not belonging anywhere. After listening to her, the Guardians accept this part of her—but in a really funny way!

THIS SPREAD: Eidos-Montréal played around a lot with color contrasts with the aim of creating strange alien worlds, and helping the player gain an idea of what sort of environment—hostile or peaceful, busy or quiet—they were entering. This mixture of purples, blues and yellows is at first striking and beautiful, but after a while might become slightly sickly and nauseating.

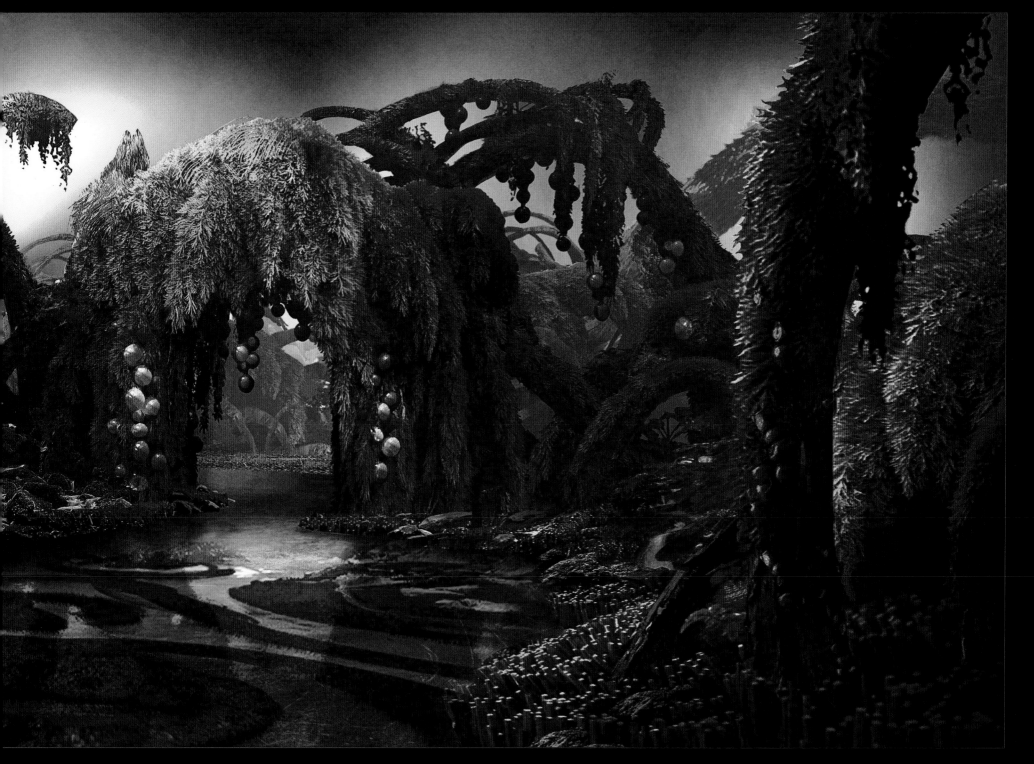

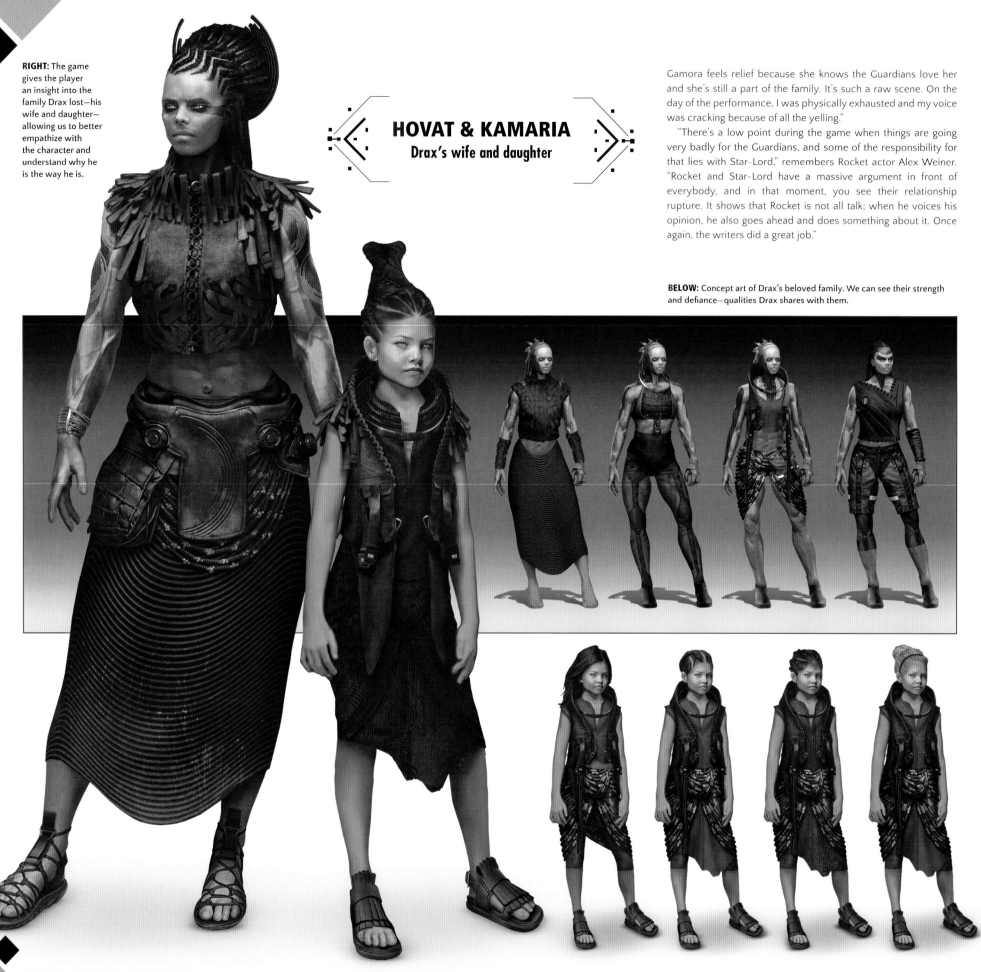

RIGHT: The game gives the player an insight into the family Drax lost—his wife and daughter— allowing us to better empathize with the character and understand why he is the way he is.

HOVAT & KAMARIA
Drax's wife and daughter

Gamora feels relief because she knows the Guardians love her and she's still a part of the family. It's such a raw scene. On the day of the performance, I was physically exhausted and my voice was cracking because of all the yelling."

"There's a low point during the game when things are going very badly for the Guardians, and some of the responsibility for that lies with Star-Lord," remembers Rocket actor Alex Weiner. "Rocket and Star-Lord have a massive argument in front of everybody, and in that moment, you see their relationship rupture. It shows that Rocket is not all talk; when he voices his opinion, he also goes ahead and does something about it. Once again, the writers did a great job."

BELOW: Concept art of Drax's beloved family. We can see their strength and defiance—qualities Drax shares with them.

Words are not always needed to be impactful; a simple gesture can make even the toughest heart break. "One of my favorite scenes is when the Guardians are inside Drax's mind, trying to save him from the Promise," remembers Groot actor Robert Montcalm. "We see Drax's most tragic memory [the death of his family], and it was extremely moving to have the group trying to pull their friend out of this dark place. I won't divulge the meaning behind the 'I am Groot' I give to Drax, but there's a moment when I open my hand and grow a flower from my palm. I've been friends with Jason [Cavalier, Drax actor] for years, and to work with him in that scene was fantastic."

Not every cherished scene was a big emotional moment. Some, such as this one chosen by Montcalm, recognize smaller beats. "It was fun to perform as these really wacky and original characters. In one scene, I, a walking talking tree, am speaking to a telepathic Soviet dog [Cosmo]... and it somehow makes perfect sense! As an actor, I was contemplating questions like, *Should I play fetch with this dog with one of my body parts?* and *What if the dog tries to pee on me?* There are so many absurd little details that I adore!"

RIGHT: With his purple skin and huge chin, Eidos-Montréal's Thanos is easily recognizable but, as always, they've put their own spin on the design.

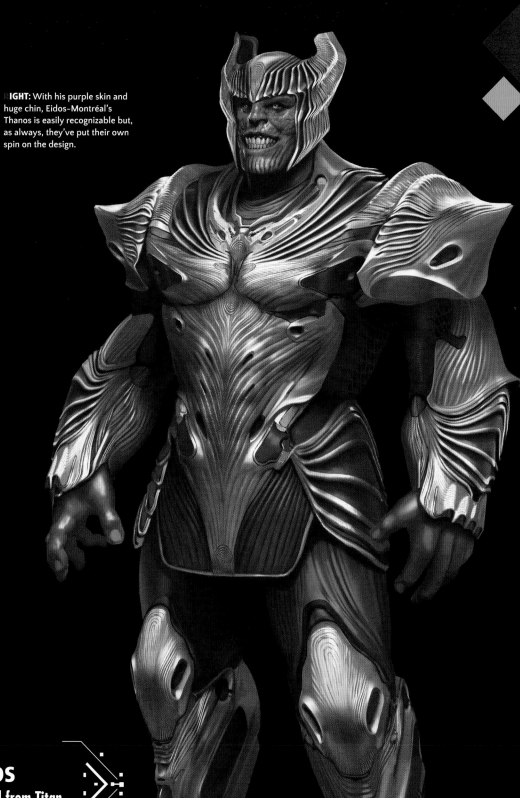

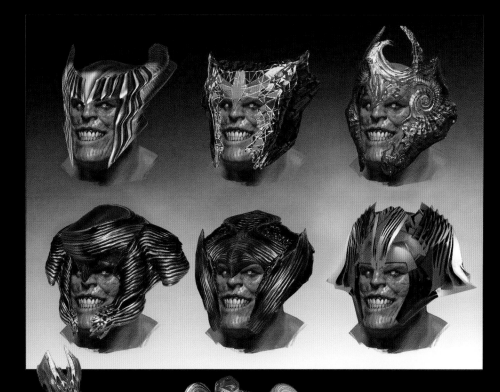

THANOS
A genocidal warlord from Titan

LEFT & ABOVE: Concept sketches for Thanos's helmet, body shape, and armor. The gold was chosen to complement the purple—both strong, regal colors.

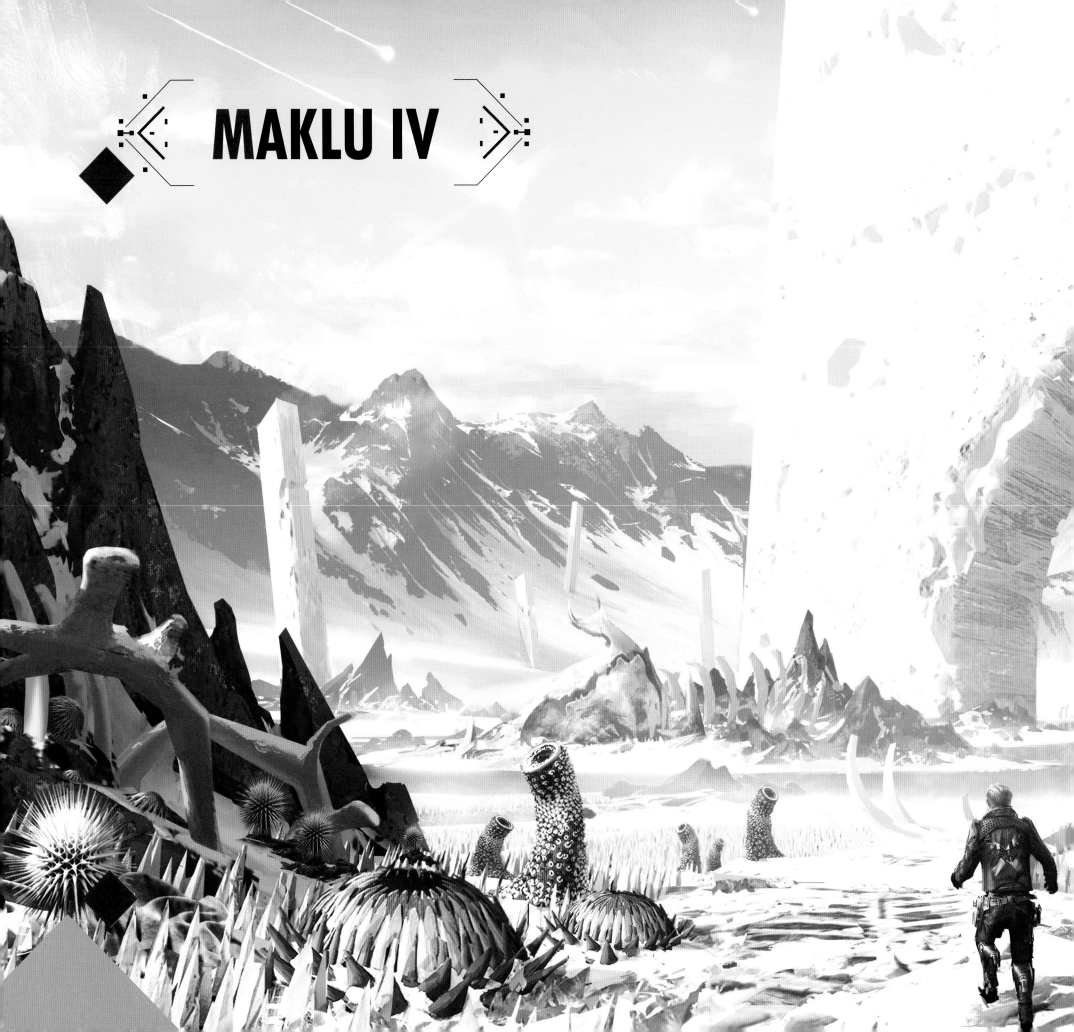

MAKLU IV

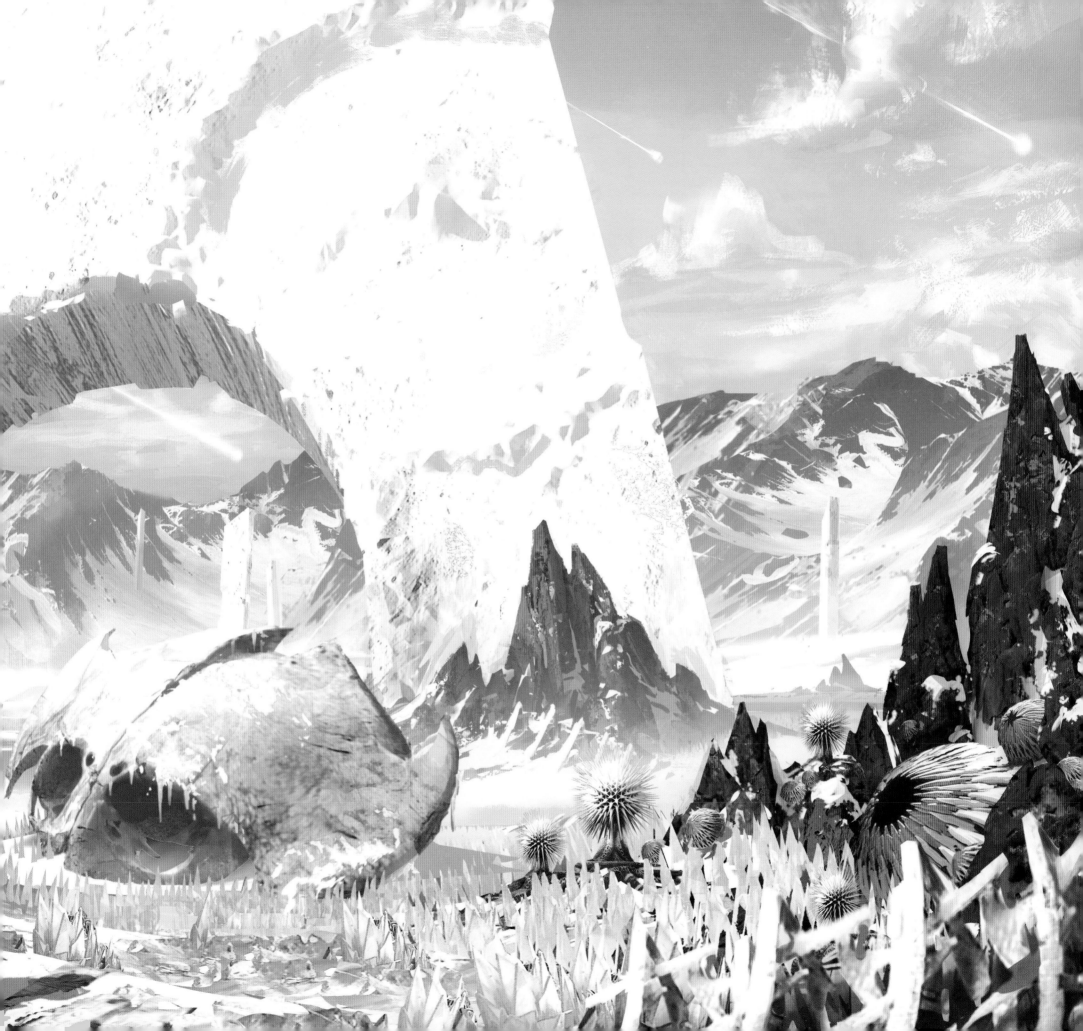

The User Interface (UI)—the HUD overlays, maps, weapon wheels, crafting pages, and so on—is a vital part of any video game. The very best UIs clearly convey all the information the player needs, are easy to navigate, and fit perfectly with the overall aesthetic and style of the game. Principal UI artist Louis Auger explains, "For the last decade, games developers have focused more on the UI as an important part of the game. For *Marvel's Guardians of the Galaxy*, I focused on making the UI pretty, fun, and with animated parts. I did the initial mock-ups for the graphic design and animation, which all had to be approved by the directors. When that happened, I passed it to the UI programmers to replicate in the game. Then we did lots of play testing to see if everything worked as it should. There was more and more focus on our department as we got near the end of the game's creation—it was like the eye of Sauron was upon us!"

Like every other aspect of the game, the UI underwent a process of change and development before the winning formula was found. Auger continues, "At one point, [senior creative director] Jean-François Dugas sat down with our department and said, 'I really don't think what you guys are doing is working. We're making a Marvel game and it's supposed to be fun and heroic, and we need to bring that into the UI.' So I met with Bruno [Gauthier-Leblanc, art director] to discuss things. We already knew the game's color scheme was going to include lots of pink and magenta, so Bruno came up with the idea that the UI should look like fancy candy. I redesigned the UI and added that aspect."

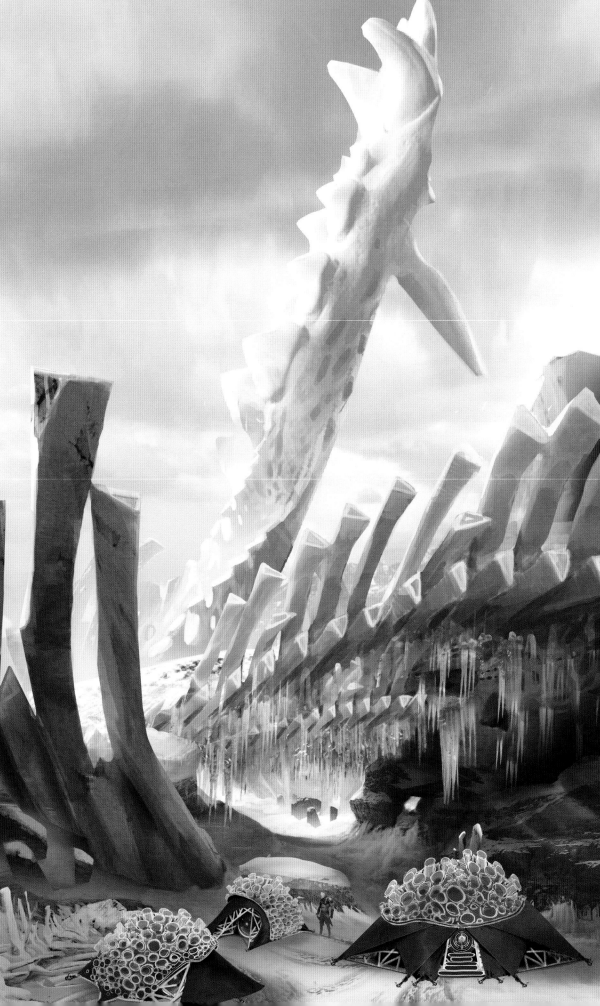

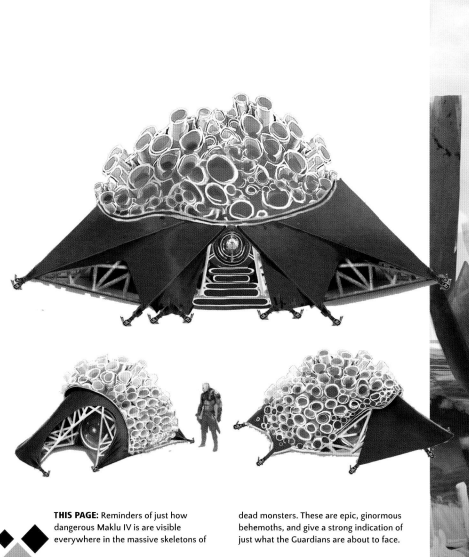

THIS PAGE: Reminders of just how dangerous Maklu IV is are visible everywhere in the massive skeletons of dead monsters. These are epic, ginormous behemoths, and give a strong indication of just what the Guardians are about to face.

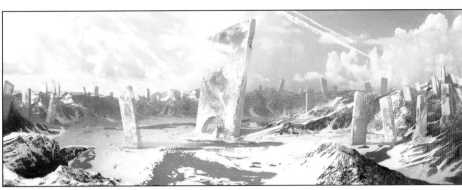

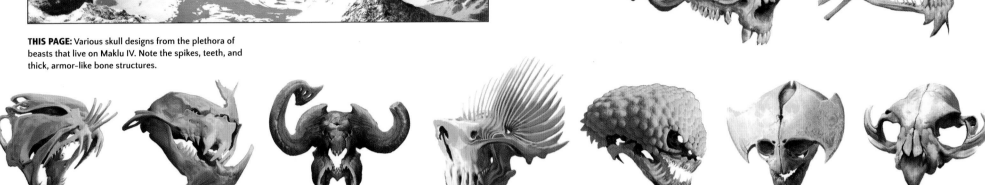

THIS PAGE: Various skull designs from the plethora of beasts that live on Maklu IV. Note the spikes, teeth, and thick, armor-like bone structures.

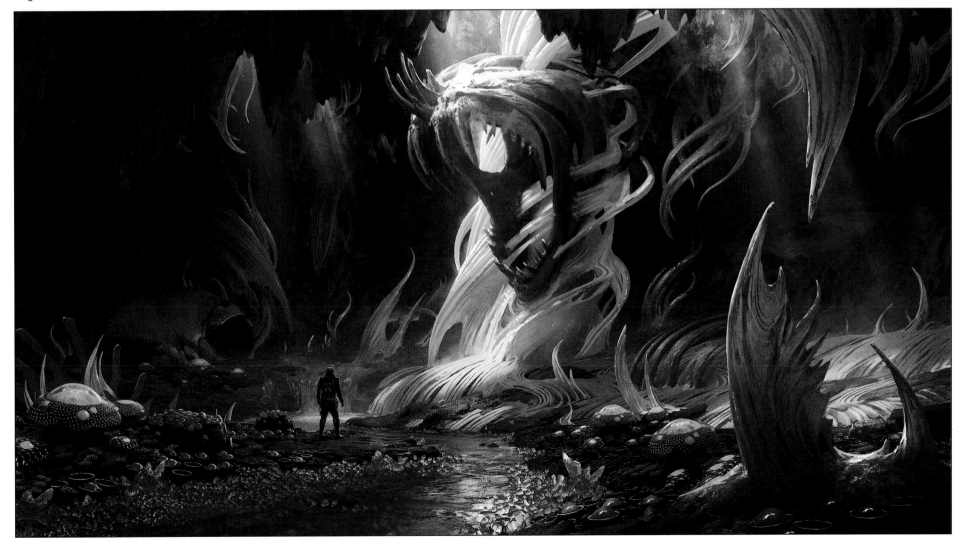

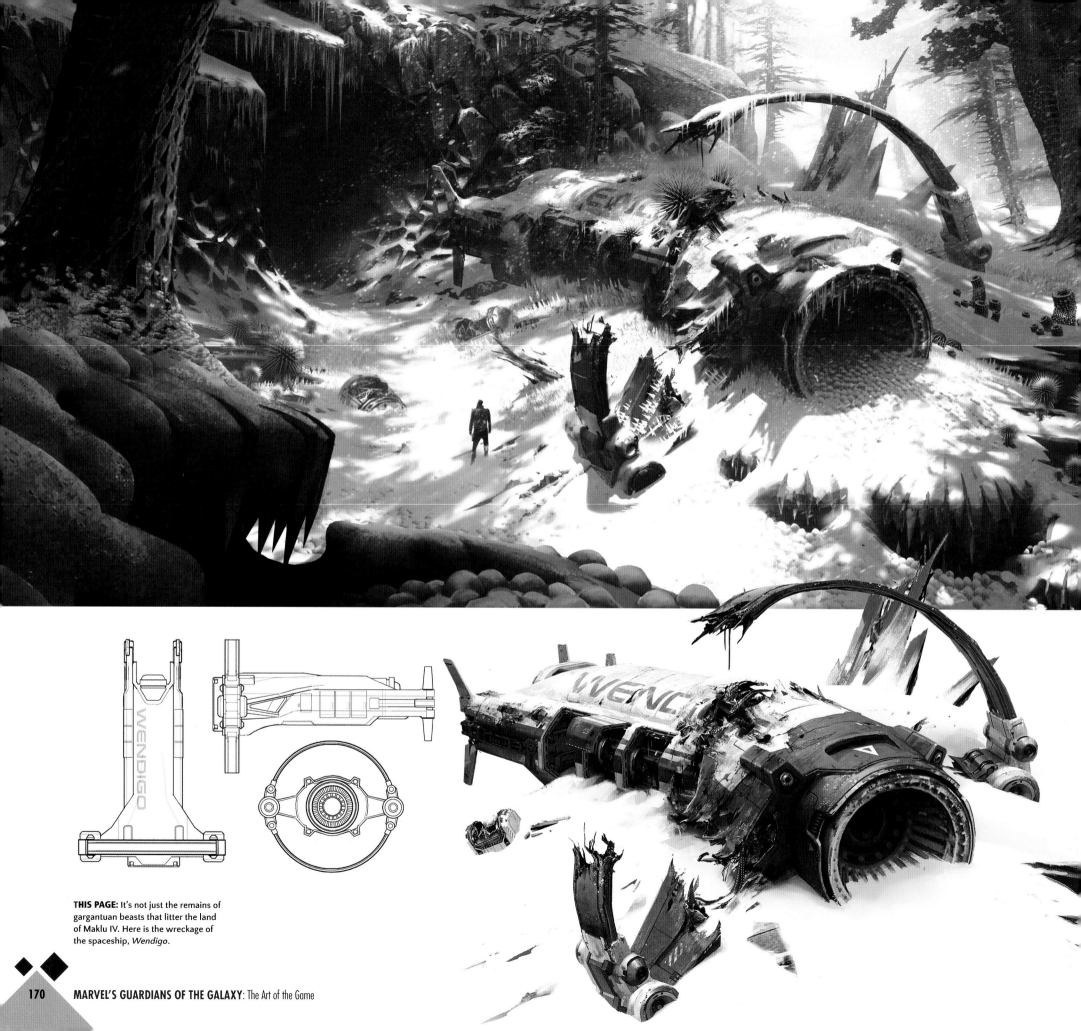

THIS PAGE: It's not just the remains of gargantuan beasts that litter the land of Maklu IV. Here is the wreckage of the spaceship, *Wendigo*.

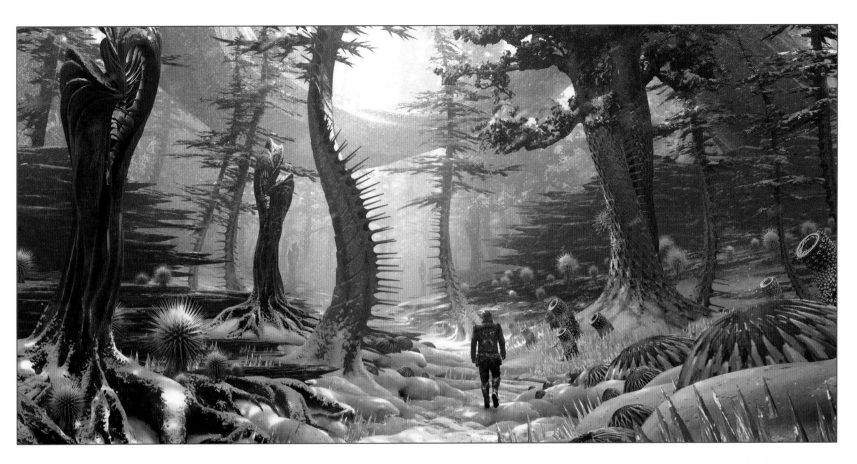

THIS PAGE: Hostility is present even in the plant life: everything is spiked or barbed, and those tree trunks look suspiciously similar to Venus flytraps. Whatever you do, Star-Lord, don't get too close.

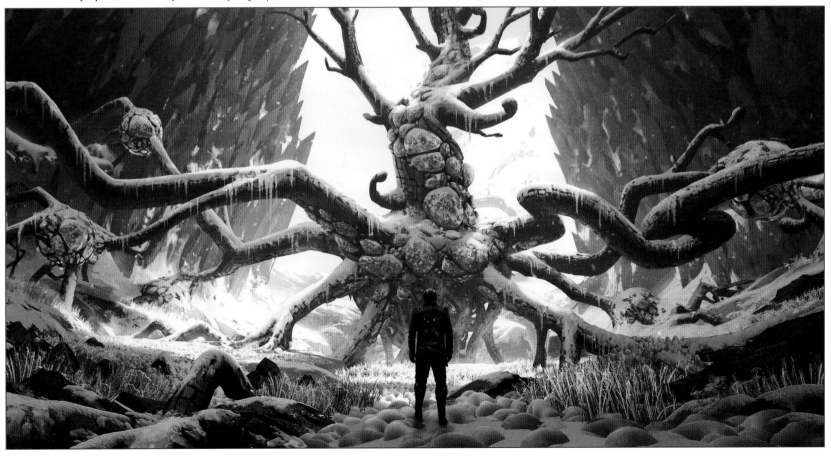

FIN FANG FOOM

The team at Eidos-Montréal appreciated the opportunity to be able to pick and choose from the vast roster of characters and creatures from Marvel's Guardians comic books. Perhaps one of the biggest dilemmas they faced was deciding which ones to include, and which ones to sadly leave out. There were many things to consider, such as how they'd fit into the developing story, and which ones the fans will most want to see brought to life on-screen.

"From the very beginning, Fin Fang Foom was on the top of our list of characters we wanted to include," says senior creative director Jean-François Dugas. "In the comic, he's a talking dragon who wears purple shorts. We didn't use that design, but we appreciated the aura around the character and knew how popular he is with the fans."

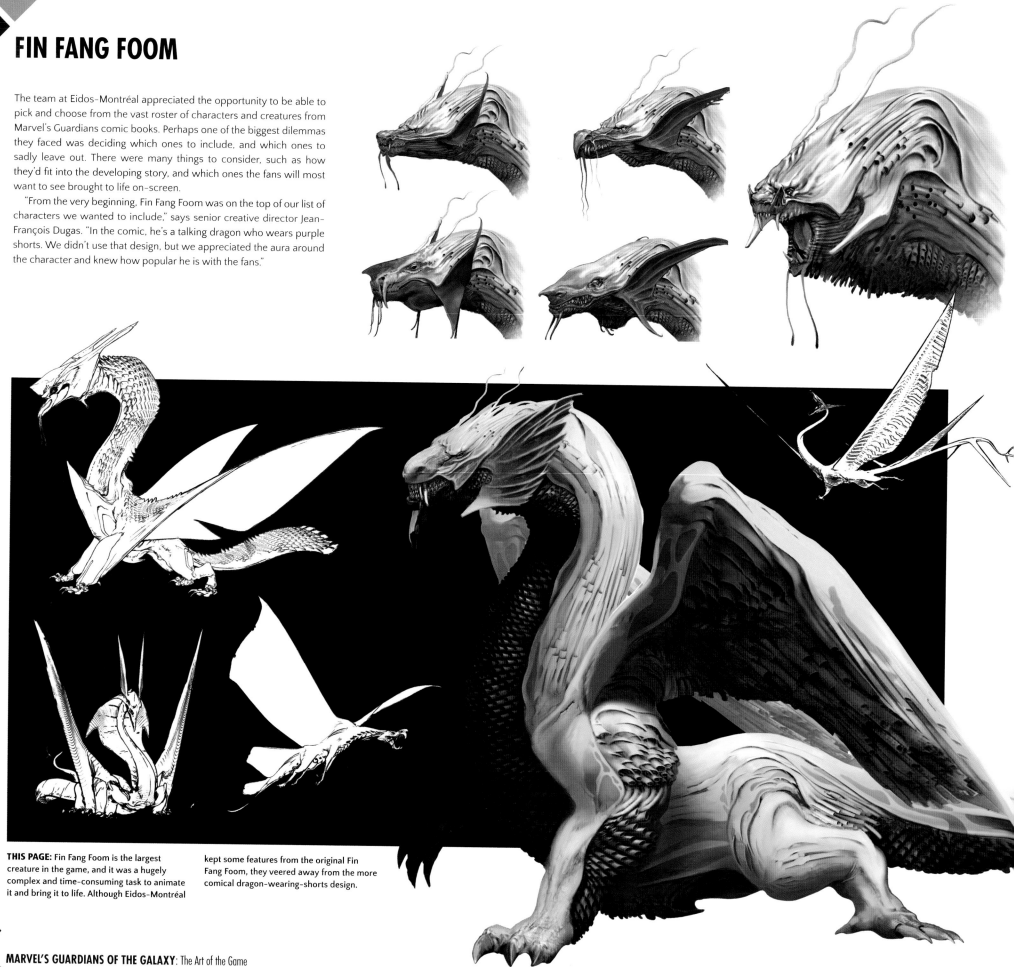

THIS PAGE: Fin Fang Foom is the largest creature in the game, and it was a hugely complex and time-consuming task to animate it and bring it to life. Although Eidos-Montréal kept some features from the original Fin Fang Foom, they veered away from the more comical dragon-wearing-shorts design.

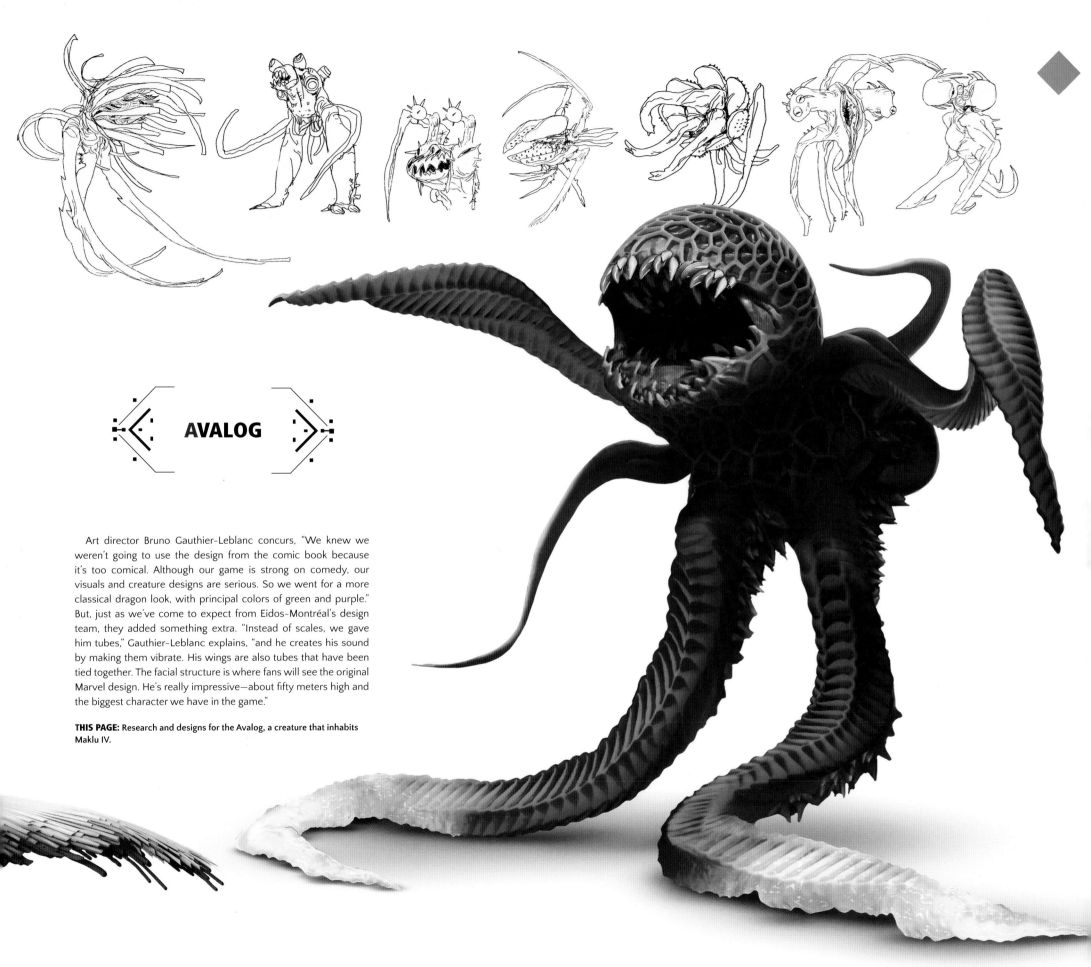

AVALOG

Art director Bruno Gauthier-Leblanc concurs, "We knew we weren't going to use the design from the comic book because it's too comical. Although our game is strong on comedy, our visuals and creature designs are serious. So we went for a more classical dragon look, with principal colors of green and purple." But, just as we've come to expect from Eidos-Montréal's design team, they added something extra. "Instead of scales, we gave him tubes," Gauthier-Leblanc explains, "and he creates his sound by making them vibrate. His wings are also tubes that have been tied together. The facial structure is where fans will see the original Marvel design. He's really impressive—about fifty meters high and the biggest character we have in the game."

THIS PAGE: Research and designs for the Avalog, a creature that inhabits Maklu IV.

WENDIGO

"Marvel gave us *carte blanche* on how we used their creatures; the 'go' to do whatever we wanted," says a grateful Bruno Gauthier-Leblanc. "Wendigos appear on the planet Maklu IV, and we gave their fur a rectangular design. If you look at Ruby Thursday [see opposite page]—who's a hunter looking to kill Fin Fang Foom in our story— you'll see that her coat is made from the fur of the wendigo. It's inferred that she's hunted a wendigo and made a nice coat from it to keep warm on this freezing planet. These are the little storytelling details we like to put into our designs. Players might not even notice it, but it's there."

MUSHIIGER
A poisonous quadruped

TOP: Concepts for the fearsome Wendigo.
LEFT: The design for the Mushiiger.

RUBY THURSDAY

"Ruby Thursday is one of our cameo characters from Marvel lore," Gauthier-Leblanc explains. "We stuck to the source material but gave her some of our own unique designs. Her face is a red ball with tendrils coming out of it. It's such a weird and original design that we didn't feel the need to stray too far from it. If something is a great idea already, we don't fight it, we use it. The ball also fits in perfectly with our Neo 3D concept."

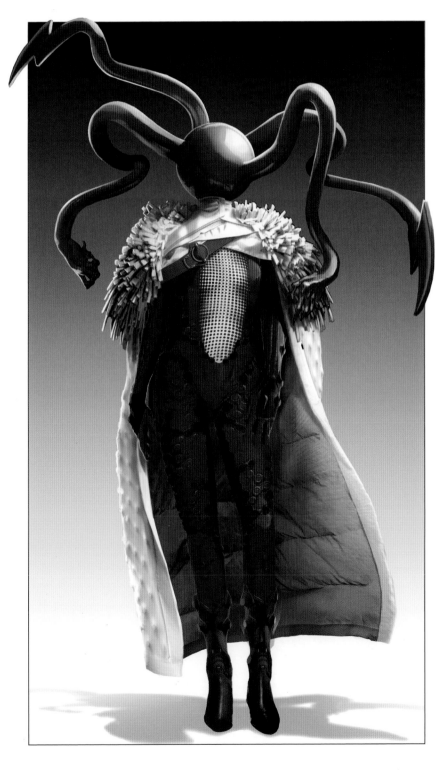

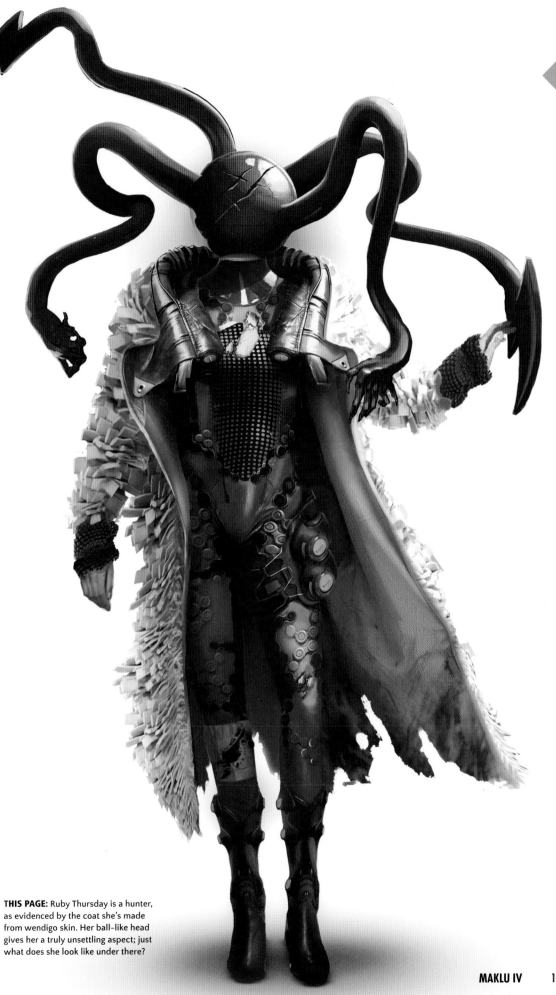

THIS PAGE: Ruby Thursday is a hunter, as evidenced by the coat she's made from wendigo skin. Her ball-like head gives her a truly unsettling aspect; just what does she look like under there?

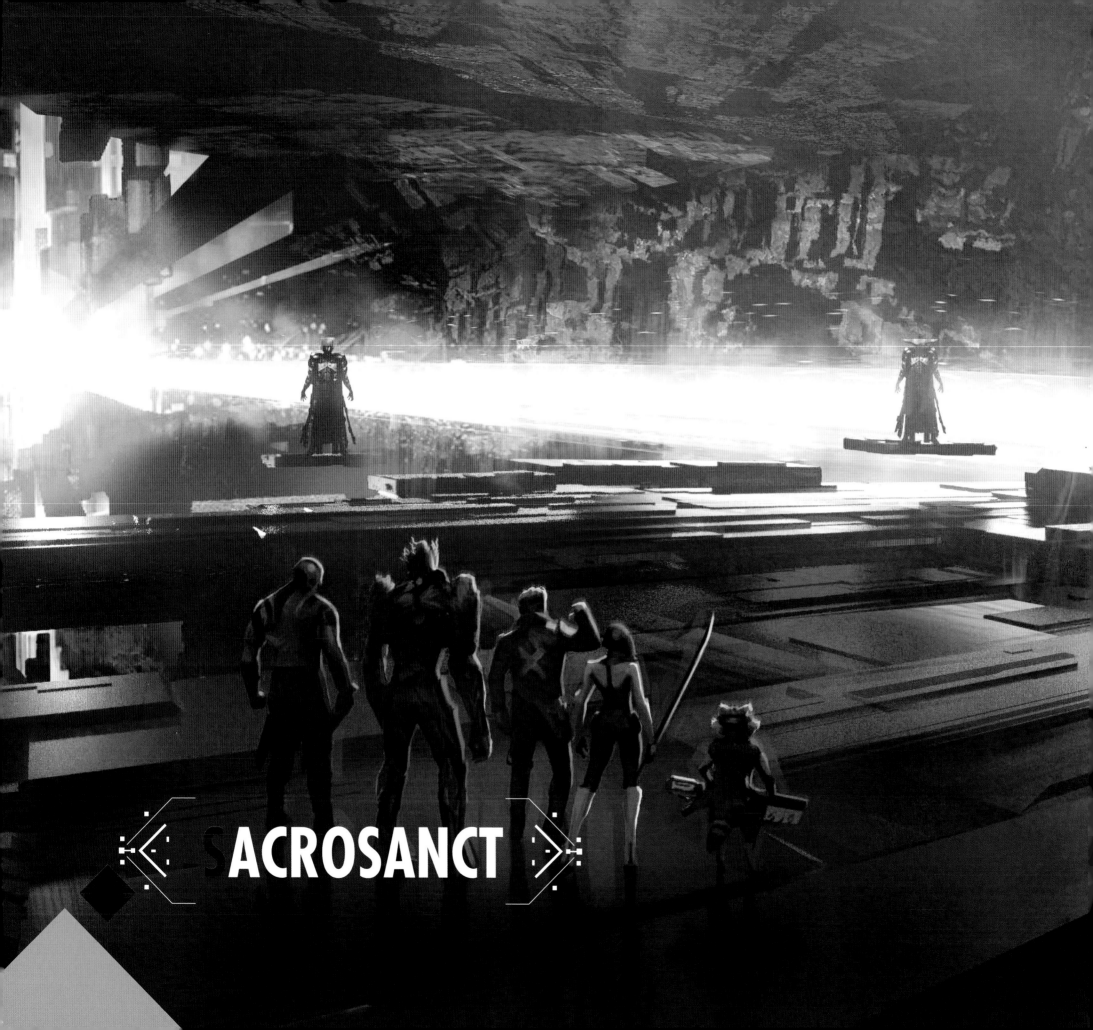

SACROSANCT

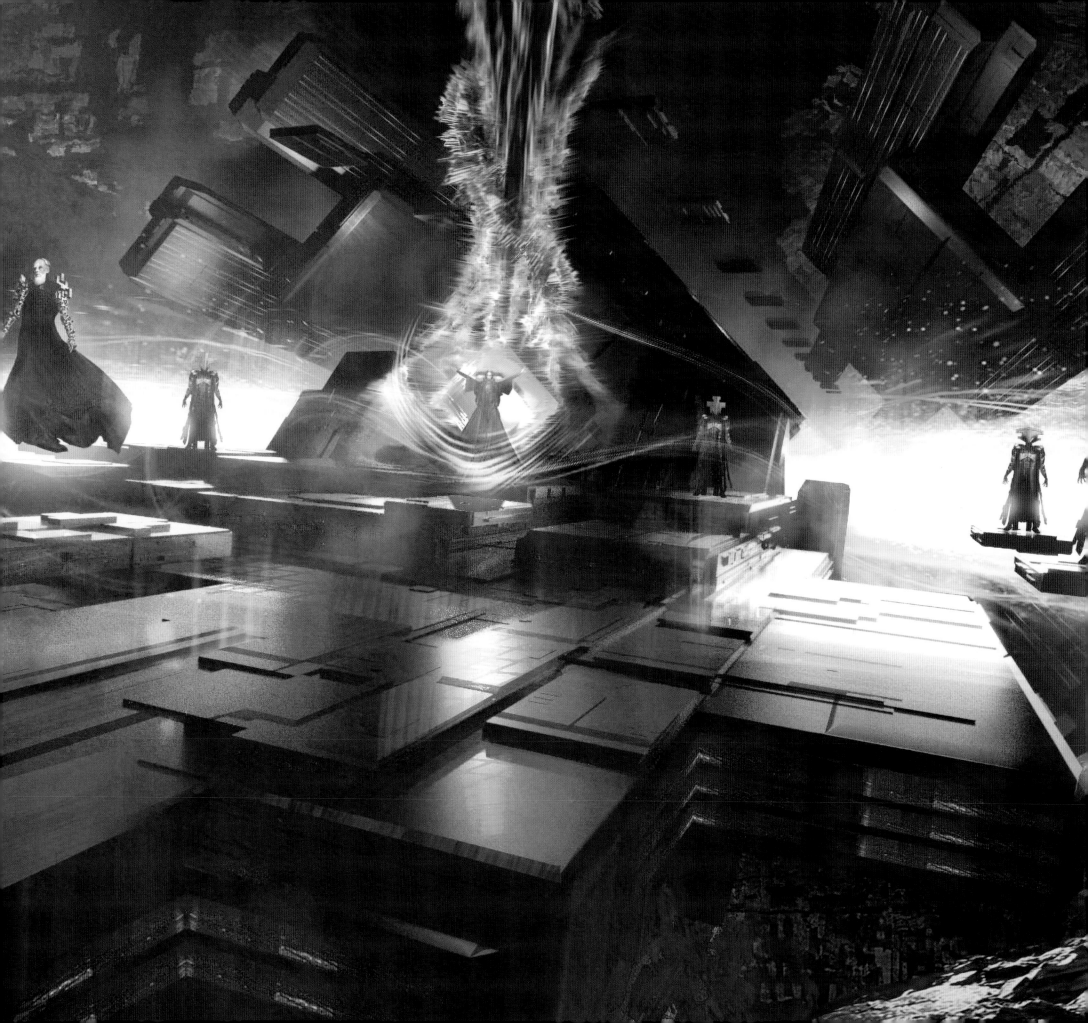

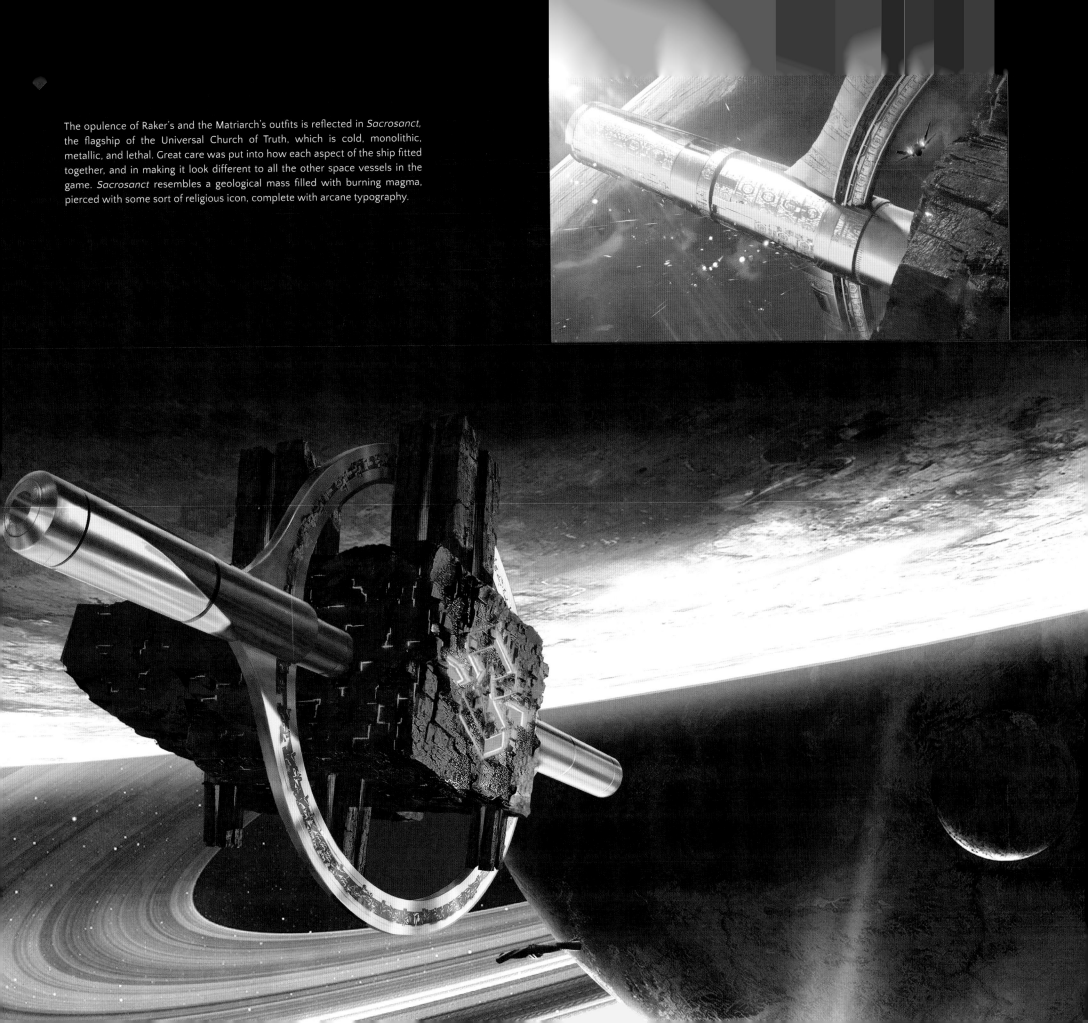

The opulence of Raker's and the Matriarch's outfits is reflected in *Sacrosanct*, the flagship of the Universal Church of Truth, which is cold, monolithic, metallic, and lethal. Great care was put into how each aspect of the ship fitted together, and in making it look different to all the other space vessels in the game. *Sacrosanct* resembles a geological mass filled with burning magma, pierced with some sort of religious icon, complete with arcane typography.

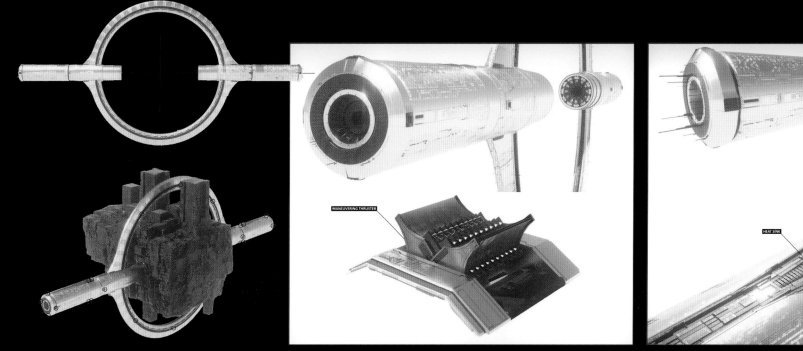
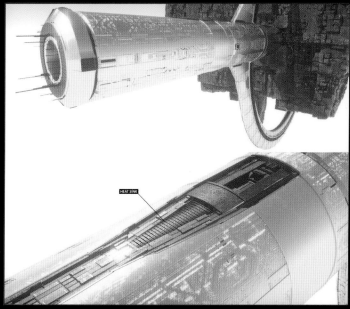

THIS SPREAD: Designs for the Church of Universal Truth's flagship, *Sacrosanct*.

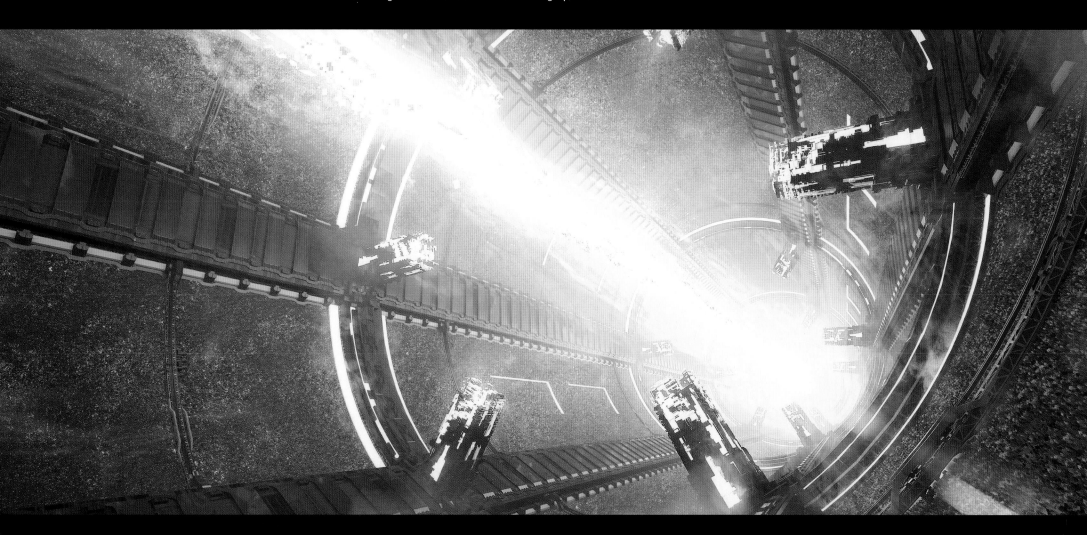

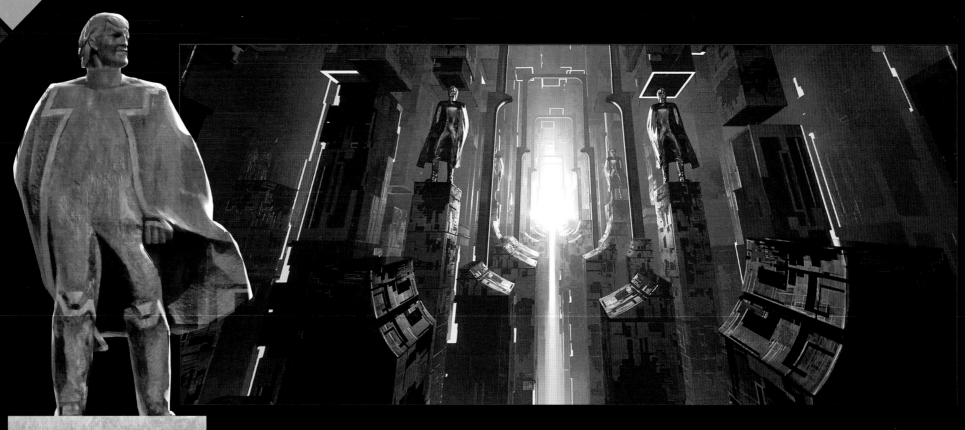

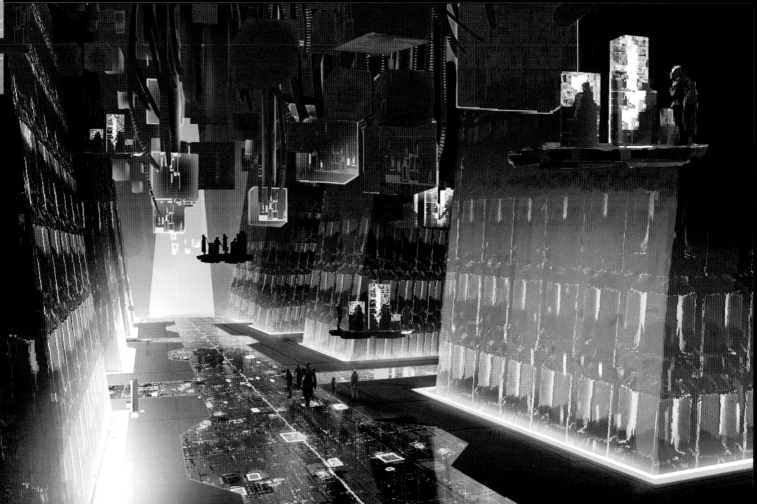

HIS PAGE: Like the most fabulous cathedral ever dreamt up in the mind of an architect, *Sacrosanct's* interior is a vast space created to venerate Adam Warlock, complete with statues and gleaming gold.

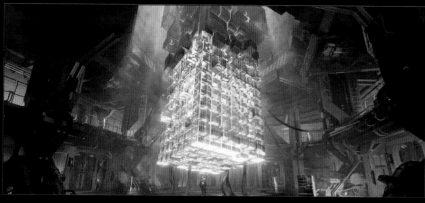

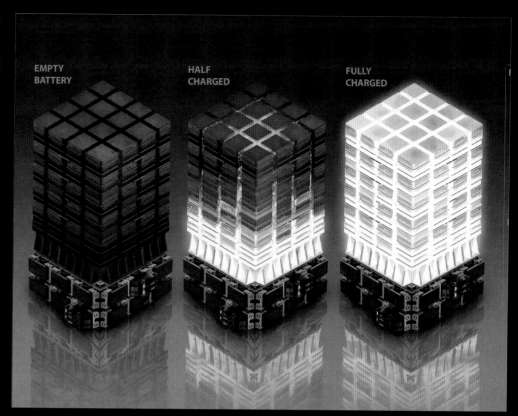

THIS PAGE: Here again we see Eidos-Montréal making the best use of color, contrast, and their Neo 3D idea of repeating symmetrical geometric shapes to create intense and arresting play spaces within the game.

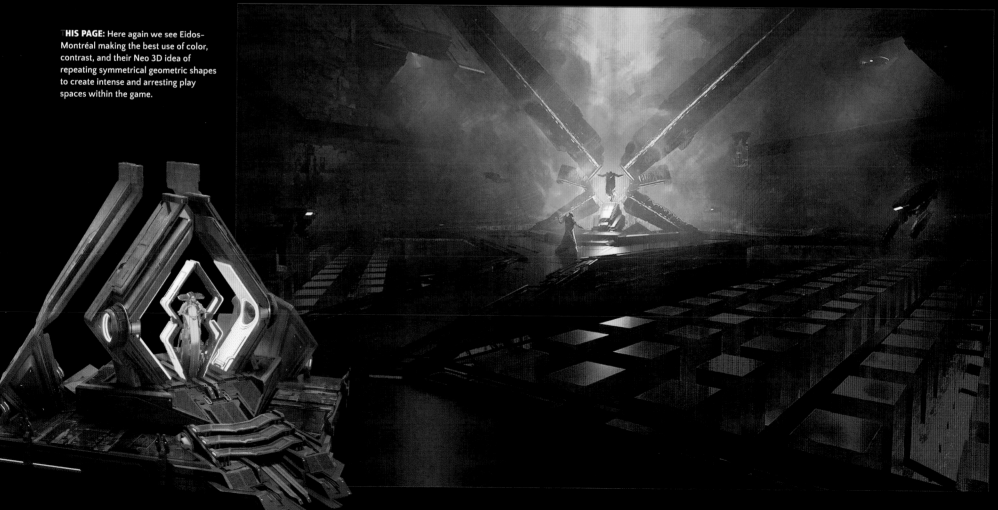

THE SCORE

ust like in the two movies, music plays a central role in *Marvel's Guardians of the Galaxy*. First here was the soundtrack, which needed to reflect he player's experiences and mirror the emotions nvoked by the events playing out on-screen. Then here were the individual licensed tracks, which were carefully chosen to fit perfectly into a scene, or emphasize a theme or emotional beat.

"We want our work to amplify what the player sees on screen," senior audio director Steve Szczepkowski explains. "Our job is to softly and organically wrap the player up in a spell, and if we succeed, the player will get deeper and deeper into the game... What we want to *avoid* is the audio breaking that spell—if the player hears something out of place, it's like we've thrown a bucket of cold water over them, dragging them out of the experience."

But casting a spell doesn't require soothing music. "I wanted something *epic*!" Szczepkowski

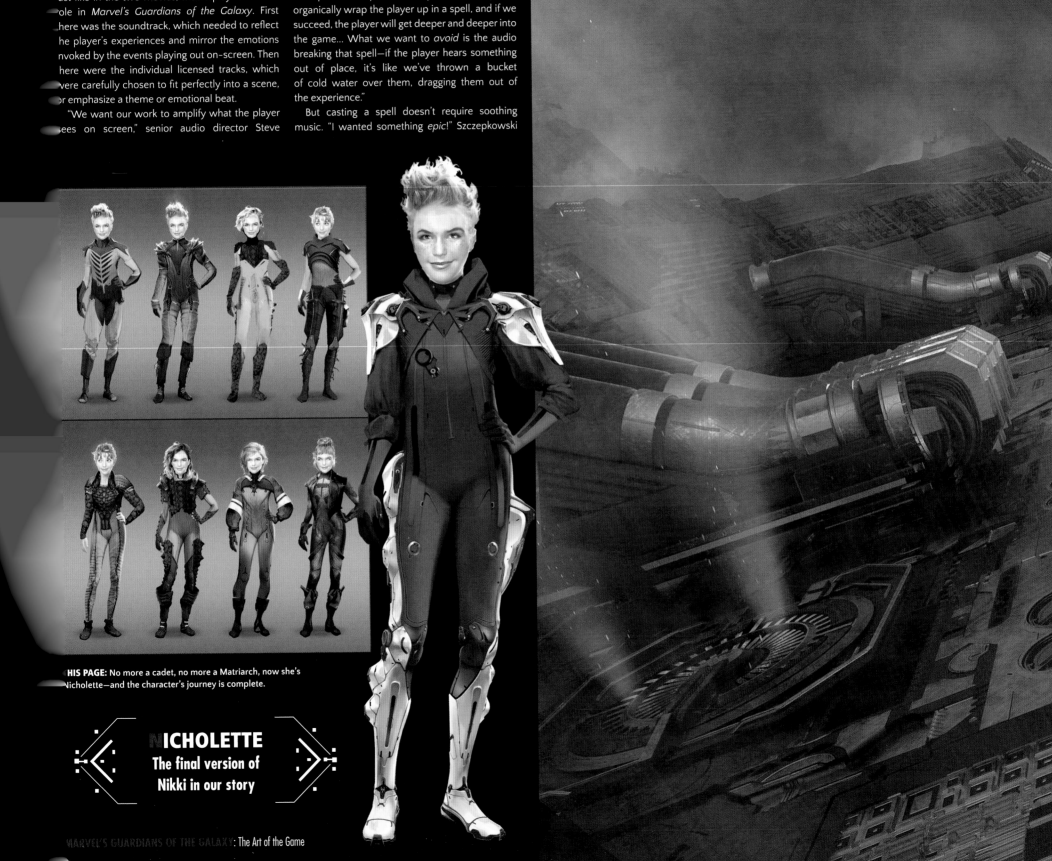

THIS PAGE: No more a cadet, no more a Matriarch, now she's Nicholette—and the character's journey is complete.

NICHOLETTE
The final version of Nikki in our story

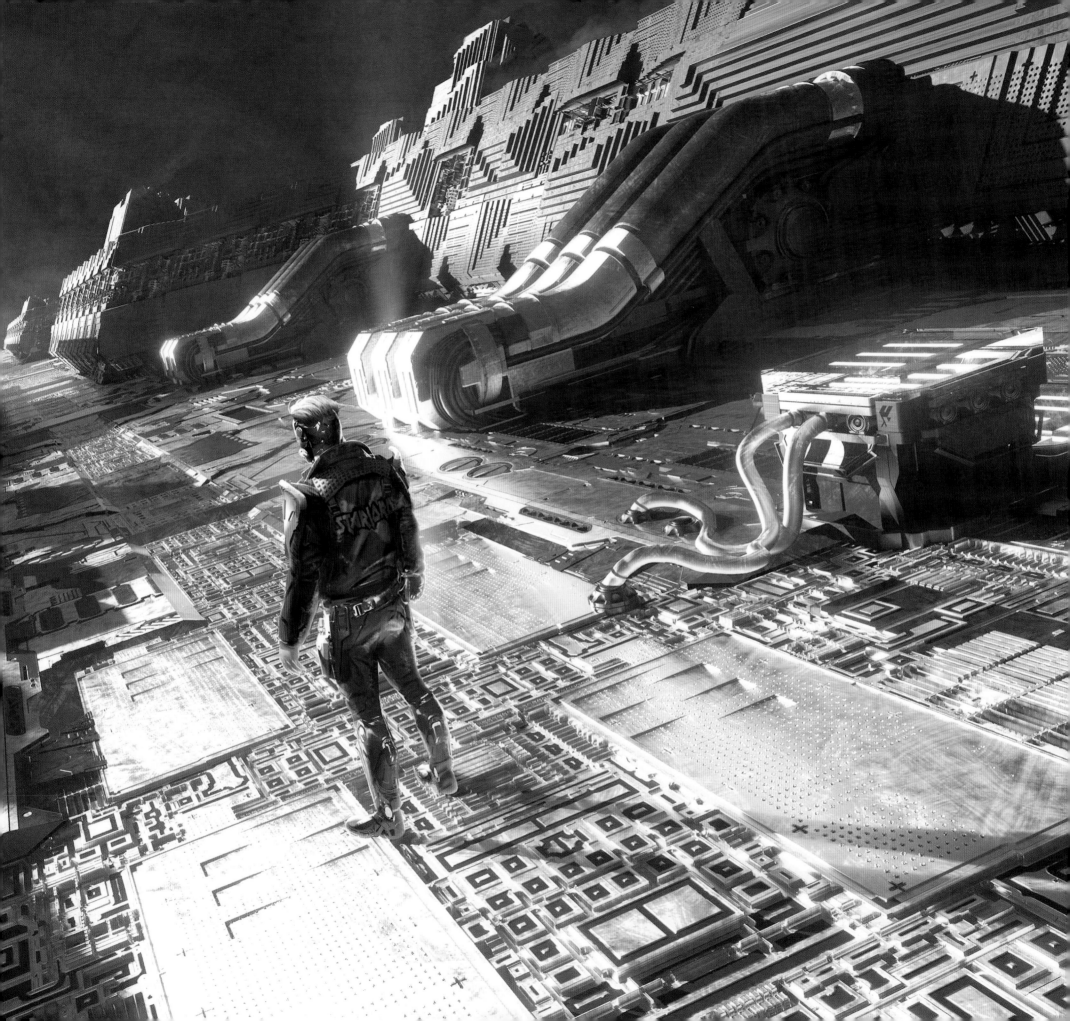

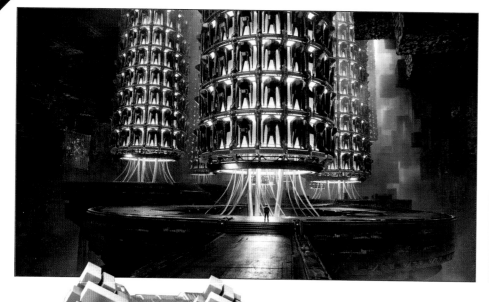

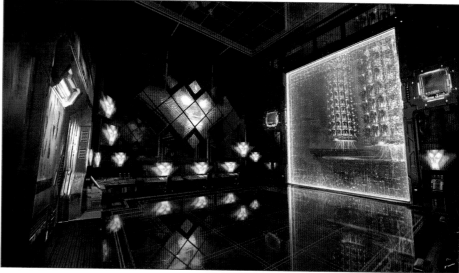

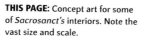

THIS PAGE: Concept art for some of *Sacrosanct's* interiors. Note the vast size and scale.

says. "A *Star Wars*, John Williams, over-the-top orchestrated score with a lot of strong themes. We chose [acclaimed British composer] Richard Jacques. We actually asked about ten top game composers to pitch for us, and as soon as I heard Richard's work, I thought, *That's our guy.* He'd sent in a few samples, including one that has actually become the Guardians' theme. It's really memorable and has a melody that sticks in your head."

AAA video games are scored with as much care and skill as any big movie, the difference being games are much longer. "Scoring a video game is not easy," Szczepkowski says. "How I go about it is by watching walk-through videos of each chapter and breaking them down. I'll note key moments that I know we'll need to hit. For example, during establishing shots when the player enters a new location, we want a musical stinger to accompany that because it makes for a much more synergy-driven experience—with the camera moving and music swelling and everything coming together.

"As I look at individual cutscenes, I might think it would be better served with a licensed track rather than a piece of orchestrated score. There's a great moment when the *Milano* is flying into the

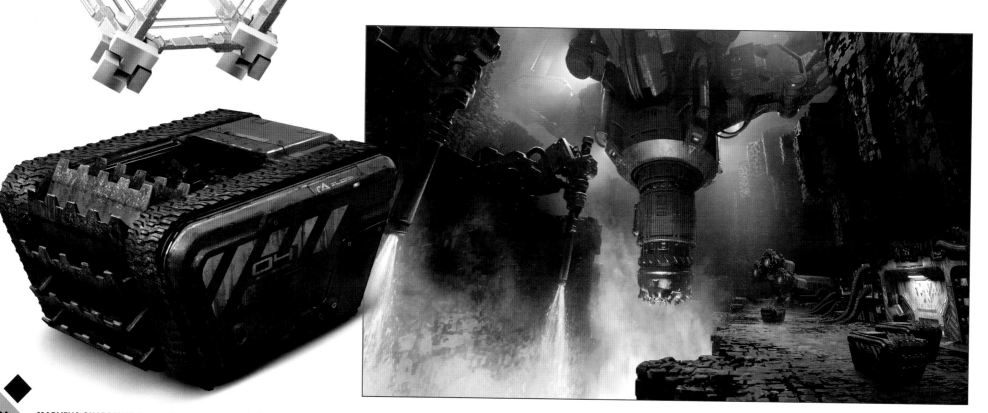

giant head of Knowhere, and I decided to score it with Gary Numan's song 'Cars'—and it works brilliantly. I can't tell you why—for me, it's a gut thing; I'll try something and decide, *That's it!* I'm always trying to think of what will get the best player reaction, what's going to put a smile on their face."

Marvel's Guardians of the Galaxy promises to have a unique blend of music, adding to its signature style. Szczepkowski grins and says, "With Star-Lord's soundtrack, the licensed music, and our death metal guys, this is a very rock 'n' roll game!"

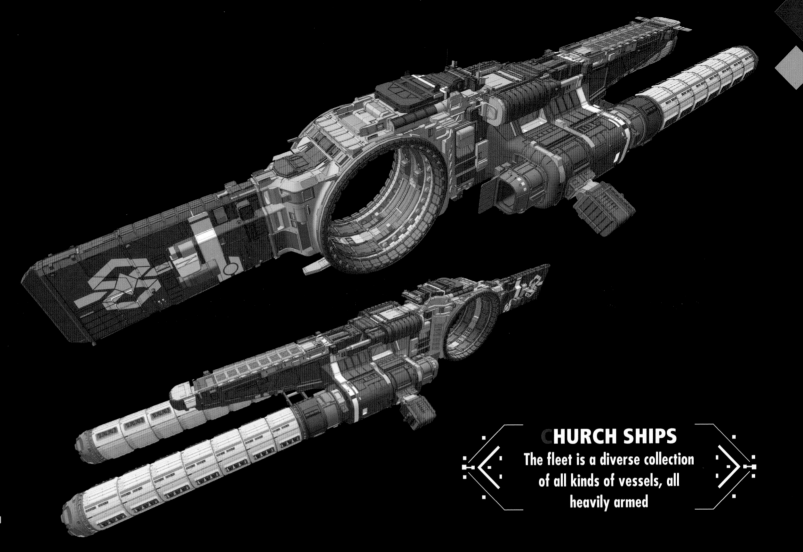

THIS PAGE: Concept art for Church ships of all sizes and shapes.

CHURCH SHIPS
The fleet is a diverse collection of all kinds of vessels, all heavily armed

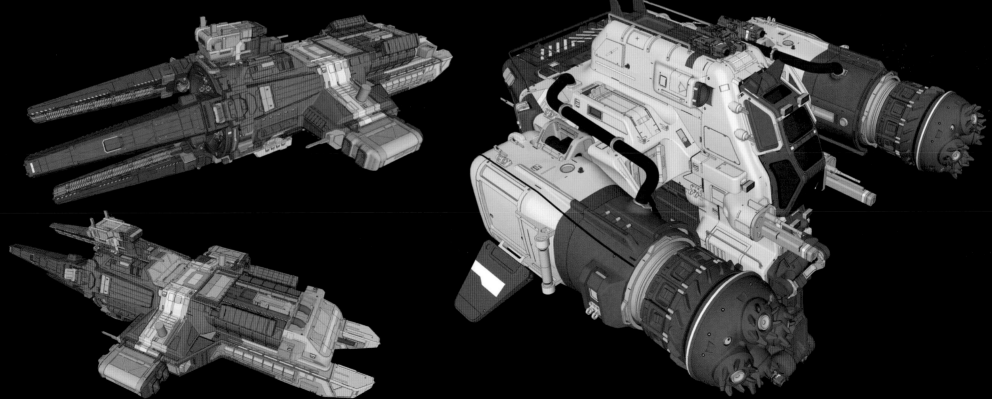

THE MAGUS

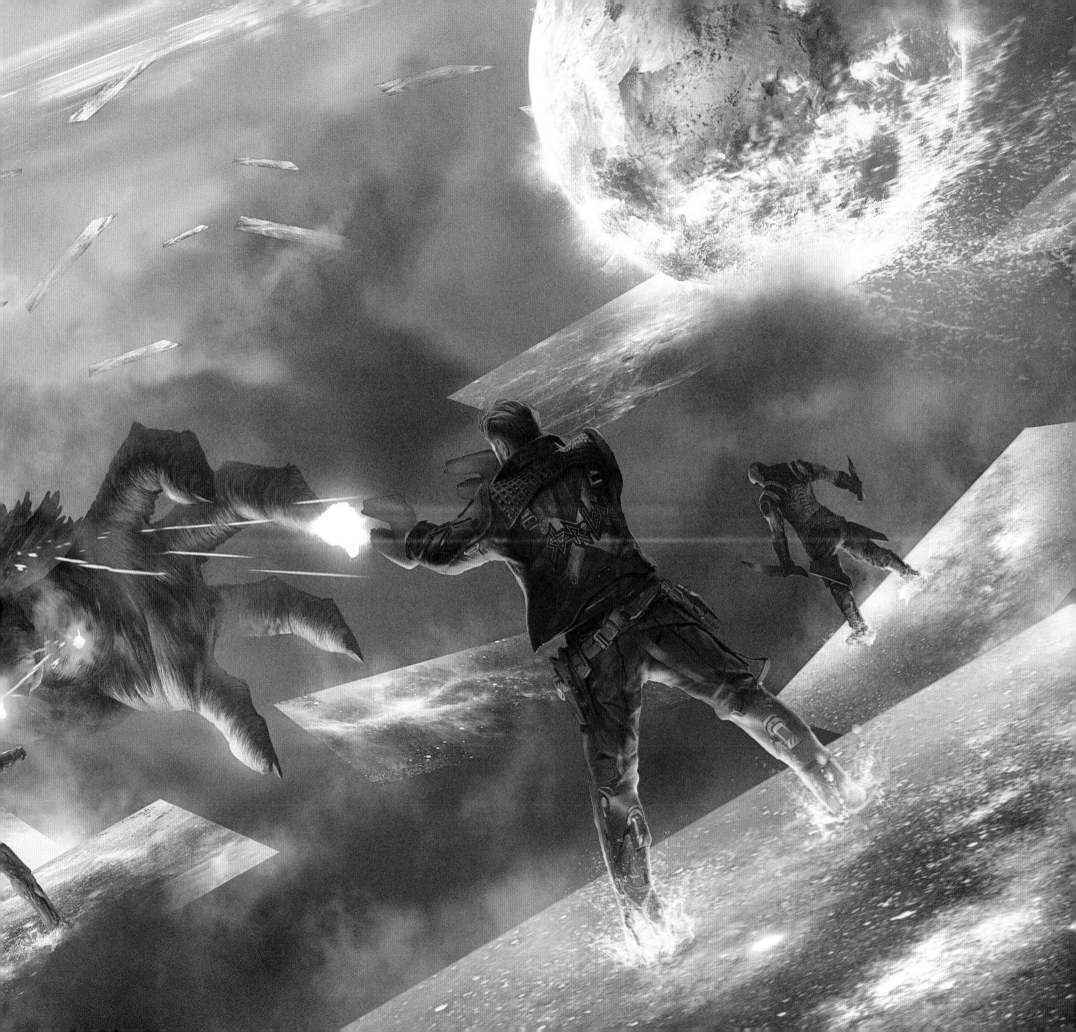

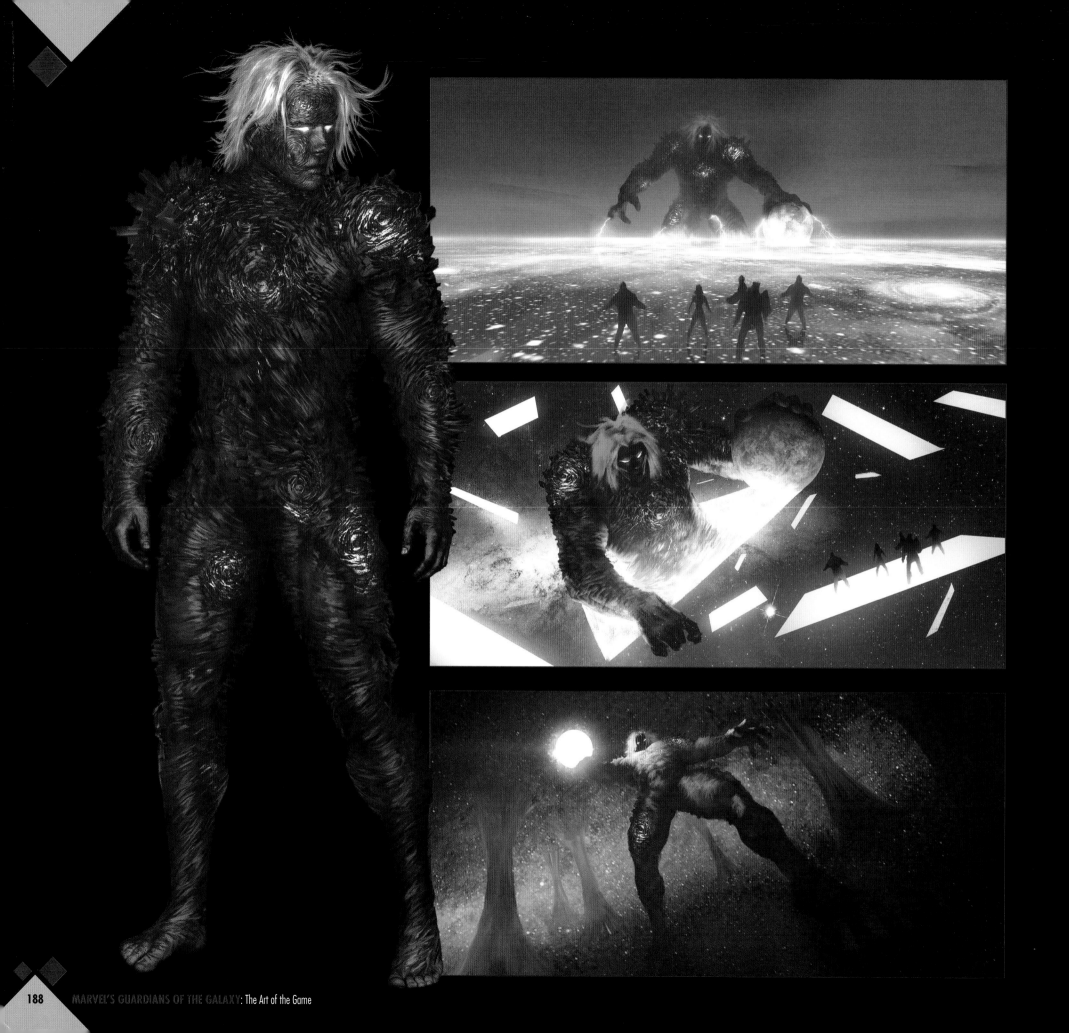

ADAM AS THE MAGUS

And so we arrive at the game's denouement. After much banter and many struggles, arguments, puzzles, (temporary) estrangements, and wrong turns, the Guardians must face their final battle—an awe-inspiring combination of the Magus Entity that Star-Lord and Rocket inadvertently released right at the start of the story, and the mysterious Adam Warlock.

"The Magus is the last boss in the game," lead character artist Genci Buxheli explains. "He's still Adam Warlock underneath, but he's covered in spirals and thick metal plates that are lit from behind and flow all over his skin. His face needed to move and emote and be expressive—it was very complicated to design and animate to make it look good, but I'm pleased with the results."

Senior creative director Jean-François Dugas is also pleased, especially with how different characters/entities in the game combine to create something unique—a special challenge for the Guardians to face. "The Magus Entity [after it's merged with Adam Warlock] has the same texture, colors, and motion as it did back in the Quarantine Zone, but the player will be able to see that it's become more than it was at the beginning of the game."

OPPOSITE RIGHT: The Guardians face off against the mighty Magus in the game's grand finale. The galactic setting, the vast open space, and sheer size of their enemy make this a showdown worth waiting for.

THIS SPREAD: This design incorporates the human (if god-like) figure of Adam Warlock with the Magus Entity the Guardians met at the start of their adventure. It has the power to destroy entire worlds, so how will our heroes kill it?

FINAL THOUGHTS

Sometimes a job is just a job. Sometimes it's a whole lot more...

"I'm going to miss the crew when the project's over," sighs Drax actor Jason Cavalier. "They're a family who I've grown to love. It's rare to have the opportunity to work with the same group of people for an extended period of time, and to develop a relationship and rapport with them. I'm sure the results of that will show on-screen and in our performances."

"The opportunity to play a Super Hero makes the little kid inside every actor overjoyed," says Alex Weiner. "It's a dream come true to be Rocket; an honor to play such a well-established character who's been developed over the years and over multiple iterations in comic books and movies. It's like being asked to play Iago—it's been done before but that's a really good thing."

"Working on *Marvel's Guardians of the Galaxy* is without doubt the best experience of my career," senior audio director Steve Szczepkowski concurs. "I've been playing in bands since I was fourteen and have spent probably half my life gigging in bars and clubs. And now I'm working on a game that's full of licensed tracks, amazing scored music, and I got to write and record an album of metal [music]. I couldn't ask for a better fit! It almost feels like my life has led me toward this point, and now it's up to me to seize the moment and make this a kind of legacy."

"I see how personal our game is to the creative team," says senior creative director Jean-François Dugas, "and that's helped make it a richer experience. When a project speaks personally to you through its story and themes, you become more passionate and you put one hundred percent of yourself into it."

Star-Lord actor Jon McLaren's delight at playing the role is palpable. "It's not often that I cry when I'm offered a role, but I did for this," he admits with a grin. "And it might sound like a cliché, but I can honestly say that working on *Marvel's Guardians of the Galaxy* has been the best project I've ever been involved in. Listen, I grew up in a small town, so to end up working for companies like Eidos and Marvel—well, it's a dream come true, man!"

McLaren thinks for a moment, then delivers a heartfelt message to the fans, "Thank you to everyone who plays the game, and for accepting us as part of the Marvel team. After four years of working with Eidos-Montréal, I can tell you that they love this universe and the Guardians as much as anyone who reads this book and plays the game. I hope you enjoy it."

AUTHOR ACKNOWLEDGMENTS

The author would like to thank all of the dedicated, hard-working folk at Eidos-Montréal and the fantastic, effervescent actors, for giving up their time to talk to me about their experiences. Without you, this book wouldn't exist.

I would also like to thank the brilliant team at Marvel, Osama Deeb for his peerless organizational skills, Tim Scrivens for making this book oh so beautiful, and Stephanie Hetherington for being such a helpful, patient, and supportive editor.

ARTIST CREDITS

Art Director
Bruno Gauthier-Leblanc

Concept Artists
Frederic Bennett
Nicolas Lizotte
Arnaud Pheu
Mathieu Chevalier
Sean Vo
Mohit Panjikar
Chase Toole
Nicolas Francoeur-Jérémie
Michel Chassagne
Francesco Lorenzetti
Nivanh Chanthara
Yohann Schepacz
Martin Sabran

Outscourcing
Denis Melnychenko
Frederic Augis
Heng Zheng
Alexey Pyatov
Matthieu Rebuffat